Turn-of-the-Century Antiques

An Encyclopedia

To Joyce

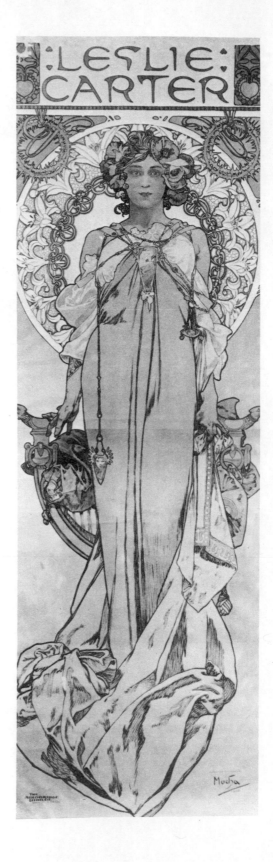

Poster by Mucha of Leslie Carter, 1908.

Turn-of-the-Century Antiques
An Encyclopedia

James Mackay

A Dutton Visual Book
E. P. Dutton & Co., Inc. New York
1974

Published in Great Britain by
Ward Lock Limited, London, as
Dictionary of Turn of the Century Antiques.

ISBN: 0-525-49504-5
Library of Congress Catalog Card Number: 74-3641

Designed by Michael R. Carter.
Text filmset in Imprint 10/11 pt by
V. Siviter Smith Ltd., Birmingham, England.
Printed and bound in Spain by
Heraclio Fournier, S.A., Vitoria.

Introduction

The turn of the century, the two decades from 1890 to 1910, was an exciting time in which to have lived. It was a period of great economic and political stability; with the exception of France and Switzerland, monarchy seemed firmly entrenched all over Europe. Apart from minor, localized affairs, there had been no major conflict involving international power groups since 1856, and fully a century elapsed between the earth-shaking events of Napoleon's Hundred Days and the holocaust of the First World War. The Balkans, Korea or any other trouble-spot of this era must have seemed very remote to the average European or American. It was an age of unparalleled industrial expansion and population growth. Solid, prosperous middle-classes emerged in even the less advanced countries, and all levels of society enjoyed a sophistication which was unknown to earlier generations. The people of the late nineteenth century could look back on the Seven Wonders of the ancient world and match them with their own: the internal-combustion engine, motion pictures, the wireless telegraph, electric light, X-rays, the phonograph and powered flight by heavier-than-air machines. Every day seemed to bring new and exciting developments in the progress of mankind.

The turn of the century was an exciting time also in the applied and decorative arts. The French expression *'fin de siècle'* has come to be synonymous with decadence. The aestheticism expressed by Oscar Wilde, J. K. Huysmans and Robert de Montesquiou had its parallels all over Europe and even extended to America. The strange, exotic, luxuriant and faintly decadent spirit of the times had its flowering in the sinuous lines of Art Nouveau. It was a period of eclecticism, when artists and designers drew freely on all the artistic styles and movements of previous generations from every part of the world, and often jumbled them together in a riotous *compôte*. The craze for Japanese art and artefacts was predominant, but inspiration was also derived from the ancient civilizations of Greece and Rome, Persia, India, Peru, Mexico, Benin and China. Nevertheless, it is significant that the German term for the turn of the century developments in the arts was *Jugendstil* or 'youth style', implying vigour, freshness, originality and modernity. The followers of the Arts and Crafts Movement, on the one hand, rejected modern, mass-production techniques and sought to return to first principles, to handicrafts and inspiration from nature; the

disciples of *Jugendstil,* on the other hand, did not spurn the machine, if it could be used to their advantage, and they looked forward, in an age of speed and light, to producing works which would express the qualities of the age.

The major countries of Western Europe and the United States each had an important part to play in the development of the applied and decorative arts. In Britain, the desire for improvement in industrial design can be traced back to the Great Exhibition of 1851 and, even earlier, to the Royal Commission on the Fine Arts in 1835. The Gothic Revival of the mid-nineteenth century stimulated interest in medievalism, manifested in the fine arts by the activities of the Pre-Raphaelites. The Oxford Movement and other trends towards high Anglicanism and Catholicism were reflected in the religious overtones of the early work of William Morris, Philip Webb and Burne-Jones. It would be difficult to overstate the importance of Morris to the artistic development of Britain in the second half of the nineteenth century. His high ideals turned him in later life towards socialism which he approached from the artistic viewpoint. As his disciple Walter Crane later wrote: 'he hated the shams and pretences and pretentiousness of modern life and its glaring contrasts of wealth and poverty; he noted the growing ugliness of our cities; he loved simplicity; and, with all his keen artistic sense and instinct for colour and inventive pattern, I believe he preferred plainness, and even rudeness, to insincere or corrupt forms of art'. Ironically, however, Morris ultimately contributed to art's exclusiveness instead of really bringing it to the masses.

Two important movements stemmed directly or indirectly from the teachings of Morris. The Arts and Crafts Movement began in the early 1880s, with the formation of such bodies as the Century Guild, the Art Workers' Guild and the Arts and Crafts Exhibition Society, aimed at bringing artists and craftsmen closer together, to raise standards of workmanship and to put artistic pride into even the most mundane articles. This glorification of craftsmanship and handicraft at the expense of mechanization was a natural reaction against the mass-production techniques which increasingly pervaded the applied arts in the nineteenth century. By the turn of the century, however, there was a compromise, and the second-generation designers of the Movement were prepared to make use of machines and mechanical techniques when these did not detract from the end product. The Aesthetic Movement, which flourished from about 1870 to the mid-1890s, was founded on an elitist principle which genuinely strove to raise standards of design and taste. In 1882, Walter Hamilton summed it up by saying that 'the essence of the movement is the union of persons of cultivated taste to define and to decide upon what is to be admired'. The Aesthetes claimed for themselves a sensitiveness to the artistic impression entirely superior to that of the 'members of the common Philistine herd' as H. G. Hutchinson later described it. At its height, the Aesthetic Movement pervaded every medium of the arts, and artists and designers such as Christopher Dresser, Bruce Talbert and Whistler were involved with wide-scale design and production in the decorative arts. This early aspect of the Movement combined the quasi-religious elements of the Pre-Raphaelites with the Japanese influence which reached its peak about 1880.

The Aestheticism of the 1890s, as expressed in the lives and work of Aubrey Beardsley and Oscar Wilde, was largely confined to literature and book- and magazine-illustration.

On the continent of Europe, the artistic styles which culminated in Art Nouveau at the turn of the century had their origins in France. Alone of all the major powers, France had suffered tremendous upheavals; politically, socially and economically. The revolutions of 1830 and 1848, which ousted the Bourbons and the Orleanists respectively, continued the process which began violently in the late eighteenth century. The splendours of the Second Empire under Napoleon III were offset by the disastrous Franco-German War of 1870–1 and tragically underlined by the Paris Commune and its hideous aftermath. Although the traditional styles of the eighteenth century lingered on, 'modernity' found readier acceptance in France than in any other country. Two major artistic movements flourished in the last third of the century: Naturalism and Symbolism. To the Symbolists the most ordinary and utilitarian objects contained hidden, mystical meaning. To the Naturalists, nothing was too mean or mundane to be transformed into a thing of beauty. To an outsider, it must have seemed as though French art was preoccupied with the seamier aspects of life, whether in the writings of Zola and Maupassant, or in the paintings of Gauguin and the lithographs of Toulouse-Lautrec. Anarchism and Utopian socialism were widespread in France in the early years of the Third Republic, and from this sprang the preoccupation with 'industrial art'. Jean Lahor imbibed the teachings of Ruskin and Morris and promulgated his own doctrines of art everywhere, in everything, for everyone. Oriental influence was very strong in France and it is significant that Bing, the promoter of Art Nouveau, had earlier made a lucrative living from the import of Japanese art and artefacts, and only turned to the 'new art' of Europe and America in the 1890s when the supply of Japanese material began to dry up. Art Nouveau was a fusion of Naturalism and Symbolism, with Oriental overtones.

Outside France, the closest parallel development in styles took place in Belgium, yet there were significant differences which arose from the consciousness of national pride, born of the fact that Belgium had only achieved independence in 1830. Attempts to find a truly national style led to the formation of the artistic group known as *Les Vingt* (the twenty) in 1884. Their influence on the applied arts was enormous and culminated in the distinctly Belgian form of Art Nouveau as practised by Victor Horta in interior design, and by Philippe Wolfers in jewellery and metalwork. To a much lesser extent, French ideals in art had their influence on Spain and Italy. At the turn of the century, France and Britain might have been at daggers drawn politically (the Fashoda incident of 1898 almost precipitated a return to the colonial warfare of the eighteenth century), but culturally there was a great deal of intercourse. The styles of Art Nouveau were enthusiastically adopted in England and given a distinctly English flavour before finding their way back across the Channel in the guise of *le style Anglais*.

The Civil War of 1861–5 was no less traumatic for the United States than the German occupation and the Commune were for France. The rapid expansion of industry, coupled with widespread immigration from Europe,

changed the character of the country in the last three decades of the century. America ceased to be a pioneer land, as the Indians were either exterminated or put on reservations. The annexation of Hawaii and Eastern Samoa; the war with Spain which resulted in the acquisition of Cuba; Puerto Rico and the Philippines passing from European to American control; and the lease of the Canal Zone from Panama; all indicated a sense of imperialism which belied the stated policy of isolationism. In the arts, as in politics, America reached out to every part of the globe. Interest in the arts of China and Japan, of Latin America and Africa was combined with the traditional styles which were themselves derived from the British, Dutch and German of the colonial era or imported with the waves of European migration from the 1860s onwards. This blend of Oriental or pre-Columbian influences with the styles and techniques of Europe could be seen in the furniture, glassware and ceramics of America in the late nineteenth century. These, especially art glass and studio pottery, found their way to Europe at the turn of the century where they exerted a considerable influence on the applied arts.

The turn of the century was an era of transition between the traditional, conventional classicism and new ideas in furniture, ceramics, glassware, textiles, metalwork and architecture. In America, still a new country, people preferred heavy 'reproduction' pieces which contrasted strangely with buildings designed on the basis of economy of structure. There was conflict between the traditionalism of the 'Beaux Arts' school and the young architects and designers of the Chicago School who revolutionized the design of buildings and furniture in the 1890s. In Europe, the break with the old ideas was often more dramatic, as, for example, in the *Sezession* movement in Austria and Germany.

The world of the arts and crafts was therefore in a turmoil at this time. Many new ideas and styles appeared; some were short-lived and have now become crystallized in the history of the period, but others contained the seeds which germinated in the 1920s and have come to full maturity nearer the present day.

Obviously there is no clear dividing line, marking off this epoch from the nineteenth century which preceded it and the twentieth which followed; and inevitably there are movements (such as the Aesthetic and the Arts and Crafts) which overlap with the period under review; they have been included in this book because of their prime importance to the developments which took place within the period. The arrangement of this book is alphabetical and lists classes of object and media, individual craftsmen and designers, manufacturers and groups, and styles and movements relevant to these two decades. The fine arts (painting and sculpture) are excluded, but painters and sculptors, such as Gauguin or Klimt, who were also active as designers or craftsmen or who had a direct influence on developments in the applied and decorative arts, are included for that reason.

Aesthetic Movement

A movement which attempted to restore beauty to an industrial age and quality to a period of mass-production, to counter the fussiness, tawdriness and ugliness which seemed to feature in the applied and decorative arts of the second half of the nineteenth century. Strictly speaking, the Aesthetic Movement is outside the scope of this book, since it began in the 1860s and attained maturity in the 1870s and 1880s, but it was the precursor of Art Nouveau and the Arts and Crafts Movement (qq.v.) and many of its protagonists were still active in the period around the turn of the century. Like its predecessor, the Pre-Raphaelite Brotherhood, the movement put forward idealist alternatives to the florid traditionalism which dominated European and American art and attempted to educate the new bourgeoisie out of their philistinism, not only in painting and sculpture, but also in furniture, silver, ceramics and the other applied arts.

It was this that inspired William Morris (q.v.) to combat pretentiousness in furniture and interior design from the 1860s onwards and led him back to simple forms adapted from traditional rural models. The Aesthetic Movement found practical expression in England with the foundation of the Art Workers' Guild (1884) and the Arts and Crafts Exhibition Society four years later, both inspired and led by Walter Crane (q.v.). The movement was exemplified in the illustrations of Crane and Kate Greenaway (q.v.), with their penchant for clear-cut lines and areas of flat colour; in the ceramics of William de Morgan (q.v.); in Morris furniture and wallpaper, and in the sconces and brackets

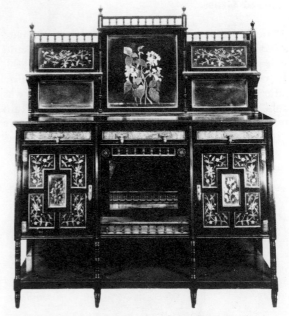

Inlaid ebonized cabinet in the style of the Aesthetic Movement, late 1880s.

of Thomas Jeckyll. The drawings of Aubrey Beardsley (q.v.) were a late manifestation of Aestheticism. Oscar Wilde, at the height of his fame in the early 1890s, was the arch-apostle of the movement. In some respects, the movement was preposterous and, like the other movements of the late nineteenth century, eclectic in its inspiration, drawing freely on Japanese art and medievalism when it suited. It was strongly derided by the traditionalists because of its extravagance, but it encouraged people to question artistic values and laid the foundations for Art Nouveau.

9

Alvin Manufacturing Company

Glass factory in Providence, Rhode Island, which flourished around the turn of the century. It specialized in a form of silver decoration on glassware using a deposit process developed in the 1880s, which was very fashionable between 1890 and 1910. In this method, silver was deposited, through electroplating, on a silver flux motif previously applied to the glass. The Alvin company used both clear and coloured glass as the basis for vases, beakers and bowls decorated with ivy-leaves, tulips, vines and other Art Nouveau designs.

Amber Glass

Type of fancy glass distinguished by its delicate shades of amber, popular with American and European glasshouses from about 1886 to 1900. It consisted of a clear yellow glass, shading almost imperceptibly into red. This effect was achieved by the judicious refining of certain portions of an amber-coloured glass until the desired reddish effect was achieved. Variations

of it were known as 'Rose Amber', 'Fuchsia Amber' or 'Amberina'. It was widely produced in the closing years of the nineteenth century, and other colours, such as green or blue, may be found in combination with the amber. Although it was produced in Britain by Webb (q.v.) and in Austria by Lobmeyr (q.v.), its chief exponents were the New England Glass Company and the Libbey Glass Company (qq.v.). A rare and short-lived variant was termed 'Plated Amberina', a speciality of the New England glasshouse, and is easily identified by its opaque lining, often with a bluish tinge, and by the presence of vertical ribbing on the outer layer.

Americana

A term used loosely to describe any art or artefacts of American origin, but applied more specifically to bygones (q.v.). In its purest form, Americana embraces the various branches of folk art developed by immigrant communities from the Old World in the nineteenth century and still practised to some extent, though now

Amber glass vase by Emile Gallé, 1900.

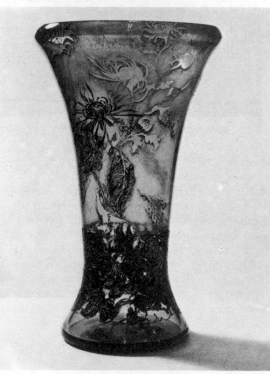

Americana: late 19th century scrimshaw work.

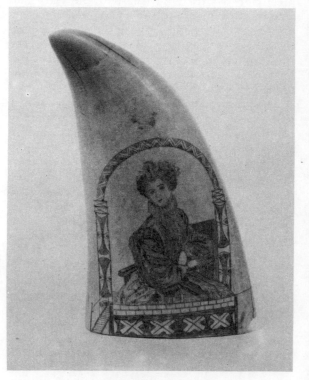

on a more commercial basis. Material of this nature is difficult to date accurately since styles and techniques are traditional and have varied little over the years, but a large proportion of the material still in existence was produced in the closing decades of the last century and the years prior to the First World War.

Although the art of scrimshaw work, or carving on bone or ivory, began to wane after the Civil War, there are many fine examples, especially of landscapes or political scenes, which date around the turn of the century. These naïve little vignettes often include lengthy inscriptions and dates which help to establish their provenance.

Wood carving was widely practised eighty years ago and manifests itself in many different forms. Whirligigs of painted wood were often designed as angels, soldiers and other human figures with paddle arms and revolving bodies, and served as weather-vanes on many farmhouses and cottages. More elaborate were the cigar-store Indians, life-size wooden figures which stood in the doorways of cigar-stores and alluded to the fact that the Indians were the first to develop the tobacco habit. These figures have long been popular with collectors and are now comparatively scarce, but carved figures of people and animals featured prominently in many other trade signs and examples of these may still be found. By the turn of the century, however, the traditional wooden sign was giving way to the mass-produced enamelled metal sign. Not so long ago, these forerunners of the neon-lit hoarding were to be found on the walls of buildings in many country towns, but now they have virtually all disappeared into the hands of collectors and museums. Carved decoy ducks, said to have been invented by Indian hunters, are a peculiarly American contribution to the history of folk art, and these are being made to this day.

Circus memorabilia is a large branch of Americana. The production of wooden painted figures for carousels or roundabouts received great impetus after the formation of the Barnum and Bailey circus in 1881. Phineas T. Barnum and James A. Bailey had countless imitators and the pomp and pageantry of the circus 'big parade'

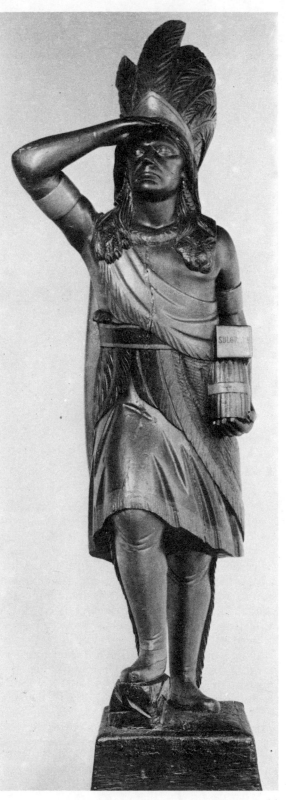

Indian Scout cigar store figure, by Samuel Anderson Robb, New York, c. 1890. (Heritage Plantation of Sandwich)

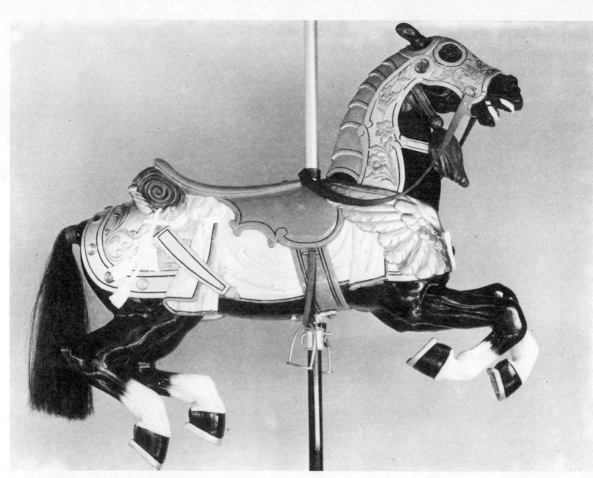

Carousel horse by Charles I. D. Looff, Riverside, Rhode Island, 1910. (Heritage Plantation of Sandwich)

was to become part of the American way of life in the years before the First World War. Milwaukee and Barboo, Wisconsin, for many years the traditional winter quarters of circuses, were the centre of an industry devoted to the production of these figures and other circus equipment, though the best examples of the dapple-grey wooden horses, so prized nowadays by collectors, came from Gustav Dentzel's Carousel Factory in Germantown, Pennsylvania in the 1890s.

Apart from material which comes into the category of folk art, the bulk of Americana consists of utilitarian articles which, due to changes in design or living patterns, have become obsolete and thereby acquired some antiquarian interest. The bygones of the turn of the century represent a particularly rich field for the collector. Industrialization, on the same scale as Britain and western Europe, did not reach the United States until the decade

after the Civil War, but development was so intense and rapid from then onwards that, on the eve of the First World War, it was the most highly industrialized country in the world. America today has the most sophisticated consumer society in the world, but this position may, in fact, have been reached as early as 1900. A comparison of mail-order catalogues in Britain and the United States of this period shows that the range and diversity of goods available to the consumer in the latter country was larger, perhaps because the spending power of the average worker's wages was much greater even then.

The population of the United States expanded phenomenally in the half century following the Civil War. In 1869, it stood at 39,000,000; by 1890 it had risen to 63,000,000, and in 1915 it had reached 100,000,000. Immigration, as well as a rising birth rate, contributed to this phen-

12

omenal growth. Today the population of the United States has more than doubled the 1915 figure and trebled the figure at the turn of the century. This enormous expansion, over a relatively short period, means that the supply of collectables available today falls far short of the demand, and this explains the great popularity of mundane objects, especially those from the period covered by this book. The collecting 'mania' developed in the United States long before it did in Europe and although this meant that a great deal of material in the truly antique sense was exported from Europe to America in the immediate postwar years, it also meant that American collectors were forced to consider the possibilities of material which was regarded as junk everywhere else.

The extraordinary interest in strictly utilitarian objects of yesteryear must be considered in the light of the fact that America has the consumer society *par excellence,* where last year's model is on today's scrap-heap, and objects are scarcely beginning to gather dust on the shelf before they are regarded as antique. A recent survey of material now being seriously studied and collected in the United States includes the following objects: apple parers, bib holders, dolls' furniture, babies' rattles and teething-rings, barrels, chamber-pots, bells, biscuit tins, bread boards, butter boxes, can-openers, cigar boxes and cutters, cash registers, door-knobs, coat hangers, coffee grinders, corkscrews, curtain rings and poles, drawer handles, duplicating apparatus, hooks of all kinds, ice picks, inkwells, key chains and rings, lemon squeezers, meat cleavers, mechanical banks, mucilage bottles, moustache combs, oil cans, paper-clips, pencil-sharpeners, pickle jars, potato mashers, rice boilers, rolling pins, rowing machines, sand buckets, skewers, slot machines, stair rods and buttons, stamp moisteners, staple fasteners, thermometers, towel rails, transom catches and undertakers' hardware. In the period from 1890 to 1910, even the humblest of functional objects were subjected to decorative treatment. Metal parts were cast or die-stamped with the lily and ivy motifs of Art Nouveau and this type of ornament is to be found on everything from paper-knives to sewing machines. It was a period when novelty shapes were applied to all manner of everyday objects found in the nursery, the bedroom, the kitchen or the office and, in this respect, the up-and-coming American manufacturers surpassed their European counterparts. No motif was too bizarre, no decoration too whimsical, to be applied to items which nowadays would be quite devoid of embellishment.

But preoccupation with the American past is not limited to objects with a decorative treatment. Two of the most popular forms of Americana today are barbed wire and electric insulators, both of which are connected with the romantic story of the development of the United States in the closing years of the nineteenth century. Although a form of barbed wire had been invented in France, it was not until 1873 that an American, Henry M. Rose, patented a kind of wire fencing which was subsequently developed and improved by Joseph Glidden and Isaac Ellwood. Barbed wire was initially used by the 'nesters' and homesteaders to protect their arable land from marauding cattle. The cattlemen bitterly resented the wire, which symbolized the end of their free-ranging activities, but eventually came to realise that it would also be useful to them. Many different types and patterns of wire have been recorded; among the 400-odd types recorded are such rare and exotic brands as Meriweather's Snake, Reynolds' Hanging Knot, Kelly's Thorny Fence, Pooler Jones, Stover Clip and Concertina Steel. Electric insulators are more technical and less romantic and the collectable variants are limited

Coca Cola sign, 1900.

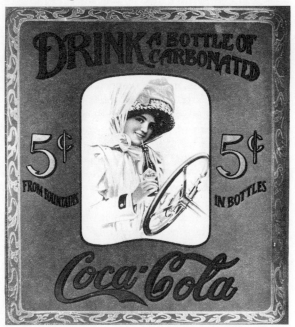

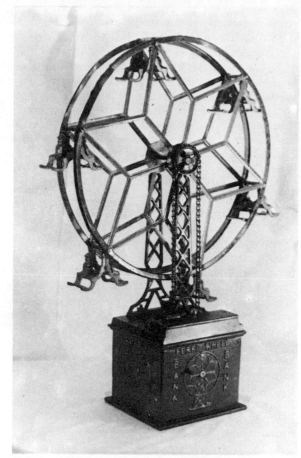

Cast iron Ferris wheel, mechanical bank *c.* 1900.
(Barenholtz Collection)

pill-boxes also offer considerable scope to the collector.

Buttons, badges and belt-buckles, particularly those connected with the development of the West, are eminently collectable. Old-time law enforcement insignia, sheriff's stars and prison guard's badges, the extravagantly decorated belt-buckles affected by cowboys and the handsome pictorial buckles worn by Wells Fargo personnel—all have a strong following among collectors in the United States and even in Britain, France and Germany, where there are now specialist dealers. Souvenirs of the great expositions and world's fairs, most of which had their hey-day in this period, are also keenly sought after. Finally, the combination of mass-production with a genuine desire to give the customer a 'high class' product, resulted in eclecticism of the worst sort. The combination of motifs from classical Greece, China and Aztec Mexico, often in a riotous jumble which appealed to the exuberant new Americans of the 1890s, was totally rejected in the 1920s, regarded with amused tolerance in the 1950s as 'camp', and is now the subject of serious study and collecting.

Amstelhoek Pottery

Dutch pottery produced by the Amstelhoek workshops under the artistic direction of Christian Johannes van der Hoef. The patterns and decorative motifs of this pottery were cut out of the thin walls with a knife and filled with a clay of another colour. Usually blue, green, white or black clays were inlaid on a yellow ochre or brick-red ground. The decoration and the shapes of the vases were derived from classical Greek, as the names 'Amphorae', 'Cantharae' and 'Paterae' suggest. Stylized birds and animals, geometric patterns and spiral motifs were favoured. Amstelhoek amalgamated with Haga in 1907 and De Distel in 1912.

Animalier Bronzes

Small bronze figures of animals, popularized in the nineteenth century by a group of French sculptors known as *Les Animaliers*. Towards the end of the century, the fashion for realistic animal sculpture was waning, other than for equestrian studies by such sculptors as Gode-

to type, trade-names and serial numbers; although some of the early glass insulators, with attractive pink, green and blue shades, have a certain aesthetic appeal, especially if they can definitely be attributed to one of the glass-houses which also produced decorative glassware at the turn of the century.

Bottles are a very large field, reflected in the growth of specialist literature on such subjects as Coca Cola, Avon and Jim Beam bottles in recent years. Because the novelty-shaped bottles have been avidly collected for some time, unscrupulous individuals have been tempted to market modern 'reproductions'. The collector will find, however, that milk and mineral-water bottles of the turn of the century are just as collectable; even if their shapes are basically simple, their lettering (which often includes early examples of advertising) has a distinct period charm. Old patent-medicine bottles and

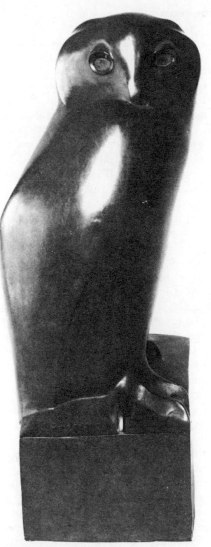

Animalier bronzes: owl by Pompon.

animal sculpture in 1890. His work was little known until 1921 when he exhibited in the *Salon d'Automne* and, from then until his death in 1933, he was a regular contributor to this and other exhibitions. Though fame came to him late in life, the bulk of his work was executed in the period from 1890 to the outbreak of the First World War. He also produced a few portrait busts but, after 1905, he worked exclusively on animal figures. Stylistically Pompon broke with the mainstream Animaliers and adopted a more impressionistic approach, carving the features of his birds and animals out of solid masses. His figures were characterized by their restful, static poses, often heightened by the sleek, streamlined surfaces of his sculpture. Pompon's sculpture was astonishingly varied in its range and subject, from domestic animals to exotic beasts and birds from Africa and Asia.

Rembrandt Bugatti's short and tragic career (1901–16) has left an impressive legacy of animal sculpture, bridging the gap between the realism and naturalism of the mainstream Animalier tradition of the mid-nineteenth century and the animal sculptors of the early twentieth century, who used animal subjects to create an increasingly formalized and intensified reality. Bugatti's work belongs to neither, or perhaps to both, categories for he achieved, at his best, something far subtler and more difficult—a purely abstract beauty of plastic harmony and rhythm without ever sacrificing the literal structure and vitality of the animals he portrayed.

Gnu by Bugatti.

froid Devreese, Gaston d'Illiers, Georges Malissard, Louis de Monard and René Paris. Georges Gardet is best known perhaps for his larger works in marble, but these were subsequently offered to the public as bronze reductions and many of these were also reproduced in Sèvres porcelain. Among these works may be mentioned his figures of panthers, lion and lioness, Chantilly dogs and fallow deer. African animals were a speciality of Paul-Louis-Emile Loiseau-Rousseau in the 1890s.

Undoubtedly the finest and most original of the Animalier sculptors of this period was François Pompon, a pupil of Mercie and latterly assistant to Rodin, who began specializing in

Anquetin, Louis

French painter and graphic artist, born at Etrepagny (Eure) in 1861. Anquetin studied art at the *Academie Cormon,* where he made the acquaintance of Emile Bernard, Henri de Toulouse-Lautrec (qq.v.) and Vincent Van Gogh. With his friends, he subsequently formed the *Ecole du Petit Boulevard.* He had a major influence on Toulouse-Lautrec (q.v.) and was himself influenced by the English designer Charles Ricketts (q.v.). Despite his early promise of Impressionism, he returned, after 1890, to the pompous classicism of the Neo-Baroque style in which he produced theatrical settings, book-illustrations and poster-designs. Anquetin died in Paris in 1932.

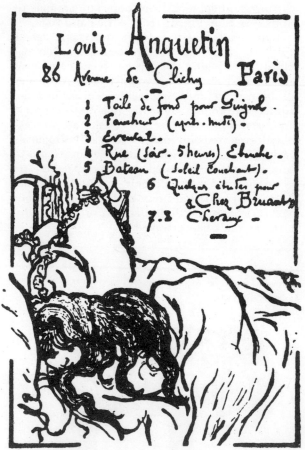

Page from a catalogue of *Les Vingt* designed by Louis Anquetin, 1888.

Art Glass

See *Glass*

16

Art Nouveau

French expression meaning 'new art', the name given to the distinctive style in the applied and decorative arts around the turn of the century. The expression was first used in 1895. In that year, the Hamburg entrepreneur Samuel Bing (q.v.) opened a shop in Paris which he called *Maison de l'Art Nouveau.* Bing offered a retail outlet for the products of Lalique, Tiffany, Gallé, Grasset (qq.v.) and others and the name quickly spread, to Britain and America in particular, to denote the new style with its characteristic dreamlike, ethereal qualities and emphasis on sinuous curves and flowing lines. Despite its name, the new style was not peculiarly French in inspiration or origins. Significantly it was better known in France as *le style Anglais* (the English style), reflecting its origins in the earlier Aesthetic and Arts and Crafts Movements (qq.v.). In Italy, it was known as *lo stile Liberty* (q.v.) after the London company which pioneered the style in England as Bing did in France. Its German counterpart, *Jugendstil* (q.v.), developed along parallel lines and had many points of similarity.

The closing years of the nineteenth century were an exciting time in industry and technology; electricity was still a novelty and man-powered flight was just around the corner. People were more conscious than ever before of living in a 'modern' world. At the same time, the late nineteenth century was an age of romanticism, and it was this combination of the romantic with the modern which spawned the remarkable phenomenon known as Art Nouveau.

Art Nouveau derived much of its power from the fusion of the two principal art movements of the latter half of the nineteenth century, Symbolism and Naturalism. The Symbolists regarded even the most mundane, workaday objects as symbols conveying messages. Quite ordinary things and functions were imbued with hidden meanings ranging from the mystical to the whimsical. Thus nothing was too utilitarian for artistic interpretation. Every kind of domestic appliance, from coffee grinders to clothes-mangles, was lavishly treated with contemporary decoration. The tulip or ivy leaf ornament, which became the virtual hallmark of Art Nouveau, was applied to paper-knives and crumb-trays, fire-dogs and fenders, wrought-

Late 19th century English 'Aesthetic' teapot. ▶

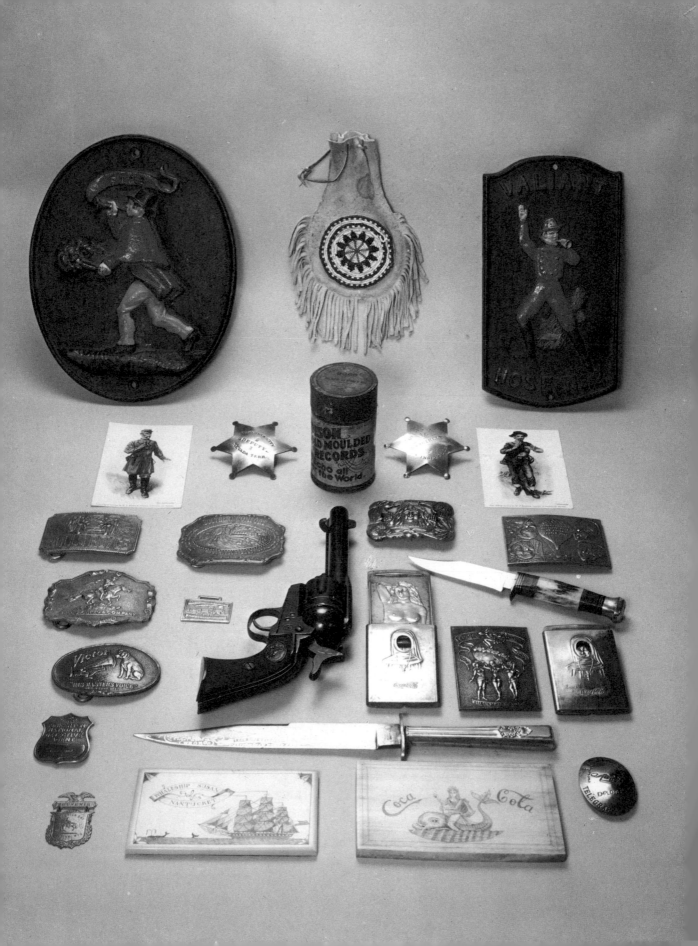

iron brackets and wall-sconces. Nothing was too humble; the rococo curves and tendrils of Art Nouveau were even applied, in underglaze blue, to lavatory bowls. Expressions of Art Nouveau were to be found all over Europe in public and semi-public buildings of the period, from Miss Cranston's tea-rooms in Glasgow to the Casa Battlo in Barcelona. Probably the finest example of Art Nouveau in the public domain was the Paris Metro, built between 1899 and 1904. The novelty of an underground electric railway appealed to the romanticism of Hector Guimard (q.v.) who designed a startling series of entrances to the various stations. Wrought-iron stalks thrust their tendrils and foliage up out of the concrete paving like some strange plant from another planet. The twin stalks, entwined round the gateways of the Metro, concealed electric light-bulbs, thus combining art with the greatest amenity of the age. Attempts to use electric light as an art form in itself were manifest in the bronze lamps of Raoul Larche, Antoine Bofill and others, using such dancers as Cleo de Merode and Loie Fuller as their subjects; the light-bulb was concealed within the swathes of material, either glass or bronze, which represented the diaphanous veils of the dancers.

An aspect of Art Nouveau which is sometimes overlooked is its preoccupation with industrialism. Industrial art was hailed as the art of the future. At one extreme, it was evident in the artistic treatment of machinery, but more often it manifested itself in the art of the poster (q.v.) which flourished in western Europe on an unprecedented scale at the end of the century. Mucha's (q.v.) advertisements for bicycles or Cheret's (q.v.) posters for Job cigarettes proved that nothing was too mean for an artistic interpretation. Jean Lahor believed that artistic surroundings would bring contentment to the industrialized masses and allay their demands for revolution. He preached the message of 'art everywhere, in everything and for everyone'. The artistic posters on the hoardings of France and Belgium were designed to put Lahor's preachings into practice, but unfortunately they were instantly recognized as works of art and promptly removed by collectors. Although manufacturers did their best to follow Lahor's teachings, the results, at the lower end of the commodity scale, were often tawdry. It has to be admitted that Art Nouveau only functioned well when allied to what would now be termed as luxury goods. With increasing competition in industry, manufacturers were forced to cut out the frills, and the idea of grafting 'mystical naturalism' on to most utilitarian objects soon died out.

The strange, bizarre, often contorted lines of Art Nouveau were more suited to certain media than to others. Undoubtedly glass was the finest medium for the fertile imagination of the exponents of Art Nouveau, experimenting with combinations of clear and opaque glass, as in *marqueterie de verre,* or applying traditional processes such as acid-etching and enamel-painting to new forms. The dreamy quality of Art Nouveau was captured in the jewellery of the period—small, fragile, with infinite variety of colour and shape. Relatively little jewellery was made in the Art Nouveau style but what

Art Nouveau inlaid mahogany display cabinet, 1910.

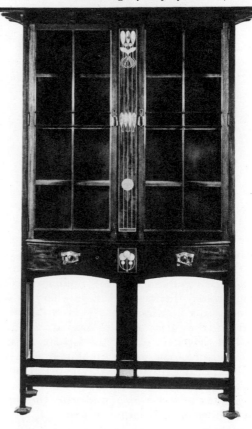

◀ Americana from 1890–1910: fire-marks, Indian beadwork pouch, early phonograph record, trade cards, law enforcement badges, Wells Fargo belt buckles, Colt revolver and Bowie knives.

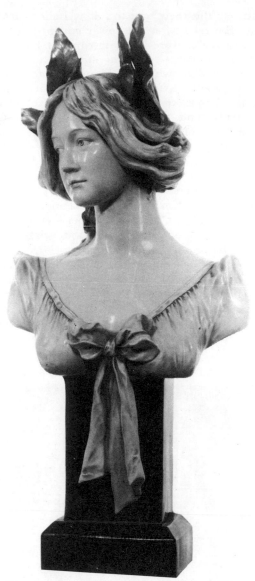

Art Nouveau bust in Bohemian porcelain, 1900.

Gallé (q.v.), best known for his glassware, also manufactured some outstanding furniture and was the pioneer of the Nancy School (q.v.) of cabinet-making from 1885 onwards. Naturalism predominated in the furniture of the period, but was sometimes taken to extreme lengths. Swirling and voluptuous plant motifs were used extravagantly and resulted in cabinets, chairs and tables bordering on the fantastic. The cabinet-makers of Nancy and Paris, who became the prime exponents of Art Nouveau furniture, showed a reckless disregard for 'truth to materials' which offended the disciples of Dresser and Morris in England. Guimard (q.v.) for example designed furniture on a sculptural basis, often preparing clay models which his craftsmen were expected to translate into wood. Guimard regarded himself as an 'architect of art', an exponent of abstract naturalism whose furniture anticipated the surrealist fantasies of later decades. The Belgian architect-designers, on the other hand, wished to create a total effect. Men like Serrurier-Bovy, Horta and Van de Velde (qq.v.) designed houses and the furniture that went with them, based on a unity of style which strove to eliminate the confusion and eclecticism which went before. Van de Velde went even farther than most of his contemporaries, designing exquisite jewellery as well as furniture. Curiously enough the one enduring feature of Art Nouveau furniture was bentwood (q.v.), pioneered in Austria by Michael Thonet (q.v.) who devised techniques for bending and shaping wood and applied them to mass-produced chairs and tables which had such a universal and timeless appeal that their popularity has continued undiminished down to the present day.

In ceramics, there was less experimentation than with glass and the older established potteries were content to continue with traditional forms and patterns. But this was also a period in which many smaller potteries flourished and, being less commercially orientated, they could afford to be more adventurous. Studio pottery (q.v.) was produced in great abundance in America, England and the Low Countries at the turn of the century. Although oriental influence was strong, the potters adapted Chinese and Japanese motifs freely, experimented with new glazes and produced their own distinctive form of Art Nouveau. The American Rookwood Pottery (q.v.) was typical of the enterprises which came to prominence at the close of the nineteenth

there was was outstanding, often extremely inventive and always well-made—a rare combination of qualities. Artists and craftsmen who made their reputation in other media sometimes demonstrated their talents in jewellery as well: Lalique (q.v.), whose name is a household word in the glass of the period, produced excellent jewellery using glass-paste, enamels and semi-precious stones combined with gold or silver; and Christophle (q.v.), better known for their silver, also produced some fine brooches and pendants recreating in miniature the characteristic lines of their larger pieces.

20

century. Founded by a wealthy socialite, Mrs Maria Longworth Nichols, it had an almost dilettante approach. Useful wares were speedily abandoned in favour of decorative vases, bowls and sculptured art forms under the prevailing influence of Art Nouveau in other fields. Rookwood did in pottery what Tiffany (q.v.) was doing in glass, evolving luxurious and exotic shapes, colours and surfaces and their success—and ultimate downfall—may be taken as typical of Art Nouveau in general. There was a return to nature and inspiration was clearly derived from organic forms, but the original goal of simplicity which had motivated Morris was soon lost sight of. After 1905, Art Nouveau became increasingly stereotyped and lost its original vitality. By 1910, it was giving way to the more linear approach expounded by Charles Rennie Mackintosh (q.v.) which foreshadowed the austerity and angularity of the *Bauhaus* movement and Art Deco in the 1920s and 1930s. See *Brussels School*, *Jugendstil*, *Sezession*, *Stile Liberty*.

Art Pottery

See *Studio Pottery*

Arts and Crafts Movement

Term coined in the early 1880s by T. J. Cobden-Sanderson to denote the revival of interest in traditional skills in manufacture and the various attempts to imbue industrial processes with some sense of artistry. The movement was peculiarly English in its origins and development, though eventually it exerted a great influence on the applied and decorative arts in Europe and, to a lesser extent, in America. The movement pervaded every aspect of design, from architecture and interior decoration to ceramics, glassware and book-binding. It challenged established practice in design and offered alternatives which were often radical and always original. Above all, it made people aware of the inter-relationship of design and manufacture and sought to raise both moral and aesthetic standards in craftsmanship.

The movement began in the mid-nineteenth century with the Gothic revival and the concern of such individuals as Henry Cole (alias Felix Summerly), whose desire for the elevation of

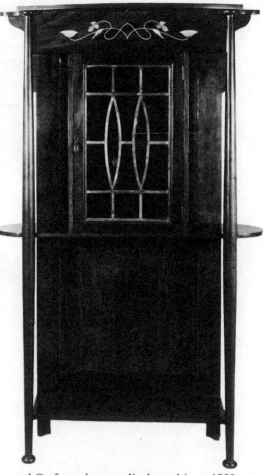

Arts and Crafts mahogany display cabinet, 1900.

standards in industrial design culminated in the Great Exhibition of 1851. Even earlier, William Ewart instigated the Royal Commission for the Fine Arts in 1835 which resulted in the establishment of the Government Schools of Design. Charles L. Eastlake (q.v.), in his seminal work *Hints on Household Taste* (1868), urged the infusion of art into industry. 'To be genuine and permanent' he wrote of art, 'it ought to animate with the same spirit the blacksmith's forge and the sculptor's atelier, the painter's studio and the haberdasher's shop'.

The Gothic revival of the mid-nineteenth century, with its quasi-religious overtones and desire to get back to the first principles of design as practised in the Middle Ages, was an early manifestation of a reaction against the mechanization of the modern age. Among the pioneers of what was later to become the Arts and Crafts Movement were designers and architects such

21

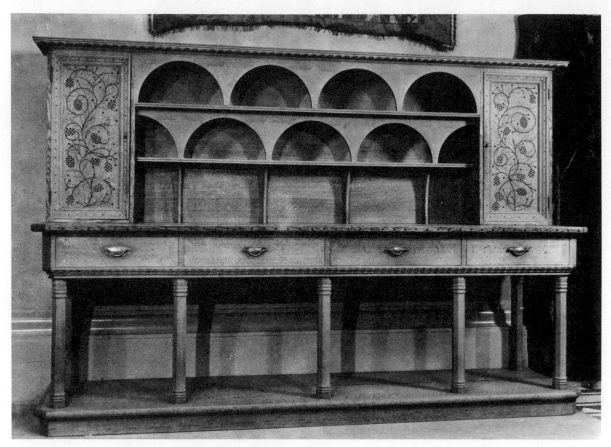

Arts and Crafts sideboard designed by W. R. Lethaby, 1900.

as Augustus Welby Pugin and George Edmund
Street, both devout churchmen, who exercised
a profound influence on William Morris, Philip
Webb and Norman Shaw (qq.v.). Medievalism
captured the imagination of the Pre-Raphaelites,
Rossetti and Burne-Jones (q.v.) and they, in
turn, influenced architects and designers like
Walter Crane and C. R. Ashbee (qq.v.).

These influences found a practical outlet in
the various societies and organizations which
sprang into existence in the 1880s: the Century
Guild (1882), the Art Workers' Guild (1883),
the Arts and Crafts Exhibition Society (1888),
the Guild of Handicraft (1888), the Home Arts
and Industries Association (1889) and the Wood
Handicraft Society (1892) among others. In
these organizations, such men as Ashbee, Crane,
Morris, Mackmurdo, Lethaby and Voysey (qq.v.)
were leading members. Other artists, architects,
designers and craftsmen who became involved
in the movement included Christopher Dresser,
Ambrose Heal, M. H. Baillie Scott, Ernest

Gimson and the Barnsley Brothers (qq.v.) whose
influence on the applied arts at the turn of the
century, and thereafter, was profound. They
produced works of art in diverse media and at
many levels. They preached what they practised
and many of them wrote lucidly and at length
about their work and the principles by which it
was guided, so that others might be inspired to
follow on and develop their ideas. Parallel with
the rise of these organizations was the develop-
ment of the art schools in the major towns and
cities of Britain. Apart from the national arts
and crafts organizations, there were numerous
local movements, such as the Red Rose Guild
in Lancashire, the Leek Society of Embroiderers
and the Royal Irish Industries Association.

The Arts and Crafts Movement is often
regarded as the epitome of inspired amateurism,
wrapped in a nostalgia for a medieval ideal
which never existed. Nevertheless it played a
major part in raising the level of artistic and
aesthetic consciousness among the populace in

general and latterly its pre-occupation with socialism transformed it into a movement in which art for everyone, and in everything, could be envisaged as the aim of a new social order.

Ashbee, Charles Robert

Architect and designer, born in Isleworth near London in 1863. Ashbee was educated at King's College, Cambridge. After serving his architectural apprenticeship with a firm of church builders, he came under the influence of William Morris (q.v.) and began designing houses down to the smallest detail. In 1888, he founded, in the East End of London, a workshop named the Guild of Handicraft which subsequently moved to Chipping Campden, Gloucestershire. The guild was organized on non-capitalist principles but did not entirely eschew the use of machinery. Ashbee was the chief designer but the products of the Guild evolved out of group discussion. Delicately chased and embossed silverware, and silver jewellery anticipating the style of Art Nouveau, were the chief products but there were some interesting experiments in furniture as well. After Morris's death Ashbee founded the Essex Press in 1896, best known for its production of the Coronation Bible for Edward VII in 1902. In that year, Ashbee was awarded honorary membership of the Munich Academy of Arts. Ashbee's designs in silver and furniture were copied by some of the London companies, notably Liberty (q.v.), and as they were able to improve on the workmanship without increasing the cost, they undoubtedly forced him out of business: the Guild closed down in 1909. The

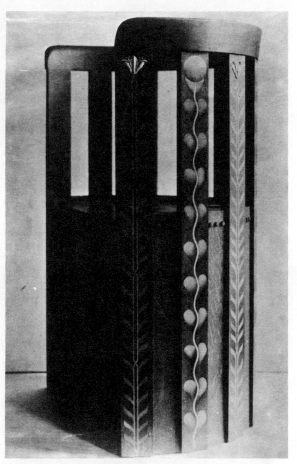

Armchair designed by M. H. Baillie Scott and made by C. R. Ashbee, *c.* 1898.

influence of Ashbee can be seen in the furniture of Ambrose Heal and Ernest Gimson (qq.v.). Ashbee died in 1942.
See *Private Presses*

Silver tray by C. R. Ashbee, 1896.

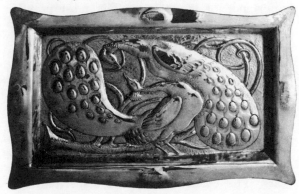

Asprey

London firm of fine art dealers, founded by William Asprey in 1781. The present premises in Bond Street were first occupied by the company in the 1830s. Although now primarily concerned with jewellery and retailing glassware, ceramics and silver, Asprey themselves produced fine silverware for much of the nineteenth century and specialized in tea and coffee services in the Art Nouveau style. These, rather than their larger and more ostentatious presentation pieces (q.v.), are now highly regarded by collectors.

23

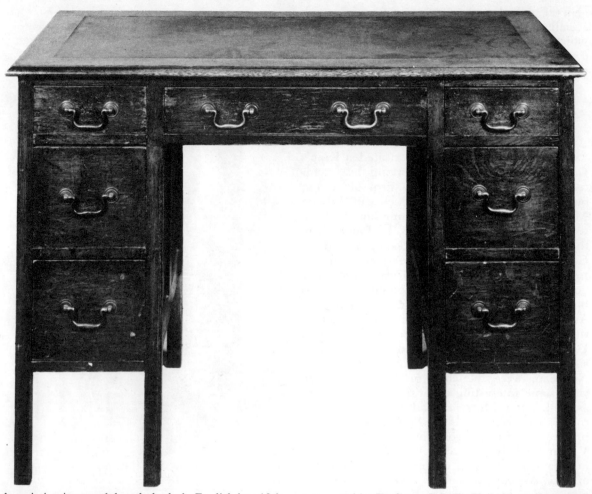

Association item: oak kneehole desk, English late 19th century, used by Professor J. R. R. Tolkien, author of *The Lord of the Rings*.

Association Items

Under this heading come all kinds of object which owe their interest to the collector to their association with some famous person or event. Many of these objects, such as jewellery or silverware, are collectable in their own right but their interest and value are enhanced by the association. Presentation silver (q.v.) is the most obvious type of association material, since its provenance can be attested by the inscription on the piece and the circumstances surrounding the presentation are easily verified in most instances. The provenance of a piece of jewellery or costume may be established if photographs or paintings exist showing the item actually being worn by the person concerned. More mundane articles are usually harder to authenticate and

supporting documentary evidence: letters, certificates of ownership or tradesmen's invoices naming the person in question; is relatively easy to fake. The value of such items is problematical, and depends largely on the historical importance of the person. The most popular association items are those connected with royalty. Material relating to Queen Victoria, King Edward VII and his consort Queen Alexandra is still reasonably plentiful though popular, and bidding at auction for authenticated items is usually keen. Relatively little interest is shown in objects formerly in the possession of other European royalty, though material relating to Kaiser Wilhelm II of Germany or Tsar Nicholas II of Russia and their immediate families has acquired a notoriety value in recent years. The collecting of relics associated with

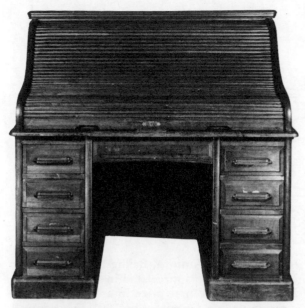

Association item: mahogany cylinder bureau, English late 19th century, owned by Sir Winston Churchill.

William McKinley, Theodore Roosevelt or William Howard Taft has a certain following in the United States but does not extend beyond that country.

Ephemeral material, such as letters, diaries, warrants and commissions, relating to the chief military events of the period—the Spanish-American War (1898), the Boer War (1899–1902) and the Boxer Rebellion (1900)—are now being explored as a hitherto neglected aspect of militaria.

See *Royal Relics*

Ault Faience

Exotic pottery manufactured by William Ault at Swadlincote, Derbyshire between 1887 and the end of the nineteenth century. William Ault served his apprenticeship as a potter in Staffordshire and was employed for many years by the Linthorpe Pottery (q.v.), executing designs by Christopher Dresser (q.v.). Ault was in partnership with Henry Tooth in the Bretby Pottery (q.v.) from 1882 to 1886, but left to found his own pottery. His wares were marketed under the name of 'Ault Faience', but were strongly reminiscent of the Linthorpe pottery in style and glazes. Between 1892 and 1896, Christopher Dresser produced a series of designs for Ault; examples of this pottery bear Dresser's signature stamped on the base. 'Ault Faience' specialized in larger items, such as bowls, vases, *jardinieres* and ornamental pedestals, but grotesques and Toby jugs were also produced. Particularly prized are the vases decorated with plants and butterflies and bearing the initials 'c.j.a.' for Clarissa Ault, William's daughter.

Vase designed by Christopher Dresser and made by William Ault, 1892–6.

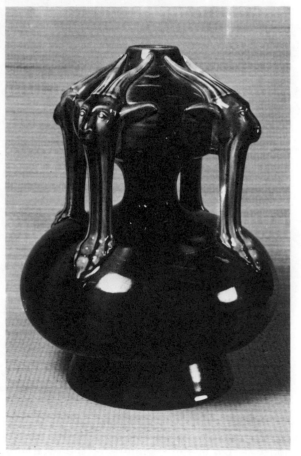

Bailey, C. J. C.

Proprietor of a pottery known as C. J. C. Bailey & Co. In 1864, he acquired the Fulham Pottery, an old-established pot-bank in the London area, best known for the seventeenth century earthenwares of John Dwight. Bailey encouraged the production of artistic pottery and gave employment to the French artist-potter, J. C. Cazin, who fled to England after the collapse of the Paris Commune in 1871. Under Cazin's influence, the Fulham Pottery began producing decorative wares with a highly distinctive geometrical ornament, combined with naturalistic flowers in the Japanese idiom. Another employee of Bailey's was Wallace Martin, eldest of the Martin brothers, before he established his own pottery in 1873. Much of the early Martinware (q.v.) was actually fired in Bailey's kilns. Subsequently Bailey produced excellent salt-glazed stoneware, and a fine range of figures, of which his street-sellers are the best known.

Baillie-Scott, Mackay Hugh

Architect and designer, born in Douglas, Isle of Man in 1865. Baillie-Scott was in the forefront of the movement known as the Domestic Revival and was the leading innovator in British house design at the beginning of the twentieth century. Like Mackintosh (q.v.), he believed in designing the total concept of a house, down to the cutlery and the door-knobs. Today he is best remembered for his 'Manx style' of furniture which had close affinities with the perpendicular style of Mackintosh and the Glasgow group (q.v.). Like Mackintosh, Baillie-Scott was better known and more appreciated in Europe than in Britain. He took first prize in an industrial arts competition in Germany in 1901 (Mackintosh won second prize) and he received many commissions from European royalty and nobility, notably the Grand Duke of Hesse. Baillie-Scott lived and worked at Fenlake Manor, Bedfordshire and died in 1945.

Bakalowits Glass

E. Bakalowits Söhne of Vienna was one of the leading firms of glassmakers at the turn of the century. A distinctive feature of Bakalowits glass was the close, regular festoons of decoration in contrasting colours of glass or gilding on the sides of vases and beakers. Iridescent glass was a favourite line with this factory and some of this, bearing a large ground pontil mark on the base, has in the past been erroneously attributed to the Lötz glasshouse (q.v.). Bakalowits produced glassware designed by Professor Rudolf Bakalowits of Graz and also by Josef Hoffmann and Koloman Moser (qq.v.). After 1900, Bakalowits virtually ceased production of art glass.

Bamboo Furniture

Furniture in pseudo-Oriental styles using bamboo or similar woods in its construction. The craze for bamboo furniture came to America in the wake of the trade which developed between Japan and the United States from 1853 onwards, but only became widespread after the Centennial

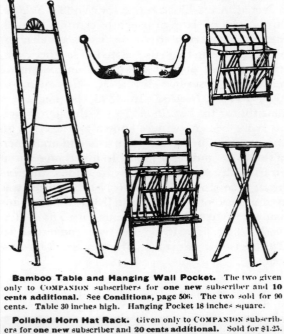

Typical bamboo furniture produced in the United States *c.* 1890.

Exposition of 1876 and reached its peak in the late 1880s. It spread to Europe rather later and was at the height of its popularity from 1890 to 1900. Vantine's New York Emporium was the chief retail outlet for imported Oriental bamboo furniture whose light yet resilient qualities popularized it. In the 1880s, American bamboo furniture was manufactured by Nimura and Sato of Brooklyn and J. E. Wall of Boston, using imported bamboo cane. Subsequently imitation bamboo furniture, using other woods (principally maple), was produced in the 1880s and 1890s by George Hunzinger, Kilian Brothers and C. A. Aimone. Although the inspiration was Oriental, the form of this furniture was definitely Western. Strong, rectilinear forms, the widespread use of panels and galleries of spindles recall the American Reform furniture of the 1870s. In Britain and Europe, various types of fruit woods were employed, often in combination with fine basket- or cane-work or plain wood (especially in table tops and the panelling of desks and cabinets).

Barkentin, William Slater

American designer and graphic artist of Anglo-Danish descent (1874–1962). His father, George Slater Barkentin, was a silversmith and artist who went to the United States as a war artist for the *Illustrated London News* during the Civil War, but subsequently married and settled in the United States. William Barkentin founded the Barkentin Studios in New York City and designed silver and metalwork as well as two-dimensional graphics. His best known work was the Coca Cola sign, designed in 1910, of which his wife later said, 'It goes before me all the days of my life'. The family business in London, Barkentin and Krall, continued to design and produce sumptuous silverware, mainly for ecclesiastical purposes.

Barker Brothers

English firm of silversmiths, second only to Elkington (q.v.) in the Midlands. The firm originated as Barker and Creed in 1820 and changed its name in 1860 when it passed to William and Matthias Barker, the sons of the original proprietor. William's sons, Frank and Herbert, formed the business into a public company in 1907, with its headquarters in Birmingham. The company produced sterling silver, electroplate and toilet sets, incorporating enamelling and tortoise-shell.

Barnsley, Ernest and Sidney

English architects and furniture designers. Ernest (1863–1926) and Sidney (1865–1926) Barnsley, together with Ernest Gimson (q.v.) came under the influence of William Morris (q.v.) and, in turn, exerted a tremendous influence on other craftsmen and designers in Britain. Late in 1890, Gimson and Sidney Barnsley formed the furniture business known as Kenton and Company, London. Professional cabinet-makers were commissioned to interpret their highly original designs and many of these

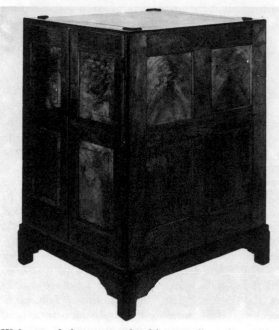

Walnut and ebony record-cabinet attributed to
Edward Barnsley, early 20th century.

pieces were subsequently shown at the annual
Arts and Crafts Exhibitions. The original com-
pany was dissolved in 1893 when the Barnsleys
and Gimson moved to the Cotswolds, to practise
the tenets of Morris. First at Cirencester and
latterly at Sapperton, they produced their dis-
tinctive type of furniture. Ernest designed some
furniture while continuing to practise mainly
as an architect, but Sidney, having developed
his skill as a cabinet-maker, both designed
and executed his own pieces. The early pieces
were experimental in design and construction,
mainly in oak with large flat surfaces, bereft
of any ornament, carving or painting. In this
respect, they differed from Morris, whose flat
surfaces were intended for painted decoration.
The Barnsleys preferred the proportions, quality
and graining of wood and workmanship to speak
for themselves.

Beardsley, Aubrey

Illustrator, born at Brighton in 1872. Beardsley
was self-taught and, by the age of fifteen, was
producing caricatures and illustrations for
periodicals. In 1888, he became an architectural
pupil, but four years later, at the behest of
Burne-Jones (q.v.), he entered the Westminster
Art School for a short period. Beardsley was
strongly influenced by the music of Richard
Wagner, the art of the Pre-Raphaelites and the
ideas of the Morris movement in general. In
1892, he produced the illustrations for Mallory's
Morte d'Arthur in the manner of Burne-Jones,
but the sight of Whistler's Peacock Room
turned him towards Japonism (q.v.) and this is
reflected in his illustrations for Wilde's *Salome*.
His study of late nineteenth century French
literature contributed to his work an element
of decadence, in the sense related to Aestheticism,
implying that pursuit of strange and exquisite
sensations described by J. K. Huysmans in
his novel *A Rebours*. In 1893, he became a
contributor to *The Studio* (q.v.), through which
his work became widely known and exerted an
enormous influence on the artists and craftsmen
of the 1890s and early 1900s. In his strange, often
bizarre, drawings Beardsley heralded the ex-
travagance of Art Nouveau (q.v.). Beardsley was
at the peak of his career in 1895–7, when his
name was virtually synonymous with *The Yellow
Book* (q.v.). In 1897, he was converted to
Catholicism and died at Menton the following
year.

Binding designed by Beardsley for *Morte d'Arthur* by
Sir Thomas Mallory, 1893.

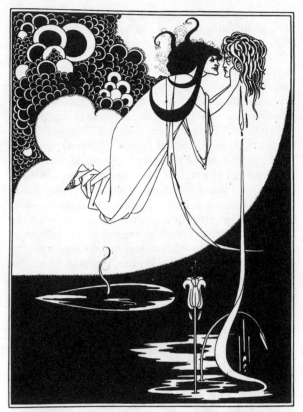

Salome with the head of John the Baptist, by Aubrey Beardsley.

combined with classical elements. A great deal of the silver produced by Tiffany and Company (q.v.) between 1875 and 1900 consisted of elaborate pieces in the Beaux Arts style. The Beaux Arts School of applied arts seemed to lose ground at the turn of the century, although *The House Beautiful* was sadly over-optimistic in proclaiming, in 1900, 'the day of cheap veneer, of jig-saw ornament, or poor imitations of French periods, is happily over'.

Beckerath, Willy von

German painter and designer, born at Krefeld in 1868. Beckerath trained at the Düsseldorf Academy and subsequently worked in Munich and Hamburg, being appointed a professor on the teaching staff of the *Kunstgewerbemuseum* in 1907. While resident in Munich, he became a member of the *Vereinigte Werkstätten* (q.v.) for which he designed furniture decorated with wrought iron hinges and panels in the *Jugendstil* (q.v.) manner.

Design for a washstand and wardrobe by W. von Beckerath, 1903.

Beaux Arts School

Term used, sometimes derisively, to describe the revival of 'Old World' styles in furniture, silver and ceramics in the United States in the 1890s. The Columbian Exposition of 1893 (q.v.) represented the high-water mark of this movement which, nevertheless, has endured, in an attenuated form, to the present day. The bulk of the furniture, which combined elements from the three Louis styles of eighteenth century France and the Renaissance styles of seventeenth century Italy, was produced in the large factories of Grand Rapids to fill the Beaux Arts chateaux and villas in Newport and the new French and Gothic town houses in New York. Although some excellent examples of Beaux Arts furniture were hand-made, the bulk of it was mass-produced. The silverware of the period was a confused hybrid of Baroque, Rococo and other Old World styles of the eighteenth and early nineteenth centuries, often

Beggarstaff Brothers

The pseudonym adopted by William Nicholson and James Pryde (qq.v.) in 1895, when they

became partners in poster design. Individual items are sometimes signed 'J.' or 'W. Beggarstaff'.

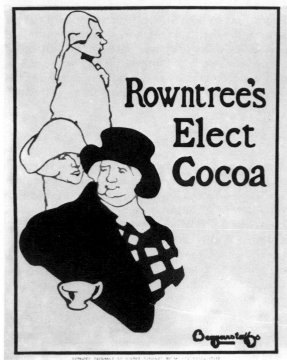

Poster designed by the Beggarstaff Brothers for Rowntree's Cocoa, c. 1895.

Behrens, Peter

Painter, graphic artist, architect and designer, born at Hamburg in 1868. Behrens received his formal art training at the *Kunstgewerbeschule* in Karlsruhe, Düsseldorf and Munich. Up to 1890, Behrens lived in Munich and came under the influence of the Bavarian *genre* painters. In that year, however, he travelled to Holland and studied the art of the Luminarists, especially Israels and Neuhuis, and subsequently he came under the influence of the *Ecole du Petit Boulevard* in Paris. In 1893, he became a founder member of the Munich *Sezession* (q.v.) and a pioneer of the two-dimensional aspects of *Jugendstil* (q.v.) in 1895–6. After travelling in Italy, he settled in Darmstadt (1900) and subsequently held appointments in Nuremberg (1901–2), Düsseldorf (1903) and Berlin (1907). In 1922, he was appointed head of the faculty of Architecture in the Vienna Academy. In 1936, he received a similar appointment in the Prussian Academy of Arts in Berlin and died in 1940.

Behrens came closest to the Renaissance ideal of the all-round artist-craftsman. As architect and chief designer for A.E.G. (*Allgemeine Electricitäts Gesellschaft*) he demonstrated his versatility by designing their Berlin factory and also the firm's trademarks and letter headings. He was equally at home designing factories and showrooms, restyling the company's products or devising new forms of packaging. With Richard Riemerschmid (q.v.), Behrens brought German industrial design to a peak of perfection far ahead of the rest of the world. After 1904, he abandoned the more dreamy aspects of *Jugendstil* and developed a more logical, angular style in which simplicity and functionalism were the keynotes. He exerted a tremendous influence over his contemporaries and paved the way for the styles of the 1920s. Walter Gropius, founder of the postwar *Bauhaus* movement, was a disciple of Behrens.

Book decoration by Peter Behrens from *Der bunte Vogel*, 1898–9.

Belleek Porcelain

Type of very thin porcelain manufactured by Ott and Brewer of Trenton, New Jersey at the turn of the century. The mark consists of a

crown impaled by a sword, with 'BELLEEK' above and 'O & B' below. This firm specialized in vases of an asymmetrical shape with uneven, undulating mouths like folding leaves, based on contemporary Japanese models. Rustic handles inspired by Beaux Arts (q.v.), Rococo and a super-abundance of floral and plant excrescences suggest the influence of contemporary Art Nouveau. This highly distinctive ware should not, of course, be confused with the Irish porcelain factory of the same name, founded in 1857 and still in production. Irish Belleek porcelain at the turn of the century followed the traditional patterns, using a matt unglazed parian body or a distinctive iridescent glaze. Openwork baskets with floral encrustations were a speciality of the Irish firm in the early 1900s. Walter Scott Lenox (q.v.) was Art Director of Ott and Brewer for a time in the late 1880s.

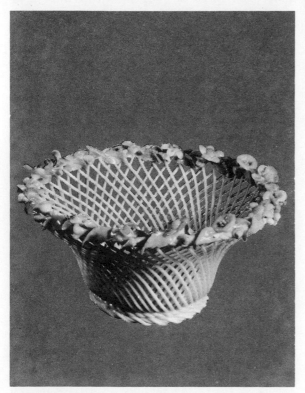

Beleek porcelain basket, hand-made by Joseph Shelton, *c.* 1900.

Benson, W. A. S.

English architect and designer (1854–1924). Benson was a lifelong friend and disciple of

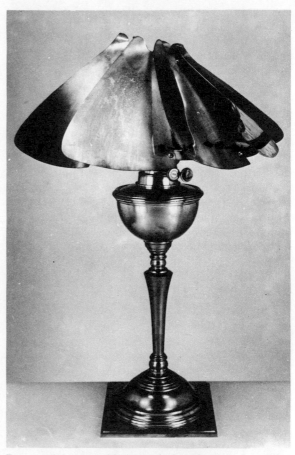

Brass and copper table lamp designed by W. A. S. Benson for Morris & Co., 1895.

William Morris (q.v.) and collaborated in the foundation of the Art Workers' Guild (1883) and the Arts and Crafts Exhibition Society (1888). He established a workshop in Hammersmith in 1880, where he concentrated on the design and manufacture of metalware, principally copper and brass but also including silver, though he did not register hallmarks until 1898. After Morris's death, he became a director of the Morris company, for whom he designed metalware and furniture. Unlike Morris, however, Benson was a firm believer in the use of machinery and designed metalwork for production by mechanical processes. His silver and copperware, with its clean, simple lines, was described by the *Magazine of Art* (1896) as 'palpitatingly modern'. Benson's silver was shown at the *Exposition Universelle* (q.v.) and retailed by Samuel Bing (q.v.) in his *Maison de l'Art Nouveau*. He was also an important theorist,

expounding his ideas in *Elements of Handicraft and Design*, published in 1893. Following the outbreak of the First World War, the Hammersmith workshop was turned over to munitions production and the firm closed down in 1920.

Bentwood Furniture

Furniture constructed from strips of wood (usually copper-beech), bent and laminated. This distinctive style of furniture, which is still popular, was pioneered by the German manufacturer Michael Thonet (q.v.) (1796–1871), who invented a series of techniques for bending and shaping wood. He began applying these techniques to the production of chairs in 1830.

Bentwood chair by Gebrüder Thonet, production no. 13.

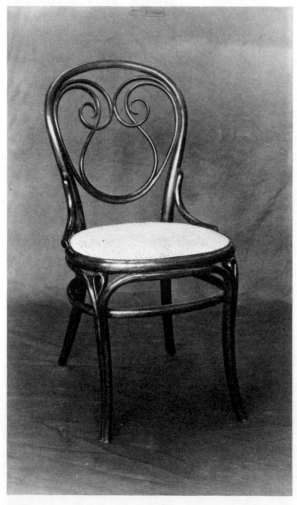

In the early decades, his furniture was handmade and destined for the palaces and castles of the Central European nobility but, from 1850 onwards, he increased his output enormously by the use of mass-production methods. After his patents expired in 1869, bentwood furniture spread rapidly to all parts of the world and variations on the basic theme were evolved in Britain, France and America as well as Germany and Austria where this type of furniture had long been established. By the turn of the century, the Thonet family had six factories in production, with a prodigious output of chairs, rockers, tables, *chaises longues,* sofas and even bed-steads. Marquetry (q.v.) and basketwork were incorporated in the more elaborate models, but Thonet took pride in being able to make a chair out of as few pieces as possible. The best examples of the Thonet craftsmanship have no more than three or four pieces in their construction. Thonet unconsciously produced something approaching the ideal of William Morris (q.v.)—noble art for the masses—but used the mass-production techniques which Morris detested. Nevertheless his durable but elegant furniture appealed to everyone in the late nineteenth century and it was equally at home in a Parisian cafe or in an archduke's palace. The bentwood furniture of that era foreshadowed the tubular steel furniture of the 1930s.

Berlage, Hendrik Petrus

Dutch architect and furniture designer (1856–1934). He studied architecture at the Zürich Polytechnic (1875–8) and later in Frankfurt am Main. In the early 1880s, he travelled extensively in Italy, Austria and Germany, imbibing the latest ideas in architecture which he applied in his native Holland in the 1890s. He rapidly became the foremost architect in the Netherlands and exercised a strong influence on his contemporaries, advocating the natural use of building materials, especially bricks and tiles. Architecturally his greatest work was the planning for the extension of The Hague (1907–8) and Amsterdam (1913). Like many architects of his day, he was also concerned with the design of interiors and individual pieces of furniture characterized by simple lines without ornament or ostentation. The Amsterdam Bourse (1898–1903) is a characteristic example of his massive angular style in decor.

Berlepsch-Valendas, Hans Edouard von

Swiss furniture and ceramics designer, born at St. Gallen in 1849. He studied architecture under Semper at the Zürich Polytechnic, and subsequently studied industrial design in Frankfurt (1872) and the Munich Academy (1875). He later visited England where he came under the influence of William Morris (q.v.) and his circle. After 1897, he was employed as a furniture designer by the *Vereinigte Werkstätten* (q.v.) in Munich and also designed tablewares for the Nymphenburg porcelain factory.

Berlin Porcelain

The *Königliche Porzellan Manufactur* (King's Porcelain Manufactory) was purchased by Frederick the Great in 1763 from Johann Ernst Gotzkowsky and continues to this day to produce fine table and decorative porcelain following traditional patterns. This pottery, located in Berlin, was one of the first to produce lithophanes, a process which impresses figures in

Berlin porcelain plaque of *c*. 1890 showing Psyche.

porcelain which become visible by transmitted light. Neo-classical motifs predominated throughout the *Biedermeier* era (1820–50). At the turn of the century, the factory was producing excellent figures of pastoral subjects, hand-painted porcelain plaques reproducing works of art and allegorical compositions. The manufacture of classical figures, in white glossy glazes with little colouring, was carried out under the supervision of Max Adolf Pfeiffer, modelled by Paul Scheurich, until the Second World War. The plant was destroyed during the war but, in recent years, has operated from Selb in Bavaria.
See *Porcelain Plaques*

Bernard, Emile

French painter, graphic artist and textile designer, born at Lille in 1868. He served his apprenticeship with the *Atelier Cormon* in Paris. He came under the influence of the Impressionists and, from about 1885 onwards, he began developing an early Expressionist style. Up to 1886, he used to spend his summers wandering on foot through Brittany, working at Cormon in the winter. In the summer of 1886, he met Gauguin (q.v.) in Pont-Aven and the following year he made the acquaintance of Toulouse-Lautrec (q.v.) and Van Gogh, with whom he formed the *Ecole du Petit Boulevard* which developed a kind of monochrome 'mood' painting. By 1888, Bernard's style of painting had clearly developed the characteristics of Art Nouveau and he is regarded as the pioneer of this style in French painting. Bernard also produced wood-carvings in the same *genre*, but he is best known for his tapestry designs, usually on the theme of Breton peasant women gathering fruit and berries. Bernard died in Paris in 1941.

Billing, Hermann

German architect and industrial designer, born at Karlsruhe in 1867. Billing was educated at the local art and technical high schools and subsequently became lecturer (1901) and professor (1906) of Architecture at the *Karlsruhe Technische Hochschule*. He is known mainly for his museum buildings, of which the Mannheim Kunsthalle (1907) is the best example. In his designs for furniture, Billing grafted

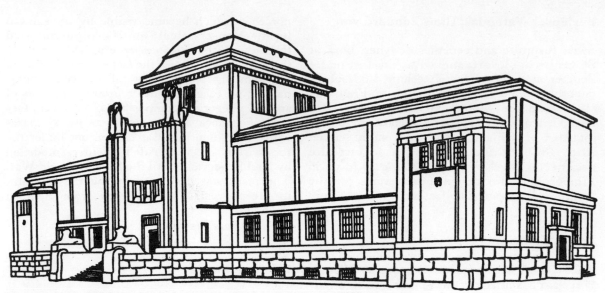

The Art Gallery at Mannheim designed by Hermann Billing in 1907.

elements from eighteenth century Baroque on to the *Jugendstil* (q.v.) of his contemporaries.

Bindesböll, Thorvald

Danish architect and designer, born at Copenhagen in 1846, the son of an architect. As the leading exponent of architectonic design in Scandinavia, his crowning achievement was the Copenhagen General Post Office, built in 1901. In the spirit of the times, however, Bindesböll was also a prolific designer of furniture, silverware, book-bindings, ceramics, leather goods, embroidery and metalwork. He is regarded as the father of modern Danish design in the applied arts. He died at Copenhagen in 1908.

Bing, Marcel and Samuel

Samuel (Siegfried) Bing (1838–1905) is the key figure in the development of Art Nouveau (q.v.). He has been styled variously as the philosopher and the impresario of the movement. Certainly he coined the name by which the style is generally known, after his shop in the Rue Provence in Paris. He aimed to show 'the workings of the hitherto unrevealed forces in art of our day'. This ranged from the paintings of Toulouse-Lautrec and Bernard (qq.v.) to the glassware of Tiffany and Lötz (qq.v.) and the products of

his own workshops which specialized in furniture, ceramics and jewellery. He tried to restore the 'grace, elegance, sound logic and purity' of the French tradition in art. To achieve this, Bing, a German from Hamburg, employed George de Feure (q.v.), a Dutchman, as his chief designer. With Eugène Gaillard and Eugène Colonna (qq.v.), de Feure was responsible for the design of Bing's pavilion at the *Exposition Universelle* (q.v.) of 1900. Associated with Samuel was his brother Marcel who specialized in jewellery, using gilt copper, *cloisonné* enamels (q.v.) and semi-precious stones in the production of brooches and pendants with a strongly medieval character.

Black, Starr and Frost

American firm of silversmiths, founded in 1810 and now the second oldest retail company in New York City. Throughout the nineteenth century, this firm were renowned for the most sumptuous and grandiose pieces in gold and silver. After various changes in name, the title Black, Starr and Frost came into use in 1876 and remained current until 1929. At the turn of the century, the company specialized in jewellery, silverware and objects of vertu, but made little concession to the vogue for Art Nouveau and continued in the Beaux Arts (q.v.) tradition.

Burmantofts vase, *c.* 1890. ▶

34

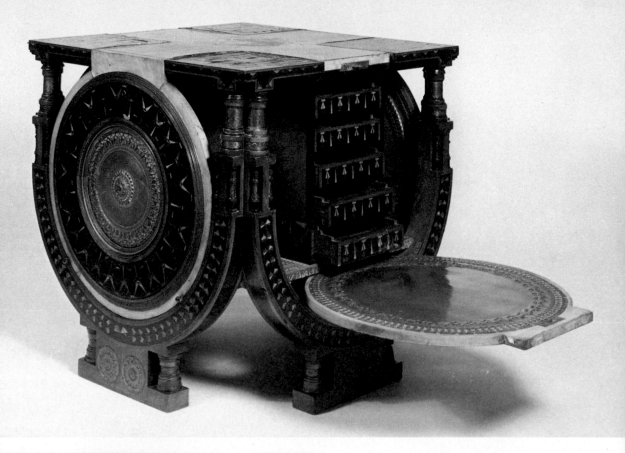

Combined table and cabinet by Carlo Bugatti, *c.* 1900.

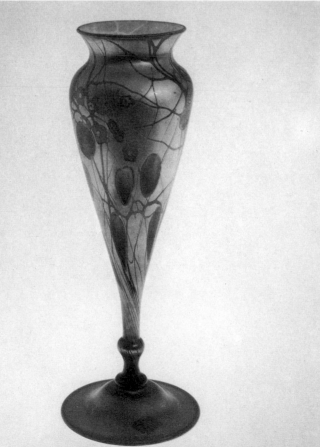

'Gold Aurene' vase with trailed and *millefiori* decoration, by Frederick Carder.

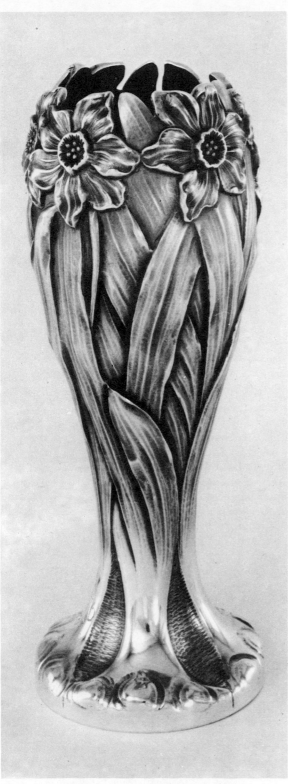

Silver vase by Black, Starr and Frost, c. 1910.

Book-bindings

There were two major developments in book-binding at the turn of the century: the fashion for pictorial trade bindings in machine-made books for general consumption, and the revival of the art of fine hand-made binding by the private presses (q.v.). In the second half of the nineteenth century, it became customary for books to be bound before they reached the retail bookseller and this encouraged the development of the so-called publisher's bindings, whereby all copies of an edition were case-bound in the same design and materials. At the same time, improved machinery revolutionized the book-binding industry and various processes for the decoration of bindings were devised. Metal dies were evolved for the impression of the covers, either blind or in gold or silver, and, by the end of the century, quite elaborate pictorial vignettes were being die-stamped on cloth bindings. The use of metal-embossing declined in the early 1900s, its place being taken by coloured impressions applied directly to the cloth. This, in turn, declined after the First World War when paper dust-jackets came increasingly into use. Pictorial trade bindings of the late nineteenth century offer the collector of modest means the opportunity to acquire fine examples of a transient art, but already the prices of books of this period, which would otherwise be undistinguished, are rising.

Book-binding as an art stagnated for much of the nineteenth century, but it revived dramatically in the 1890s, inspired largely by William Morris (q.v.) and parallel to the development of the private presses. Principal among the exponents of fine binding at the turn of the century were T. Cobden-Sanderson who established the Doves Press and bindery and whose pupil, Douglas Cockerell, has carried on the traditions of beautiful craftsmanship in this field to the present day. Charles Ricketts (q.v.) and his Vale Press also produced many excellent ornamental bindings for limited editions. In the early years of this century, there were several notable British craftswomen in this field including Sarah Prideaux, E. M. McColl, Sybil Pye and Mary Robinson. This art, which had its origins in England, spread to France, Germany and the United States. In Belgium, Henry Van de Velde (q.v.) designed beautiful bindings for the craftsman P. Claessens. In the United States, where commercial printing and

37

binding had fallen to deplorable levels, the renaissance of fine binding was led by Theodore L. De Vinne (1828–1914), a founder member of the Grolier Club who was responsible for many of its early publications. Walter Gilliss (1855–1925), secretary of the Grolier Club, designed many privately-printed volumes in the early years of this century, though he was also interested in more commercial ventures and was concerned in the design, layout and typography of such magazines as *Life* and *Vogue*. Daniel Berkeley Updike (1860–1941) founded the Merrymount Press in 1893 and produced many beautiful books. The earliest works were closely modelled on the English private presses and the work of William Morris. Subsequently the typography became much lighter, but the quality of the bindings remained uniformly high. Bruce Rogers entered the field as an illustrator and designer in 1890 but, from 1900 to 1912, he supervised the production of limited editions in fine bindings by the Riverside Press in Cambridge, Massachusetts, renowned for their

Garnett's *An Imaged World,* bound *c.* 1899 by the Guild of Women Binders.

range and versatility as well as their beauty and craftsmanship.

In this period, a greater variety of materials came to be employed in fine bindings. In Europe, there was a vogue for embroidered bindings; a wide range of leathers of different colours and textures was used, and half-vellum binding with hand-painted paper on boards was extensively practised. Both blind and gold tooling were used to great effect.

Book bindings: *Cours de Danse Fin de Siècle,* bound by Solomon David, Paris, 1892.

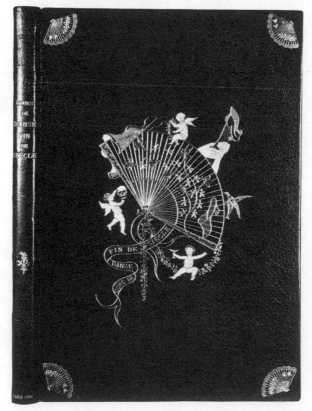

Bradley, William H.

American graphic artist, born at Boston in 1868, the son of an engraver. He was trained as a printer in north Michigan and in various printing houses in Chicago between 1881 and 1890. In the last decade of the nineteenth century, he began designing posters, book- and magazine-illustrations, embracing the Art Nouveau style more enthusiastically than any other American artist of that period. In 1885–6, he was a staff artist with Rand-McNally in Chicago, but subsequently worked as a freelance designer, producing covers for such magazines as *The*

Inland Printer and posters. His work was strongly influenced by William Morris, Burne-Jones and Walter Crane (qq.v.) but it was because of his imitation of Aubrey Beardsley (q.v.) that his work was often savagely criticized. In the early 1890s, he worked for Stone and Kimball, but the example of Morris and the Kelmscott Press induced him to establish his own press in 1895. The Wayside Press in Springfield, Massachusetts was short-lived, closing down in 1897, but during those two years it produced a little magazine *Bradley : His Book,* devoted to the theory and practice of fine printing, the arts and literature in general, and illustrated with Bradley's own wood-cuts. Subsequently he held an appointment for many years at the University Press, Cambridge, Mass. and also produced *The American Chap-book,* a monthly periodical, on behalf of the American Type

Design for *The Chap-Book* by Will Bradley, January 1895.

Founders Co. He died in 1962 and is regarded as one of America's leading typographers.

Brangwyn, Frank

Painter, graphic artist and designer, born at Bruges in 1867. While he was still a boy, his family moved to London where he enrolled at the South Kensington School of Art and studied under William Morris (q.v.) for three years. Between 1885 and 1898, he exhibited his paintings at the Royal Academy. In 1891–5, he worked in the *Academie Julian* in Paris where he made the acquaintance of the *Nabis* and exhibited in the *Salon d'Automne*. From 1897 to 1910, he exhibited his works in the Venice Biennale. In 1904, he was made an Associate of the Royal Academy. With Walter Crane (q.v.), Brangwyn exerted a great influence on the development of book- and magazine-illustration, but he is best remembered for his textile-designs, used for drapes and tapestries, and his Art Nouveau designs for glassware and mosaic panels.

Bretby Pottery

Art pottery established in 1883 at Woodville in South Derbyshire, England. The founder of the company, Henry Tooth, had had a varied artistic career, working as a theatrical scene-painter before joining the Linthorpe Pottery (q.v.) in the late 1870s. Tooth went into partnership with William Ault in 1882 and the Bretby Pottery began production the following year. Disagreement between the partners led to Ault setting up his own pottery at Swadlincote in 1886. The early Bretby wares had a close affinity to the Linthorpe pottery, with flowing, particoloured glazes. Bretby ware was renowned for its excellent *sang-de-boeuf* glaze and strongly Oriental character. In the late 1880s, Bretby began producing a distinctive pottery known as 'Copperette', because it simulated hammered copper. At the turn of the century, Bretby was producing pottery simulating bronze, with imitation cabochon gems applied to the surface. In the early 1900s, Clantha ware was evolved, with its distinctive black matt glaze, decorated in angular patterns reminiscent of the Glasgow Style (q.v.). The Bretby Pottery went into decline by 1910 and ceased production in 1920. See *Ault Faience*

39

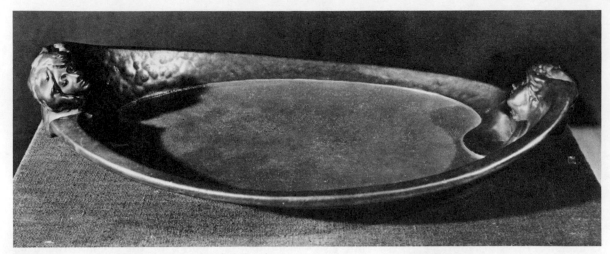

Earthenware dish with a copper lustre glaze by the
Bretby Art Pottery, *c.* 1900.

Bronzes

Individual works of sculpture, in the realm of
fine art, are beyond the scope of this book.
The late nineteenth century, however, was a
time when *bronzes d'edition* were very popular
with the new middle classes and this industry
developed especially in France, where such
bronze-founders as Barbedienne, Susse Frères
and Siot-Decauville produced excellent statu-
ettes and ornaments. Figures of dancers and
actresses, in particular, caught the popular
imagination at the turn of the century. Sarah
Bernhardt, who dabbled in bronze sculpture
herself, was a favourite subject and there is a
strange affinity between the posters and the
bronzes which feature her in some of her heroic
roles, such as the Princess Lointaine (from the
play by Rostand first produced in 1895). The
famous *danseuses* Loie Fuller and Cleo de
Merode were immortalized in bronzes which
were intended for use as lamps (q.v.), concealing
electric light bulbs within the folds of thin
bronze veils, though moulded glass was often
incorporated for this purpose. Bronzes of ac-
tresses were the speciality of Antoine Bofill,
Louis Chalon, Raoul Larche, Agathon Léonard
and Marius Vallet. Allegorical figures, such as
Nature unveiling herself to Science, were produced
by Ernest-Louis Barrias in the 1890s. Felix
Fix-Masseau (1869–1937) sculpted figures in
wood or ivory and many of these were subse-
quently reproduced for the mass market in
sand-cast bronzes.

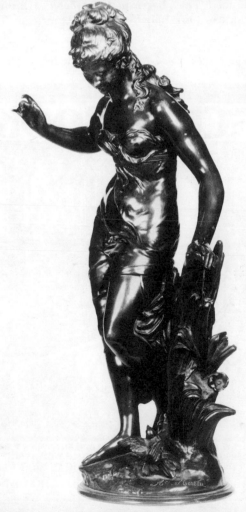

'Libellule' bronze nymph after Auguste Moreau,
French, *c.* 1900.

40

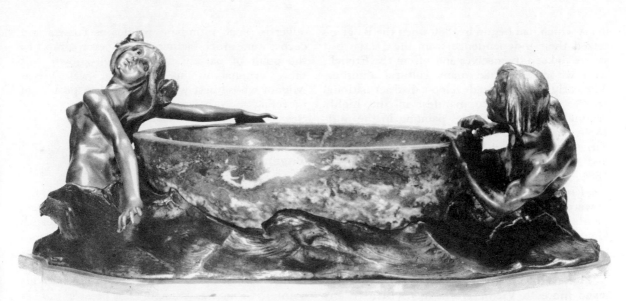

Gilt-bronze and red marble Art Nouveau group and dish, *c.* 1900.

Alphonse Mucha (q.v.) collaborated with the sculptor Auguste Seysses (1862–1946) to produce bronze busts of girls with the characteristic flowing tresses seen in Mucha's poster designs and, indeed, the originals of some of these portrait busts may be traced to calendars and commercial advertisements designed by Mucha. The bronzes produced by Mucha and Seysses were often gilded or silvered and set with semi-precious stones. Charles Korschmann (like Mucha, a Czech resident in Paris) also produced bronze figures as table ornaments or fitted for use as lamps. In these bronze figures of the turn of the century, the flowing lines of Art Nouveau were stylized almost to the point of affectation, and this may explain their relatively brief popularity. By 1905, they had gone out of fashion, though interest in them has been revived in recent years.
See *Animalier Bronzes*

Brouwer, W. C.

One of the leading Dutch potters at the beginning of this century. Brouwer worked originally at Gouda but moved his studio to Leiderdorp in 1901. The pottery which he produced at the turn of the century was strongly influenced by Van de Velde (q.v.) but Brouwer had his own inimitable style. Bowls and squat, chunky vases were worked in coarse clay glazed green or yellow, with rudimentary abstract designs cut in relief and coloured a darker shade.

Bruckmann, Peter

The German firm of silversmiths, based in Heilbronn, Württemberg. It was founded in 1805 and has been in the hands of successive generations of the Bruckmann family ever since. In the late nineteenth century, the company founded the Professional Bruckmann School for Designers, Chasers, Engravers and Silversmiths and broke with the Neo-classical tradition dominating German silverware by exploring the trends in design which culminated in *Jugendstil* (q.v.). Bruckmann-trained artists and craftsmen had a great influence on the development of metalwork in Germany at the beginning of this century and took a prominent part in the *Werkbund* movement.

Brussels Style

Form of Art Nouveau (q.v.) developed in Belgium, with its own distinctive and original qualities. In the applied and decorative arts and architecture, the Brussels Style stood out for its uncompromising refusal to borrow from history or from other parts of the world. The Brussels Style was, in fact, the culmination of a movement

in art which had begun in 1830 when the Belgians seized their independence from the Dutch but strove to keep themselves apart from the French, with whom they had many cultural affinities. The early attempts to develop a distinct national artistic identity were manifest in the highly original Belgian School of painting in the mid-1850s and the constant quest for the *avant-garde,* characterized by Octave Maus who founded the progressive review *L'Art Moderne* in 1881. The group of modern artists known as *Les Vingt* (the Twenty) led the world, from 1884 onward, in publicizing the work of radical painters. As a result, the works of Cézanne, Gauguin (q.v.), Seurat and Toulouse-Lautrec (q.v.) were better known in Belgium than they were in France.

The evolution of a distinctive Brussels Style owed more to Victor Horta (q.v.) than to any other man. Horta's highly original designs for the *Maison Tassell* (1892), the Hotel Solvay (1895) and his own house in the rue Americaine (1898) brought the highly idiosyncratic style dramatically to the attention of the public. The best example of his work, the *Maison du Peuple,* built in 1896–9 as the headquarters of the Brussels Co-operative Society, was unfortunately demolished in 1966. Austere structural elements, combined with the sculptural qualities of serpentine curves and sinuous lines, are the hallmarks of Horta's style and distinguished it from the more ethereal Art Nouveau styles developed in France and Germany. In furniture, designers were influenced by William Morris (q.v.), Viollet-le-Duc and Octave Maus, and reproduced the architectural qualities demonstrated in the work of Horta. They went back to unpretentious materials and true craftsmanship and produced a startling range of furniture for the new industrial middle classes. Apart from Horta himself, the most notable furniture designers of the Brussels school were Gustave Serrurier-Bovy and Henry Van de Velde (qq.v.). Their counterparts in the field of ceramics were Isidore de Rudder (q.v.) and P. J. Laignel of Courtrai. De Rudder exerted a great influence over Philippe Wolfers (q.v.) who became the leading exponent of Art Nouveau jewellery in Belgium, though Van de Velde also was highly successful in this field. Only in the field of posters did the spirit of originality begin to wear thin. Privat-Livemont (q.v.), the foremost Belgian poster artist, was a disciple of Mucha (q.v.) and, in his use of girls in dreamy, romantic settings to advertise such mundane articles as corsets and cocoa, went much farther than Cheret, almost to the point of parody. Not so well-known, but more original in his approach, was Victor Mignot whose best work consisted of posters of bicycling and other sporting pastimes.

See *Art Nouveau, Jungendstil*

Bugatti Family

Italian family prominent in art circles at the turn of the century. The Bugattis traced their descent from Zanetto Bugatti, the fifteenth century Milanese portrait painter, and Giovanni Francesco Bugatti, the seventeenth century engraver. Carlo Bugatti (born 1855) was the brother-in-law of Giovanni Segantini the famous painter. Carlo was trained as a painter but, at the turn of the century, designed silverware, metalwork and furniture in the prevailing *Stile Liberty* (q.v.). His two sons are much better known. Ettore (1882–1947) received an artistic

Italian walnut armchair by Carlo Bugatti, *c.* 1900.

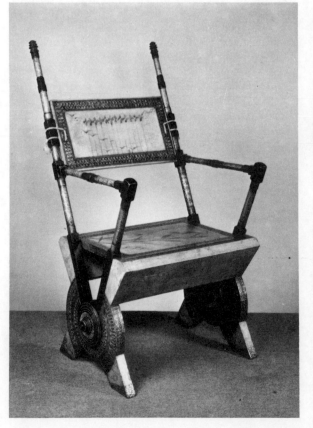

training but his passion for motoring led him to build his first car at the age of eighteen. His first commercial project was a four-cylinder car, built in 1900, which was an immediate success. The best of the Bugatti sports cars were made from 1911 onwards. It has been said of him that he designed cars 'in much the same way as a court clock-maker of the eighteenth century would design and build a time-piece for his royal patron'. There was a sculptural quality about the engines and the sleek lines of the bodywork. His younger brother Rembrandt (1885–1916) trained as a painter and sculptor, worked in Paris from 1901 to 1906 and then spent the last decade of his life mainly in Antwerp. He returned to Paris at the outbreak of the First World War but committed suicide in January 1916, following bouts of depression and migraine. Rembrandt Bugatti achieved fame in his all too brief career as a sculptor of animalier bronzes (q.v.).

Bulgari, Sotirio

Italian silversmith, born in Albania in 1857 and died in Rome in 1932. Bulgari was the son of a Greek silversmith, George Boulgaris, who fled with his family to Italy during the Christian massacres of 1877. Sotirio established a small silverware business in Naples, specializing in objects in the Turkish or Persian styles. The shop was burgled in 1881 and Sotirio, penniless, moved to Rome where he gradually re-established himself, first as a street-seller of trinkets and then in a shop in the Via Sistina, subsequently moving to the present site on the Via Condotti. In 1905 he returned to Greece and later established an emporium specializing in jewellery in both classical and modern styles. Sotiro's sons, Constantino and Giorgio, carried on his tradition for fine craftsmanship in silver and jewellery, Giorgio being a prolific writer and scholar on the subject of antique jewellery.

Bürck, Paul

German painter, graphic artist and industrial designer, born at Elberfeld in 1878. Bürck received his art training at the Industrial Design School in Munich. Bürck was one of the more versatile exponents of *Jugendstil* (q.v.), producing designs for curtains, tapestries and other textile media, stained-glass windows and book-bindings. He experimented with wood-cuts in which the lines appeared white against a dark ground, and extended this technique into his designs for book-bindings. With Hans Christiansen (q.v.), he evolved a highly distinctive style of tapestry at Darmstadt, where he worked between 1899 and 1902. Textile designs with such evocative names as 'Morning Wind', 'Times Past' and 'Desire', were characterized by brilliant colours, serpentine motifs and a plethora of meaningless ornament devoid of application. Many of his designs were also reproduced as wallpaper by the Mannheim firm of H. Engelhardt from 1898 onwards.

Burmantofts Pottery

Type of faience (q.v.) named after the Leeds, Yorkshire, suburb of Burmantofts where the pottery of Wilcock & Company was located. Wilcocks originally produced industrial and architectural tiles and earthenware but, from 1880 onwards, began manufacturing decorative wares. The Burmantofts faience consisted of a very hard biscuit-coloured earthenware fired to a very high temperature and covered with a fine felspathic glaze. At first this was used for decorative tiles designed for both interior and exterior walls of houses and public buildings but, from 1890 to the outbreak of the First World War, Burmantofts pottery was also used for vases, bowls and other tableware. A series of figures, based on Chinese originals, was also modelled in Burmantofts faience. Copper and silver lustreware on deep blue or red grounds was another speciality of this company.

Burmese Glass

Type of opaque art glass containing gold and uranium oxides producing delicate tones ranging from pale yellow to a rich pink. Burmese glass was patented by Frederick Shirley of the Mount Washington Glass Company (q.v.) in December 1885 and rapidly became one of the company's most popular lines. Shirley, an ex-patriate Englishman, sent a tea service to Queen Victoria decorated in what he termed 'Queen's Burmese' pattern. Queen Victoria was enchanted by it and ordered further examples of Burmese ware. Subsequently Shirley granted a concession to

Burmese glass centre-piece by Webb, *c.* 1890.

Thomas Webb (q.v.) of Stourbridge, England to produce this glass. Such pieces bear an impressed mark on the base, 'Thos. Webb & Sons, Queen's Burmese Ware, Patented'. The popularity of Burmese glass declined rapidly after 1900 but fine examples are now highly prized by collectors. Apart from tablewares, it was a fashionable medium for lamps.

Burne-Jones, Sir Edward

English painter and designer, born in Birmingham in 1833. Burne-Jones was the youngest of the Pre-Raphaelites, a pupil of Rossetti and a

Merton Abbey tapestry *The Pilgrim in the Garden,* designed by Burne-Jones and woven by Taylor, Martin & Ellis, 1901.

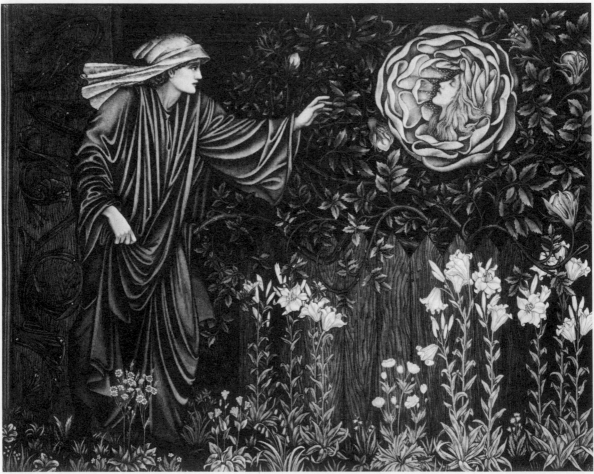

colleague of William Morris (q.v.) for whom he designed furniture, mosaics, stained-glass windows, murals, wall-hangings and tiles (q.v.). Burne-Jones also designed some jewellery but, apart from some bronze candlesticks, none of his metalwork seems to have survived. The best-known contribution of Burne-Jones to the Arts and Crafts Movement (q.v.) was the series of tapestries, telling the story of the Arthurian legend of the Holy Grail, woven at Merton Abbey (q.v.). Burne-Jones died in 1898.

Bygones

Strictly speaking, anything belonging to times past could be described as a bygone, but the term is usually reserved for objects which rely for their antiquarian interest not so much for their aesthetic qualities as for their age and old-fashioned appearance. Anything rendered obsolete by changing fashions or technological progress may come under this heading. The turn of the century was a fruitful period for the sort of material now classed as bygones; it was an era of great industrial expansion, when gadgetry and patent devices of all kinds were finding a use in the home or the office, when the doctrine of art for all, everywhere, was applied enthusiastically to numerous objects which might not otherwise have had ornament lavished on them. It was an age which took great delight in novelty in everything, from pencil-sharpeners to can-openers. Many of the mechanical aids of the present day, which we tend to take for granted, were still in their formative stage at the beginning of this century and examples of these bygones have a distinctive period appeal. In this category come ornately decorated cash registers, slot machines and early typewriters with rotating drums of type or unusual arrangements of the hammers before the modern banks of keys became standardized. Souvenirs of the great exhibitions and world's fairs of the period, from the Columbian Exposition of 1893 (q.v.) to

Bygones: Junior Monarch gramophone with mahogany horn, 1895.

the Hudson-Fulton Celebrations of 1909, or patriotic mementoes of the Spanish-American and Boer Wars are specialized categories of bygones, each of which now has a strong following. The 1890s saw the development of tourism on a commercial scale, manifest in such bygones as picture postcards and paperweights (qq.v.) with views of tourist resorts pasted to their base. This was also the heyday of crested china ornaments and china fairings—both long neglected by collectors but now subject to renewed interest. Other branches of bygones which are worth investigating include kitchen utensils and equipment, scientific and medical instruments, children's toys and games, dress accessories and early mineral-water bottles.

See *Americana, Industrial Archaeology*

Cameo Glass

Type of decorative glass developed in Britain in the late nineteenth century and peculiar to that country. Cameo glass of a sort was also produced in France by Emile Gallé (q.v.) but differed from its English counterpart in many respects. Cameo glass involved the revival of techniques known to the Romans and seen at their best in the famous Portland Vase. It consists of cased or flash glass, with several layers and usually incorporating an opaque glass on a coloured ground with a matt finish. The cameo effect was achieved by carving, or otherwise removing, the outer layer to reveal the opaque glass underneath. The best and earliest cameo glass was engraved by hand but, towards the end of the century when cameo glass increased in popularity, various mechanical processes were introduced. Cutting could be done on a wheel, but more often decoration was applied in acid-resistant materials and the surrounding area then removed by immersing in acid. The best examples of cameo glass include the various copies made of the Portland Vase between 1873 and 1880. The Elgin Marbles were another source of inspiration and formed the character of English cameo glass, which was almost entirely classical in composition. Cameo glass on a commercial basis, using acid-etching, was introduced by Thomas Webb (q.v.) in 1884 and from then until 1911, Webb Cameo glass, with its white floral or classical motifs on a coloured base, was exceedingly popular. These pieces were invariably stamped 'Webb's Gem Cameo' and many examples in the 1890s also bore the date of manufacture.

The best of the hand-engraved cameo glass was produced for Webb by George and Thomas Woodall (q.v.). Excellent cameo glass was also produced by Stevens & Williams of Stourbridge, either alone or in conjunction with J. & J. Northwood.

From about 1884, Emile Gallé began producing a type of cameo glass, in which the decoration was cut by a wheel into the various layers of coloured glass. Gallé also adopted acid-etching in the 1890s to cope with the demand for cameo glass, mainly from the Near East and Mediterranean markets. Cameo glass is sometimes confused with a white enamel-painted glass, of German or Bohemian origin, designed to compete against cameo glass for public favour.

See *Pâte de Verre*

Cameo glass vase by Stevens & Williams of Stourbridge, *c.* 1900.

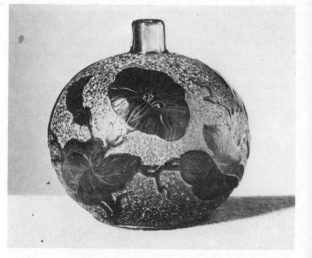

46

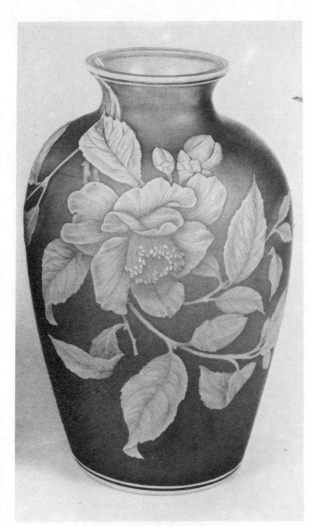

A cameo-glass vase with white floral motif on translucent blue ground, 1890.

Glass candlesticks were made, with slender plant motifs, by the French and Austrian glasshouses in particular. The greatest scope exists, however, in metalwork and ranges from silver candlesticks in traditional patterns to the more austere copper and pewter candlesticks in the 'Tudric' and 'Cymric' patterns of Liberty (q.v.). R. C. Silver designed superb metal

Seven-branched candelabrum in the Art Nouveau style by Gebrüder Hepp, Austrian, 1900.

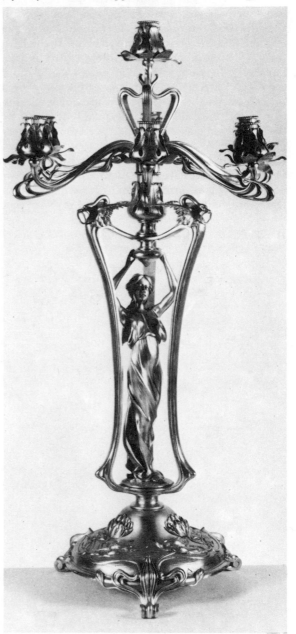

Candlesticks and Candelabra

Although electric lighting was becoming more commonplace towards the end of the nineteenth century, candles were still widely used, and candlesticks were therefore a considerable end-product of the materials and artistic styles favoured at the turn of the century. Brass candlesticks in standard 'Georgian' designs continued to be popular and examples are reasonably plentiful to this day, but the collector will be more interested in examples which reflect the trends of the late nineteenth and early twentieth centuries. Elegant candlesticks were produced in art pottery (q.v.) and were a speciality of the Roseville Pottery Company in the United States.

candlesticks for the Birmingham firm of W. H. Haseler (q.v.) in the early 1900s and examples of these tall, slim Art Nouveau pieces are now highly regarded. Tall, angular candelabra and candlesticks were also designed by C. R. Mackintosh and C. R. Ashbee (qq.v.).

Canes and cane-handles

As dress accessories, canes went out of general use shortly before the First World War, though they reached the zenith of their popularity at the end of the nineteenth century. From the collector's viewpoint, the main interest lies in the handle. The acme of good taste was a gold handle, relatively devoid of decoration except for the owner's crest (if he was fortunate enough to possess one). Silver handles were despised by the wealthier classes but, as they stood a better chance of avoiding the melting pot, they have survived in larger numbers and exhibit a wide variety of decorative treatment, from the comparatively plain, armorial or regimental style to the more flamboyant excesses of Art Nouveau.

Ivory handled canes in the form of a snake and a tiger's head.

Handles from two horsewhips with wire-mesh shafts and ornaments in electroplate and parcel-gilt silver.

Carved wood or ivory or even porcelain handles may be found dating from the turn of the century. Those in grotesque animal or human form are highly prized nowadays. Also much sought after are those with a patent catch concealing a spirit flask, tobacco pipe or even a tiny fire-arm for personal safety.

Cardeilhac, Ernest

French silversmith and head of the firm founded by his grandfather, Vital Antoine Cardeilhac, in 1802. Ernest Cardeilhac and his chief designer, Bonvallet, produced jewellery and silverware in the best tradition of Art Nouveau, eschewing the more bizarre fantasies of the style and concentrating on good, sober designs which were eminently saleable in the 1890s. Cardeilhac died in 1904, but his sons, James and Peter, carried on the family tradition. The company amalgamated with Christophle (q.v.) in 1951.

Carpets and Tapestries

The late nineteenth century was the period in which the new middle classes and prosperous working classes of Europe and America first began using carpets to any great extent. Hitherto carpets had been used exclusively by the wealthier sections of the population, and the lower classes had made do with occasional rugs, many of them home-made in a form of folk art which was widespread all over Europe. The demand for carpets in the Oriental taste led to the rapid development of commercial textile factories in Paris, Brussels, Berlin, the London area, Kidderminster and Glasgow. Formalized patterns, more or less modelled on Chinese or Turkish originals, predominated for much of the late nineteenth century.

The first attempts to break away from the Oriental tradition came in 1879 when William Morris (q.v.) began designing carpets, machine-made by the Heckmondwike factory in the styles of Axminster, Kidderminster, Brussels and Wilton. From 1882 onwards, however, Morris produced his own carpets at Merton Abbey (q.v.). Original designs of high quality were produced until about 1905, but thereafter the firm's output became stereotyped. The floral designs of Merton Abbey exerted a tremendous influence on carpet design in Europe and America at the turn of the century and the Morris tradition is to be found in the work of Alphone Mucha, Emile Bernard and Otto Eckmann (qq.v.). Morris also pioneered pictorial wall-hangings, derived from the tapestries of medieval times. His designers included Walter Crane, Edward Burne-Jones and Frank Brangwyn (qq.v.). Popular motifs with names like 'Wandering Wood', 'April Shower' and 'Summer' were copied on the Continent, as well as by other British textile companies.

The French factories in Paris, Aubusson and Beauvais enthusiastically embraced the styles of Art Nouveau taught at the *Ecole des Beaux Arts*. Outstanding designers included Gustave Moreau, chief technician of the Gobelin Company in Paris, and artist-craftsmen such as Emile Bernard (q.v.). Paul Gauguin (q.v.) produced a number of designs, subsequently utilized in the manufacture of carpets and wall-hangings. From 1890 to 1898, the painter Paul Ranson (q.v.) experimented with carpet design and also produced large tapestries such as 'Two Women in White' or 'Woman in Oriental

'The Wykehamist' Axminster carpet designed by C. F. A. Voysey, 1896.

Garb'. Samuel Bing (q.v.) was instrumental in making the wall-hanging fashionable, first in France and later throughout western Europe. The sculptor Aristide Maillol studied medieval tapestry in Cluny Museum and then designed a series of wall-hangings between 1892 and 1898, subsequently woven by Gobelin. In Belgium, the leading carpet-designer of this period was Van de Velde (q.v.) influenced by Gauguin in his use of colour and form. Many of his motifs were religious in composition. The influence of Morris was particularly strong in Scandinavia. From 1874 onwards, the *Svenska Slöjdforeningen* of Stockholm produced excellent hand-made carpets in textile designs pioneered by Morris

Hammersmith rug by William Morris, 1880–90.

bouring Scandinavia, set the trends in German carpet design. Brinckmann's assistant, Friedrich Deneken (a native of North Schlewsig) pioneered the distinctive blue-white-red patterns based on the colours of the Schleswig-Holstein flag. Among the designers who received their training at Scherrebek were Eckmann and Christiansen (qq.v.), Walter Leistikow (Berlin), Otto Ubbelohde (Marburg), Alfred Mohrbutter (q.v.) and Ernst Nicolai (Dresden). Samuel Bing publicized the works of the Scherrebek school beyond their native land and exported their carpets and wall-hangings to Switzerland, Belgium, Russia, Italy and the United States as well as France.

The interrelation of textile-design with wallpaper during this period should not be overlooked. Many of the designs were subsequently modified for interpretation in the latter medium. See *Fabrics, Wallpapers*

Cartier, Louis François

French silversmith and jeweller who established a modest workshop in Paris in 1857. He had the good fortune to come to the notice of Princess Mathilde Bonaparte who gave him many valuable commissions, which enabled him to expand his business. Under the management of his grandsons, Pierre and Jacques, the firm moved to its present location on the Rue de la Paix at the turn of the century. Cartier's enjoyed the patronage of most of the royalty and nobility of Europe in the years before the First World War, opening branches in London, New York, Cannes and Monte Carlo. The English branch became a separate company in 1921.

Cartier's ignored the contemporary trends in 'art' jewellery and concentrated on diamonds in gold settings in the high fashion of the late nineteenth century.

Cauldon Porcelain

Cauldon Place, Hanley was the location of a pottery which specialized in fine porcelain. The pottery was operated by John Ridgway, Potter to the Queen, until 1855 when the business was transferred to the firm of Brown-Westhead and Moore. Excellent decorative and tablewares were produced around the end of the nineteenth

in 1873, but a more distinctive Nordic style evolved towards the end of the century, thanks to the efforts of the designer Gerhard Munthe and the weaver Frida Hansen (q.v.). The carpets and wall-hangings of Sweden and Norway were a curious blend of old Norse motifs, *Japonaiserie* (q.v.) and the ethereal elements of the Macdonald Sisters (q.v.).

In Germany, the lead was given by Justus Brinckmann, Director of the Hamburg Industrial Arts Museum, who encouraged the development of a school of weaving in the North Schleswig village of Scherrebek. From 1896 to 1903, this school, imbibing the best ideas from neigh-

Late 19th century urn by Cauldon.

Centrepieces

The *piece de resistance* of the dinner service, the centrepiece enjoyed a late flowering at the end of the nineteenth century and many sumptuous pieces in sterling silver or silver-gilt were modelled by Tiffany, Liberty (qq.v.) and other leading silversmiths in Europe and America. The chrysanthemum was the most popular motif, a symbol of longevity borrowed from the Japanese. The long, graceful stems of the wild chrysanthemum were ideally suited to the sinuous curves of Art Nouveau. The majority of the centrepieces of this period were a riotous mixture of Baroque, Rococo, *Japonaiserie* (q.v.) and other styles popularized by the Beaux Arts school (q.v.). Elaborate epergnes, table fountains and candelabra (q.v.), set with semiprecious stones, were fashionable wedding or anniversary presents among the wealthier classes but, in the main, they conformed to mid-Victorian traditions in styling. Relatively few examples of centrepieces are to be found in strictly Art Nouveau patterns; the light, romantic qualities of the style were not ideally suited to the florid ebullience which such pieces demanded. See *Presentation Silver*

century, the principal decorators of this period being T. J. Bott, J. Ellis, C. Harrison and E. Sieffert. The company produced elegant vases, colossal candelabra and lavish centrepieces. Dessert services were decorated with motifs from La Fontaine's fables. Porcelain by this company bore the mark 'B.W.M.' or 'Cauldon'. After 1904, the marks took note of the fact that the firm had become a limited company. Much of the Cauldon porcelain of the early 1900s was exported to the United States. Pictorial potlids (q.v.) were also produced by this company and, although their heyday had passed by 1890, they were still being made as exhibition pieces, for display at the Columbian Exposition of 1893 (q.v.).

Silver centrepiece by John Round and Sons, 1906.

Chaumet

French silversmiths and jewellers, founded in 1780. Chaumet's made the crown jewels used by Napoleon I at his coronation in 1804. Joseph Chaumet began the firm's international expansion in 1875 when a branch was opened in London. Subsequently branches were established in other parts of the world and Chaumet's won many awards in international exhibitions, specializing in gold and diamond jewellery for European and Eastern rulers and potentates.

Cheret, Jules

Decorative painter and poster artist, born at Paris in 1836. Cheret received his art training with a lithographic company and also spent some time working in London. In 1866, he formed his own printing company importing chromolithographic equipment from England, and gradually developed the advertisement poster

Lithographic poster of Loie Fuller by Jules Cheret, 1893.

(q.v.) as an art form in its own right. His work was strongly influenced by the painter, Toulouse-Lautrec (q.v.), but, from 1893 onwards, he and Mucha (q.v.) may be said to have interacted mutually in the development of the Art Nouveau poster. In 1889, Cheret was awarded the *Legion d'Honneur* in recognition of his work in creating 'a new branch of art by applying art to commercial and industrial printing'. His early posters, though robust and colourful, lacked the shimmering and graceful qualities of his later work, from about 1893 onwards. In the 1890s, he developed his inimitable girls, languorous beauties who danced across the hoardings of Paris and have since enchanted the world. Cheret was a prolific artist, producing about nine hundred different posters, half of which advertised music halls and cabarets and the rest publicized commercial products: cycles, cigarettes, cocoa and corsetry. Cheret's designs were delicate, whimsical, sentimental and often bordering on the fantastic, in contrast to the stark realism which was often featured in the posters of Toulouse-Lautrec. After 1900, however, he gradually adopted a more impressionistic style and his output declined sharply by 1910, though he lived on until 1930.
See *Posters*

Chicago School

Generic name for a group of architects, furniture-makers and designers centred on Chicago between 1889 and the First World War. During the 1880s, Chicago developed rapidly into one of the leading centres of American furniture production. With the commercial development of the Middle West, Chicago itself grew dramatically and became a focal point for young architects intent on experimenting with new forms and materials. The earliest sky-scrapers and buildings using steel in their construction, were erected in Chicago. Doyen of these architect-designers was Louis Sullivan (q.v.), but among his contemporaries were Holabird and Roche, Burnham and Root, pioneers of a distinctive American style of architecture in the Monadnock Building (1889), the Marquette Building (1894) and the Guaranty Building in Buffalo (1895). The pretentiousness of mid-Victorian architecture was eliminated and buildings took on a

Fashion plate from *Les Modes,* 1901. ▶

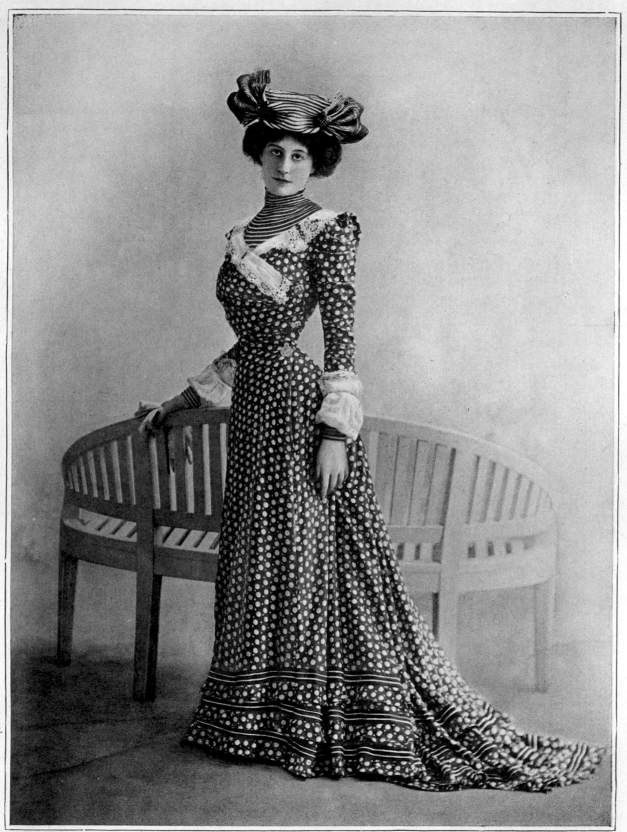

ROBE DE JOUR

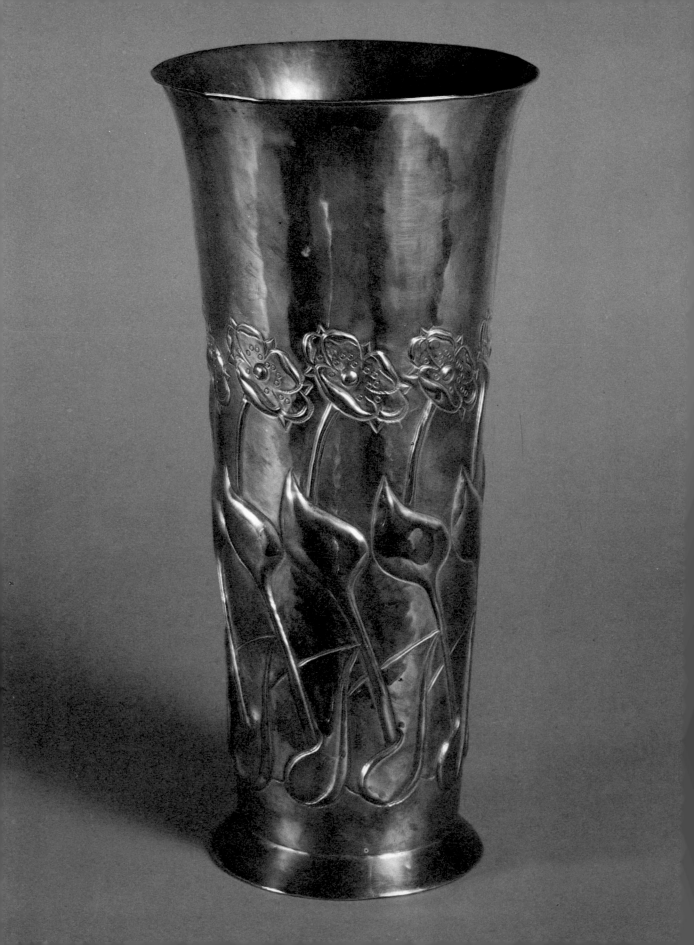

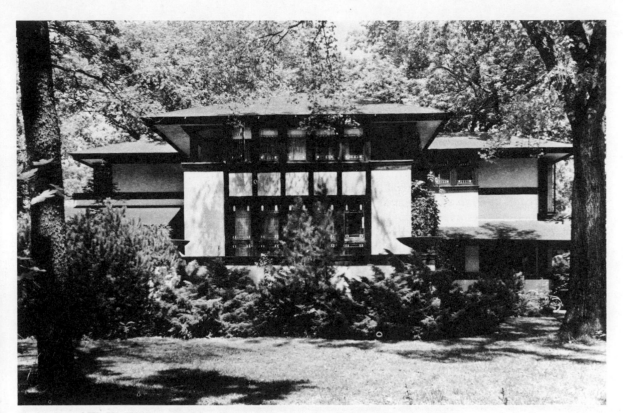

Residence of W. W. Willitts, Highland Park, Illinois, by Frank Lloyd Wright, 1902.

new functional beauty. Their ideas of bringing art into the most ordinary structures were inspired by William Morris (q.v.) and his circle.

Frank Lloyd Wright (q.v.) came to Chicago in 1887 and, after working for Sullivan, established his own architectural practice in 1893. Wright was a pioneer of built-in furniture, but he also designed individual pieces. Unlike the disciples of Morris, Wright was a firm believer in machine-made furniture and he expressly designed chairs and tables which were best suited to mechanical production. Wright's contemporaries as architect-designers were George Maher (1864–1926) and George Grant Elmslie (1871–1952) (qq.v.), pioneers of the Prairie style of ranch houses which have dominated American architecture ever since. Both Maher and Elmslie designed furniture and interiors for their houses, characterized by angular lines. Although the bulk of the furniture made in Chicago at the turn of the century was mass-produced, a small band of artist-craftsmen

demonstrated great skill and versatility in their fine range of custom-built furniture. Chief among these craftsmen was Isaac Scott (1845–1920), the architectural form of whose furniture was Gothic in inspiration. The Tobey Furniture Company (q.v.) was the outstanding manufacturer of furniture in which the Chicago School's concepts of utility and innovation were most perfectly expressed. The remarkable architecture of the Chicago School influenced all the applied arts in America: however wide the gap between aesthetics and architecture, it was the clean silhouette, great central arches and massive corner piers, hallmarks of the new architectural styles, which had the strongest influence on the furniture, glass, silverware and industrial design of the early twentieth century.

Choo, Suzuki

Japanese goldsmith and metalworker (1848–1919). Choo was the most outstanding exponent of wrought-gold work in the late nineteenth century and one of the last of the traditional

◀ Copper vase, by the Keswick School of Industrial Art, c. 1900.

55

master artisans in this field. His pupil Eiichi (born 1878) adapted traditional techniques in wrought-metal to the new spirit of Westernization which pervaded every aspect of the arts and crafts in Japan at the turn of the century.

Christiansen, Hans

German decorative painter and designer, born at Flensburg in 1866. Christiansen received his art training at the Munich industrial arts school and the *Academie Julian* in Paris. He also travelled in Italy before settling down as a decorative painter in Hamburg. For a time he also worked in Darmstadt and died at Wiesbaden in 1945. Christiansen is best known for his distinctive style in textile-patterns and wallpaper (q.v.), evolved with Paul Bürck (q.v.) at Darmstadt. Motifs derived from nature and repetitions of serpentine lines characterized his designs. Christiansen also designed jewellery in silver, principally brooches and pendants.

Christmas Cards and Seals

Greetings cards for use at the Christmas season were an English invention, the first appearing in December 1843. John Horsley designed the first card, showing a typical Victorian family drinking a toast to absent friends. The cards were published by Henry Cole at his Felix Summerly's Home Treasury. The idea spread gradually to other countries and, by 1890, the volume of Christmas cards had reached such proportions that postal administrations had to make special arrangements for the handling of such mail. The cards most prized by collectors are those manufactured by Marcus Ward, who employed Walter Crane, Kate Greenaway (qq.v.) and H. Stacy Marks as his designers. Raphael Tuck, who began producing Christmas cards in 1871, became the largest manufacturer of greetings cards by 1900 and the more expensive range were of a very high standard in design and execution.

In design, Christmas cards were relatively

A New Year's greeting card in the 'artistic' style by Marcus Ward.

WELCOME NEW YEAR, WELCOME MAY! WE'LL CROWN THEE FLORA'S QUEEN TO-DAY!

conservative, preferring traditional themes which remain popular to this day. Cards with Art Nouveau motifs are comparatively scarce and are consequently highly prized nowadays. Although the vogue for elaborate cards, composed of scraps, silk vignettes and lace ribbons, was over by 1890, their place was taken by novelty cards with pop-up pictures or animated devices and these are worth looking out for. After 1900 and up to the First World War, Christmas cards in the form of picture postcards (q.v.) were fashionable. Floral compositions or real photographs of very young children were favourite subjects.

Allied to the cards themselves were Christmas seals, invented by Einar Holboell and introduced by Denmark in 1904. The earliest examples came from the Scandinavian countries, including Iceland, and the Danish West Indies (now the U.S. Virgin Islands) and examples from the last-named are relatively scarce. Seals spread to the United States about 1910 and to Britain and other European countries rather later.

Special postmarks, to denote cards posted in advance for delivery on Christmas day, were used in Britain from 1902 to 1909 and are now highly prized.

Christophle, L'Orfèvrerie

Leading French silversmiths, founded in 1839 by Charles Christophle. Christophle are best known for pioneering electroplate in France, many millions of pieces having been produced since 1861. With the rival firm of Cardeilhac (q.v.), Christophle employed artists and architects such as Tony Selmersheim, Lucien Gaillard, Eugène Colonna and Georges de Feure (qq.v.) to design silverware and jewellery on the typical Art Nouveau lines.

Cigarette and Trade Cards

Decorative cards included in packets of cigarettes, confectionery and other merchandise.

A comic American Christmas card sent by a firm in Pittsburg to its clients.

Montage of late 19th century American trade cards.

They had their origin in 1879 when American cigarette manufacturers introduced a pictorial element onto the small card stiffeners inserted in the flimsy paper packets to protect the contents. The application of modern techniques of colour-printing by offset-lithography came in 1885 and, two years later, W. D. & H. O. Wills

became the first British tobacco company to put cards in their cigarette packets. By 1890, the custom of issuing different pictorial cards in sets was established and eventually there was tremendous competition between the various companies in producing cards which were not only attractive to look at but which also purveyed

a considerable amount of information. The craze of card collecting spread rapidly throughout America, Britain and the countries of Europe. Eventually there must have been few countries in the world where cigarette cards were not a popular feature in cigarette packets.

From the collector's viewpoint, the most highly prized cards are those which were produced in the latter years of the nineteenth century. This was the period when numerous small companies, all but forgotten today, competed against each other for the favours of the collector who would often switch from one brand to another if the cards were more attractive or instructive. Today the cards published by some of these lesser-known companies command high prices. The manufacturers whose cards are now particularly in demand, include Ainsworth of Harrogate, Alberge and Bromet of London, MacDonald of Glasgow and Taddy of London. The year 1902 was an important one in the history of the cigarette card and, in some ways, it marks the division between the 'classics' and the not so desirable issues of more recent times. In that year, James Duke of the American Tobacco Company, made an all-out attack on the British tobacco market using, as part of his sales campaign, cigarette cards of such beauty and technical accomplishment that it is believed each card cost more than the packet of cigarettes was worth! The British tobacco industry was in jeopardy as smokers, beguiled by the cards, switched to American Tobacco Company brands. It was in a move to counteract American Tobacco that the majority of the British manufacturers merged into the Imperial Tobacco Company. The amalgamation did not diminish the spate or variety of cigarette cards produced in Britain. Cigarette smoking increased enormously in popularity during the First World War and consequently the 1920s and 1930s were the hey-day of the cigarette card which, by 1930, had reached editions as high as 70,000,000 per set. There was a marked decline in the quality of design and production after 1914, and it is the cards issued between 1890 and that date which now command the greatest interest among collectors.

Almost every subject under the sun was reproduced on cigarette cards. Beauty queens, kings and statesmen, actresses, characters from literature, reproductions of famous paintings, military uniforms, fishes, ships, trains: these and a thousand and one other subjects were dealt with. It became customary to print on the back of the card a brief description of the subject and, over the years, a fantastic amount of information must have been dispensed in this way. The cigarette companies also published albums in which the cards could be housed. The later sets were issued with gummed backs to facilitate mounting in these albums. The American Tobacco Company, having absorbed all its rivals, no longer felt the necessity to give away such inducements to American smokers, and their cigarette cards declined rapidly after 1900. In Europe and other parts of the world, the sale of tobacco was often held as a government monopoly and this likewise rendered the cigarette card superfluous. Thus it was mainly in Britain that the cigarette card survived up to the outbreak of the Second World War when paper shortages sounded its death knell.

Since the Second World War, pictorial cards of a similar kind have become an increasingly common feature of marketing all manner of products. At the turn of the century, however, this extension of the trade card outside the tobacco industry was confined to the products of the European Liebig food company. Liebig cards, printed in many different languages, rank among the most artistic and highly regarded cards of the early 1900s.

Cigarette Cases

Special cases for carrying cigarettes which evolved out of the leather containers for cigars which first became popular in the mid-nineteenth century. After the American Civil War, when cigarette smoking gradually overtook cigar smoking, special, slim cases in leather or *papier mâché,* often richly decorated with floral motifs or geometric patterns, became popular. Leather continued to be the most fashionable material, often re-inforced with silver rims, clasps and mounts, down to the end of the century. After 1900, however, cigarette cases of an all-metal construction came into fashion. The more robust material offered greater scope to the designers and craftsmen and soon the cigarette case rivalled the snuff-box of earlier generations as an object of vertu, on which enamelling, filigree work, guilloche engraving and other decorative techniques could be lavished. The outstanding exponent of the cigarette case was Peter Carl Fabergé (q.v.).

Clocks and Watches

Although the styles established earlier in the nineteenth century remained popular until the First World War, the turn of the century witnessed many interesting developments in both clocks and watches and these are now attracting the attention of collectors. Longcase (or grandfather) clocks on traditional lines were a perennial favourite in Britain and Europe but, by the end of the century, the designers of Art Nouveau furniture were producing matching cases for such clocks. Unfortunately many of these designs acquired a 'dated' look after the First World War and were scrapped, whereas the traditional longcase styles of the eighteenth and early nineteenth centuries survived. The same is true of watch-cases with typically Art Nouveau motifs. They enjoyed a relatively brief vogue in the early 1900s, but never ousted the traditional designs, and had themselves gone out of fashion by 1914. Fine examples of watches with Art Nouveau motifs are now much sought after.

Billiard room clock, English late 19th century.

French Art Nouveau gilt-bronze clock by Jonchery, *c.* 1900.

On the other hand, considerable scope is afforded by the many novelty clocks and watches produced in the 1890s. The novelty clock was especially popular in the United States and there was keen competition between the various manufacturers to devise new gimmicks in order to stay in business. The leading manufacturer of novelty clocks was the Ansonia Clock Company of Ansonia, New York, which produced an enormous variety of shapes, ranging from ormolu extravaganzas based on eighteenth century French originals to children's clocks incorporating automata, such as a pendulum featuring a child on a swing, or animals whose heads nodded in time with the clockwork action. A popular novelty clock, reflecting social attitudes of the period, was the Black Sambo with its golliwog clock-face.

On the technical side, this period was one of great innovations. The Plato time indicator, patented in 1902, was the forerunner of the modern ticket clock, in which the time is shown digitally by numbered discs or tickets, instead of by hands. By 1906, the Ansonia Company had produced no fewer than 40,000 of these clocks. Tiffany (q.v.) pioneered the electric clock, with the battery-operated 'Never-wind', which had a torsion pendulum oscillating slowly beneath the dial. Towards the end of the century,

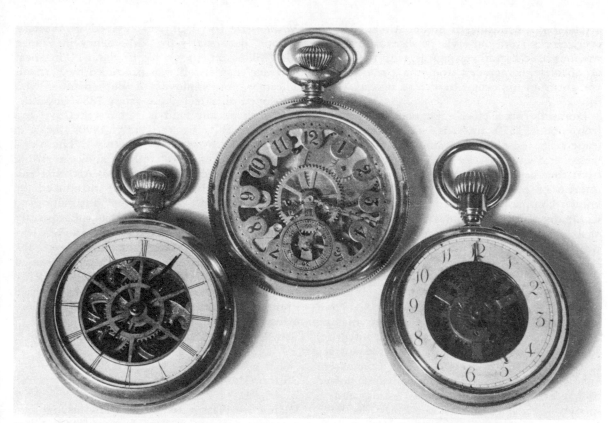

Non-jewelled or Yankee 'dollar' watches by the
Waterbury and New England Cos, *c.* 1900.

American manufacturers also pioneered the
rotary watch, which had its moving parts
revolving inside the case to reduce positional
errors in timekeeping. Of particular interest in
this category was the Waterbury 'Long Wind',
which had a mainspring more than eight feet
long and took a considerable time to wind. At
the same time, automatic and self-winding
watches were beginning to appear and examples
of keyless mechanisms are collectable in their
own right. This was an era in which the tech-
niques of mass-production were first applied to
clocks and watches, especially in Switzerland
and the United States. The early, and often
unorthodox, models of such companies as Rolex,
Omega, Longines, Vacheron and Constantin
and Le Coultre are still comparatively neglected,
but are worth looking for. Engineering clocks,
associated with locomotives, ships, beam engines,
boilers, motor cars and even early aircraft, form

Plate 'Time Indicator' clock by the Ansonia Clock
Co., 1904–5. (Irving Cooperman)

a relatively unconsidered group. Already, however, clocks from old-style railway stations and watches used by railway guards, with the names of obsolete companies from the pre-grouping era, form an important branch of railway relics (q.v.).

Domestic shelf-clocks, popular in America from about 1870 onwards, early alarm-clocks (especially those incorporating tea-making devices) and musical clocks are other categories from the turn of the century now catching the interest of collectors. Fine watches by lesser-known companies, such as the Howard Watch Company, Tixier, Thomas Russell and Peter Visbach, dating from the early 1900s, are also worth considering.

Cloisonné Enamels

The commonest form of enamelling, making use of *cloisons* (tiny cells composed of wire) soldered in honeycomb fashion to the surface of the object to be decorated. The transparent enamel was then poured into the cells and allowed to harden. This technique was widespread in medieval Europe, but subsequently declined. It remained popular in China and Japan and, with the late nineteenth century craze for

Japonaiserie (q.v.), it was revived in Western Europe, particularly by Barbedienne in France and Elkington (q.v.) in England. The best *cloisonné* enamelwork was produced by Fernand Thesmar, an employee of Barbedienne, who developed this technique from 1880 onwards. His work in this field is rather repetitive and ponderous but, by the early 1890s, he also experimented in *pliqué-à-jour* (q.v.). Thesmar's enamelled boxes and trinkets show a strong Chinese influence combined with Art Nouveau motifs. Adrien Dalpayrat (q.v.) introduced the revived technique of *cloisonné* enamelling to England in 1885, and it was subsequently developed by artist-craftsmen of whom Alexander Fisher and Archibald Knox were the leading lights. Liberty (q.v.) marketed objects of vertu in silver with *cloisonné* enamelling. René Lalique, Henri Vever, Eugène Grasset and Philippe Wolfers (qq.v.) all produced jewellery using *cloisonné* techniques.
See *Enamelled Boxes, Enamelled Glass*

Clutha Glass

Distinctive glass patented by the Glasgow firm of James Couper & Sons in the 1890s. Glass historians have sometimes, though erroneously,

Group of Japanese *cloisonné* enamel vases, *c.* 1890–1900.

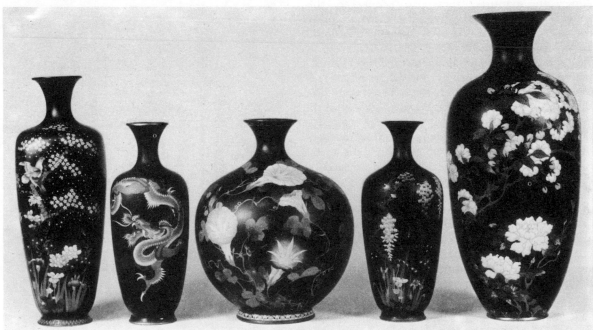

stated that the name means 'cloudy', from the distinctive appearance of the glass; but Clutha is, in fact, the ancient and poetic name for the Clyde, Glasgow's river. No doubt the waters of that river resemble the streaky, bubbly character of this type of glass. Shades of green predominate, but turquoise blue, brown and even smoky black may be found. Simple, antique shapes were designed for interpretation in Clutha glass by George Walton (q.v.) who worked for Couper in 1896–8. Christopher Dresser (q.v.) also designed vases, bowls and goblets manufactured in Clutha glass. Pieces by him are often marked on the base 'Clutha designed by CD'. Clutha glass is sometimes confused with the 'Old Roman' glass marketed by Thomas Webb (q.v.) from 1888 onwards, but may be distinguished from it by the specks of aventurine (copper crystals) in the metal.

Cohr, Carl M.

Danish silversmith and jeweller whose father, Ditlev Cohr, founded the family business in Fredericia in 1860. The firm expanded rapidly at the beginning of this century, doubling its work force between 1900 and 1907. Originally the firm had specialized in flatware and engage-ment rings, but began producing holloware in 1895. Knud von Engelhardt, who designed the Copenhagen tramcars in 1908, designed silverware for Cohr at the turn of the century, augmenting the 'Old Danish' range of cutlery with simple, functional, yet high-quality pieces.

Coins

The most important effects on the coinage of the world at the turn of the century were political. In the Netherlands and Spain, the accession of the youthful Wilhelmina and Alfonso XIII respectively meant frequent changes in coin portraiture between 1894 and 1906 as these monarchs progressed from infancy and childhood to maturity. The death of Queen Victoria in 1901 and the accession of King Edward VII resulted in a spate of new coins in Britain and those overseas dominions and colonies which had distinctive coinage: Canada, Newfoundland, Ceylon, India, the Straits Settlements and Hong Kong among others. Politically the Australian Commonwealth came into being in 1901 but a unified Commonwealth coinage did not appear until 1910, when silver coins from 3d to the florin (2s) were released with the profile of King Edward. The separation of Norway from

Clutha glass finger bowl and vase, designed by G. Walton for James Couper, 1896.

Sweden in 1905 resulted in a series commemorating independence and a definitive range portraying King Haakon in 1906. The Spanish-American War of 1898 resulted in the granting of independence to Cuba and the Philippines. The latter began issuing distinctive coins in 1903, but Cuba did not follow suit until 1915, though silver pesos were produced in 1897–8 under the auspices of the Provisional Government and featured Liberty and the republican coat-of-arms.

This period witnessed the dramatic growth in the popularity of commemorative coins, which waned after the outbreak of the First World War and did not recover again until the late 1950s. Although a unified series for use throughout the German Empire had been introduced in 1873–4, no fewer than twenty-five principalities, kingdoms, duchies and free cities continued to mint their own coins of higher denomination (2 marks upward) until the First World War, and many of the coins issued were commemorative in nature. The United States pioneered the commemorative coin in its modern form, with the silver half and quarter dollars issued in 1893–4 to mark the Columbian Exposition (q.v.). Subsequently silver dollars commemorated Lafayette (1900), Lewis and Clark (1904) and two gold dollars of 1903, portraying Presidents Jefferson and McKinley, celebrated the centenary of the Louisiana Purchase. Other important commemorative sets were issued by Brazil (1900) to mark the quatercentenary of discovery; by Austria (1908–12) to celebrate the jubilee of Emperor Franz Josef; by Bulgaria (1908) to mark the elevation of the country to the status of a kingdom; and by Rumania (1906) in honour of King Carol's fortieth anniversary.

New coins were introduced by France (1898) and Italy (1901–2), both of which used allegorical designs under the influence of Art Nouveau. Oscar Roty's spirited Sower obverse for the French coins was also used for that country's stamps (q.v.) and was revived in 1960 for the new franc denominations following the currency reform. The only other coin which reflected

Group of coins: Canada 1 cent with Art Nouveau treatment of the maple leaf emblem; France 25 centimes, 1904; United States 5 cents, 1897; United States 'Indian Head' cent, 1897; Great Britain crown, 1889; Philippine Islands peso, 1908; Oscar Roty's 'Sower' obverse introduced in 1898.

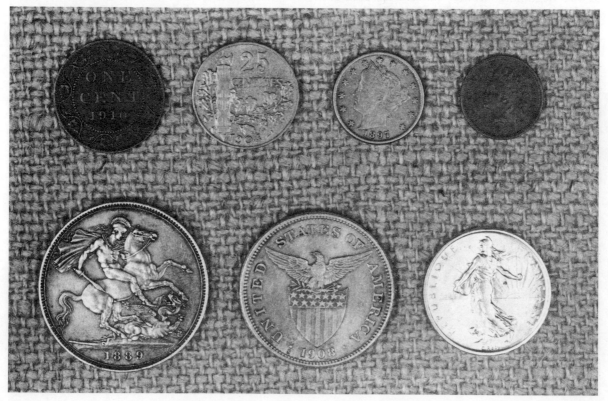

the artistic style of the time was the British trade dollar, with its splendid standing Britannia obverse. A standing figure of Britannia was also used for the reverse of the Edwardian florin of 1902; all other British coins bearing this allegorical figure have shown her seated. American coins in this period maintained traditional styles in design, though new profiles of Liberty were introduced in 1892 for the dime, quarter and half dollar denominations. The only other notable innovation was the retirement, in 1909, of the Indian Head cent, in favour of the cent portraying Abraham Lincoln on the occasion of his birth centenary.

See *Commemorative Medals*

Colonna, Eugène

French industrial designer, employed by Samuel Bing (q.v.). The latter commissioned him to arrange complete room settings for his pavilion at the 1900 *Exposition Universelle* (q.v.). His curiously attenuated furniture, against green velvet walls, created a tremendous impact at the exhibition. Colonna also produced silver and metalwork, textile-designs and jewellery, the last-named influenced by the work of René Lalique (q.v.). Colonna's work in these media was also shown at the Munich *Sezession* (q.v.) exhibition (1899) and the Turin Exhibition (1902).

Columbian Exposition, 1893

The quatercentenary of the discovery of America was commemorated by the World's Columbian Exposition held at Chicago. The 686 acre site in Jackson Park and the adjoining Midway included 188 acres of buildings. The buildings, planned by a commission headed by Daniel H.

The Administrative Building, Columbian Exposition, Chicago, 1893.

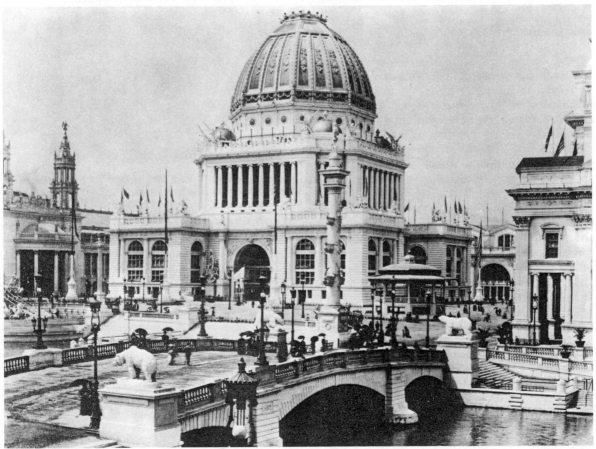

Burnham and John W. Root of Chicago, were hailed at the time as a collection of remarkable beauty and they had a profound effect on the development of Neo-classical architecture all over America in the ensuing decades. In many respects, the architecture and applied arts of the Exposition marked the consummation of the pretentiousness of the pseudo-classical and Renaissance styles. Henry Adams denounced it as the 'product of the Beaux-Arts artistically induced to pass the summer on the shore of Lake Michigan' while the progressive architect Louis Sullivan (q.v.) commented forcibly that it was 'a naked exhibitionism of charlatanry in the higher feudal and domineering culture, conjoined with expert salesmanship of the materials of decay'. The glass, silver, ceramics and furniture, exhibited at this fair, reflected, in their peculiar eclecticism, all the elements of the revivals of the Colonial and 'Old World' styles and represented the highwater mark of late Victorian fussiness in design and ornament.
See *Beaux Arts School*

Commemorative Medals

Medals struck or cast to commemorate persons and events originated in Renaissance Italy, but improved techniques of engraving dies and the mechanization of production resulted in hackneyed forms which have continued down to the present day. In the last two decades of the nineteenth century, however, there was a partially successful attempt to break down the stereotyped academic traditions. Credit for this is due mainly to the French medallist, F. J. H. Ponscarme (1827–1903), who tried to get back to the basic principles of the art by eliminating the raised border which had been fashionable for two centuries, by searching for a dignified realism combined with harmonious backgrounds, and by greater concentration on the character of the person portrayed. The French school attained the peak of its perfection under J. C. Chaplain (1839–1909) who rejected the use of machinery in the spirit of William Morris (q.v.). Oscar Roty, on the other hand, exploited mechanical techniques with immense skill, though he is often accused of being facile. French medals in the early 1900s, engraved by Roty and his followers, are often beautiful, though mannered and lacking in vigour and sincerity. In Germany, a tradition of rugged

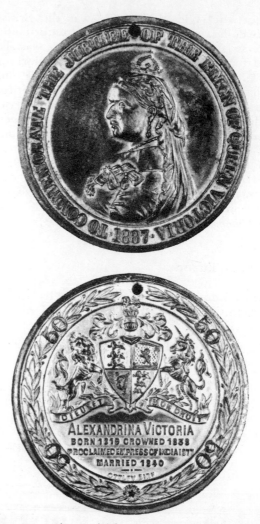

Commemorative medal for the Golden Jubilee of Queen Victoria, 1887.

virility was established by Anton Scharff (1845–1903) and his disciples and their medals echo the crude effectiveness of the seventeenth century thalers. In England, Alphonse Legros (q.v.) likewise rejected mechanical techniques and produced a remarkable series of cast portrait-medals, but a generation passed after his death before other medallists began to follow his example.

Apart from medals conceived as miniature examples of the sculptor's art, the period up to the First World War witnessed the proliferation of cheap bronze, brass and pewter medals sold to the public to commemorate all manner of events and personalities. Several hundred different medals were struck, for example, to mark the

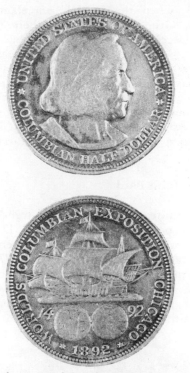

Obverse and reverse of the commemorative half dollar of 1892 marking the quater-centenary of Columbus and the Columbian Exposition.

Commemorative Pottery and Porcelain

The late nineteenth century was the hey-day of the commemorative rack-plate portraying popular heroes and celebrities. Queen Victoria was a perennial favourite, and her Diamond Jubilee in 1897 was the occasion for numerous examples of tankards, mugs, bowls and vases as well as plates, decorated with her august portrait and often embellished with scenes from her life or vignettes reflecting the intensely imperial sentiment of the period. Other royal events of the early 1900s which were commemorated in pottery and porcelain included the coronations of Edward VII and George V, in 1902 and 1911 respectively, and, to a lesser extent, the investiture of the Prince of Wales (later Duke of Windsor) in the latter year. The Boer War witnessed a spate of commemorative crockery of all kinds but, as well as the earthenware plates with photographic transfer prints of generals and popular heroes like Baden-Powell, aimed at the popular market, there were limited editions in fine porcelain, catering to a more select clientele. In this category come the figure entitled 'A

Earthenware mug commemorating the centenary of the death of Robert Burns, 1896.

coronation of King Edward VII in 1902; many civic authorities, organizations, industrial concerns, business firms and private individuals producing medals and medalets for the occasion. The great international exhibitions and world's fairs (q.v.) from 1893 to 1909, the early Olympic Games (1896–1908), political rallies and the women's suffrage movement were but a few of the events which caught the public imagination and were immortalized by medals. Relatively few patriotic medals were produced during the Boer War of 1899–1902, but there was a last, hectic outburst of popular medals issued by all the belligerent countries during the First World War. Germany, in particular, mastered the art of the satirical medal for propaganda purposes. As a popular medium for the dissemination of a political, religious or nationalist viewpoint, however, the medal went into decline in the face of the political cartoon, radio, cinema and the popular press; and, as a pure art form, it barely existed from 1915 until its fitful revival after the Second World War. Its place as an official mark of commemoration was largely taken by the commemorative coin (q.v.).

Doulton's mug commemorating the coronation of King Edward VII, 1902.

Volunteer in Khaki', produced by the Royal Worcester Porcelain Company (q.v.), and the 'Transvaal War' loving cup by Copeland (q.v.). This piece, its sides decorated with transfer-prints of heroic motifs and patriotic inscriptions, was produced in a limited edition of 100 for Thomas Goode and Company. Comparatively few patriotic plates were produced by either side during the First World War. Political figures, especially W. E. Gladstone and American presidents, were also popular subjects for this type of commemoration; plates, mugs and plaques bearing their portraits were considered part of the stock material during election campaigns.

Staffordshire pottery flat-back figures (q.v.), which had their hey-day in the mid-nineteenth century, continued to appear unabated until the First World War, and the heroes of the Boer War were appropriate subjects for this distinctive type of folk art. Although pictorial pot-lids (q.v.) virtually went out of production following the death of Felix Pratt in 1894, the last of them included several excellent commemorative items produced in connection with the Columbian Exposition (q.v.) and featuring scenes from American history. Christmas plates originated

in 1895, when the Danish porcelain firm of Bing & Grondahl produced their first one. Every December since then, a plate with an attractive pictorial design has appeared in a limited edition. These plates were decorated in underglaze blue and bore the inscription '*Jul Aften*' or '*God Jul*' with the appropriate date. Subsequently similar plates were manufactured by the Royal Copenhagen Porcelain Company (1908) (q.v.) and Swedish manufacturers.

Cooper, John Paul

British architect, silversmith and jeweller, *c*.1896–1933. Cooper was articled first to J. D. Sedding and later to Henry Wilson (q.v.) who encouraged him to take up silversmithing in 1897. Cooper taught metalwork in Birmingham from 1904 to 1907, before establishing his own workshop in Kent. His son, Francis, has carried on as a silversmith.

Beaten and engraved copper rose-bowl by J. Paul Cooper, 1900.

Copeland Porcelain

At the turn of the century, this famous Staffordshire pottery continued to produce fine tea and dinner services in traditional patterns, as well as

Jewelled porcelain dessert plate by Copeland, hand-painted by Samuel Alcock, *c.* 1890.

figures and centrepieces in parian ware (q.v.). In the 1890s, however, they followed contemporary trends in *Japonaiserie* (q.v.). Oriental motifs were delicately painted on plates and vases, distinguished by the excellent finish of their matt surface and tooled gilding. Though they produced many thousands of parian figures in this period, their production of ordinary porcelain figures was virtually non-existent. The leading artists, employed by the firm in the late nineteenth century, were R. F. Abraham (Art Director until his death in 1895) and his son Robert John Abraham (1850–1925). John Arrowsmith was employed in the 1890s as a floral artist, but turned his attention to bird painting in the early 1900s. The finest work was produced by Samuel Alcock, who specialized in figure painting after the style of Sir Lawrence Alma-Tadema, and produced a series of white porcelain plates decorated with figures in contemporary costume with richly jewelled borders. Charles Brough painted floral, bird, fish and figure subjects at Copeland up to 1903, when he joined Doulton (q.v.). James Weaver and his son Charles painted mainly birds and cattle subjects respectively. Attractive landscape motifs were painted by W. Yale. Apart from fine porcelain, Copeland also produced excellent tiles (q.v.) and animal figures in majolica (q.v.). See *Commemorative Pottery and Porcelain*

Copenhagen Porcelain

The Royal Copenhagen Porcelain Factory was founded in 1771 by Franz Heinrich Müller, assisted by J. G. von Langen, as a private company with Queen Juliane Maria as chief shareholder. Nine years later, to prevent bankruptcy, the firm was taken over by the king and henceforward was redesignated *Den Kongelige Danske Porcelaen Fabrik*. In the ensuing century, porcelain in contemporary Neo-classical styles was produced. In 1867, the company reverted to private ownership and, although sumptuous services continued to be the main product, excellent *bisque* figures, after sculpture by Thorvaldsen, gave the firm a new direction. Under the partnership of Philipp Schou (1838–1922), the chemist Adolphe Clement (1860–1933) and the architect and designer Arnold Krog (1856–1931), the company turned towards naturalism and *Japonaiserie* (q.v.) and became one of the leading producers of underglaze painting on vases, bowls and dishes. Birds and flowers were the principal motifs, painted by such artists as August Hallin, Olaf Jensen, Wilhelm Fischer, Gotfred Rode, Gerhard Heilmann and Anna Smidth. Excellent animal and human figures were modelled in the distinctive white, grey and blue shades by C. F. Liisberg, C. Thomsen and E. Nielsen. The first of the famous Christmas plates issued by this company appeared in 1908.

Porcelain bowl with hand-painted decoration by R. Böcher, Royal Copenhagen Porcelain Company, *c.* 1900.

Cork Pictures

Pictures made from strips of cork enjoyed a certain vogue in the closing years of the nineteenth century. The idea came from Japan where intricate compositions, using the dried bark of the Abemaki tree, had long been popular. Thin strips of the cork were carved in minute detail and then assembled in layers to create a three-dimensional effect. Similar pictures were composed of the bark of the evergreen oak, a native of the Mediterranean area, and cork pictures formed part of the folk art of Spain and North Africa. The majority of the surviving examples are Near Eastern or Far Eastern in origin. On account of the brittleness of the material and the high degree of skill required to carve the intricate layers, this art never caught on in Europe and relatively few examples will be found with distinctive Art Nouveau motifs.

Corning Glass Company

Probably the largest glassworks in the world today, the Corning Glass Company was founded in 1875. Since 1933, it has incorporated the Steuben Glass Works (q.v.). During the period under review, this company specialized in industrial glassware and produced relatively little in the decorative line.

Costume

In costume, the end of the nineteenth century was an age of transition. The bustle was going out of fashion in France by 1890, though it lingered on elsewhere for several years and, in general, women's outer garments were becoming looser and less cumbersome. The fearsome underwear which developed throughout the century, however, actually reached its zenith at the turn of the century and did not give way to greater freedom until women were liberated by the exigencies of the First World War. By 1900, the height of fashion was the S-line, fashion's counterpart of the serpentine curves in Art Nouveau, especially in architecture and furniture design. The S-shape was achieved at the expense of great suffering and discomfort. Corsets became long and had long metal busks in front which crushed the abdomen instead of flattening it. The lower end of the corset cut unmercifully

Lace purse, French, 1901.

into the wearer's groin, forcing her to pull in the small of her back and push forward her bust.

This corset was worn over a chemise which, in turn, was tucked into the drawers. The latter garment was often no more than a kind of sack with two short legs attached, either with an open crotch or with a flap arrangement over the seat. Plain cambric was favoured for underwear, but more elegant underwear, for special occasions, was manufactured in silk and lavishly decorated with lace and ribbons at waist and knee. Petticoats continued to be as voluminous as ever, with three or four garments being worn in the early 1890s. By the end of the century, the requirements of the S-line reduced the number of petticoats considerably. The earliest types of brassiere did not appear until 1912 but, in the preceding decades, a corset cover was worn over the bust and these garments were frequently decorated with lace or embroidery. The emancipation of women in sport resulted in several new forms of costume. The most radical of these was the cycling costume known as bloomers, after the American dress reformer, Amelia Bloomer. This practical and sensible garment, so vast and baggy as to avoid any suggestion of

Earthenware bowl, designed by Christopher Dresser,
Linthorpe Pottery, *c.* 1890.

Girl's dress, French, 1901.

Dish by William de Morgan, late Fulham period,
c. 1898–1907.

A fashion plate of 1903 from *Les Modes*.

The S-line in a day dress, French, 1901.

A highly-decorated evening dress showing several typical Art Nouveau motifs, 1901.

shape, tended to give the impression of drawers worn as an outer form of dress and therefore had intense erotic overtones. By 1910, bloomers as an outer garment had disappeared, but out of this evolved the style of underwear known as directoire knickers, elasticated and shorter in the leg than the drawers of the late nineteenth century.

This neater form of underwear was more in keeping with the simpler, more angular lines in dress which developed from 1908 onwards, paralleling the trends in architecture and the applied arts. There were also important changes in dress accessories. Apart from the almost seasonal whims and caprices in millinery up to the outbreak of the First World War, shawls, stoles and feather boas for every-day wear gradually went out of vogue. As hem-lines rose, the wearing of boots by women declined and shoes became more fashionable. Tippets and muffs remained popular until the early 1900s but were not so commonplace by 1914, though gloves continued to be worn by both sexes on every occasion and, in the immense variety of

their design, material and purpose, offer considerable scope to the collector.
See *Fans, Hatpins, Jewellery*

Craig, Edward Gordon

British stage-designer, the son of the theatrical architect Craig and the actress Ellen Terry, born in 1872. Craig began his artistic career as an actor in 1889, under the direction of Sir Henry Irving, but subsequently he became the director of a group of wandering actors. In 1898, with the encouragement of William Nicholson and James Pryde (qq.v.), he began designing stage sets, bringing an entirely fresh viewpoint to bear on the problems of stage scenery. In the first decade of this century, he was responsible for revolutionizing stage design in England, but he felt that the contemporary London stage offered little opportunity for creative experiments so he went to Europe, first to Berlin (1904) and then to Florence (1906), where he later founded a school for the Art of the Theatre.

Set design for *Hamlet,* by Edward Gordon Craig.

He founded *The Mask* (1908), a journal devoted to the arts of the theatre, containing his essays and illustrations explaining his philosophy on theatrical art and its practical application. He raised theatre decoration to the status of an art form in its own right.

Crane, Walter

English artist and designer (1845–1915). The second son of Thomas Crane, a portrait painter and miniaturist, Walter Crane was born in Liverpool, but moved to London at the age of twelve. He was a disciple of Ruskin and was strongly influenced by the Pre-Raphaelites. His artistic career began as a wood-engraver and he prepared the works of Millais, Rossetti, Tenniel and others for book illustration. Other early influences included the Italian Renaissance and Japanese colour prints. Among his earliest original work were his illustrations for a series of sixpenny toy-books of nursery rhymes, begun in 1864. His distinctive style developed with *The Frog Prince* (1873) and *The Goose Girl* (1882), the latter designs being subsequently produced in the form of tapestry. In 1894, he collaborated with William Morris (q.v.) in the page decoration of *The Story of the Glittering Plain,* published at the Kelmscott Press. In purely decorative interest, his finest work con-

sisted of the illustrations to Spenser's *Faerie Queene* (1894–6). In the latter year, he published *Cartoons for the Cause,* an anthology of the cartoons he drew for the left-wing periodicals, *Justice* and *The Commonweal.*

Crane took an active part in the work of the Art Workers' Guild and founded the Arts and Crafts Exhibition Society in 1888. From 1896,

Earthenware vase designed by Walter Crane for Maw of Jackfield, 1899.

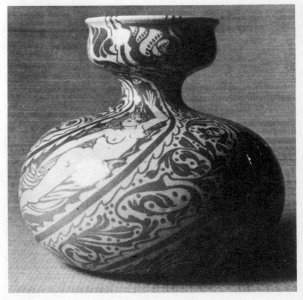

Silver cutlery designed by C. R. Ashbee and made by the Guild of Handicrafts, 1900–2.

he was also Director of the Manchester School or Art. His theoretical writings, widely translated, exercised an enormous influence on the development of the applied and decorative arts. Although chiefly remembered as a magazine and book illustrator, Crane also designed tiles (q.v.) produced in majolica (q.v.) by Maw of Jackfield, and designed some of the ruby lustre dishes and vases manufactured by the same company. For a time, he also designed plaques for Minton (q.v.).

Cutlery

Traditional designs in knives, forks and spoons continued unabated throughout the *fin de siècle* period, but many of the designers of the early 1900s produced cutlery notable for its simplicity, angularity and streamlined form, anticipating the designs which have become popular since 1950. In Britain, cutlery which echoes the Scandinavian flatware of the present day, was being designed by C. R. Mackintosh (q.v.) about 1903, and a few items were also designed by Mackmurdo, Voysey and Baillie Scott (qq.v.) but the bulk of modernistic cutlery was produced on the Continent. In the Netherlands, the most notable work in this field was designed by Frans Zwollo and Jan Eisenloeffel (qq.v.). In Denmark, the architect Bindesböll (q.v.), Mogens Ballin and Siegfried Wagner designed cutlery with restrained abstract ornament and compact form. Interesting designs for cutlery, as part of silverware services, were formulated by Van de Velde (q.v.) in Belgium; by Riemerschmid and Hoffmann (qq.v.) in Austria; and by Bruno Paul and Bernard Pankok (qq.v.) in Germany. See *Silver*

Dalpayrat, Adrien

French ceramic artist (1844–1901). He designed and produced distinctive art pottery for A. Desbros et Cie of Bourg-la-Reine in the 1890s. His stoneware vases and beakers were strongly influenced by Japanese shapes, but were distinguished by their vigorous red glazes, streaked with shades of green or blue.

French porcelain vase by Albert Dammouse, 1896.

Dammouse, Albert

French studio potter who flourished at the turn of the century. Like many of his contemporaries, Dammouse learned his art at the Sèvres porcelain works before branching out into art pottery. More than any other French potter of the period, Dammouse was inspired by Japanese originals and, as a result, his work is mainly derivative. He went farther than Dalpayrat in his quest for extravagant and exotic glazes and combinations of colour. Dammouse also worked in a very fine type of opaque glass known as *pâte d'émail* which resembles eggshell china. The fragile walls of his vases were modelled with trails of seaweed or flowers in blue, brown or grey.

Daum Glass

A glassworks was founded at Nancy in 1891 by the brothers August (1853–1909) and Antonin (1864–1930) Daum. They were inspired by the success of Emile Gallé (q.v.), whose works they closely imitated. They produced coffee and tea services in opaline glass painted with landscapes and vignettes *en camaïeu* in the style of the eighteenth century. In 1893, however, Daum Frères began producing cameo glass (q.v.), using acid-etching techniques to decorate their wares with bouquets of flowers, clusters of fruit and scenery. Though their work closely parallels that of Gallé, it is much more yellow and orange in colour. Glassware by this company was signed 'DAUM NANCY' with the Cross of Lorraine.

Silver-mounted carved cameo glass vase by Daum Frères, *c.* 1900.

Plate painted by Alice and Joseph Lindon Smith from the Dedham Pottery, Mass., *c.* 1897.

Dedham Pottery

American art pottery founded at Dedham, Massachusetts in 1895 by Hugh Robertson, formerly of the Chelsea Keramic Art Works. Robertson emulated the distinctive crackle glazes found on Japanese pottery, on a heavy stoneware lavishly decorated with borders of bird and animal designs. Dedham Ware was produced in forty-eight different patterns and was immensely popular at the turn of the century. Rabbits were a favourite motif on jugs and plates and were also modelled as crouching figures, used as knife rests. The rabbit features in the firm's trademark, stamped on the base of pottery.

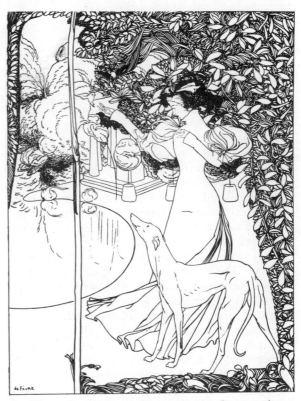

La Charmeuse d'Oiseaux, illustration by Georges de Feure, *c.* 1897.

De Feure, George

Dutch artist and designer (1868–1928), described as 'the most highly strung and feminine of *fin de siècle* designers'. De Feure was employed by Samuel Bing (q.v.) to design his salon at the 1900 *Exposition Universelle* (q.v.). An extremely versatile artist, he designed furniture for Bing of a highly sculptural quality; moulded glassware for Fauchon of Paris decorated with friezes of classical figures; and designed a number of posters, mainly for the Belgian market, including the outstanding *Le Journal de Vent à Bruxelles* and the enigmatic *Diable au corps*.

Delaherche, Auguste

French ceramic artist belonging to the same school as Dalpayrat and Dammouse (qq.v.). Delaherche was particularly concerned with the texture and appearance of the glazes, experimenting with startling combinations of one colour streaked through another. He also decorated his stoneware vases with heavy arabesque patterns cut through grey slip.

Della Robbia Pottery

English studio pottery which functioned at Birkenhead, Cheshire between 1894 and 1906. It was founded by Harold Rathbone, a pupil of Ford Madox Brown. As the name suggests, this pottery was originally inspired by the ceramics of the Italian Renaissance and, at the beginning, its wares were strongly derivative in both shape and decoration. Subsequently highly distinctive and original designs were evolved, often with a hint of Hispano-Mauresque about them. Decorative tablewares, tiles (q.v.) and even extravaganzas intended as garden ornaments were produced by the Della Robbia factory. The 'architectural faience' comprised decorative panels and plaques modelled in high relief by such artists as R. Anning-Bell, Conrad Dressler and Rathbone himself. The hollow wares are distinguished by their brilliant colouring and their unusual, often grotesque, shapes. Decoration was applied in a combination of sgraffito and underglaze painting. The majority of individual pieces from this pottery are signed by the artist, as well as showing the 'DR' monogram and medieval galleon trademark. Vases,

Stoneware bottle designed and decorated by A. Delaherche, 1889.

beakers, flasks and jugs may be found with the initials of Charles Collis, Ruth Bare, Casandia Ann Walker, Carlo Manzoni and Liza Wilkins.

De Morgan, William

English potter, born in London in 1839. Educated at the Royal Academy Schools, De Morgan was a close friend and disciple of William Morris and Edward Burne-Jones (qq.v.). His artistic career began about 1864, when he was primarily concerned with designing stained glass. He turned seriously to pottery in 1872, establishing a pottery at Orange House, Chelsea. Ten years later he established another pottery near Merton Abbey (q.v.), but in 1888 he went into partnership with the architect, Halsey Ricardo, and founded the Sands End Pottery, Fulham.

Earthenware vase of the late 19th century by the
Della Robbia Pottery.

Ill health from 1892 onwards forced him to
winter in Italy and lack of supervision contributed
to the decline of his business, especially after
1900. Latterly it was known as De Morgan,
Iles and Passenger, Frank Iles being the chief
kiln-firer and the Passenger brothers, Fred and
Charles, being employed as decorators. In 1905,
De Morgan retired from the business, which
was wound up two years later. After his retire-
ment from the pottery, De Morgan turned to
writing and produced seven highly successful
novels between 1906 and his death in 1917. At
the time of his death, he was better known as a
novelist, and it is only within comparatively
recent years that his importance as a potter of
the Arts and Crafts Movement (q.v.) has been
fully appreciated. De Morgan demonstrated his
versatility by inventing many of the tools and

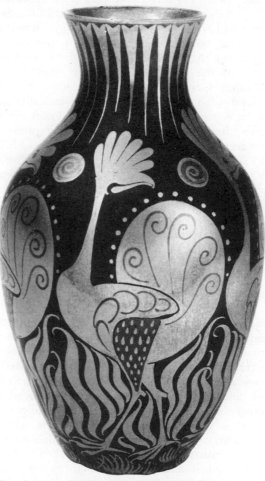

De Morgan dish painted by Charles Passenger, late
Fulham period, 1898–1907.

Silver lustre painted vase by William de Morgan,
c. 1900.

techniques used in his pottery, but he also designed bicycle gears and, towards the end of his life, was concerned in aircraft design and anti-submarine devices! His striking originality and individuality were expressed in his pottery. He is best known for his fine lustreware and pottery vessels decorated in so-called Persian colours—vivid blues, greens and turquoises. His tiles (q.v.), decorated with animals or mythical beasts, were intended as individual pieces rather than as parts of wall panelling. His imaginary creatures, quaintly humanized, have a close affinity to the grotesqueries of the Martin Brothers (q.v.).

Denis, Maurice

French painter and graphic artist, born at Grandville in 1870. Denis studied at the *Academie Julian* in Paris and, in 1889, joined with Serusier, Ranson (q.v.) and others in the group known as the *Nabis,* whose theoretician and propagandist he became. At the same time, he discovered the works of the artists of the Pont Aven group including Gauguin (q.v.). His later work was imbued with mysticism and 'neo-catholicism', and he founded the *Atelier d'Art Sacre* in 1919. Denis died in Paris in 1943. His figures of women, as seen in his painting of *The Muses* (1893) or his drawings in the *Revue Blanche* in the 1890s, contrast strangely with the long-haired maidens of Mucha and Cheret (qq.v.). His women have their hair drawn tightly into a bun and the severe, austere lines of their clothing and their poses have more affinity with the work of Toorop (q.v.) in the Netherlands.

De Rudder, Isidore

Belgian sculptor and potter specializing in stoneware. De Rudder had his own studio in Brussels before working for the Vermeren-Coche pottery. He modelled masks based on theatrical characters and figures taken from Belgian folklore, and these were subsequently produced by Vermeren-Coche in porcelain or stoneware, either as unique pieces or in editions with a maximum of fifty. He also designed plaques and panels, featuring typically Art Nouveau women, in blue, white and pink. Some of his work was produced by Boch Brothers and the French firm of Emile Muller of Ivry.

Dolls

The most expensive dolls produced at the end of the nineteenth century had cloth or wooden bodies and wax heads. This industry was revolutionized in the 1850s by Augusta Montanari and her son, Richard Napoleon, who invented new techniques which resulted in wax dolls of great beauty and realism. The hair, eyelashes and eyebrows were painstakingly inserted into the wax, one at a time, with a hot needle. The Montanaris won special prizes for their dolls at all the major international exhibitions from 1851 to 1900. Because of their prohibitive price—£5 ($25) being average for an unclothed doll—relatively few of them have come down to posterity. Wax dolls were also manufactured in England by the Pierotti family and these could be purchased in Hamley's of Regent Street, London as late as 1930, though they reached their zenith at the turn of the century. The only indigenous British wax doll-maker of note was Charles Marsh, who specialized in wax over *papier mâché.* His blonde, blue-eyed dolls, produced in the 1890s, had a distinctive 'English' appearance. Mrs Lucy Peck produced fine-quality play dolls, including some with movable eyes operated by wire; but her speciality was character and portrait dolls. Herbert John Meech, Dollmaker to the Royal Family, manufactured

Pedlar doll, English, late 19th century.

American steel-jointed doll by Isaac Riseley and Vincent Lake, Metal Doll Co., New Jersey, c. 1902.

Edison talking doll, U.S.A., c. 1889. (Greenfield Village and the Henry Ford Museum, Michigan)

rather disappointing wax dolls, with disproportionately small hands and feet and unimpressive features.

Although there were estimated to be about forty manufacturers of wax dolls in London at the end of the century, they had largely been overtaken by production of *bisque* dolls, imported from France and Germany. The *bisque*-headed dolls were cheaper, more finely modelled and more durable. Porcelain had been used in the manufacture of German dolls since 1844. By the end of the century, this practice had spread to France and considerable quantities of doll heads were being made in finely glazed china, parian ware and matt *bisque*. The hair was either an integral part of the porcelain and was denoted by different coloured glazes, or was inserted separately in the same manner as the wax dolls. The outstanding manufacturers of

porcelain dolls were Conta and Boehme of Possneck in Saxony, and the Parisian firm of Jumeau. Porcelain dolls were not made to any extent in England until after the outbreak of the First World War cut off supplies from Germany.

After the establishment of more modern premises at Montreuil in 1878, the Jumeau family gradually took over the French market and also exported dolls in vast quantities to Britain and America. Emile Jumeau was created a *Chevalier de la Legion d'Honneur* in 1886, for his outstanding services to doll-making. By the end of the century, Jumeau had absorbed the majority of the other leading French companies, faced with severe competition from Germany, and this combination became known as the *Société Française de la Fabrication des Bébés et Jouets*. Jumeau *bisque* dolls continued to be produced until the Second World War.

Although they originated the porcelain doll, the Germans allowed the French to develop it in the 1880s, before adapting the principle of the *bébé* and producing excellent copies which undercut the cost of the French models. By 1900, German *bisque* dolls were being imported into France by many of the lesser French companies, who then dressed them and prepared them for the retail market. By the turn of the century, the leading German doll manufacturers were Simon & Halbig, who also produced many of the heads used by other firms. Other companies, whose dolls are now highly prized, include Kestner, Kammer & Reinhardt, Armand Marseille and Cuno & Otto Dressel. Fleischmann & Bloedel patented a walking doll in 1895, with chain-driven mechanism in the body controlling the legs. Heubach of Koppelsdorf pioneered the character doll, with smiling, puzzled or downcast expressions. Realism became the keynote of German dolls from 1900 onwards, a reaction against the large-headed 'baby'-faced dolls favoured by the French manufacturers. Kammer & Reinhardt began producing realistic dolls in the costume of the German *länder* from 1908 onwards. These were followed, in 1910, by a whole range of dolls with individualistic expressions and included a baby doll which was so realistic that it was rumoured to be modelled on the Kaiser's infant son!

The earliest talking doll was patented by the Edison Phonograph Company of America in 1890 and sold originally for $10. By 1895, Jumeau had gone a stage farther and was marketing a doll with a more advanced mechanism and interchangeable records. Eating dolls and breathing dolls were patented by Bru of France in 1879 and 1892 respectively. By 1900, expensive mechanical dolls were being manufactured on a large scale in France, Germany and the United States. At the other extreme, an enormous quantity of fine-quality rag dolls was produced in America from 1889 onwards, when a Mrs Chase began making them for a Boston department store. After 1910, the Chase Stockinet Factory concentrated on life-sized dolls, used in the training of doctors and nurses. A popular line in dolls was the 'Brownies', patented by Palmer Cox in 1892, and based on the little people of Scottish folklore. Palmer Cox 'Brownie' dolls appeared in a wide range of costume: sailor, Chinaman, Scottish kiltie, Uncle Sam and policeman being but a few examples. Albert Schoenhut patented his Humpty Dumpty circus series of dolls in 1903 and they soon became a great favourite in America; by 1911, the Schoenhut factory in Philadelphia was one of the largest of its kind anywhere in the world. The Humpty Dumpty dolls had articulated joints, originally controlled by elastic but later by complex steel springs and swivels. The sports equipment manufacturer, E. I. Horsman, began producing rag dolls in 1901 but, in 1909, he took over the Aetna Doll and Toy Company and subsequently

English doll's house drawing room, *c*. 1890.

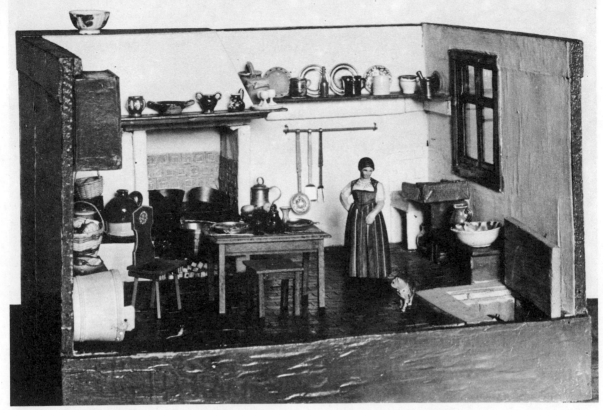

Swiss toy kitchen, *c.* 1900.

revolutionized the American market with his unbreakable dolls, of which the Campbell Kids (produced originally as a sales gimmick for Campbell's Soups) were the most successful.

In 1909, Rose O'Neill created an enchanting series of little people—'Palmer-Coxy pages' she dubbed them—with distinctive top-knots and an expression of perpetual wonderment at their ineffectual little exploits. These creatures she called Kewpies, a childishly-spelled diminutive of Cupids, and they made their debut as illustrations for *Ladies Home Journal*. Subsequently they appeared as Kewpie Kut-outs in the *Woman's Home Companion* and, shortly afterwards, they were manufactured as dolls by Kestner in Germany. After the First World War, the Kewpie doll became universally popular and continues to this day. First rubber, then plastics, were used in its manufacture, but the early Kestner Kewpies, with fine *bisque* heads, are among the major rarities of doll-collecting.

Samuel Dean's Rag Knockabout dolls first appeared in 1908 and later swept the world.

Margarete Steiff (1847–1909) produced soft toys and rag dolls, distinguished by a button in the ear and a squint in the eye. Margarete Steiff is often credited with the invention of the Teddy Bear, based on a political cartoon of Theodore Roosevelt, in 1902. That other perennial favourite, the golliwog, first appeared in *The Adventures of Two Dutch Dolls and a Golliwogg* by Florence Upton in 1895. Many subsequent Golliwogg *(sic)* stories popularized this character up to the First World War and the distinctive black-faced rag dolls began to appear in the early 1900s.

Dorflinger, Christian

American glassworker who founded a decorative glass company at Honesdale, Pennsylvania in 1901. Dorflinger glass combined traditional motifs, derived from Chinese or Islamic originals, with the most advanced ideas in design. The result was a distinctive form of glass, cased in brown and gold and etched with interlacing

85

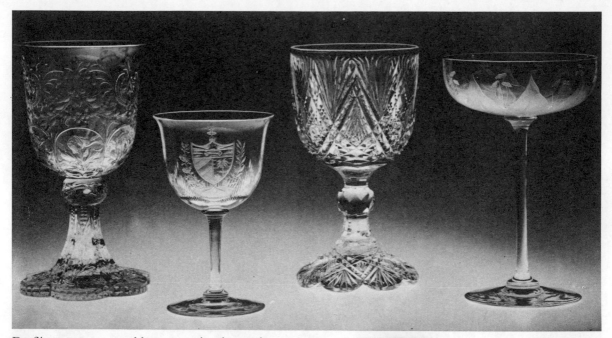

Dorflinger stemware goblets, port wineglass and
punch cup, 1890–1905.

patterns on a frosted ground. The sinuous
lines of the Art Nouveau style were enlivened by
gilt arabesques, usually near the base and rim.

Doulton Pottery

English pottery established at Lambeth, London
in 1815. Doulton was best known for its indus-
trial pottery: plumbing materials, bathroom
fittings, electrical insulators and ginger-beer
bottles. Doulton, however, revived the art of
decorative salt-glazed stoneware in 1871 and
was in the forefront of the Arts and Crafts
Movement (q.v.). The encouragement given by
Doulton to the students of the Lambeth School
of Art led to the development of studio pottery
(q.v.) in England. After experiments with faience
(q.v.) and impasto in the 1870s, Doulton began
producing a type of unglazed brown stoneware
which they named 'Silicon', smoother and
harder than terracotta. This was followed by
'Carrara', a dense white stoneware decorated
with coloured patterns, often having a lustred
effect. Both 'Silicon' and 'Carrara' wares were
produced in great quantities in the last decade of
the nineteenth century. Other wares, manufac-
tured at this time, were 'Chine' and 'Mar-

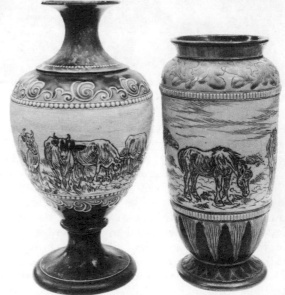

Doulton stoneware vases decorated by Hannah
Barlow, 1883–90.

queterie', distinguished by a lace-impressed
effect or mosaic patterns respectively. At the
turn of the century, sculptured figures in salt-
glazed stoneware were produced by George
Tinworth, Mark V. Marshall and F. C. Pope.
Stoneware vases with Art Nouveau motifs,
naturalistic and grotesque figures were produced
in the early 1900s.

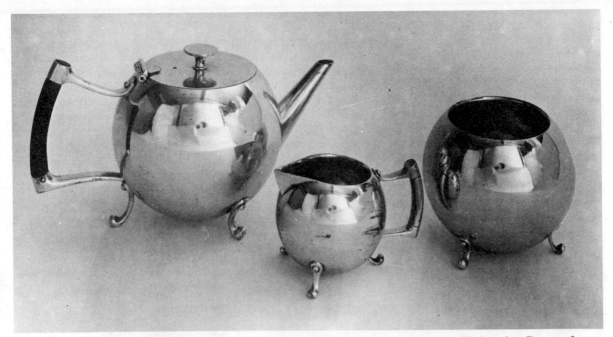

Pewter tea-set designed by Christopher Dresser for J. Dixon & Sons, Sheffield.

Dresser, Christopher

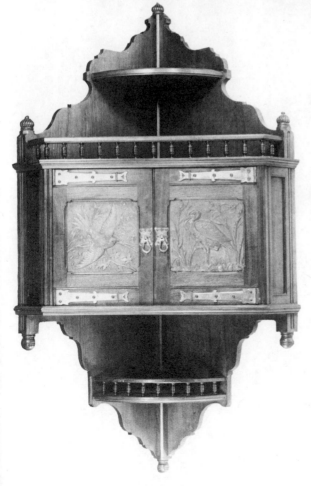

English designer working in every medium of the applied arts. Dresser, was born in 1834 and died in 1904 and was thus an almost exact contemporary of William Morris (q.v.). Although he spent two years at the Somerset House School of Design, he subsequently trained as a botanist and lectured in that subject. Later he was to combine his botanical studies with his early art training and revolutionize the late Victorian approach to the applied arts. He soon realized that design had been confused with choice of ornament and he set out to produce plain forms of design made with the absolute minimum of material. Unlike Morris, he was prepared to compromise with mechanization and make the best use of materials prepared by mechanical methods. His relation of the structural functions of plant-life to design was the basis of his outstanding contribution to the applied arts of the late nineteenth century. In the 1880s, he organized the somewhat ephemeral Art Furniture Alliance, which produced furniture and metal-

Bronze-mounted mahogany hanging corner cabinet attributed to Christopher Dresser.

work based on Japanese designs which Dresser had observed during a visit to the Far East in 1876. He was thus one of the principal innovators in *Japonaiserie* (q.v.) and this continued to influence his work until his death in 1904.

One of Dresser's earliest collaborators was Arthur Lazenby Liberty (q.v.) who offered a retail outlet for Dresser's designs from 1877 onwards. Dresser designed silverware for Liberty, but his best work was probably in the field of ceramics. He designed a great deal of pottery whose angular shape and ornament tended to suggest pre-Columbian American pottery. Dresser worked as a designer for the Linthorpe Pottery (q.v.) and derived inspiration from a wide variety of sources: Japanese, Islamic, Greek, Roman, Indian, Chinese, Peruvian and Celtic among others. Dresser designed tea services, produced in electroplate by James Dixon of Sheffield, and he also designed textile-patterns and wallpapers (q.v.) for the Morris company. To a lesser extent, he designed furniture and glassware, but his influence on other designers was immense.

Gold-mounted dressing-table set, English, 1899.

Russian costume figures in semi-precious stones by
Faberge, late 19th century.

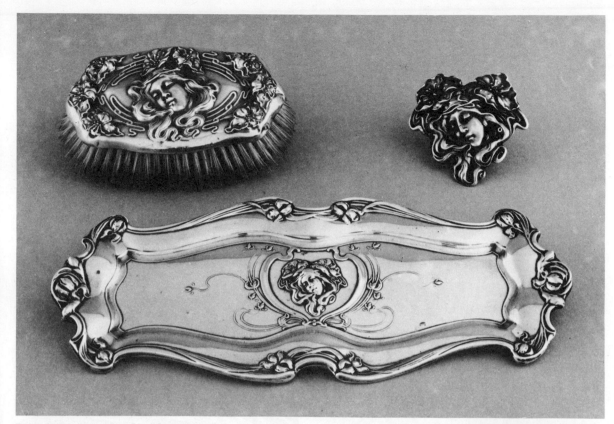

Brooch, brush and tray by Unger Brothers, Newark, *c.* 1903.

Dressing-table Sets

Many collectable items from the late Victorian and Edwardian periods are associated with the dressing-table. Jars in glass or porcelain, often highly decorative, were produced at this time for face powder, with silver mounts decorated in Art Nouveau styles. Glass trays in matching sets accommodated hairpins (themselves widely differing in decorative treatment), trinkets and rings. Matching sets of brushes and hand-mirrors may be found with silver, electroplate or enamelled backs in contemporary motifs. Perfume bottles by Lalique, Daum and Gallé (qq.v.) are worth looking for.

◀ Ebonized wood armchair designed by E. W. Godwin and made by W. & A. Smee, *c.* 1890.

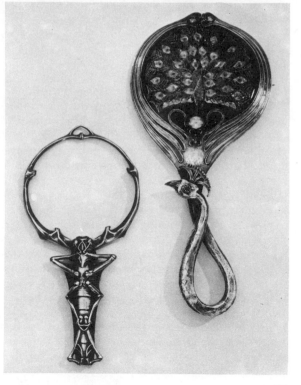

Hand mirror with peacock motif by Louis C. Tiffany, *c.* 1900 (Museum of Modern Art, N.Y.); magnifying glass with silver frame by Lucien Gaillard, *c.* 1900.

Eastlake, Charles Lock

English architect, designer and art historian (1836–1906), the son of Sir Charles Lock Eastlake, the painter. Eastlake was an early advocate of functionalism in furniture and his book *Hints on Household Taste* (1868), a best seller, revolutionized interior design especially in the United States where 'Eastlake' was used as a term to describe simple rectangular furniture with rich ornamentation and high-class craftsmanship. Like his father, Eastlake was Keeper of the National Gallery, London.

Eckmann, Otto

German painter, graphic artist and designer, born at Hamburg in 1865. Eckmann was trained at the schools of arts and crafts in Hamburg and Nuremberg and latterly at the Munich Academy. In 1894, he switched from painting to the applied arts. He produced wood-cut illustrations for the periodicals *Pan* and *Jugend* (q.v.) in the style of Japanese prints. In 1897, he was appointed a lecturer at the Berlin school of art and died in 1902 at Badenweiler. During the last ten years of his life, Eckmann was a prolific designer of textile-patterns, furniture and metalwork as well as book- and magazine-illustrations in the atmosphere of *Jugendstil* (q.v.). He was responsible for the highly distinctive Eckmann Alphabet, a type-face which combined elements from Gothic script and the simulated brushwork more characteristic of Arabic and Japanese writing. The 'curvaciousness' of this alphabet made it particularly suitable for *Jugendstil*.

Crab motif by Otto Eckmann, from *Jugend*, 1899.

Eclecticism

A term used primarily in philosophy and theology for a composite system of thought, made up of views chosen from various other systems, but used also to denote the hodge-podge of styles, from different cultures, which designers drew upon for inspiration, particularly in the late nineteenth century. Occasionally one particular

92

style, such as *Japonaiserie* (q.v.), predominated, but more often than not quite disparate sources combined to produce something which was unlike anything that had gone before. Typical results of this eclecticism were the glassware of L. C. Tiffany (q.v.), combining Japanese with Persian influence; the Rookwood pottery (q.v.) combining Islamic shape with Japanese flower ornament; the 'Congolese' jewellery of Philippe Wolfers (q.v.); Rozenburg pottery (q.v.) with Near Eastern shapes allied to Javanese batik patterns; and the metalwork of Liberty (q.v.) which derived inspiration from Graeco-Roman and Celtic originals.

Eisenloeffel, Jan

Leading Dutch jeweller (1876–1967) at the turn of the century. Eisenloeffel studied with Josef Hoffmann (q.v.) in the *Wiener Werkstätte* (q.v.) and subsequently produced jewellery in the distinctive 'chequerboard' idiom pioneered by the Austrians. He turned to silver tableware and won acclaim at the Turin Exhibition of 1902 with an elegant table service. Subsequently he abandoned precious metals and concentrated on copper, brass and enamelware, even making decorative panels for the furniture designer Berlage (q.v.).

Electroplate

The process of depositing a layer of a metal (usually silver or gold) on a base metal (usually copper or nickel) by electric current. The object to be plated is immersed in a vat containing a 'pickling' solution in which the metallic ions of the precious metal are present. The passage of an electric current (electrolysis) results in an electrodeposited coat being applied to the base metal object. Plating has widespread industrial applications, of which chromium plating, the nickel facing of copper plates and the galvanization of iron are the commonest. The use of electroplating in the fine and applied arts developed in the early nineteenth century, but received great impetus from the discovery of John Wright, a Birmingham surgeon, of the electrolytic properties of a solution of cyanide of silver in cyanide of potassium. By this method, he was able to deposit an even coat of silver on copper. The silversmith Elkington (q.v.) pur-

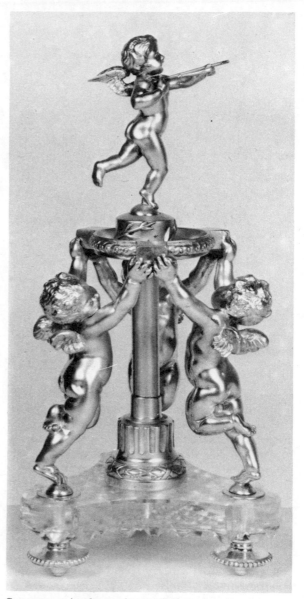

Scent spray in electroplate and silver, by E. H. Stockwell, 1893.

chased and patented Wright's process in 1840 and subsequently acquired the rights of other processes and improvements. Electroplate immediately superseded the older, and more cumbersome, Sheffield plate, which required the fusion of a thin silver sheet to a copper base. The relatively inexpensive process of electroplating enabled the new middle classes of Britain to emulate the aristocracy in the sumptuousness of their table services, and some of the worst excesses in late-Victorian tableware were exe-

93

Cast iron medallion, with bronze plating, designed by George Grant Elmslie for the elevator doors of Schlesinger & Mayer Department Store. (Art Institute, Chicago)

cuted in this manner. But the greater durability of electroplate, allied to cheapness, meant that it steadily ousted pure silverware, especially for the more functional items such as tea and coffee services. By the turn of the century, the Elkington monopoly of electroplate diminished as the original patent rights expired, and this period witnessed the enormous increase in output of the Birmingham, London and Sheffield manufacturers, not to mention the increasing popularity of electroplate in Europe and America. Christopher Dresser (q.v.) produced some outstandingly modern designs for electroplate tea services, interpreted by Liberty (q.v.) and Dixon of Sheffield in the 1880s and 1890s. Electroplating was also used extensively for the mountings and backing of many small decorative and functional objects, from belt-buckles to hairbrushes, from crumb-trays to cutlery (q.v.). Electroplating, combined with mass-production techniques of metal-stamping, was especially popular in America in the early 1900s and the scope for the collector is very wide.

Elkington

Birmingham silverware company producing fine silverware and silver plate. The company passed

to the nephew of the original proprietors, George Richards Elkington (1801–65), who took out patents for the plating of articles in 1836, 1838 and 1840. The last of these involved electrolytic deposit and laid the foundations for the modern electroplating industry (q.v.). Elkington subsequently took his cousin Henry Elkington into partnership. Elkington merged with Mappin & Webb in 1963 to form British Silverware. At the turn of the century, the firm's reputation was based mainly on its top-quality electroplate, but it also produced excellent silver, including presentation pieces and commemorative medals (qq.v.).
See *Electroplate*

Elmslie, George Grant

American architect and designer (1871–1952). Elmslie worked for Frank Lloyd Wright (q.v.) but subsequently became one of the Prairie School of architects who popularized the so-called ranch house, which blended into the flatness of the midwestern prairie. Elmslie, like his contemporaries, believed in the concept of a unified whole and therefore turned his attention to furniture, carpets and drapes as well as exterior design. Elmslie worked for Louis Sullivan (q.v.) for twenty years (1889–1909) and, during that period, designed many pieces of furniture. Among his better known works were the furniture and fittings for the Babson house in Riverside, Illinois, designed by Sullivan in 1907. When the house was extended five years later, Elmslie designed the interior and every aspect of the furniture. Emphasis was laid on vertical linear forms, in contrast to the long, low lines of the house itself.

Enamelled Boxes

The art of enamelling snuff-boxes, card-cases and other small boxes fell into decay in England in the early nineteenth century and, by 1850, none of the factories in Bilston and Birmingham, which formerly produced this work, was still in operation. Ruskin mourned this loss and offered a prize for the best piece of enamelling in the *champlevé* style in 1860. It was, in fact, won by a jeweller who seems to have produced nothing further in this line. Enamelling on metal, for the production of plaques, decorative panels and

small boxes, was not revived until the late 1880s when Alexander Fisher, who was largely self-taught, began producing enamelled boxes for Liberty (q.v.). Apart from his own practical example, Fisher inspired other craftsmen in his writings. His great dictum was: 'Enamels should never be copies of anything in nature, nor of any other process of painting in art. They should be creations.' In a subsequent book he elaborated this idea: 'Let us then start by thinking of enamels as creations, not copies, made as it were, of precious stones, only with this difference—that instead of a narrow range, they are capable of an infinite variety of colouration.'

In France, Adrien Dalpayrat (q.v.) and Fernand Thesmar revived the art of enamelled boxes. In Switzerland, where the art of enamelling had never died out and, in fact, continued to flourish in the Chaux-de-Fonds district in particular, fine enamelled jewel-boxes in Neoclassical designs continued to appear until well into the present century and included fantasies modelled in the form of butterflies, birds and fishes. Enamelled boxes with geometric patterns in the *cloisonné* (q.v.) technique were produced in Vienna at the turn of the century by such artists as Professor Prutscher, A. von Stark and A. Berger, the last-named anticipating the cubist designs of the later Art Deco period of the 1920s and 1930s.

See *Cloisonné, Cigarette Cases*

Enamel plaque, on silver, by Arthur Manock, *c.* 1901.

Enamelled Glass

Enamelling on glass was widely practised in Europe in the seventeenth and eighteenth centuries, but had declined sharply in the nineteenth. It was revived in the 1860s, largely due to the

French enamelled box, probably Limoges, *c.* 1900.

French craftsman, Joseph Brocard, who began producing fine imitations of Islamic glass about 1867, specializing in copies of Syro-Egyptian mosque lamps dating from the fourteenth century. Towards the end of the century, however, Brocard developed a distinctive style of enamel decoration on glass, much lighter and less restrained than his early work. Bowls and vases enamelled by Brocard about 1900 have a rare delicacy in line and colouring. Similar enamelled glassware was produced by Emile Gallé (q.v.), who also imitated the medieval Islamic lamps; Gallé's products were lighter than Brocard's and were less confident in their engraving and enamelling. Many of these pieces were experimental and are consequently rare today. Good enamelled glassware was also manufacturered by such French glasshouses as Arsall, Delatte, Muller Frères and Michel at the turn of the century. Pantin produced vases decorated with flowers enamelled and gilt on a frosted ground. Enamelled glass was made on a comparatively limited scale in the United States, the Mount Washington Glass Company (q.v.) being the prime exponent of this work. Vases and lamps in Burmese ware (q.v.) were richly enamelled and gilded in imitation of the porcelain known as 'jewelled Sèvres'. Enamel was applied to other opaline types of glass—'Albertine', 'Crown Milano' and 'Napoli', often used for cake stands —but production declined sharply after 1900 when this type of art glass went out of fashion.

Endell, August

German industrial designer, born at Berlin in 1871. Endell studied philosophy and, as a designer, was largely self-taught. He was strongly influenced by Riemerschmid (q.v.) and the Munich school of interior decorators, especially Obrist (q.v.). In 1896–7, he designed the photographic *Atelier Elvira* in Munich, with its wrought-iron serpentine window frames and dragon motifs on the facade. His furniture, influenced by Gaudi and Horta (qq.v.), drew on insects and marine plants for their bizarre shapes, but Islamic and Japanese inspiration can also be discerned in his work. Endell designed textile patterns and jewellery in the same strange *genre*. After 1900, he was Director of the Academy for Arts and Crafts in Breslau and died in Berlin in 1925.

Acid-etched vases, gilded and enamelled by the Honesdale Decorating Co. for Dorflinger, *c.* 1900–10.

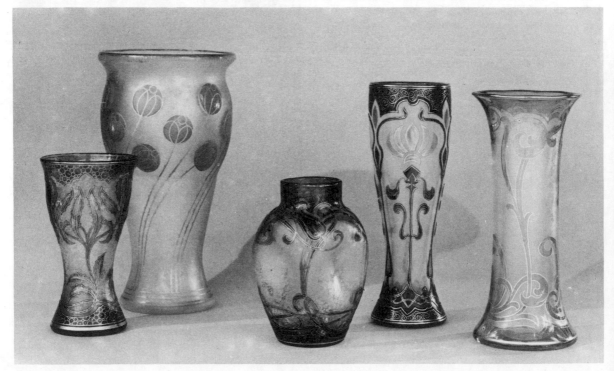

Engraved Glass

Engraving on glass came back into fashion in the late 1860s, when new techniques, based on Renaissance crystal carving, were developed. One form of engraving which was very popular in England and France was known as cameo glass (q.v.), though this effect was achieved latterly by using acid-etching. German craftsmen developed the art of *geschnitz* glass in which the surrounding glass was chipped away from a portrait or decorative subject. Allied processes which were popular at the turn of the century were acid polishing, etched *marqueterie* (flashed

French clock with engraved glass mount, *c*. 1900.

glasses engraved or etched in a combination of several colours), and sand-blasting. Glass jugs and bowls with landscapes applied by wheel-engraving were imported from China about 1900 and were popular up to the First World War. Some of the finest and most extravagantly engraved glassware produced at the end of the nineteenth century came from the Libbey Glass Company (q.v.) of Toledo, Ohio, combining wheel-engraving with acid-etching and other techniques to produce elaborate compositions on large objects such as punch bowls.
See *Cameo Glass*

Ephemera

Strictly speaking, this term covers all manner of two-dimensional objects of passing interest, but certain categories have now advanced in importance and are dealt with separately. Christmas cards, cigarette and other trade cards, picture postcards, posters, postage stamps and valentines (qq.v.) are distinct branches of ephemera which have long been popular with collectors but, in recent years, increasing attention has been paid to more mundane examples of typography and graphic art. Because of their small size and the ease with which they can be housed, such items are gaining rapidly in popularity. The collection of crests and transfers (known as decalomania) was popular at the turn of the century and special albums were even published to cater for such tastes. Although this hobby went out of fashion for many years, it has been revived in America and Europe within the past decade. Tickets of all kinds of transportation (railways, buses, shipping) or admission to exhibitions and other forms of entertainment continued to be artistic in design until the First World War and typify in miniature the styles in graphic art which had developed in the late nineteenth century. This was a period of great technical advances in newspaper and magazine illustration, and line blocks were gradually being superseded by half-tone and photogravure pictures. Early examples of newspapers and periodicals exhibiting these developments are now highly prized. Decorative notepaper and envelopes, commercial bills and letter-heads, insurance policies, bank cheques, government bonds, stock and share certificates—even paper bags and wrappers with commercial advertising on them—are now the subjects of serious study.

Ephemera: shilling postal order, 1899.

Ephemera: sheet of scraps by Raphael Tuck, 1898–9.

Erinnophily

A bastard word to denote a hobby which reached its peak at the turn of the century, from the German *erinnerung* (commemoration) and Greek *philos* (love). It was a hobby which grew up parallel to stamp collecting, when anything faintly resembling a postage stamp (q.v.) was considered collectable. Labels advertising exhibitions or commemorating historic anniversaries developed very slowly in the second half of the nineteenth century. Significantly, the exhibitions and world's fairs (q.v.) from 1851 onwards gave erinnophily its greatest impetus, but also contributed to its downfall, for the countless thousands of different labels produced in connection with the *Exposition Universelle* (q.v.) in 1900 diminished the popularity of the hobby. Relatively few labels appeared each year throughout the world from 1851 to 1888, but, from then on, the output increased enormously, mainly in France and Germany where the hobby was most firmly entrenched. France was the headquarters of *Arc-en-Ciel* (rainbow), described as 'the international society for collectors of commemorative stamps and all non-postal labels'. At that time, the application of proper postage stamps to commemorative purposes was in its infancy and official or semi-official labels were produced to fill the gap. The Diamond Jubilee of Queen Victoria was celebrated in Britain by two issues of expensive charity labels on behalf of the Prince of Wales' Hospital Fund; they had official backing but had no postal validity. The literature on erinnophily was short-lived but considerable. Apart from the *Arc-en-Ciel* publications, German col-

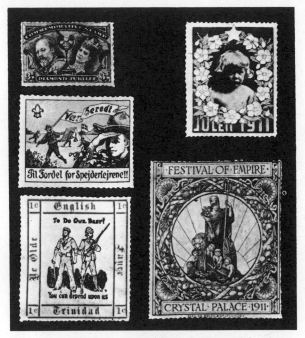

Erinnophily: British 'commemorative stamp' for the
Diamond Jubilee, 1897; Danish Boy Scout label, 1910;
Ye Olde English Fayre, Trinidad, raising funds
for the Boer War, 1899; Danish Christmas seal, 1911;
Festival of Empire, London, 1911.

lectors had a regular magazine, *Das Blaue Blatt*,
devoted to the subject, while the catalogues of
Mathes in France and Ferencz Kölbig in
Austria and, finally, the definitive work of Cazin
and Rochas established some form of order in
an otherwise chaotic field. The undue pro-
liferation of labels in fancy colours, the rise of
commemorative and charity (semi-postal) stamps
and the outbreak of the First World War sounded
the death-knell of erinnophily, though it has
begun to revive in recent years.
See *Postage Stamps, Royal Relics*

Erler, Fritz

German painter, graphic artist and designer,
born at Frankenstein in Silesia in 1868. Erler
studied under Albert Bräuer in Breslau and
worked in Berlin and Munich in the early
1890s, continuing his studies at the *Academie
Julian* in Paris from 1892 to 1894, when he made
the acquaintance of the *Nabis*. He began pro-
ducing designs for theatrical sets in Paris and
subsequently designed mosaics and furniture.
He returned to Munich in 1895 and, four years

later, was a founder-member of the *Scholle*.
Subsequently he was granted honorary member-
ship of the Munich and Milan Academies. He
died at Munich in 1940.

Exhibitions and World's Fairs

International exhibitions have played an im-
portant part in bringing new developments in
the arts and crafts to the attention of the public,
ever since the Great Exhibition was staged in
London in 1851. The exhibitions of 1851 and
1862 in London, and the Parisian exhibitions of
1867 and 1878, were designed solely with this
purpose in mind. The last-named also served as
a boost to the national image, demonstrating to
the world the rapid recovery of France after the
disastrous war of 1870–71 and the fall of the
Second Empire. The first of the great world
exhibitions staged to commemorate a specific
event, was the Centennial Exposition at Phila-
delphia in 1876, celebrating the centenary of
the American Declaration of Independence, and
it was in the Western Hemisphere that the great
commemorative world's fairs first developed.
The most prominent was the Columbian Ex-
position (q.v.), staged at Chicago in 1893 to
mark the quatercentenary of the discovery of
America by Christopher Columbus. These ex-
hibitions provided a unique opportunity for the
commerce and industry of the world to be par-
aded before the public. Many countries par-
ticipated with splendid pavilions, which acted
as shop windows for their arts and crafts as well
as the latest technical achievements. Subsequent
American events were on a smaller scale than
the Columbian Exposition, but were important
milestones nonetheless in publicizing the trends
in the applied arts. The later fairs included the
St Louis International Exposition of 1904 (com-
memorating the centenary of the Louisiana
Purchase), the Jamestown Tercentenary Ex-

Labels advertising the Pan-American Exposition in
Buffalo, 1907.

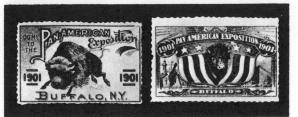

position of 1907 and the Panama-Pacific Exposition of 1913–15 celebrating the opening of the Panama Canal. In addition, important regional exhibitions included the Trans-Mississippi Exposition at Omaha (1898), the Pan-American Exposition at Buffalo (1901) and the Alaska-Yukon-Pacific Exposition (1909). These great fairs were a phenomenon of the period, coinciding with the mushroom growth of American industry as well as dramatic developments in the arts and crafts. The exhibitions were a manifestation of this growth and, in turn, greatly stimulated its development. In Europe, the outstanding international exhibitions of this period were those held in Paris (1900) and Turin (1902). The exhibitions charted the progress of the various influences in the arts and crafts. Just as the Columbian Exposition represented the high-water mark of the Beaux Arts School (q.v.), the *Exposition Universelle* of 1900 marked the zenith of Art Nouveau. At Turin, only two

Jacket of *The Youth's Companion* showing the Administrative Building at the Columbian Exposition, 1893.

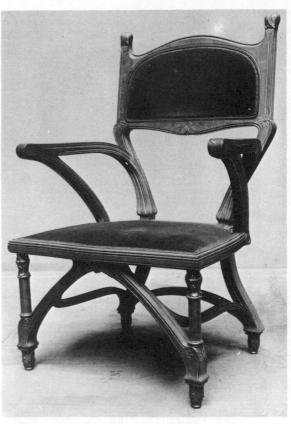

Pearwood armchair covered in yellow velvet by E. Bagues, shown at the *Exposition Universelle,* 1900.

years later, there was a distinct turning away from the more extravagant and ethereal qualities of Art Nouveau, as designers concentrated on more angular and geometric forms from then onwards.

Apart from their importance in the development of artistic styles in this period, these great international exhibitions are of interest, in retrospect, to the collector for the wealth of material they purveyed. Apart from the exhibition catalogues and associated literature connected with the exhibitions, there were special stamps, coins, medals, posters, postcards and other ephemera (qq.v.). Many manufacturers produced souvenirs to mark the occasion, from glass paperweights to pictorial pot-lids (qq.v.), plaques and rack-plates, designed either to publicize the event or to promote the wares of the manufacturer. The great *tours de force* of the individual craftsmen, artists and designers listed in this book were often produced in connection with international exhibitions. Al-

though later world's fairs witnessed many innovations, such as neon-lighting at the Chicago Century of Progress Fair (1933) and nylon at the New York World's Fair (1939), none of these later fairs had the impact on the arts and crafts expressed by the great exhibitions at the turn of the century. International exhibitions at Glasgow (1901 and 1911) and in Antwerp (1894), Brussels (1897) and Liège (1905) testified to the importance of the Brussels and Glasgow styles (qq.v.) in the applied arts of this period.

Exposition Universelle

Five international exhibitions of this title were held in Paris in the second half of the nineteenth century. The first, held at the Champs Elysées in 1855, was a propaganda exercise for the Second Empire, following the coup of Louis Napoleon; the second, held in 1867, was a counter to the British exhibition of 1862 but, financially, it was a disaster. The third, held in 1878 to mark the recovery of France after the Franco-Prussian War and the fruits of reconstruction under the Third Republic, is best remembered for the Trocadero Palace which was built for the occasion. The fourth and fifth come within the period under review and both had a marked effect on the development of *fin de siècle* trends in the fine and applied arts. The fourth *Exposition* was held in 1889 to celebrate the centenary of the outbreak of the French Revolution. More than thirty-two million visitors flocked to see this exhibition, whose principal landmark

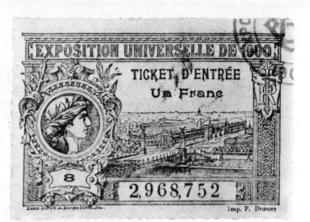

Admission ticket to the *Exposition Universelle,* 1900.

was the Eiffel Tower, 984 feet high. The Arts and Crafts Movement, *Japonaiserie* (qq.v.) and other influences on furniture, ceramics, metalwork and textiles were very much in evidence at this fair and, as a signpost of artistic styles, it was more important than the American Columbian Exposition four years later, though only a third of the size. The greatest of the world's fairs at the end of the nineteenth century was the fifth *Exposition Universelle,* held in 1899–1900 on the Champ de Mars. In area (600 acres), the number of exhibitors (9,000,000) and its visitors (50,000,000), it held the world record for more than thirty years. Art Nouveau (q.v.) was then at the height of its popularity and midway through the remarkable decade in which it flourished so luxuriantly. It is hardly surprising therefore that *le style 1900* is a term synonymous with Art Nouveau.

Fabergé, Peter Carl

Russian goldsmith and jeweller (1846–1920) of Huguenot descent. His ancestors were craftsmen in metal, expelled from France after the revocation of the Edict of Nantes in 1685 and subsequently domiciled in Germany and Scandinavia. A branch of the family settled in Russia early in the nineteenth century and, in 1842, Gustav Fabergé, father of Peter Carl, founded a business in St Petersburg, manufacturing and retailing jewellery and *bijouterie*. Peter Carl began producing the costly trinkets and objects of vertu, associated with his name, from about 1870. He came to prominence in 1882 when his elegant jewellery was shown at the Pan-Russian Exhibition in Moscow and thenceforward he was patronized by the Tsar and other members of the Imperial Family. Fabergé and his brother Agathon, with whom he was in partnership, studied art in Dresden and Paris and much of their nineteenth century work reflects the in-

Pair of silver *kovsch* by Fabergé.

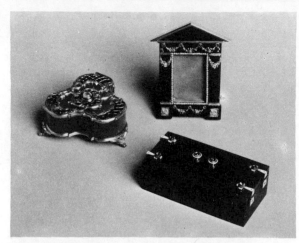

Inkwell, trinket-box and photograph frame by
Fabergé.

fluence of Baroque and Rococo styles prevalent
in eighteenth century France and Germany.
In the 1880s, Islamic and Far Eastern art also
influenced Fabergé, whose eclecticism (q.v.)
was matched only by his great skill and ingenuity
in handling precious metals and stones and his
mastery of traditional Byzantine techniques of
niello (oxydised silver) and enamelling.

Although he is best remembered for the series
of extravagant Easter eggs made for the Tsars
from 1884 to 1916, Fabergé designed and pro-
duced jewellery, trinkets and toys which became
popular with the nobility and upper classes
of Europe. To this period belong the series of
hardstone figures of Russians in peasant costume,
reflecting the revival of Pan-Slavism at the end
of the nineteenth century. His jewellery and
bijouterie relied heavily on plant, insect and
animal forms, and was executed in gold, silver
or platinum, using a wide variety of precious
and semi-precious stones. For a relatively short
period (1893 to 1900), Fabergé was an enthusiastic
exponent of Art Nouveau. Thereafter his work
took on a more geometric, functional appearance,
though he continued to produce elaborate jewels
and toys and on an even greater scale than before.
Prior to 1900, Fabergé's work was little known
outside Russia, although his patrons included
most of the crowned heads of Europe. At the
Exposition Universelle (q.v.), however, his work
came to the attention of a much wider public
and thenceforward he catered for the prosperous
middle classes of Europe and America. His out-
put in the remaining years up to the First World
War, was phenomenal and he even had a branch

in London (1903–15) augmenting his workshops
and showrooms in Moscow, St Petersburg,
Odessa and Kiev. With such a prodigious
output, it is impossible to attribute much with
certainty to the hand of Peter Carl himself.
Fabergé, his brother and his sons worked as
part of a large team of designers who also in-
cluded, at one time or another, the Swiss
designer François Birnbaum and the Russian
jewellers Ruckert and Britzin. The bulk of the
actual production was farmed out to small
craftsmen and independent workshops. The
initials of the individual workmasters are often
to be found on Fabergé products. At the turn
of the century, Fabergé employed more than
five hundred craftsmen, either directly or in-
directly, and thus he occupied the position of a
sort of retailer cum impresario.

Although his name will always be linked with
his jewelled Easter eggs and other non-functional
extravaganzas, Fabergé was also the greatest
exponent of cigarette cases (q.v.) at the begin-
ning of the twentieth century and, in fact, raised
this humble item to the rank of an art form in
its own right. The range was enormous, from
plain gold boxes (relying on combinations of
two or more different qualities of gold for
decorative effect) to elaborately enamelled cases
in innumerable combinations from the spectrum
of 144 available colours. A speciality was the
cigarette case whose panels were constructed
on the *samorodok* principle, with a rough nug-
getty surface achieved by bringing the metal
almost to melting point and then removing it
quickly from the heat so that the sudden reduc-
tion in temperature shrank the metal and gave
it its rough, pitted surface.

Fabergé jewellery ranged from decorative
tiaras and diadems to functional studs and
cuff-links, the latter often modelled in the
idiosyncratic animal or plant forms associated
with the name of Fabergé.

Art Nouveau silver buckle by Fabergé.

Fabrics

Modern fabric design may be said to have started in 1873 when William Morris (q.v.) produced his first textile pattern, known as 'Tulip and Willow'. This was printed for him by Thomas Clarkson of Bannister Hall near Preston, Lancashire, but Morris felt that the results were unsatisfactory. Subsequently he modified the pattern and, two years later, produced the 'Tulip' design, printed by Thomas Wardle of Leek, Staffordshire. In the ensuing fifteen years, Morris experimented constantly with dyestuffs, applying his customary principles to this field by going back to old vegetable dyes such as brown madder and indigo. From the early formative period came such chintzes as 'African Marigold', 'Honeysuckle' and 'Snakeshead'. Woven fabrics followed, the first of these being the patterns known as 'Anemone' and 'Honeycomb', woven in combinations of silk and wool on Jacquard looms by H. C. McCrea of Halifax, Yorkshire. In 1877, Morris installed his own Jacquard loom and employed a Lyons silk-weaver, M. Bazin, to operate it. Furnishing silks and heavier damasks were produced in the 1880s, with such evocative names as 'Flower Garden', 'Bird' or 'Peacock and Dragon'. Embroidery with plant and bird motifs, showing the inimitable Morris mastery of construction while retaining a feeling for living growth, was also produced for fire-screens and upholstery. These and his carpets and tapestries (q.v.) were produced at Merton Abbey (q.v.). After 1905, when the company became more commercialized a decade after Morris's death, a vast amount of 'reproduction' chintzes and damasks was produced. A popular line in the 1890s was the predominantly blue 'Avon' chintz with its finely curved floral and leaf motifs. Many of the Morris fabric patterns were also produced as wallpaper (q.v.).

Roller-printed cotton designed by Harry Napier for Turnbull & Stocker, 1903.

'Burges' jacquard-woven silk designed by Silver Studios, c. 1900.

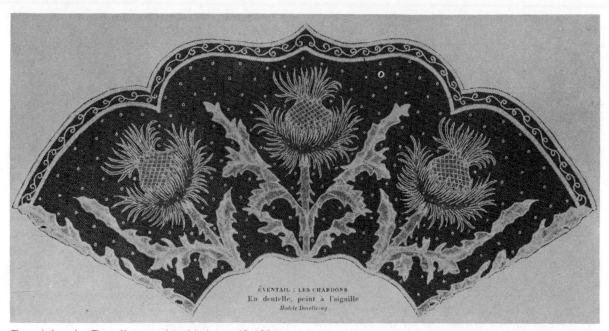

French lace by Duvelleroy, with thistle motif, 1901.

On the Continent, greater attention was paid to printed and woven fabrics than ever before. The late nineteenth century witnessed the development of needlework and embroidery societies and weaving schools which revolutionized fabric design and manufacture by getting back to natural principles. The influence of these organizations was strongest in Germany, Austria, Switzerland and France. Some of the finest and most original fabric designs were produced between 1903 and 1914 by the *Wiener Werkstätte* (q.v.) under the direction of Josef Hoffmann, Koloman Moser (qq.v.) and Fritz Wärndorfer. The *Werkstätte* had a separate fashion department to cope with the tremendous, world-wide demand for its fabrics. Many of the *Werkstätte* designs are strikingly modern in appearance and would not be out of place in contemporary settings.

See *Carpets, Morris, Wallpaper*

Faience

Tin-glazed earthenware, said to have originated in the Italian town of Faenza in the late Middle Ages. Maiolica and delftware are later variations of this pottery which remained popular until the late eighteenth century. There was a revival of interest in tin-glazed wares towards the end of

the nineteenth century and the name came to be loosely applied to any kind of highly-decorated earthenware. John Sparkes, in his 1880 lecture to the Society of Arts, stated 'faience is a convenient term for any sort of earthenware that is not white; it is a conventional term for painted

Pair of faience urns and covers in the Louis Seize manner, with decorations after Boucher, French, *c.* 1900.

105

pottery, on any ordinary natural clay as a body'. Faience required two firings, both at relatively low temperatures, to fire the body and then to fire the painting and the overlying glaze. Faience was produced in great quantities by Doulton of Lambeth (q.v.) in the last years of the nineteenth century. In the Low Countries, Joost Thooft (q.v.) revived the traditional delft-ware, using geometrical designs heightened with green slip and the so-called 'Jacoba' faience using red and green lustre. In America, the best-known exponents of this type of earthen-ware were the Grueby Faience Company (q.v.) which began with tiles (q.v.) and pottery for industrial purposes but, latterly, were associated with Tiffany (q.v.) in the production and marketing of decorative wares.

Fans

At the turn of the century, three major types of fan were still in used, an indispensable dress accessory for ladies attending balls and other functions. The folding fan, consisting of leaves mounted on sticks which were joined at the foot, was the commonest. Paper was used in the cheaper fans, but parchment (made from the skin of young turkeys) or silk were preferred in the more expensive varieties. The leaves were richly gilded and painted, often with Neo-classical motifs and scenery spreading across the leaves, so that they presented a panoramic effect when the fan was fully extended. The sticks and guards were made of exotic woods or ivory, embellished with silver or gold mountings. Mother-of-pearl and boulle inlays were fashionable, but semi-precious stones and pearls were also favoured, especially in fans decorated in the Art Nouveau style. The *brisé* fan, in which the leaves were replaced by broad-bladed sticks held in place by a ribbon threaded through slots at the broad end, was also popular at this time, and the broader surface of the sticks afforded greater scope for Art Nouveau decoration. The *brisé* fan was treated almost as a type

Late 19th century English fan.

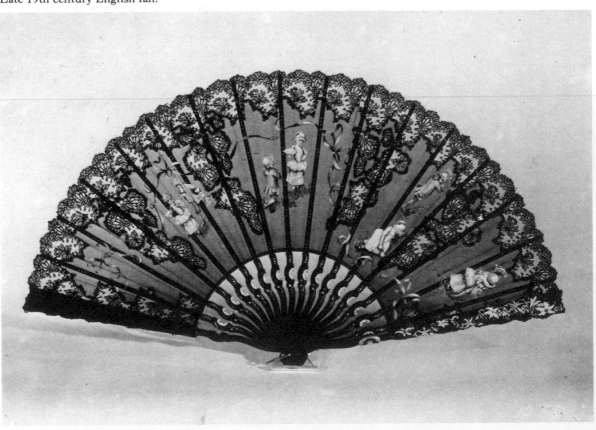

Ewer mounted with silver gilt, and matching bowl by Emile Gallé, *c.* 1900. ▶

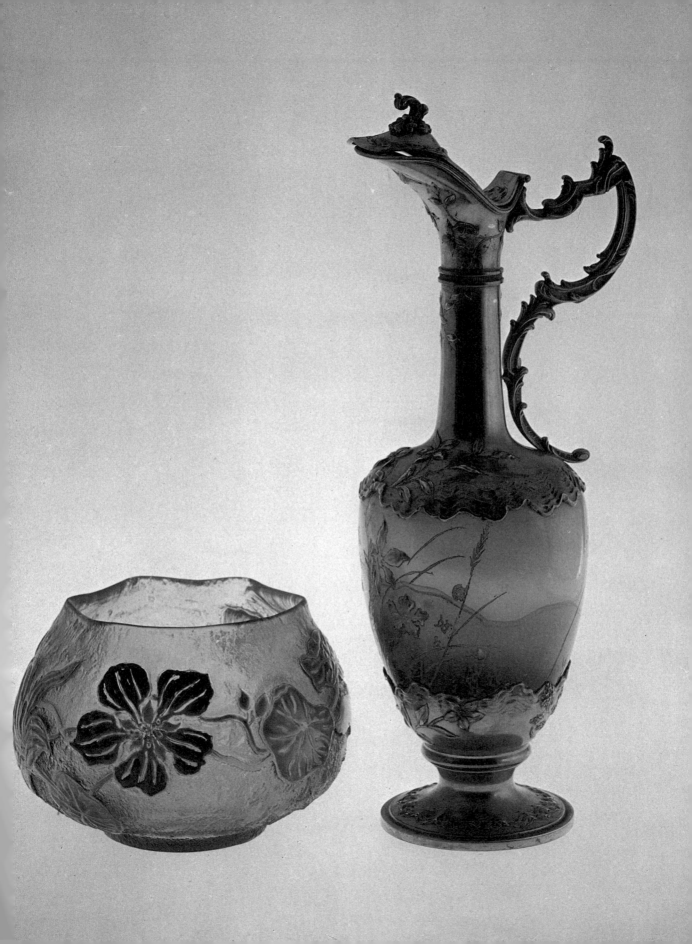

Three carved ivory fans, French, *c.* 1898.

of jewellery and its surfaces often richly enamelled, gilded and set with glass-paste cameos and gemstones. The craze for *Japonaiserie* (q.v.) led to the fashion for Japanese open fans, with broad palmate leaves of parchment painted in Oriental styles. Small Oriental fans with narrow sticks and paper leaves decorated with Eastern flower and bird motifs became very popular in the 1880s and 1890s, not as a dress accessory, but as part of an 'aesthetic' scheme of interior decoration. Fans were wedged behind every picture-frame and mantelpiece ornament, and even stitched to tablecovers and drapes.

Feuillâtre, Eugène

French sculptor, goldsmith and enameller (1870–1916), employed by René Lalique (q.v.). Feuillâtre conducted research into the problems of enamelling on silver and also exhibited his jewellery independently, at the exhibitions of the *Société des Artistes Françaises* from 1899

Entrance hall of the Gamble House, Pasadena, U.S.A., designed by Greene and Greene. (The Gamble House)

onwards. He was awarded prizes at the *Exposition Universelle* (q.v.) and the Turin Exhibition in 1900–2. Feuillâtre specialized in hollow ware of translucent enamel and glass, with silver mountings.

Finch, Alfred William

Painter, graphic artist and ceramicist, born in 1854 in Brussels of English parents. He studied at the Brussels Academy from 1878 to 1880 and, four years later, became a founder-member of the artistic group known as *Les Vingt*. Through his friendship with the Belgian ceramic artist Anna, he was introduced to the Keramis pottery, a subsidiary of the German company of Villeroy & Boch Brothers. Finch applied the theories of divisionist painting to earthenware and produced highly distinctive vases and dishes with a rough, red, gritty body covered with slip and glazed in shades of green, brown or yellow-ochre, either with contrasting decoration of lighter glaze or sgraffito patterns. Much of his early work was sold at *La Maison Moderne,* the boutique operated by Julius Maier-Graefe in conjunction with Henry Van de Velde (q.v.). In 1891, Finch visited England to study the techniques of the Arts and Crafts movement (q.v.). After *Les Vingt* was re-organized in 1893 as *La Libre Esthétique,* Finch showed both paintings and ceramics at the annual exhibitions. In 1897, Finch was invited to go to Finland to lecture on ceramics and to direct the Iris workshop in Borga. From 1902 onwards, he lectured in ceramics at the school of arts and crafts in Helsinki, exerting a great influence on the subsequent development of both painting and pottery in Finland.

Fouquet, Georges

French artist-jeweller (1862–1957) who ranks with René Lalique (q.v.) as the best and most inventive of the Art Nouveau jewellers. Whereas Lalique concentrated on floral and bird motifs, Fouquet's jewellery struck a more sombre note of realism, deriving much of his inspiration from spiky plants such as thistles, and often sinister-looking insects. Fouquet inherited the family jewellery business from his father, Alphonse Fouquet, in 1895 and shortly thereafter developed Art Nouveau pendants and brooches,

109

Metal bas-reliefs by Sir George Frampton, 1894.

using designs by Grasset, Mucha (qq.v.) and other artists. Mucha designed new premises for him at 6 rue Royale in 1901. He had a profound influence on French jewellery for much of his long life, reflected in his position of chairman of the jewellery sections at the *Exposition Internationale des Arts Décoratifs et Modernes* (1925) and the Paris International Exposition of 1937.

110

Frampton, Sir George

English sculptor and craftsman, born in 1860 and died in 1928. Frampton studied under W. S. Frith at Lambeth, in the Royal Academy schools and in Paris under Mercie. Frampton became A.R.A. in 1894, R.A. in 1902 and was knighted in 1908. At the turn of the century, he was one of the foremost figures of the English

art Establishment. He first exhibited his sculpture in 1884 but his work reached maturity in 1893 when his celebrated *Madonna and Child* was exhibited. A distinctive feature of this work was his experimentation with the use of colour. Thenceforward he experimented increasingly with decorative sculpture, utilizing many different kinds of material and striving to associate sculpture with the arts and crafts. Frampton executed many important public commissions in London, Glasgow, Leeds and cities in India and Canada. Among his best-known works are the statue of *Peter Pan* in Kensington Gardens, and the controversial *Memorial to Edith Cavell* in St. Martin's Lane, London. As a designer, Frampton was closely connected with the Arts and Crafts Movement (q.v.) and was at one time Master of the Art Workers' Guild. He was anti-classical in spirit and wished to substitute natural forms for architectural devices, both in sculpture and in furniture and jewellery.

Functionalism

The belief that 'the essential and necessary structure of an object should never be lost sight of nor concealed by secondary forms or ornament' was propounded by John Ruskin and echoed in the writings of Charles Lock Eastlake (q.v.) and in the practical example of William Morris and the Arts and Crafts Movement (qq.v.) in England. In *Hints on Household Taste,* Eastlake condemned the contemporary fashion for furniture in the 'French taste' whose unnecessary curves denied the essential function of a piece of furniture, which should be strong of construction, forthright in its purpose and, above all, comfortable. He went even further and argued that all furniture should be held together with wooden pegs and dowels and never with nails and screws. Though he did not go as far as Morris in rejecting veneering as immoral, he decried it because it was so often used to cover up shoddy cabinet work. The sensible proposals of Eastlake, backed up by practical suggestions for implementing them, created a minor revolution in the applied arts towards the end of the nineteenth century, especially in the design of furniture and silver, the media which had hitherto been so prone to the worst excesses of mid-Victorian bad taste. The key-words in Eastlake's philosophy were sincerity, artistry, picturesque and quaint—a curious combination

in retrospect. Unfortunately Eastlake's precepts were not always interpreted wisely. In 1868 he wrote that 'the smallest example . . . of anything which illustrates good design and skilful workmanship should be acquired whenever possible, and treasured with the greatest care . . . that they may each become in turn a valuable lesson in decorative form and colour'. It was this notion that popularized the collection of bric-a-brac which cluttered the drawing-rooms of America and Britain in the closing decades of the nineteenth century. His attempts to get back to the basic principles of medieval furniture were misunderstood and soon what had been intended as a return to simplicity had developed into a whole new fanciness of its own. It was not until the late 1880s that functionalism was really established in furniture, with the sturdy, four-square pieces manufactured by Gustav Stickley (q.v.). The 'Mission' furniture (q.v.), popular at the end of the century, was the prototype of the functional furniture of the present day. In Europe, the bentwood furniture (q.v.) of Michael Thonet reached the height of its popularity in this period and may be regarded as one of the purest forms of functionalism in this medium, though it was arrived at without the philosophizing of Ruskin, Morris and Eastlake.

In silver, the apostle of functionalism was Matthew Digby Wyatt whose book, *Metalwork and its Artistic Design* (1852), contained this remarkable passage: 'We may draw attention to two or three indisputable requisites to a good design for silversmiths' work. In the first place, the object must be so formed as to fulfil the purpose for which it is intended: that object must in no way be disguised, but, on the contrary, should be apparent on the first cursory inspection; the general outline should be symmetrical and the disposition of the various parts as proportioned as to appear strong, and equal to the constructive duties they may be called upon to perform; the amount of ornament should be proportioned to the purpose of the object and the means and conditions of its proprietors; there should be no direct imitation of nature, and yet no perversion of her forms; and lastly, it would be well if a system of judicious contrast of plain surfaces and enrichment were carried throughout such works, and each ornament applied only to those points where the general form appears to demand accentuation.' It was not until the advent of Christopher Dresser (q.v.) that purely functional designs for silver

111

and electroplate (qq.v.) began to appear to any great extent.

In architecture, functionalism began with the Chicago School (q.v.) of H. H. Richardson and Louis Sullivan (q.v.) and attained its peak in the works of Frank Lloyd Wright (q.v.). Functionalism in architecture and the applied arts was largely an American concept which spread to Europe at the turn of the century and was re-introduced to the United States in the Art Deco of the 1920s and 1930s. Significantly, the term 'functionalism' first appeared in the catalogue of an exhibition of architecture and industrial design, held at the Museum of Modern Art in 1932.

Furniture

In furniture, more than anything else, people tend to be conservative. For this reason the ideas of Eastlake, Morris and Dresser (qq.v.) among others, formulated in the 1860s and 1870s, were relatively slow to take root and only came to fruition around the end of the century. The bulk of the furniture produced well into the twentieth century continued the massive, over-ornamented styles which became popular

Beechwood bergére, probably French, c. 1900.

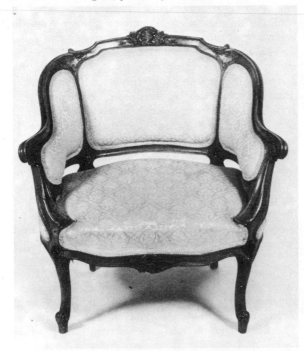

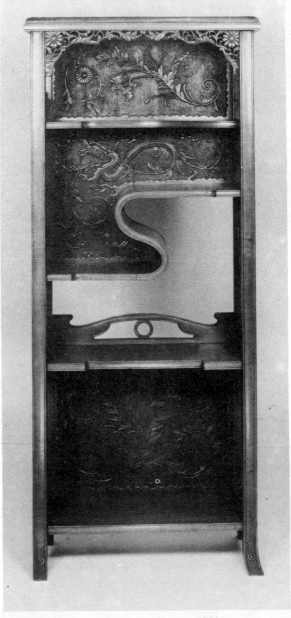

French mahogany display cabinet, c. 1900.

in the mid-nineteenth century, their florid ebullience limited only by the exigencies of mass-production. Art furniture evolved in the 1870s as a reaction against the monstrosities of Victorian bad taste. The early manifestations of Arts and Crafts (q.v.) furniture were strongly influenced by Bruce Talbert's *Gothic Forms Applied to Furniture* and Charles Lock Eastlake's *Hints on Household Taste* (q.v.), published

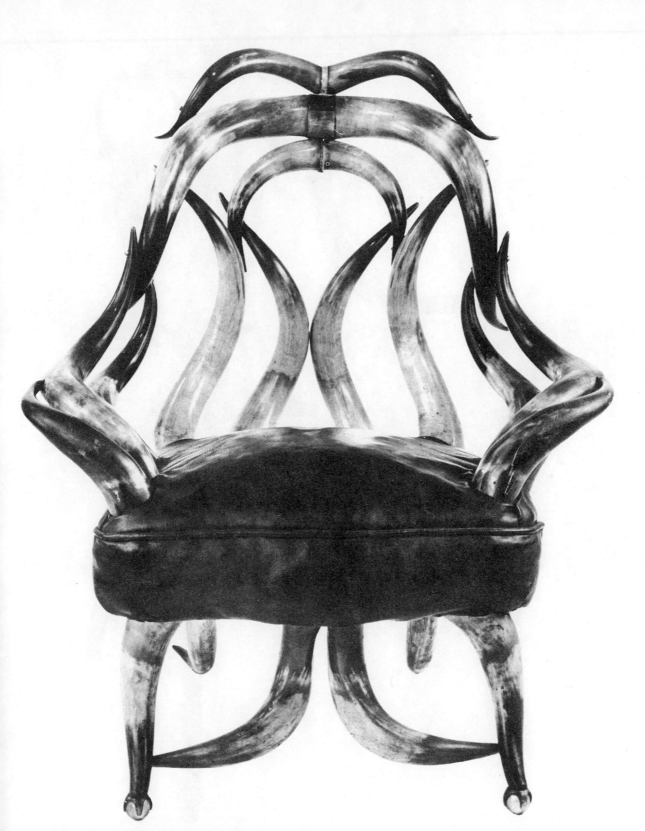

American chair, 1900, composed of steer horns.
(Greenfield Village and the Henry Ford Museum, Michigan)

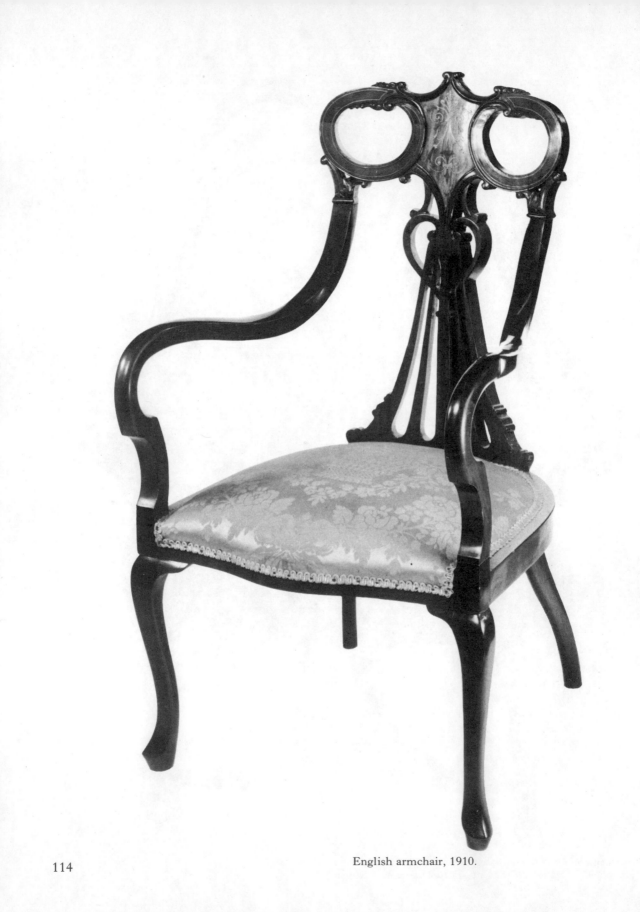

English armchair, 1910.

in 1867 and 1868 respectively, though most of the credit for the practical application of their ideas must go to William Morris (q.v.) whose company, Morris, Marshall and Faulkner, designed and made good-quality functional furniture. As a result of Morris's endeavours, many architects, designers and cabinet-makers became interested in the revival of good design and honest workmanship. The Century Guild, founded by A. H. Mackmurdo (q.v.) in 1882, aimed 'to render all branches of art, the sphere no longer of the tradesman but of the artist'. Two years later, Walter Crane (q.v.) founded the Art Workers' Guild and then, in 1888, C. R. Ashbee (q.v.) established his Guild and School of Handicraft. These organizations, the pillars of the Arts and Crafts Movement, inspired the development of good-quality furniture of original design and basically simple lines in the closing decade of the century. The designers of this period have sometimes been accused of dilettantism, since they were primarily trained in other disciplines. In Britain, the most prominent designers were men who had trained as architects—the Barnsley brothers, Ernest Gimson, Mackmurdo and C. R. Mackintosh (qq.v.), though subsequently Sidney Barnsley not only designed but also made his own furniture. Other furniture designers included the stage-designer and painter E. W. Godwin and the artist, W. R. Lethaby (q.v.), but the second generation of designers reared in the Arts and Crafts tradition included Sir Ambrose Heal (q.v.) and Sir Gordon Russell whose machine-made furniture helped to popularize the modern styles and set high standards which have never been surpassed anywhere in the world.

In France, the traditional lines of Empire furniture lingered on until the end of the century, but Paris and Nancy then developed rapidly as centres for the design and production of furniture in the Art Nouveau style. Emile Gallé (q.v.) began designing furniture in 1885 and became the foremost designer of the Nancy School (q.v.). His theories on design were published in 1900 in the *Revue des arts décoratifs* : 'As for the shape of limbs, one can either adopt traditional shapes, which leaves little scope for fantasy, or draw one's inspiration from the shape of plants. This last is the only solution we can genuinely recommend'. He suggested that the outlines of plants should form the basis for the decorative mouldings, while flat surfaces were to be filled with marquetry (q.v.) which was likewise derived

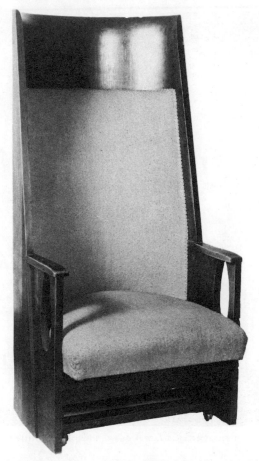

High-backed oak armchair by C. R. Mackintosh with mother-o'-pearl inlay, 1905–10.

from nature. This was all very well in theory, but the technical limitations of furniture-production tended to restrict the French Art Nouveau furniture. It has been cogently argued that the curving lilies of Art Nouveau chairs and tables were nothing but the old cabriole style with superficial plant ornament added. Like his glassware, Gallé's furniture was often embellished with lines of Symbolist poetry and many of his pieces were given extremely poetic names. Much of his later furniture had a distinctly surrealist quality about it.

Gallé influenced the other leading French designers, such as Eugène Vallin and Louis Majorelle (qq.v.). With them is associated Victor Prouvé, who designed marquetry panels for the furniture of Nancy. In Paris, the impresario of Art Nouveau furniture was Samuel Bing (q.v.) who employed the remarkable trio of original talents, George de Feure, Eugène Gaillard and

115

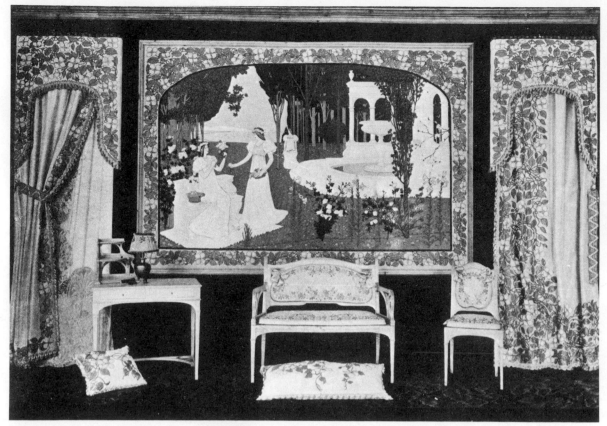

Interior design from *Les Modes* showing furniture, wall-hanging, drapes and carpet fashionable in 1901.

Eugène Colonna (qq.v.) as furniture designers; their work won wide acclaim at the *Exposition Universelle* (q.v.) of 1900. Hector Guimard (q.v.) worked on his own in Paris and designed furniture of great individuality. His self-styled profession of 'an architect of art' reflects his preoccupation with the design of houses and interiors down to the last mantelpiece and doorknob. Much of his work, however, was beyond the comprehension of his contemporaries and it was often strongly criticized. His 'abstract naturalism' is seen at its most typical in the Castel Beranger which he designed and fitted out between 1896 and 1899.

A parallel development in the Low Countries centred on the activities of *Les Vingt* who began including the applied arts in their repertoire from 1891 onwards. Their successors, *La Libre Esthétique*, under the aegis of Octave Maus, laid the foundations of modern Belgian furniture design whose most notable exponents in this period were Victor Horta, Henry Van de Velde and Gustave Serrurier-Bovy (qq.v.). Like their

English and Scottish counterparts, the Belgian designers were trained originally as architects and they sought to achieve a unity of spirit between architecture and furniture, down to the smallest detail. Although these three were the most prominent in this field, the work of lesser designers is now attracting the serious attention of collectors and students. They included Paul Cauchie (1875–1952), Paul Hankar (1861–1901), Georges Hobe (1854–1936), and Georges Antoine Peereboim (1848–1932).

In the late 1890s, the new styles of furniture design spread from the Low Countries and England to Germany, and the first fruits of this were seen at the Seventh International Arts Exhibition held in Munich in 1897. Seven leading artists and designers formed the nucleus of the Munich Circle—Otto Eckmann, Hermann Obrist, Peter Behrens, Bernhard Pankok, August Endell, Richard Riemerschmid and Bruno Paul (qq.v.), subsequently joined by Hans Edouard von Berlepsch-Valendas (q.v.). Like their counterparts in Belgium and Britain, the German

116

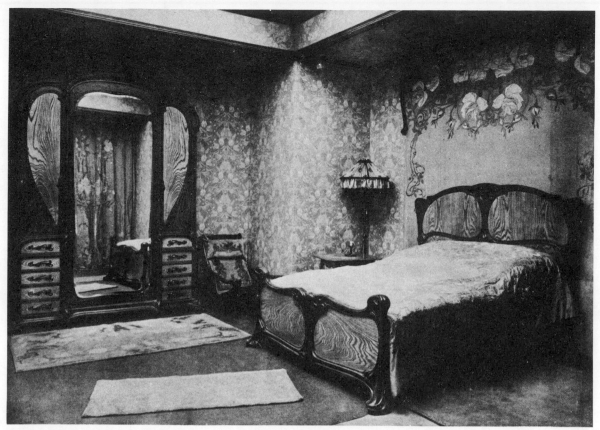

French bedroom furniture of 1907.

furniture-designers were primarily architects and painters and, to an even greater degree than the English, they tended to show their versatility in many different fields, without concentrating wholeheartedly on furniture. Their work was co-ordinated after 1898 when the *Vereinigte Werkstätten für Kunst und Hand-werke* (q.v.) (the united workshops for arts and crafts) were founded by F. A. O. Krüger in Munich. A similar institution was established a short time later in Dresden, as an outlet for the work of Gertrud and Erich Kleinhempel (q.v.), Margarete Junge and Ernst Schaudt.

In Austria, the modern movement was pioneered by the architect Otto Wagner (q.v.) who employed Josef Hoffmann and Joseph Maria Olbrich (qq.v.) as designers before they branched out in other directions. Olbrich moved to Darmstadt in 1899 while Hoffmann subsequently founded the *Wiener Werkstätte* (q.v.) in 1903. Among the earliest furniture designs of *Wiener Werkstätte* were some remarkable cubist designs of a type which was not to be seen again

until the *Bauhaus* moved to Dessau in 1925. The finest achievement of the *Wiener Werkstätte* was the design and outfitting of the Villa Stoclet in Brussels between 1905 and 1911. The entire furniture and fittings were constructed in Vienna and then shipped to Brussels, where twenty-one *Werkstätte* joiners were employed from 1908 onwards in their installation.

American furniture developed along quite different lines in the closing years of the nineteenth century. Mass-production techniques aided the dramatic growth of an indigenous furniture industry centred on Grand Rapids, Chicago and Cincinnati to supply the demands of a population whose size was matched by its rapidly increasing prosperity. Much of this factory-made furniture was constructed on pseudo-traditional lines and suffered from the over-elaboration which was the malaise of that era. The reaction to this resulted in the foundation of such firms as the Tobey Furniture Company and the Roycroft Shops (qq.v.) and the emergence of craftsmen of the calibre of

117

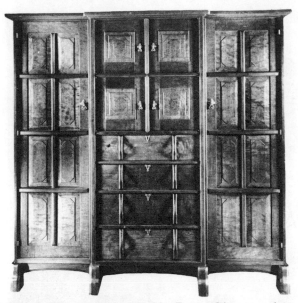

Java teak wardrobe designed by Ernest Gimson and executed by Peter Waals, 1905.

Elbert Hubbard and Gustav Stickley (qq.v.). Stickley's Mission furniture (q.v.) was copied extensively all over America at the turn of the century. In contrast to the 'craftsmen' school of furniture designers were the architects of the Chicago school (q.v.), of whom Frank Lloyd Wright (q.v.) was the outstanding figure. The best of his furniture in the Arts and Crafts *genre* was produced between 1893 and 1914. Unlike his English counterparts, Wright did not disparage the use of machinery in furniture-production but adapted his designs to take advantage of mechanized techniques. Wright's contemporaries included George Maher and George Grant Elmslie (qq.v.), pioneers of the ranch-style house and the so-called Prairie style of interior decoration. Other notable designers of this period were Henry Babson, who worked with Elmslie on the interiors of houses by Louis Sullivan (q.v.) and Robert Jarvie, also of Chicago. Oddly enough, Art Nouveau, in the European idiom, had little effect on American furniture during this period until after 1910. Much of the so-called Art Nouveau furniture, which was manufactured between that date and the end of the First World War, was a very much diluted and bastardized version which lacked the grace, elegance and imagination of the better European pieces. A notable exception, however, was the New York firm of George C. Flint which produced excellent copies of designs by Majorelle (q.v.) between 1900 and 1913. Marquetry was a characteristic feature of the furniture produced by Tiffany (q.v.) in the 1890s. A Tiffany speciality was the horn chair, whose back, sides, arms and legs were constructed entirely of buffalo horns. Chairs of this type, evoking the romance of the Wild West, were popularized by Theodore Roosevelt in the 1880s and 1890s and enjoyed a certain vogue in America towards the end of the century. *Japonaiserie* (q.v.) strongly influenced the furniture of the brothers Charles and Henry Greene (q.v.) at the turn of the century. The Greenes, trained as architects, believed in the use of natural materials and straight-forward construction, eschewing historicism and sham ornament.

Towards the end of the century, a distinctive 'Glasgow' style (q.v.) was evolved by the architects Charles Rennie Mackintosh and Herbert MacNair (qq.v.). Their furniture, more angular than the English or Continental Art Nouveau, owed much to Celtic decorative idioms, but was restrained in its use of ornament and foreshadowed the austere lines of the postwar *Bauhaus* movement.

Detail of a carved walnut chair covered in leather by A. Darras, French, *c.* 1900.

118

Gaillard, Eugène

French furniture designer (1862–1933) employed by Samuel Bing (q.v.) to design room settings for his salon at the *Exposition Universelle,* 1900. Gaillard specialized in bedroom and dining-room furniture and fittings.

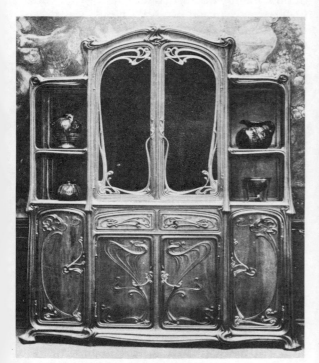

Side cupboard by E. Gaillard, 1907.

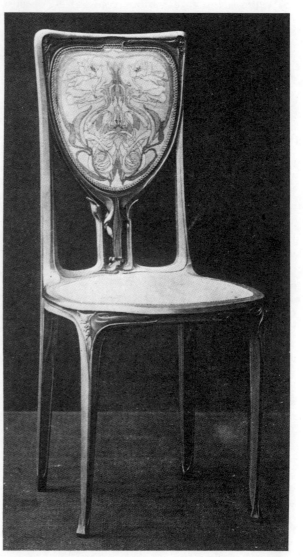

Chair with Art Nouveau upholstery and carving by Gaillard, 1907.

Gallé, Emile

French designer of glass, furniture and jewellery (1846–1904) and leader of the Nancy School (q.v.) in the applied arts. He was undoubtedly the most outstanding of the French glassmakers of the late nineteenth century. After studying the techniques of glass production abroad, Gallé began experimenting with coloured glass, attempting to improve the range of colours without diminishing the transparency of the material. These early experiments culminated in the vivid blue glass, created by means of cobalt oxides, which came to the attention of the discriminating public at the 1878 *Exposition Universelle*. In the ensuing decade, he continued to experiment with various colours, eventually achieving success with the full range of colour from deep purple to bright orange. Throughout his long career, however, Gallé was pre-occupied with the decoration of glassware rather than the manipulation or transformation of the substance itself. The earliest type of embellishment consisted of enamelling, a technique which he gradually improved. Gallé's finest glassware

Honey bowl by Gallé, late 1890s.

was produced at the turn of the century. By 1897, he was melting pieces of other glass or enamels of different colours into his glass, creating articles which were individualistic expressions of the highest artistic ideals. Compared with such artistic media as porcelain and silver, glass usually presents many problems of attribution, mainly because so little of it was marked. Gallé, always proud of his creations, was exceptional in that he invariably signed his works, usually in gilt or brown enamel, in his own hand.

By the time of his death in 1904, his workshop had become a highly successful business with a considerable output, though quality was never sacrificed to quantity. Up to the time of the First World War, the factory continued under the guidance of Gallé's friend, the painter Victor Prouve, and glass made in this ten-year period (1904–14) continued to bear Gallé's signature, preceded by a small star. Production was halted by the course of the war, but some attempts at reviving the business afterwards were only partly successful and the Gallé factory finally closed its doors in 1935. Gallé's workshop stood at the centre of the naturalist movement associated with Art Nouveau, and he had many imitators. The Daum brothers (q.v.) alone came close to rivalling him in quality. Gallé also produced his own distinctive form of cameo glass (q.v.), the layers of opaque glass being acid-cut. Gallé experimented with glass-paste and enamel jewellery, but comparatively little of it has survived and can definitely be attributed to his *atelier*.

From 1885 onwards, Gallé designed and produced furniture, resolutely ignoring the eclecticism (q.v.) of so many of his contemporaries and concentrating entirely on natural forms.

Ash and walnut marquetry work-table by Emile Gallé, 1900.

His furniture had exotic names, such as *Heureux les Pacifiques* or *Les Parfums d'autrefois*. Though not the most outstanding of the furniture designers of the Nancy School, he was certainly their ablest propagandist, expressing the aims and ideals of the Art Nouveau *ébénistes* in the pages of the *Revue des arts décoratifs*. Many of his pieces were *meubles parlants,* their decoration incorporating quotations or lines of poetry in marquetry. Gallé's furniture was either commercial, for the mass-market, or consisted of custom-built pieces for individual commissions. It is in the latter that his surrealist genius was allowed full play and some of his most memorable items (such as the dragonfly tables or butterfly beds) were designed for individual clients.
See *Cameo Glass, Furniture, Glass*

Games and Pastimes

Increasing leisure among all classes, in an age before motion pictures were commonplace and radio and television were still in the future, made games and pastimes of all kinds extremely popular at the turn of the century. Like the old-established chess and draughts or chequers, many of the games current in the late Victorian era originated in the Orient. Mah Jong was introduced from China and many fine sets of pieces date from the 1890s. Ludo, based on an Indian game called *pachisi,* was patented in 1896 and became a firm favourite overnight. Halma, a game played on a chequerboard with wooden or ivory pegs, developed about 1880 and remained popular until the First World

Group of late 19th century American toys: marbles, Palmer Cox Brownies, games of 'Hens and Chickens' and 'Mansion of Happiness', and stationery bank.

War. There were many different card games designed for children and therefore often of an 'improving' or educative character. These games were thematic, like the modern Happy Families, but had such subjects as Celebrated Poets, Peerless Authors or Crowned Heads of Europe. History, geography, botany and literature could thus be imparted painlessly and effortlessly to the young, disguised as a game. Logos, the prototype of Scrabble, was patented at the end of the century, and there were various money games such as Moneta which gradually developed into the familiar Monopoly. Bagatelle, the forerunner of the modern pin-table, was a popular parlour game in Edwardian households. Jigsaws became popular in the mid-nineteenth century. The early examples, which are now very scarce, had relatively simple outlines and were often designed for instructional purposes; lengthy texts accompanying the pictorial vignettes were the rule. The jigsaw puzzles from the turn of the century are more plentiful and the familiar pattern of a single picture composed of interlocking pieces was beginning to emerge. Old favourites, such as cribbage, dominoes, dice and playing cards, with a *fin de siècle* flavour in their decorative treatment, are now in great demand by collectors of Art Nouveau.
See *Toys*

Gaskin, Arthur

English painter, graphic artist and metalworker (1862–1928). Gaskin studied at the Birmingham School of Art and subsequently became a lecturer. He played a leading part in bringing the Arts and Crafts Movement (q.v.) to the Midlands. In 1894, he turned to metalwork and produced his first jewellery five years later. In 1902, he became head of the Victoria Street School for Jewellers and Silversmiths. Gaskin transcended the homeliness of the Arts and Crafts silverware, to produce caskets and hollow ware whose disciplined craftsmanship was of unsurpassed excellence. He used enamels, pearls and gemstones to enrich the finely engraved surfaces of his silver.

Gaudernack, Gustav

Norwegian designer and silversmith of Czech origins, born in Bohemia in 1865. Gaudernack studied in Vienna and emigrated to Christiania (Oslo) in 1891. He designed glassware for the *Christiania Glasmagasin* and subsequently worked for the silversmith David Andersen. In 1910, he established his own workshop but died four years later. Gaudernack began with silverware in the

Rough design by Gaudi for a house.

heavy Norse 'dragon' style, but influenced by Art Nouveau (q.v.) he developed lighter, more willowy designs. He won two gold medals at the *Exposition Universelle* (q.v.) and took the *Grand Prix* at the St Louis International Exposition in 1904. Shortly before his death, he was awarded the Norwegian Centenary Exhibition's gold medal for metalwork.

Gaudi y Cornet, Antoni

Spanish architect (1852–1926) and the greatest exponent of Art Nouveau in architecture. Gaudi was trained as a sculptor and there is a strong sculptural quality about his buildings, the most notable of which are in Barcelona: the Casa Vicens (1878), Palau Güell (1884–9), Santa Coloma de Cervello (1898), Güell Park (1900), the greater part of the façade and decor for the Sagrada family chapel (1903) and the Casa Batlo and Casa Mila (both begun in 1905). As the son of a coppersmith, Gaudi paid close attention to the metalwork of his buildings, producing wrought-iron railings and balustrades noted for their grotesque and surrealist qualities. His furniture, especially the chairs, benches and stools, have an insect or plant-like appearance, often on spindly curving legs of wrought iron reminiscent of beetles. The same, almost nightmarish, approach in furniture, metalwork and facades may be found in the work of August Endell and Victor Horta (qq.v.). Curiously enough, Gaudi was very much a solitary phenomenon; there was no distinctive Spanish school of Art Nouveau to carry on or expand his theories though, in the sphere of the fine arts, both Picasso and Dali show the influence of Gaudi in some of their work.

Gauguin, Paul

French painter and pioneer of the post-Impressionists, born at Paris in 1848. In 1881, he gave up his position as a bank clerk to devote himself entirely to art. After spending some time in Martinique, he returned to France in 1888 and settled in the artists' colony on Pont Aven where he soon became the leader of the group of painters known as the Synthesists, which included Emile Bernard (q.v.). The period spent at Pont Aven and subsequently at Pouldu

Stoneware dish by Paul Gauguin, probably in collaboration with Ernest Chaplet, 1888.

(1888–91) was a fruitful one, not only for the development and widening of Gauguin's art, but for the influence which he had on such young artists as Bonnard, Ranson (q.v.), Vuillard and Maillol. Gauguin was a founder-member of the *Société des Peintres-Graveurs* in 1889 and his ideas revolutionized poster-design (q.v.). He exercised a profound influence on the arts and crafts of France at the turn of the century and such craftsmen-designers as Van de Velde and Gallé (qq.v.) owed much to Gauguin. Though best known for his paintings, heavily impregnated with symbolism, which belong to his Tahitian period (1891–1903), Gauguin also produced textile-designs, wood-carvings and terracottas, some of which were subsequently cast in bronze. During his Pont Aven period, he collaborated with the ceramicist Ernest Chaplet in the production of stoneware. Gauguin's work in this medium shows a dramatic conflict between sculpture and ceramics. Most of his pieces are technically poor and totally unfunctional, though some show artistic genius in their conception.

Gillow & Company

English furniture company, founded by Robert Gillow (1703–73) and originally operating in Lancaster. Robert's younger son, Robert, established a branch of the business in Oxford Street, London. During the nineteenth century,

Steel firedogs designed by Ernest Gimson and made by Alfred Bucknell, *c.* 1910.

Gillows became the leading manufacturers of furniture for the rising middle-class market. Their craftsmanship was always of a very high order; notwithstanding the fact that they concentrated on 'reproduction' pieces, and contributed much of the massive, florid furniture which has come to be associated with the excesses of Victorian taste. Both Pugin and Talbert designed furniture executed in the Gothic or Neo-medieval styles, which Gillows helped to popularize. The firm's interest in Chippendale styles dated from the 1830s but, by the late 1870s, it had revived the light Sheraton styles of the late eighteenth century.

Although steeped in the English equivalent of the Beaux Arts (q.v.) tradition, Gillows were not averse to experiment with the styles advocated by the Arts and Crafts Movement (q.v.) and even went so far, in 1893, as to take part in the Arts and Crafts Exhibition of that year—though this was never repeated in subsequent years. Much of the furniture produced by the company at the turn of the century was massive and ugly, with fussy marquetry (q.v.), overelaborate inlays and a riot of carving and moulding which combined elements from the styles of every era. Gillows are important to any survey of furniture from the turn of the century because of their position as trend-setters; their furniture was slavishly copied by lesser cabinet-makers of the period and their influence even extended

across the English Channel. The Prince of Wales's Pavilion at the *Exposition Universelle* (q.v.) was decorated by Gillows and traces of their florid styles may be discerned in much of the Beaux Arts furniture produced in France immediately before the First World War.

Gimson, Ernest

English architect (1864–1919), strongly influenced by William Morris (q.v.) in the Arts and Crafts Movement (q.v.). Gimson, together with Sidney Barnsley (q.v.) and a few friends, formed the firm of Kenton and Company at the end of 1890 for the manufacture and sale of furniture which he designed. Gimson and the Barnsley brothers moved from London to the Cotswolds in 1893, first to Cirencester and then, in 1903, to Daneway near Sapperton. Unlike Sidney Barnsley, who developed skills as a cabinet-maker, Gimson concentrated on design and employed up to twelve cabinet-makers to interpret his ideas. He was a very prolific designer. Though his name is always associated with oak, he designed furniture which was intended to emphasize the special qualities of walnut and other timbers. Gimson worked very closely with his foreman, Peter Waals, and the production team, and insisted on handwork of the highest precision. Over the years, his furniture became more sophisticated, blending different woods with a rare skill. Great care was given to the metal fittings and every lock-plate and drawer handle was finished meticulously. Gimson also designed a great deal of church furniture.

Glasgow Style

A style in architecture and the applied arts developed between 1893 and about 1904 by the architect, Charles Rennie Mackintosh, the designer, Herbert McNair, and their respective wives, the sisters Margaret and Frances Macdonald (qq.v.). It was at the Glasgow School of Art (designed by Mackintosh) that the Four, as they are often termed, first met in 1893. They were introduced by the Director of the School, Francis H. Newbery, who recognized the similarities in their work. This was mainly two-dimensional; drawings and water-colours which derived to some extent from the work of

American art glass: (left to right) Wild Rose vase by
New England Glass Co.; Hobbs Brockunier facsimile
of the famous Morgan Peach Blow Vase; Agata bowl
by the New England Glass Co.; Burmese candlestick,
Mt. Washington Glass Co.; enamelled Peachblow
bowl by Mt. Washington Glass Co. (Corning Museum
of Glass)

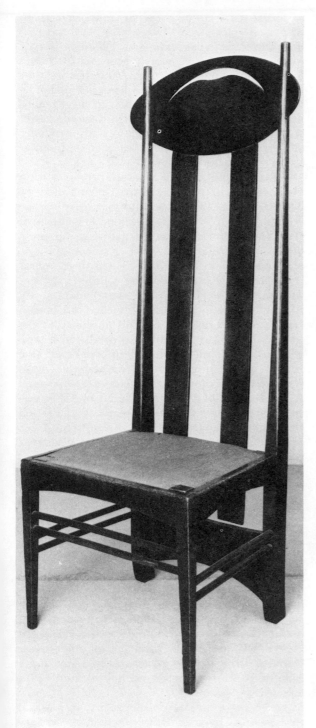

Glasgow style furniture: chair by C. R. Mackintosh, 1897.

◀ Silver inkwell by Omar Ramsden and Alwyn Carr, 1901.

the Dutch artist, Jan Toorop (q.v.), but also took its inspiration from Celtic and medieval Scottish art forms.

Mackintosh and McNair produced furniture designs from about 1891, strongly influenced by the English Arts and Crafts Movement (q.v.), but, by 1896, they had moved away from this and the work which they exhibited that year at the movement's London exhibition was severely criticized. Although Mackintosh received a number of important commissions in Glasgow, the work of the Four was better appreciated in Paris, Vienna, Turin and other European centres than it ever was in Britain. The Macdonald sisters did not design furniture themselves, but concentrated on ancillary subjects such as decorative panels in *repoussé* metalwork or painted gesso, curtains, drapes and upholstery with richly embroidered motifs, leaded glass and jewellery.

The Glasgow Style was parallel to, but quite distinct from, the trends in Art Nouveau which developed in France, Belgium and Austria at the turn of the century. Mackintosh furniture was restrained, austere and light; his best-known and most characteristic designs were the high-backed chairs designed for Miss Cranston's Glasgow tea-rooms. He was fortunate in gaining commissions to design not only houses but their interiors, down to the cutlery and door-hinges. Especially in their later work, the Four moved away from the ethereal quality and sensuous curves of Continental Art Nouveau and produced more linear shapes which were a foretaste of the Art Deco styles of the 1920s.

Other artists whose work was akin to the Four were E. A. Taylor and Talwin Morris, but they had relatively limited talent and tended to graft the Glasgow Style on to traditional designs, not always with conspicuous success.

Glass

More than any other medium in the applied arts, glass made enormous technical strides during the nineteenth century. Entirely new techniques, such as pressed and moulded glass, were allied to the more traditional processes of cutting and engraving which were themselves improved considerably. Acid-etching, the use of opaque and coloured glass, the gradation and combination of different colours and qualities of glass, the revival of *millefiori* mosaics for paper-

127

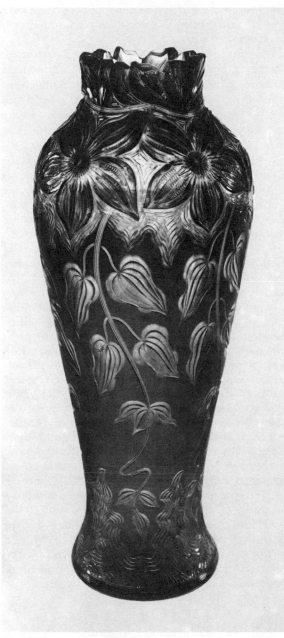

Intaglio-cut vase by Stevens & Williams, Stourbridge, 1901.

to feel the effects of these two opposing viewpoints. As early as 1859, Philip Webb (q.v.) had designed glassware for William Morris (q.v.). These glasses were produced by James Powell and Sons (now the Whitefriars Glass Company), but their austere lines did not meet with public approval. It was left to the Frenchman Gallé (q.v.) to break away from the classicism of mid-nineteenth century glass, and to pioneer the types of glass which became so popular at the turn of the century.

The Neo-classical fashion in Britain during the second half of the century, exemplified by Northwood's Elgin Vase and his copy of the Portland Vase, led to the development of cameo glass (q.v.) and the use of acid-etching on a commercial scale. Glass-paste cameos and the *crystallo-ceramie* patented by Aspley Pellatt (1791–1863) popularized the sulphide paperweights of the 1850s, but were adapted by French and Belgian glasshouses for the manufacture of decorative glass and jewellery at the end of the century. Gallé also produced a type of cameo glass, but developed his own distinctive style of decorating coloured flashed-glass with engraved plant designs. His glassware, displayed at the *Exposition Universelle* (q.v.) of 1889, was an immediate success and inspired other French glasshouses, notably Daum Frères (q.v.), to emulate it. The zenith of French art glass was reached in 1900, when such artists in glass as Albert Daiguperce, Emile Munier, Paul Oldenbach and Julien Roiseux were awarded silver medals at the *Exposition Universelle* and Gallé himself was awarded a double *grand prix* and the cross of the *Legion d'Honneur*. Glass in the style of Gallé was also manufactured at the end of the century by Verrerie de la Paix (Paris), Cristallerie de Sèvres and Christian & Sohn of Meisenthal (Lorraine). Similar glassware was produced at this time by Belgian glasshouses in Namur and especially Val-St.-Lambert, one of the largest glassworks in Europe, which employed Henry Van de Velde (q.v.). The other great name in French glass of this period was René Lalique (q.v.) who preferred figural motifs and colourless glass.

The most dramatic developments in glass in the second half of the nineteenth century occurred in the United States. The 1880s, in particular, were a decade marked by new techniques and inventions as well as artistic originality. Coloured glass was an American speciality and the art glass produced at the end of the

weights (q.v.) and enamelling and gilding for decorative hollow ware; all belong to the mid-nineteenth century, a period generally criticized for its tastelessness. The clash between mechanization and artistic handcraft, which affected all branches of the applied and industrial arts, was demonstrated most dramatically in the field of glass, and it was one of the earliest media

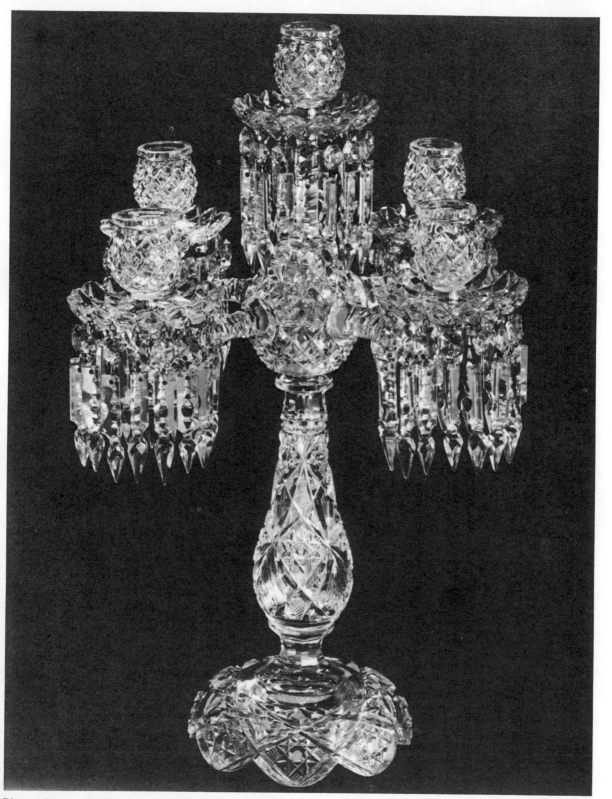

Blown glass candelabrum in 'Marlboro' design,
Dorflinger, 1895–1900.

129

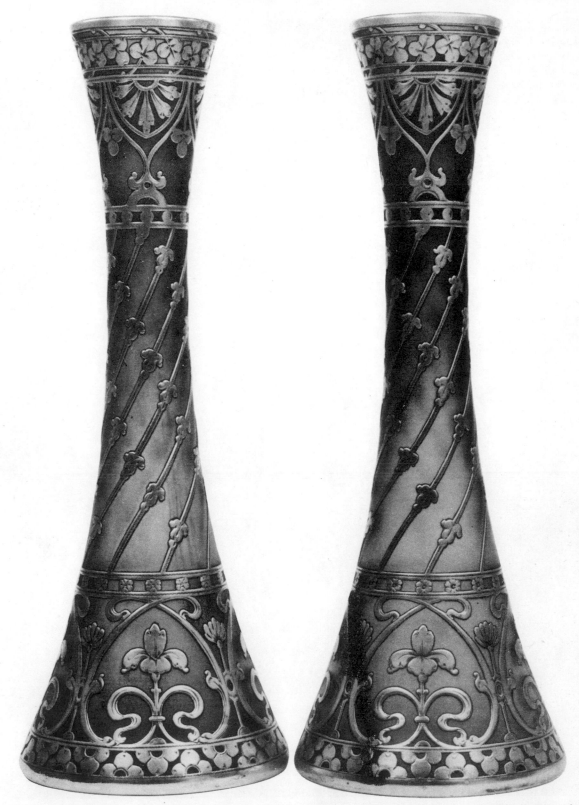

130

Pair of purple frosted glass vases with silver overlay,
c. 1900.

century was notable for its combinations of colour and shade. Joseph Locke of the New England Glass Company (q.v.) patented his 'Amberina' glass in 1883 and soon other companies were experimenting with attractive colour combinations. Joseph Webb of the Phoenix Glass Company patented 'M.O.P. (mother-of-pearl) satin glass', Locke subsequently produced his 'Agata' (white to pink) glass, and Hobbs Brockunier (q.v.) of Wheeling, West Virginia introduced 'Peachbloom'. Textures as well as colours preoccupied the American glasshouses. The Mount Washington Glassworks (q.v.) specialized in alabaster glass roughened with hydrofluoric acid, but also produced a type of mother-of-pearl glass and patented Burmese glass (q.v.), which was subsequently manufactured under licence by Thomas Webb of England (q.v.). Towards the end of the century, Louis Comfort Tiffany (q.v.) turned his attentions to glass manufacture. At first he concentrated on stained glass for church windows, but, in 1893, he patented his 'Favrile' glass, whose iridescent, lustred effect resembled the weathered appearance on ancient glass. Iridescent glass, under the trade name 'Aurene', was also produced by Frederick Carder of the Steuben Glassworks (q.v.), and under the name 'Quezal' by the Quezal Art Glass & Decorating Company.

Enamelled scent bottle in ruby glass; pink and white latticinio scent bottle; green glass Birmingham scent-bottle, 1901.

Lötz vase in grey glass with gold lustre, c. 1900. Base engraved LOETZ, AUSTRIA.

Tiffany exerted a great influence on the Austrian glassmakers at the end of the century. Tiffany glass came to the attention of European collectors and students in 1895 when it was retailed by Samuel Bing (q.v.) in his Parisian shop, *La Maison de l'Art Nouveau*. Iridescent glass spread thence to Bohemia where it was enthusiastically taken up by Lötz (q.v.) of Klostermühle. Austrian iridescent glass is often regarded as but a pale imitation of Tiffany, but it is important to emphasize that this type of glass was being made in Austria, by Lobmeyr (q.v.), long before it came to America and it was from Lobmeyr that Tiffany himself acquired the techniques which he subsequently perfected. Although the Tiffany range of glassware was wider and, in many instances, of a higher quality, the Austrian wares should not be lightly regarded. Although it cannot be denied that Lötz copied Tiffany, many of the individual pieces from the Bohemian glassworks were outstanding in both quality and originality. Excellent lustre glassware was also produced by Graf von Harrach, Bakalowits and Ludwig Moser and Sons (qq.v.). Few pieces of Austrian glass, however, were marked and, as a result, there is still great confusion over the exact attribution of many items. A few pieces are

131

Pair of cut-glass and silver claret jugs by Saunders & Shepherd, Birmingham, 1892.

of Josef Emil Schneckendorf. The most elegant German glass in the Art Nouveau style was designed by Karl Köpping and Friedrich Zitzmann (qq.v.) and blown at the lamp. Peter Behrens (q.v.) designed glass which was subsequently manufactured by the Köln-Ehrenfelder Glashütte. Iridescent glass spread from Austria and Germany to Sweden at the turn of the century and some fine glass in this *genre* was made by the firms of Kosta and Reijmyre.

marked 'Loetz Austria' and it is thought that these wares, inscribed in English, were intended for the export market. Indeed it has been stated that Tiffany insisted on this marking to prevent Austrian lustre glass being confused with his own products. Excellent lustred glass was also manufactured by Adolf Zasche of Gablonz and Josef Palme König (qq.v.). Under the influence of the *Sezession* (q.v.), Austrian glassmaking

English glass flower stand, *c.* 1895.

Pressed glass bowl, 1888.

developed along new lines from 1897 onwards. Both Josef Hoffman (q.v.) and Gustav Schneider produced glass in the Art Nouveau style. After 1910, Hoffman designed his distinctive *Bronzitgläser* for Lobmeyr. Iridescent glass was also produced at the Grand-ducal Glassworks in Darmstadt from 1907 to 1911, under the direction

After 1900, iridescent glass gradually went out of favour. Flowing plant forms in decoration were superseded by straight lines and geometric patterns, with an emphasis on contour. The luxurious glittering surfaces of iridescent glass were replaced by the stark simplicity of black line on opalescent white. Emphasis was laid

on the purity of form, in which enamelling, acid-etching and faceting became more important. In Britain, the reaction against the fancy glass of the late nineteenth century was less marked, though an important development of the 1890s was clutha glass (q.v.), characterized by its delicate shades of green, blue or brown, with a streaky, bubbly effect which was ideally suited to simple, primitive shapes.

The struggle between hand-made and machine-made glass was unequal. After 1900, the mechanization of glass-making increased rapidly and this led to radical re-thinking in design and materials. Significantly this problem was faced resolutely by the *Deutscher Werkbund* when it was founded in 1907, and thereafter its members preached insistently against the decoration of useful objects, concentrating on the form and quality of the material instead, and anticipating the functionalism (q.v.) of the 1920s and 1930s.

Gorham Manufacturing Company

Hardware company founded by Jabez Gorham in Providence, Rhode Island in 1831. Under the management of his son John, the firm was expanded and modernized, and its output diversified into the applied and decorative arts. In the late 1870s, branches were opened in the principal cities of the United States. In 1887, William Holbrook became president of the company and brought over from England William J. Codman who subsequently designed much of the fine silverware and electroplate (q.v.) for which Gorham was renowned at the turn of the century. Between 1876 and 1915, Codman was largely responsible for the numerous awards made to Gorham in international exhibitions. Codman also devised Gorham's own distinctive contribution to Art Nouveau, the type of hammered silverware known as Martelé (q.v.).

Silver cigar box with Spanish cedar lining, by Gorham, *c.* 1900. (Mr & Mrs Victor H. Bacon II)

Grasset, Eugène

French painter, sculptor, poster-artist and in-
dustrial-designer, born at Lausanne in 1841
and died at Sceaux in 1917. Grasset originally
studied architecture in Switzerland but subse-
quently travelled in Egypt and the Near East
and settled in Paris after the Franco-Prussian
War, becoming a naturalized Frenchman in
1891. Grasset was exceedingly versatile and also
highly distinctive in his style. He designed
furniture for the *Chat Noir,* worked in stained
glass and was a prolific book-designer and
illustrator. Throughout his work, two qualities
predominate: a strong feeling for the medieval
and a keen sense of the dramatic. Many of his
posters have pronounced outlines, as though
they were designed for interpretation in stained
glass. Indeed, a design for the Grafton Gallery
in London, showing a girl in fifteenth century
costume, was subsequently rendered in stained
glass. With Mucha (q.v.), Grasset designed

Undated design by Eugène Grasset: *L'Etude.*

Cover designed by Eugène Grasset for *Dix Contes* by
Jules Lemaitre, 1894.

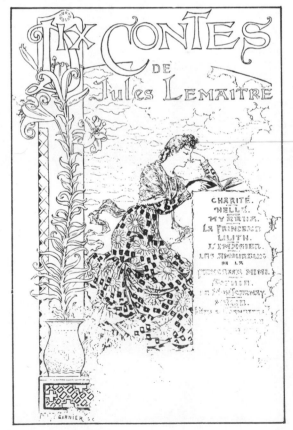

posters for Sarah Bernhardt, but sometimes his
designs were too flamboyant for this *artiste,* not
exactly noted for her reticence or restraint in
such matters. His poster showing her in the
role of Jeanne d'Arc was subsequently modified
for use as a postage stamp design. Originally
intended for France itself, this design was used
instead for Indochina in 1904–6. Grasset's
women are stately, haughty creatures, unlike
the more carefree beauties conjured up by
Jules Cheret (q.v.). Grasset also designed some
outstanding jewellery in the Art Nouveau idiom
at the turn of the century.

As a graphic artist his influence spread across
the Atlantic. Indeed, the modern American
poster may be said to have been born in December
1889 when the Christmas number of *Harper's
Bazaar* carried a cover designed by Grasset.
Prior to that date, American posters had little
or no artistic merit and were overburdened
with literal details and haphazard typography.
Grasset also designed the cover for the Christmas
1892 issue of *Harper's Bazaar* and set the trend
for American magazine covers of the ensuing
decade. *Lippincott's, The Century Illustrated*

Magazine and *Scribner's Magazine* followed the lead of *Harper's Bazaar* and gave employment to a new generation of American graphic artists following the Grasset tradition.
See *Posters*

Greenaway, Kate

English artist and book illustrator, born in London in 1846. She began to exhibit her drawings in 1868 and became established as an outstanding children's artist five years later with her illustrations for *Little Folks*. In 1877 she began drawing for the *Illustrated London News* and two years later produced the best-selling *Under the Window*. Subsequently she produced *The Birthday Book, Mother Goose, Little Ann* and other 'toy books' which are now very highly regarded by collectors. Her impact on book-illustration was tremendous and her illustrations were highly praised by John Ruskin in *Art of England* and *Fors Clavigera*, and hailed

Children's book illustration by Kate Greenaway, *c.* 1890.

Here am I, little jumping Joan,
When nobody's with me,
I'm always alone.

Candlestick designed by Kate Greenaway for Royal Worcester Porcelain Co.

by such international critics as Arsène Alexandre in France and Dr. Muther in Germany. In 1890, she was elected a member of the Royal Institute of Painters in Water Colours and, from then onwards, she exhibited her drawings regularly at the gallery of the Fine Art Society. The quaint costume in which her characters were clothed (derived from early nineteenth century styles) was quite distinctive and lent humour to her fancy. The Greenaway style of illustration was imitated by others, notably Georgina Koberwein-Terrell and Albert Ludovici. Miss Greenaway designed Christmas and greetings cards (q.v.) for Marcus Ward and Raphel Tuck. From 1883 to 1897, she published a series of *Kate Greenaway's Almanacs* which now rank among the most prized of children's books. Kate Greenaway died at Hampstead in November 1901.

Greene, Charles and Henry

American architects and furniture designers, trained at the Massachusetts Institute of Technology School of Architecture, from which they graduated in 1892. About a year later, they

moved to Pasadena, California and there began designing houses, interiors and furniture, often strongly eclectic and deriving inspiration from *Japonaiserie* (q.v.) and the Franciscan missions. By 1900, they had evolved the distinctive California bungalow style of house, playing up the qualities of natural materials and integrating the houses into the surrounding landscape. This insistence on the use of natural materials and straight-forward construction was a hall-mark of Greene Brothers furniture, which was light and graceful by comparison with the Beaux Arts (q.v.) products of the period. Square ebony pegs covering brass screw fastenings were a peculiarity of Greene furniture. All the furniture designed by the Greenes was made for them by Peter Hall, whose work so pleased them that they established him in business. The Greenes collaborated with Tiffany (q.v.) and often incorporated lamps (q.v.) and glass-ware by that company in their furniture and interior decor. The finest example of their work is the Gamble House (1907–8) in Pasadena, now preserved and maintained by the University of Southern California as a museum.

Grueby Faience

Distinctive American art pottery with a matt finish, manufactured by the Grueby Faience and Tile Company at East Boston between 1897 and 1910. The firm was founded by William H. Grueby for the commercial manufacture of tiles (q.v.) and hollow ware using a matt glaze which the French ceramicist Delaherche (q.v.) had exhibited at the Columbian Exposition in 1893. Grueby developed and perfected this matt glaze (an opaque enamel) in shades of green and tan, winning prizes in America and Europe. Grueby's glazes attracted a great deal of interest and, by 1900, they were extensively imitated, especially in the United States. Apart from the matt finish, Grueby faience owed much to Egyptian forms and heavy plant motifs in low relief. Apart from the famous Grueby green and tan glazes, other colours, such as yellow, blue or purple, may be encountered. The company made many of the bases used for Tiffany lamps (q.v.). All pots were hand-thrown and signed by the individual artist but not all items were permanently marked with the Grueby trade-mark, since a paper label was often used. The situation is complicated further by the inferior

Tile by the Grueby Faience Co., *c.* 1906.

copies of Grueby faience which flooded the market about 1910 and forced Grueby to discontinue art pottery. The company continued to produce architectural tiles until a fire destroyed the factory in 1912.
See *Faience*

Guimard, Hector

French architect and furniture designer (1867–1942). Guimard studied at the *Ecole des Arts Décoratifs* and the *Ecole des Beaux Arts* and held a professorship at the former between 1894 and 1898. He was strongly influenced by Horta (q.v.) in the use of plant forms as inspiration. His best-known work consisted of the Art Nouveau entrances to the stations of the Paris Metro (1899–1904) and the sumptuous exteriors of the Castel Beranger (1897–8). The wrought ironwork of the Metro and the terracotta panelling of the Castel Beranger have a sculptural quality derived from plants, insects and marine life. Guimard comes closest to the writhing extravagances of Endell and Gaudi (qq.v.). In furniture design, Guimard followed a highly individualistic course, having little practical contact with his contemporary designers. He liked to style himself as *architecte d'art*, a creator of an environment rather than an interior designer. He regarded furniture and the fittings of a house (down to the minutest detail) as part

of a sculptural unit—hence the unusual shapes of so much of his furniture.

In an age when the *avant-garde* was commonplace, Guimard was often ahead of his contemporaries and his work was usually controversial. The *Studio Year Book* (1908) typified the public lack of understanding: 'the fancy, the *imprévu* and the superabundant imagination of M. Hector Guimard caused him to oscillate almost simultaneously between fascinating success and disconcerting error'. Gustave Soulier, writing in 1899, was more perceptive: 'he is inspired by the underlying movements, by the creative process in nature that reveals to us identical formulae through its numerous manifestations and he assimilates these principles in the formation of his ornamental contours . . . this, the *floret* is not an exact representation of any particular flower. Here is an art that both abbreviates and amplifies the immediate facts of nature; it spiritualizes them. We are present at the birth of the quintessence of a flower.' His earliest furniture was constructed in the hard, unyielding mahogany, with members sweeping freely and self-consciously in space in somewhat mannered, asymmetrical patterns. In the second phase (1900–1910), however, he relied heavily on pearwood which lent itself readily to bending and shaping. Asymmetry

was restrained and refined; Guimard had brought his 'superabundant imagination' under control and the result was some of the finest French furniture in the Art Nouveau style. Guimard deserves to be better known as a brilliant innovator, resolving fundamental problems of non-figurative abstraction a decade before that idea entered the mainstream of modern art.
See *Furniture*

Gyokuzan, Asahi

Japanese artist and craftsman (1841–1923). Gyokuzan was one of the two greatest carvers working in bone and ivory at the turn of the century, Komei (q.v.) being the other. The westernization of Japanese dress from 1870 onwards destroyed the traditional market for *netsuke* (the intricately carved 'toggles' used to secure Japanese clothing) and Gyokuzan subsequently turned to *okimono* (literally 'place things'), small figures intended as household ornaments, which he produced in ivory, bone and wood in the early years of this century. Although the traditional necessity for *netsuke* declined after 1870, the developing market for Japanese artefacts in Europe and America in the 1880s and 1890s gave the art of Gyokuzan a new slant.

Hadley Ware

Decorative porcelain ware with coloured clay embellishments and painted with floral compositions, the speciality of a small independent pottery in Worcester, England in the 1890s. James Hadley (1837–1903) originally worked for the Royal Worcester Porcelain Company (q.v.) but became an independent modeller and decorator in 1875. Over the ensuing nineteen years, the Worcester Company absorbed all his output, but he established a separate pottery in 1894 and, with the aid of his three sons, began producing decorative porcelain in 1896. James Hadley died in December 1903 and the business was taken over by Worcester in July 1905, though distinctive Hadley ware continued to be produced under the supervision of Louis Hadley for many years. Many of the floral designs found on Hadley ware were painted in monochrome, but were always of a very high quality. Much of the Hadley ware consisted of high-class earthenware decorated with transparent glazes. See *Worcester*

Hansen, Frida

Norwegian textile designer, born at Stavanger in 1855. With the landscape painter, Gerhard Munthe (q.v.), Miss Hansen was responsible for introducing the pictorial wall-hanging to Scandinavia. Although she derived her style of weaving from old Norwegian motifs, she was

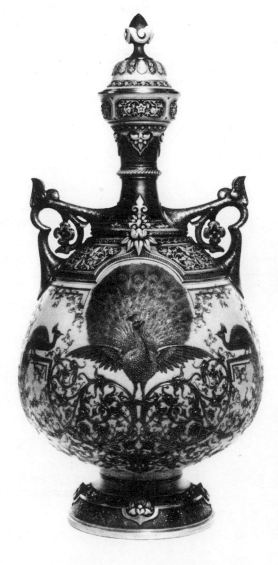

Peacock urn and cover by Hadley of Worcester.

138

influenced by the prevailing fashion for *Japon-aiserie* (q.v.) and also owed a great deal to the work of the Macdonald sisters (q.v.). Her work first came to the notice of the public in 1890 when her wall-hangings were displayed in an exhibition of furniture and household fittings in Christiania (Oslo). Three years later, she won international acclaim when her work was shown at the Columbian Exposition (q.v.). The prizes which came her way enabled her to study textile-design in Paris and Cologne in 1894–5. In 1900, she was elected a member of the *Société Nationale des Beaux Arts* and, in the same year, she exhibited tapestry at the *Exposition Universelle* (q.v.). Her best-known design was entitled 'Milky Way' and was shown at the Paris Exposition. The Pre-Raphaelite figures with their dark, flowing hair, the curving, writhing plant forms, the ethereal quality of the background and the fluid lettering of the Biblical text which adorned the margins—all were in the best tradition of Art Nouveau. Frida Hansen perfected the technique known as 'transparent weaving', which gave her figures a light, almost ghostly character.
See *Carpets and Tapestry*

Harrach, Graf von

Bohemian glass manufacturer in Neuwelt who flourished at the end of the nineteenth century. Little seems to be known of this company now, although its glassware was greatly esteemed in the years immediately before the First World War. It is best known for its excellent imitation of Tiffany (q.v.) non-iridescent glass, particularly the distinctive tall glasses with combed lines and alternating bands of transparent and opaque glass. Graf von Harrach also produced ruby-glass

Pewter cake tray, possibly designed by A. Knox and made by W. Haseler for Liberty, 1905.

vases with flowing floral ornament in polychrome matt enamel, and opaque milk-glass with a blue overlay into which the ornament was etched. His cameo glass (q.v.) is unusual, bears his signature, and is highly prized by collectors.

Haseler, W. H.

Silversmiths founded in 1870 by William Hair Haseler in Birmingham, in operation until 1927. The firm was directed from 1896 onwards by the founder's sons, William Rabone Haseler and Frank Haseler. The bulk of the company's output was retailed through Liberty's (q.v.) for whom they manufactured jewellery and the distinctive metalwares known as 'Cymric' (silver) and 'Tudric' (pewter) from 1901 onwards.

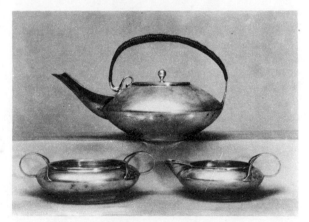

Silver tea pot by W. H. Haseler, 1904.

Hatpins

The elaborate hair-dos which were fashionable in the closing years of the nineteenth century, and the enormous hats which went with them, brought about a revival in the hatpin. Japanese originals inspired many of the large pins of the 1880s and early 1890s but, by the end of the century, Art Nouveau had taken over this medium also. The pins themselves were relatively free of ornament, though some attractive spiral decoration was often applied to the shaft. The head of the hatpin, however, afforded tremendous scope for decoration and all the techniques of glass-paste, enamelling and silverwork were applied to it. From the turn of the century down to the opening of the First World War, novelty hatpins were in vogue, their heads

139

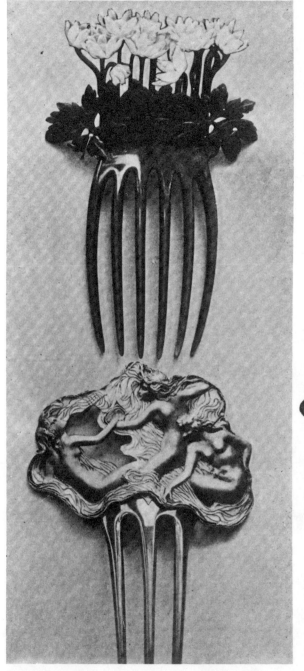
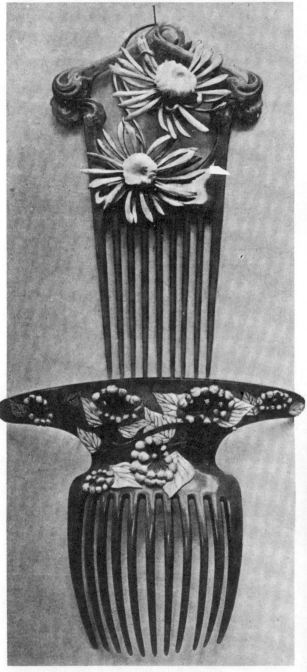

Hair ornaments and combs from *Les Modes,* 1901.

consisting of animals, musical instruments, butterflies and bees, four-leaved clovers, horseshoes and other good-luck symbols. These trinkets were produced for the mass-market and were composed of basically cheap materials. Long overlooked by serious collectors, they are still reasonably plentiful and a varied collection can be assembled for a modest outlay. At the other end of the scale, however, are the jewelled hatpins of Fabergé (q.v.) or the Art Nouveau craftsmen, such as Lalique (q.v.), and these have long been in demand.

140

Heal, Sir Ambrose

English furniture designer (1872–1959) and disciple of William Morris (q.v.). Heal was reared in the Arts and Crafts Movement (q.v.) and offered a retail outlet for its products through his famous department store in Tottenham Court Road, London. Heal was greatly influenced by the work of the Barnsley Brothers and Ernest Gimson (qq.v.) at Sapperton, and from this resulted the good quality, simply constructed oak furniture which Heal's manufactured for the mass-market at the turn of the century. Heal is also remembered, however, for his impressive virtuoso pieces, made in connection with various international exhibitions at which Heal's displayed their wares. Some of the finest cabinet-making in England this century, both hand- and machine-made, has been pro-

Mahogany bookcase inlaid with cherry, pearwood and mother of pearl. Designed by Sir Ambrose Heal, c. 1905.

Painted deal dressing-table by Heal & Sons, early 20th century.

duced by Heal's, a firm which is still in the forefront of quality and good taste.

Heine, Thomas Theodor

German painter, graphic artist and designer, born at Leipzig in 1867. Between 1883 and 1887, Heine studied at the art academy in Düsseldorf, moving to Munich in 1889. He turned to book- and magazine-illustration in that year, and collaborated with the periodical *Fliegende Blätter* and subsequently contributed cartoons, illustrations and covers to *Jugend* (q.v.) and *Simplicissimus*. In the 1920s, he became the acknowledged master of the art of the satirical drawing and was forced to flee from Germany in 1933 when the Nazis came to power. He later worked in Prague, moved to Oslo in 1938 and from there to Stockholm in 1942. He retired in 1944 and died four years later. Though best known for his cartoons, Heine was a prolific poster artist and also did various designs for the applied arts.

Herkomer, Sir Hubert von

Anglo-German painter, designer and enamellist, born at Waal in Bavaria in 1849 and died at Budleigh Salterton, Devon in 1914. As a boy, he was brought to England by his father, a wood-carver of considerable ability. He spent the early years of his life in Southampton where he began his art training. In 1866, he enrolled at the South Kensington School of Art and, three years later, exhibited his first work at the Royal Academy. His painting *The Last Muster,* exhibited in 1875, established him as an artist of the first rank. He was elected A.R.A. in 1879 and R.A. in 1890, an associate of the Royal Society of Painters in Water Colours in 1893 and a full member a year later. In 1885, he was appointed Slade professor of art at Oxford University. Herkomer was a versatile craftsman, an accomplished draughtsman, etcher and mezzotint engraver, and also took the lead, with Alexander Fisher in reviving the art of enamelling in Britain. In 1883, he founded the Herkomer School at Bushey and directed it on a voluntary basis until his retirement in 1904. Through his school and his writings, he exerted a great influence on the development of the decorative arts in general, but it is in jewellery and enamelling that he particularly made his mark. In 1907, he received the honorary degree of D.C.L. at Oxford and a knighthood for his services to the fine arts.

Hobbs, Brockunier Glass

Glassworks at Wheeling, West Virginia, renowned the world over for its fine quality,

Pressed glass butter dish, 'Spanish lace' vase, 'Hobnail' vase, by Hobbs-Brockunier & Co., Wheeling, *c.* 1890. (Corning Museum of Glass)

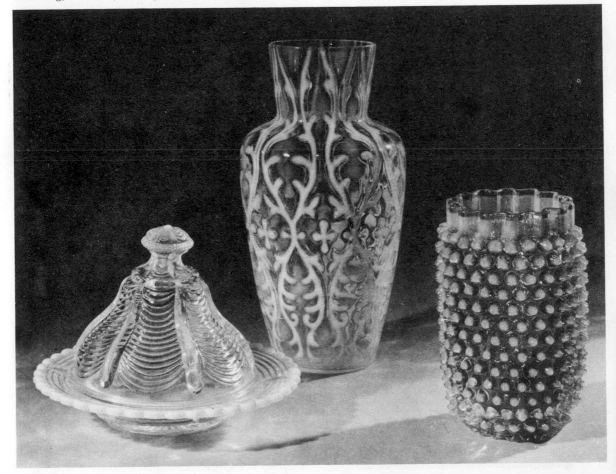

142

Necklace of opals, gold and enamel designed by L. C. Tiffany, early 20th century. (Metropolitan Museum of Art, N.Y.)

Lacquer, *Shibayama* and silver garniture by
Masayoshi; Japanese, late 19th century.

pressed-glass tableware produced in the latter half of the nineteenth century. Hobbs, Brockunier and Company established themselves as leaders of the art glass movement in the late 1880s and 1890s, with their so-called 'Wheeling Peachblow' glass. The name was a corruption of 'Peachbloom', the description given to a rare Chinese porcelain vase which fetched the record price of $18,000 when the collection of Mrs Mary Morgan was sold in March 1886. The porcelain vase caught the public interest because of its elegant shape and delicate gradation of colours. Hobbs, Brockunier were the first company to capitalize on the public demand for vases in these attractive colours. They soon produced a coloured glass similar to the glaze of the Morgan vase, with either a matt or a glossy finish. The 'Peachblow' was graded from red to yellow and the colours were applied in a transparent layer on an opaque white ground. Although the best-known Hobbs, Brockunier products were replicas of the Morgan vase, they quickly extended this technique to other wares. The English firms of Thomas Webb & Sons (q.v.) and Stevens & Williams also produced layered variations of 'Peachblow' glass, but these are comparatively rare. Both the Mount Washington and New England (qq.v.) glass companies produced a single-layered glass under the same name, but their versions are easily distinguished by the colours used.

Hoffmann, Josef

Austrian architect, graphic artist and designer, born at Pirnitz near Iglau, Austria in 1870. Hoffmann studied under Hasenauer and Otto Wagner (q.v.) at the Vienna Academy, where he was awarded the Rome Prize in 1895 for his design for a Neo-classical forum. He spent a year studying architecture in Italy before returning to Vienna in 1896. He subsequently found employment in Wagner's drawing office, where one of his colleagues was Joseph Maria Olbrich (q.v.). At Olbrich's instigation, Hoffmann joined the recently-formed Association of Austrian Visual Artists in July 1897. His resignation from the older Society of Visual Artists was followed by that of five other artists, and this was the beginning of what was known as the *Sezession* (q.v.). Thereafter Hoffmann took a leading part in the arts and crafts organizations in Austria and, in 1899, was appointed head of

Austrian chair in beech and red leather by Joseph Hoffmann, *c.* 1905.

the architectural department of the Vienna School of Applied Arts. Hoffmann took a prominent part in all the exhibitions of the *Sezession*, the zenith being attained in the 1902 exhibition, in which Hoffmann's many-sided role as furniture, metalwork, glass, leather, jewellery and textile designer was allowed full rein. Hoffmann at this time came under the influence of Charles Rennie Mackintosh (q.v.) and something of the Glasgow Style (q.v.) can be discerned in his work. Following the model of Ashbee's Century Guild and with the advice of Mackintosh, the *Wiener Werkstätte* (q.v.) was

145

founded by Hoffmann in June 1903, with the aim of applying artistic design to the widest possible range of objects. Among the earliest designs produced by Hoffmann for the *Werkstätte* were bold cubist designs for furniture and hollow ware, of a type never encountered again until the mid-1920s. About 1905, Hoffmann was producing highly distinctive furniture in oak; white colouring was rubbed into the grain of the black-stained and waxed timber, the recessed handles were of white metal and the black cowhide upholstery was self-supporting. After 1910, Hoffmann's furniture-designs became more elegant and utilized more expensive materials, such as mother-of-pearl inlays, and panelling of ebony and boxwood. Architecturally, Hoffmann designed the Purkersdorf Sanatorium (1903) and the Villa Stoclet in Brussels (1905–11). The latter building was constructed in a black and white scheme, characteristic of Hoffmann. This combination of black line on a white ground may also be discerned in the ceramics, glassware and jewellery which he designed. In 1912, Hoffmann founded the Austrian *Werkbund*. He was an honorary member of the Berlin Academy and received many academic honours from institutions in Austria, Germany and other Central European countries. Hoffmann died in 1955 and, throughout his long career, he exercised an enormous influence on the development of the applied arts in Europe.

Horta, Victor

Belgian architect and designer, born at Ghent in 1861. Horta received a conventional training in architecture under the rigid classicist Balat but, from 1892 onwards, he turned his back resolutely on historicism and developed a highly individualistic style which hit the public with dramatic impact in the Maison Tassel in Brussels, completed in 1893. Two striking features of this building were the open-plan arrangement of the interior, in which the rooms and passages merged imperceptibly into each other, and the relentless exposure of the structural elements without the usual dressing of facing brick, stone or plaster. The metalwork of the interior—balustrades, pillars, window-frames—was a tangle of writhing curves. As Horta himself stated in 1895, 'I abandoned the flower and leaf and turned instead to the stalk'. There is thus less evidence in Horta's designs of the plant motifs

which were the hallmark of Art Nouveau interiors elsewhere, though he abhorred the straight line just as much as his contemporaries. The Maison Tassel was a complete break with the previous Neo-classical designs which he had produced in Ghent and Brussels, but it was only the prelude to a much large and more ambitious work in the same *genre,* the Hotel Solvay in Brussels which he designed and constructed between 1894 and 1900. Horta was given *carte blanche* in the design of this house and he produced a series of elaborately decorated rooms, using the most expensive materials: exotic woods from Africa, semi-precious stones, crocodile skins and Oriental silks juxtaposed with the austere bare brickwork and curvilinear ironwork. Horta designed the furniture, upholstery, carpets, wall-hangings, chandeliers and such mundane items as light-switches, air vents, doorhandles and the central heating radiators. The house which he designed for himself at 25 rue Americaine (now the *Musée Horta*) in 1898 represents the high-water mark of his design; here his fantasies and experimental ideas were indulged to the full. Other remarkable examples of Horta's style were the Hotel van Eetvelde (1895–8), the Grand Bazaar Anspach (1895–6) and the Maison du Peuple (1896–9), the last-named being demolished, in face of world-wide protests, in 1965–6.

Impressive facades with continuous serpentine curves, exposed structural elements, interior arches and 'whiplash' ironwork everywhere, were the hallmarks of Horta, following his belief that ornament was an essential part of architecture. His furniture was designed as an integral part of his larger architectural works and, for this reason, it often looks strange and incongruous on its own. The unity of spirit between architecture and furniture is seen in the simple curves representing the stalks of plants. He believed strongly that the form of the building should determine the form of the furniture and this implied that each part should fit properly and harmoniously into the whole. Like Guimard (q.v.), he prepared clay models of his furniture, for interpretation by cabinet-makers. His meticulous handling of space is seen in even the smallest detail of his furniture. The rhythm of curve and counter-curve, seen at its best in the rounded angles, is emphasized by a restrained and subtle use of moulding. He was adept in the use of exotic woods imported from the Congo, in harmony with indigenous European timbers,

and in creating a harmony of mass, colour and graining in frames and panelling, allowing the tone and quality of the wood to play their decorative part. After 1913, Horta's influence on the development of Belgian industrial design increased, following his appointment as head of the Brussels Academy, though his personal contribution to the applied arts belongs to the period from 1892 to 1912. He died in 1947.

Hubbard, Elbert

American furniture designer and manufacturer (1856–1915). Hubbard was inspired by the example of William Morris (q.v.) to found the Roycroft Shops in East Aurora, New York, to market hand-made items by a group of artist-craftsmen who came to be known as the Roycrofters (q.v.). Hubbard is best-known for his simple, well-made oak tables, benches, chairs and bookcases in the Mission (q.v.) style, but he also published books and periodicals devoted to the arts and crafts which had a wide

Lamp designed by Dard Hunter for the Roycroft Shops, c. 1903. (Mr & Mrs George ScheideMantel)

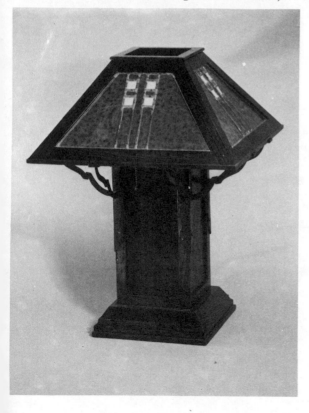

influence on America at the turn of the century. Hubbard produced pottery, including busts of William Morris, Walt Whitman and (with a fine conceit) himself. With Gustav Stickley (q.v.), Hubbard spread the gospel of honesty and simplicity in furniture design, a timely counter to the pretentiousness of the Beaux Arts school (q.v.). Hubbard was motivated by the same ideals as Morris, rejecting the use of machines and trying to apply democratic ideals to the arts and crafts.

Huber, Patriz

German architect and designer of furniture and jewellery, born at Stuttgart in 1878. Huber received his formal training at the art schools in Mainz and Munich, but came under the influence of Baillie Scott, Olbrich and Van de Velde (qq.v.). With his brother Anton, he evolved the 'skeletal' style of interior decoration, in which pillars, beams, door- and window-frames and ribbing were used for decorative effect. He came to prominence in 1898 when some of his designs were published in the Darmstadt periodical, *Innendekoration*. The Huber brothers joined the Darmstadt artists' colony in 1900, but the promising career of Patriz was cut short by his suicide in 1902. His best and most original work as a designer of furniture and jewellery was achieved during the closing years of the nineteenth century when he worked in Berlin. His furniture, distinguished by its lightness and elegance, owed nothing to historicism and its dynamic, linear and spacious qualities echo the designs of Riemerschmid in Munich and Serrurier-Bovy in Belgium (qq.v.). With F. Morawe, F. H. Werner and Hermann Hirzel, he evolved the Berlin style of *Jugendstil* (q.v.) jewellery which enjoyed a brief vogue at the turn of the century.

Hutton Silver

The Birmingham silversmiths company of William Hutton and Sons was founded in 1800 by William Hutton (1774–1842). William Hutton pioneered the manufacture in England of German silver or nickel-silver. His sons expanded the electroplate (q.v.) side of the business in the mid-nineteenth century, while two grandsons, James Edward and Herbert Hutton, managed the

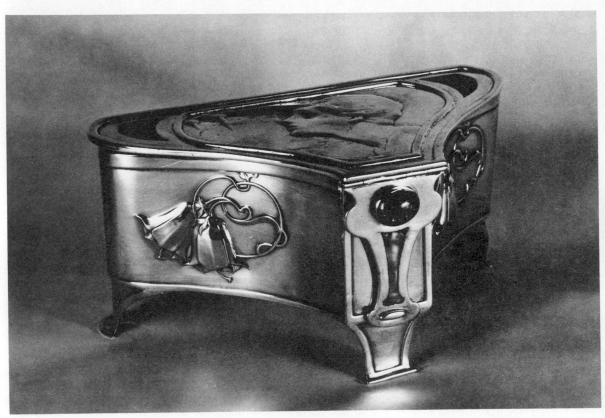

Silver and mother of pearl casket by William Hutton & Sons, 1902.

business at the end of the century. In the late 1890s, Huttons became one of the most prominent producers of silver and electroplate in the Art Nouveau style, supplying Liberty's (q.v.) with both flatware (cutlery) and hollow ware. The firm employed about a thousand in the first decade of this century, but went out of business in 1930.

Industrial Archaeology

In the broadest sense, this subject embraces all manner of gadgetry and machines, far beyond the original and strict meaning of equipment connected with industry. The epithet 'industrial' has been given to distinguish this branch of collecting from the study of the relics of long-vanished civilizations. The earliest, and most obvious, form of industrial archaeology was concerned with the remains of old railroads,

canals and other ancient transport systems, old mine-workings and factories and the implements and equipment associated with them. In recent years, however, the term has been considerably widened and now includes almost anything mechanical which has been rendered obsolete by changing fashions or advancing technology. The period from about 1890 to the First World War is a particularly fertile one; it was the heyday of the steam age and the infancy of electricity, the era which witnessed the birth

English model steam engine, *c*. 1900.

of the internal combustion engine, the heavier-than-air flying machine, motion pictures and radio-telephony; all of which have provided an abundance of artefacts for the collector.

In the home, the earliest self-standing stoves and cookers were beginning to replace the built-in coal- or coke-burning ranges. The earliest vacuum cleaners date from this period, the suction being provided by a hand-rotated wheel, but, by 1910, electric sweepers and vacuum cleaners were coming on to the market. Freezers and ice-boxes were also making their appearance, mainly in America, and the earliest varieties were surprisingly decorative in appearance. Sewing machines of a kind had been in existence since the 1830s, but mass-production techniques enabled Singer to revolutionize the world market at the end of the nineteenth century, and many of the original hand-operated or foot-treadle machines are still doing yeoman service.

In the office, mechanization made rapid progress at the turn of the century. Although typewriters were patented in the 1870s, they never became popular until 1890. Early Remington, Barlock, Imperial, Oliver and Blick machines,

Early vacuum cleaner.

The Latest and Greatest Improvement of the Writing Machine is the NEW ESCAPEMENT

of the

Remington Typewriter

It sets a new standard for LIGHTNESS OF TOUCH, SWIFTNESS OF ACTION and PERMANENT EXCELLENCE OF WORK.

The NEW REMINGTON MODELS also have a New Variable Line Spacer, New Side Guide, New Two Color Lever and other important improvements.

Remington Typewriter Company
325-327 Broadway, New York Branches Everywhere

Advertisement for Remington typewriters, *c*. 1900.

to name but a few, are now in great demand and exhibit an astonishing range, not only in decorative appearance but also in the way they functioned: the golf-ball type-head, rotating drum of characters, or keys mounted in banks on either side of the platen were three notable variants popular in the 1890s before the present system became standard. Telephones gained rapidly in popularity between 1890 and 1910 and the enormous technical developments of this period were matched by the wide variety of different styles of instrument to be found at that time. Elegant table models, for the home, were richley japanned and gilded in the prevailing Art Nouveau curvilinear motifs.

T. A. Edison and J. W. Swan invented electric lamps independently, in 1878 and 1880 respectively. These were followed by the osmium lamp (1898), the tantalum lamp (1903) and the tungsten filament lamp (1904), all of which may be found in many different forms. Electric cigar lighters were patented in 1890 and electric radiators by 1900. Electric fans became popular

in the same decade and there are many different types available. Gramophones (phonographs) with cylindrical or disc records are not uncommon from this period. A great deal of attention was paid to the cabinet-work, while the horn, pick-up head and handle were subject to lavish decorative treatment. Electric gramophones of this period are exceedingly rare. Photography is a wide field for the collector, with many developments in cameras, enlargers and other equipment dating from the end of the nineteenth century. Motion pictures made enormous strides in these two decades, but cinematographic equipment of this period has long been in demand and consequently such items are relatively expensive nowadays.

Edison phonograph, c. 1906.

Cash registers, scales and balances, weighing machines, pneumatic cash dispensers, office intercommunications equipment and other gadgets used in commerce are some of the categories of industrial archaeology worth investigating. Postal equipment is a subject which is now attracting the attention of philatelists and postal historians. Early examples of cancelling machines, such as Hey-Dolphin, Bickerdike and Columbia are scarce, but the hand-operated Krag machines (some of which are still in use) are more plentiful. Meter franking originated in Norway and New Zealand in 1904, and spread rapidly throughout Europe and America in the ensuing decade, and early examples of the machines by Pitney-Bowes and Universal Postal Frankers are worth looking out for.

See *Bygones, Railroad Relics*

Inkstands and Inkwells

Prior to the mid-nineteenth century, ink was sold in cakes, broken up and dissolved in water when required. Subsequently ink in a permanent liquid form was evolved from a solution of tannin and ferrous sulphate, and this change in fashion gave rise to a whole host of collectable objects, most of which attained their zenith at the end of the century. The earliest ink bottles were made of earthenware and, complete with the original manufacturer's label, are often quite decorative. Later bottles were made of pressed glass and fancy shapes and decorative surfaces were popular at the turn of the century. Highly ornate inkpots and wells were fashionable in the 1890s, often as part of writing sets (q.v.) or desk furniture, complete with pen-trays and blotters. Many different types of inkwell may be found, with stoppers of cut or engraved glass, or with tight-fitting lids in enamelled or gilded metal.

Inkstands, combining one or more inkwells, stamp moistener, stamp box, pin cup, and compartments for pens and pencils, are still quite plentiful and afford tremendous scope to the collector. Oriental inkstands, with exotic woods and ivory inlay, were imported to Britain and Europe from India and the Middle East. Copper, brass, silver and japanned metal were also popular materials. Relatively plain glass was favoured, but examples may be found with elaborate cutting and art glass enjoyed a brief vogue in the 1890s for this purpose. The most

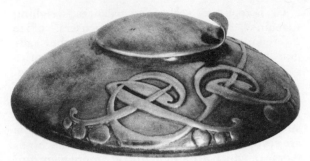

Pewter inkstand of 1904, probably designed by Knox and made by Haseler for Libertys.

elaborate and costly of inkstands were those made of lapis lazuli, malachite or other semi-precious stones, with silver or gold mounts. These were a speciality of Fabergé (q.v.) and other Russian jewellers and silversmiths. Fine porcelain inkstands were produced in France and Germany in the late nineteenth century, but examples are scarce. Novelty inkstands, made out of skulls, animal horns and horses' hooves mounted in silver may sometimes be encountered. This was also a period of patent devices and gadgets to prevent evaporation or spillage. Other inkstands incorporated tiny clocks or some form of automata and these are highly prized nowadays.

Itcho, Kawanabe

Japanese metalworker (1830–1910). Itcho belonged to the Koani School of craftsmen, working in traditional styles. Itcho was particularly noted for his sensitively designed lacquerware, which he continued to produce down to the end of the nineteenth century.

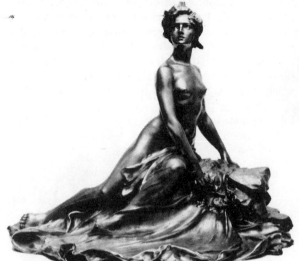

Gilt-bronze inkwell by Raoul Larche, Paris, c. 1900.

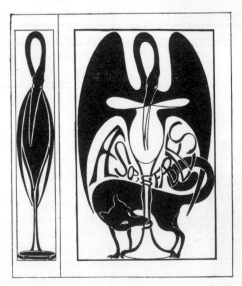

Jaccard

Jewellery and silverware company founded in 1829 in St Louis, Missouri by Louis Jaccard, a French-Swiss immigrant. The famous retail department store, Jaccard's, in Kansas City, was founded by the company in 1888 but has long ceased to be connected with the original manufacturing firm which was dissolved in 1917. At the turn of the century, Jaccard's specialized in gold and silver presentation pieces (q.v.) and trophies, as well as high-class jewellery, mainly in traditional styles.

Jack, George

English furniture designer and architect (1855–1932). Jack was a pupil and close colleague of Philip Webb (q.v.). As Webb's assistant, Jack provided many of the rich effects which contrast with the essential gauntness of Webb's work. He experimented with materials other than wood in the production of furniture, especially wrought-iron, ivory and silver inlays and lacquered gesso. He deviated, however, from the solid, honest-to-goodness joinery which Webb favoured and, towards the end of the nineteenth century, designed furniture which was both costly to produce and lavish in its overall effect. This coincided with the general trend in English furniture design, away from the austere, simple joinery originally advocated by the Arts and Crafts Movement (q.v.). Ironically it was the

Escritoire and stand with marquetry of sycamore, designed by George Jack for Morris & Co., 1893.

aims and ideals of the movement, to promote a closer understanding between craftsmen in the various media, which resulted in Jack's penchant for ornament provided by pewter, copper, glass, leather and ivory. Jack also designed furniture for Morris (q.v.); most of the pieces attributed to him were sumptuous in the extreme, executed in walnut or mahogany, totally enveloped in ornate marquetry (q.v.) and inlaid work. Characteristic examples of Jack's designs are his writing desks, bureau-bookcases and mahogany tea-tables, which are a far cry from the Gothic and pseudo-medieval furniture associated with Morris in the 1860s and 1870s.

153

Japonaiserie

Alternatively known as *Japonism*, it was an interesting parallel to the *Chinoiserie* which affected the applied arts of Europe in the seventeenth and early eighteenth centuries. European furniture, ceramics, glass and metalwork in the first half of the nineteenth century were dominated by Neo-classicism but, by the 1860s, people were becoming tired of styles which aped Ancient Greece and Rome. There was a revival of interest in things Chinese, and blue and white ceramic motifs returned to favour about this time. In 1853, however, Japan ended the long period of self-imposed isolation from the rest of the world and trade with Europe and America gradually developed. Impetus was given by the Meiji Revolution of 1867–8 which began the ruthless Westernization of Japan. As the Japanese enthusiastically embraced all things Occidental, there was a corresponding appreciation of traditional Japanese art forms in the west. Japanese colour prints, developed during the isolationist period of the Tokugawa Shoguns, were unknown in Europe and America until the mid-1850s but had an immediate impact, especially on painters and graphic artists who were quick to recognize the genius of Hokusai and other artists of the *ukiyo-e* (things of the passing world) school. The first Oriental art boutique, the *Porte Chinoise*, was established in Paris in 1862 and soon became a gathering place for such artists as Bracquemond, Degas and Manet and connoisseurs such as Baudelaire and the De Goncourts.

Two architects, William Burges and Edward Godwin, introduced Japanese art to Britain in the same year, and this coincided with the International Exhibition in London at which Japanese art and artefacts were launched on a

Vases by Brown, Westhead, Moore & Co. from *Japonaiserie* designs by E. Sieffert, 1895.

154

Japanned display cabinet, English, *c*. 1900.

wider public. Farmer and Rogers of Regent Street established their Oriental Warehouse and through this emporium passed many of the prints and ceramics which were eagerly purchased by James McNeill Whistler and Dante Gabriel Rossetti. John Ruskin and William Morris (q.v.) were early admirers of Japanese prints. Christopher Dresser (q.v.) was inspired by the display of Japanese artefacts at the 1862 Exhibition to visit the country himself and his first-hand experiences had a profound effect on his subsequent approach to design. Liberty (q.v.) was a prolific importer of Japanese wares from 1875 onwards.

Inevitably the craze for all things Japanese led to the modification of the decorative arts of the west. Edward Godwin compiled a comprehensive catalogue of furniture designs, published by William Watt in 1877, and widely disseminated on both sides of the Atlantic, where it had a great influence on British and American furniture in the closing years of the nineteenth century. Godwin's simple, light Anglo-Japanese designs, with shelves, brackets and geometric lattice-work, were a perfect complement to the silk-screens, blue and white porcelain and *cloisonné* enamel (q.v.). Lacquerware, inlaid with mother-of-pearl, and the use of ceramic tiles to ornament furniture, were

other manifestations of popular *Japonaiserie*. To these may be added the craze for cork pictures and bamboo furniture (qq.v.) which reached their peak by 1900. Japanese motifs inspired much of the glass and studio pottery (qq.v.) of the late nineteenth century in both Europe and America, though, in their mature form, these bore little direct resemblance to Japanese originals. *Japonism*, with its predeliction for plant motifs and curving lines, was one of the major ingredients in Art Nouveau (q.v.). The influence of Japanese art died down gradually from 1910 onwards but traces of it were evident in the applied arts of Europe as late as 1930.

Japanese lacquer chest, late 19th century.

Jensen, Georg

Danish silversmith, born at Raadvad in 1866. Jensen served his apprenticeship under Holm of Svartgade, Copenhagen and became a journeyman in 1884. In the 1890s, he came under the influence of Mogens Ballin and spent some time in his workshop in 1899. In 1900, he won a scholarship which took him to Italy and France. On his return, he established a small porcelain factory with Joachim Petersen but this proved abortive and Jensen then turned to jewellery, specializing in semi-precious stones and enamelware set in silver. It is as a jeweller that he is of interest to this book since his brooches, buckles and pendants combined the floral and insect motifs of Art Nouveau with something of the ancient Norse tradition. In 1907, he began

155

collaborating with the painter Johan Rohde (q.v.) in translating the forms of post-Impressionist painting into the medium of silver. The cutlery and table silver for which he was later renowned belong to the latter part of his life (1914–1935). The earliest pieces by Jensen, from 1908 to 1910, (when he won a gold medal for silverware at the Brussels International Exhibition) are much sought after.

Jewellery

The bulk of the jewellery produced during the period 1890–1910, differed little from that manufactured in earlier decades. In general, however, settings became lighter and jewellers strove to produce extremely delicate, almost invisible settings for diamonds, which were then at the height of their popularity. After 1900, platinum was virtually exclusively used for settings. Its greater durability and brightness made it more popular than silver, hitherto widely used. It was ideal for the new 'light' settings which enabled jewellers to create great brooches and corsages which would not drag down the dress materials. The stomacher was revived as an ornament covering the whole of the front of the dress. At the same time, composite jewellery became fashionable. Suites of jewellery, consisting of detachable bows, clips, pendants and brooches, became more and more popular in the years immediately before the

Art Nouveau gold brooch, c. 1900.

Belt buckle with holly motif, in gold and semi-precious stones.

First World War, permitting the wearer to vary the arrangement with little effort. At the same time, the lighter settings permitted the use of larger diamonds. This was the era of the sunray tiara, the ultimate combination of platinum and finely graded diamonds. It is difficult now to appreciate the blaze of jewellery at balls and dinner-parties in the Edwardian era; the passage of two world wars and innumerable financial crises have resulted in the breaking up of the more sumptuous pieces and the enormous increase in the value of platinum as an industrial metal has severely limited its use in jewellery. The big names in the 'commercial' jewellery of this period were J. W. Benson, Asprey (q.v.), Garrard's (the Crown jewellers), and Phillips in Britain; Black, Starr & Frost (q.v.), J. E. Caldwell and C. L. Tiffany (q.v.) in the United States; Christophle, Cartier, Cardeilhac (qq.v.) and Massin in France; W. A. Bolin in Sweden and Russia; Fabergé (q.v.) in Russia.

Curiously enough, the standard work of the commercial jewellers, often outstanding and usually elegant and charming, has largely been overlooked by collectors of the present time. As a rule, reference to the jewellery of this period is confined to the work of the Arts and

A group of late 19th century cameos in the form of rings and a brooch.

Crafts Movement (q.v.) or to the handful of artist-craftsmen who designed jewellery in the style of Art Nouveau (q.v.). Perhaps the fact that they worked in less valuable materials has tended to preserve their works for posterity, since many of the platinum and diamond confections have been broken up. Often known collectively at this time as art jewellery (on the same analogy as art glass, art pottery and art silks), the work of the Arts and Crafts jewellers used semi-precious stones, often uncut, in settings of silver or even copper. Whereas the work of the commercial jewellers was becoming more delicate, that of the 'artistic' jewellers was becoming more massive and chunky. In the former, the setting was designed to be as unobtrusive as possible; in the latter the setting was just as important as the stones (if not more so) and great care was taken in the elaborate ornamentation of the settings. Silver was cast, wrought, carved, engraved, chased, inlaid or beaten in *repoussé* or *martelé* (q.v.) techniques. The jewellery of such artist-craftsmen as Omar Ramsden, Henry Wilson (q.v.), Phoebe Traquair and Harold Stabler is self-conscious, often technically poor though highly imaginative. Unfortunately this type of jewellery was not glamorous enough for the wealthy, who preferred

impeccably cut diamonds in invisible settings, and too expensive for the masses. Consequently very little of it has survived in any appreciable quantity.

This was also the era in which cheap, mass-produced jewellery first made its appearance. Glass-paste and silver-plate were cheap and tolerable substitutes for diamonds and platinum and, because it had no scrap value, this cheap costume jewellery has survived in vast quantities. What it lacked in intrinsic value, it made up in novelty. Insect brooches and pendants were all the rage, but many other shapes, borrowed from nature, were popular: flowers, fishes, birds, snakes, lizards, and ferns. Natural motifs enjoyed a certain vogue in Europe at the turn of the century for more expensive jewellery. *The Queen* (1899) recorded 'a miniature bat, with ruby body and diamond wings, swinging from a fine gold chain set with pearls'. Parisian jewellers went even further and inserted jewels in the shells of live tortoises—much to the indignation of one British animal lover who wrote in protest, 'Who but a Parisian would conceive the idea of bejewelling a live tortoise? The little animal must obey the dictates of nature and consequently the very idea of wearing a live thing on the person is repugnant.'

157

Art Nouveau pendant jewel, combining ivory, enamel, base metals and semi-precious stones.

A curious fashion, which seems to have originated in England in 1886, was to dismantle antique watches and use their working parts as the basis for jewellery. The idea spread quickly to Europe and, in the 1890s, the working parts of fine old watches were to be found on earrings, cuff-links, tie-pins, hatpins (q.v.), brooches and necklaces, heavily plated in gold or silver and set with precious stones.

Continental Art Nouveau jewellery is relatively scarce, which is surprising since the output in France and Belgium alone, from 1895 to 1910, was considerable and such pieces had little scrap value. It has been estimated that about forty artist-jewellers were working in France in small *ateliers* at the turn of the century, while René Lalique (q.v.) employed about thirty craftsmen in his workshops in 1900. Lalique was the nearest thing to a combination of 'commercial' and 'artistic' jewellery in this period and his Art Nouveau pieces were highly esteemed on both sides of the English Channel. Queen Victoria was one of his customers and Agnew's of London held a special Lalique

exhibition in 1905, but very few of the pieces then exhibited can now be traced. Henri Vever (q.v.) published a three-volume history of French nineteenth-century jewellery in 1908 and devoted almost the whole of the third volume to Art Nouveau. Thus the documentation exists, even if the jewellery itself, for inexplicable reasons, has not survived. Such was the influence of Lalique on Art Nouveau jewellery that we may speak of a Lalique *genre* followed by such craftsmen as Eugène Colonna, Marcel Bing, Lucien Gaillard, Eugène Grasset, Georges Fouquet, Emile Gallé, Victor Prouve (qq.v.), Georges de Ribaucourt, L. Gautrait and Henri Dubret.

In the Low Countries, the outstanding name in Art Nouveau jewellery was Philippe Wolfers (q.v.) who worked exclusively in this field, but architect-designers, such as Victor Horta and Henry Van de Velde (qq.v.), also produced excellent jewellery in this style. The best Dutch jewellery was produced by Jan Eisenloeffel (q.v.). The ceramicist Lambert Nienhuis also produced a few pieces of jewellery, using gold and enamel. Frans Zwollo (q.v.) designed jewellery for such 'commercial' firms as Christophle and Cardeilhac (qq.v.), but began designing geometric pieces in 1910, anticipating the Art Deco styles of the 1920s. Comparatively little Art Nouveau jewellery was made in Scandinavia, though a few pieces were designed by Thorvald Bindesböll (q.v.) and Mogens Ballin. Georg Jensen (q.v.) worked exclusively on jewellery until 1907 when he turned to silverware. Other Danish jewellers who produced Art Nouveau pieces included Harald Slott-Möller and Erik Magnussen. *Jugendstil* jewellery made little headway in Germany and Austria, though some fine pieces in naturalistic motifs were designed and made by Hans Christiansen (q.v.) in Darmstadt, Ferdinand Hauser in Munich, Patriz Huber (q.v.) in Berlin and O. Prutscher and H. Hofstätter in Vienna. In England, there were many artist-craftsmen who dabbled fleetingly in Art Nouveau jewellery: George Frampton, Edgar Simpson, Kate Allen and Annie McLeish among others, showing a predilection for heavier items such as combs, belt-buckles and massive pendants. In Scotland, jewellery combining Art Nouveau with traditional Celtic motifs was designed by Talwin Morris, Herbert MacNair and the Macdonald sisters (qq.v.).

From 1887 to the First World War, there was a craze for enamelling coins and setting them in brooches, watch-chains, cuff-links, earrings

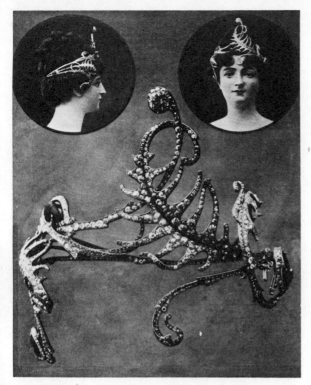

Art Nouveau tiara, French, 1901.

and pendants. The best work in this field was carried out by W. H. Probert and Edwin Steele in Birmingham and Louis Elic Millenet in Paris. Contemporary British, Burmese and French coins were those most frequently used. See *Memorial Jewellery*

Jinbei, Kawashima

Japanese weaver and textile designer (1853–1910). Jinbei trained as a weaver at Kyoto in traditional Japanese techniques, but went to France in 1887, where he studied western methods at the Gobelin works. Subsequently he introduced French techniques to the Nishijira weavers of Kyoto. At the turn of the century, he produced large tapestries, adopting Western techniques with embroidered figures in traditional Japanese style.

Jones, A. Edward

English silversmith (1879–1954). Jones studied at the Central School of Art in Birmingham under Edward Taylor and was apprenticed to the metalwork firm of Woodward in Paradise Street. Jones founded his own company in 1902 and rapidly made a reputation for excellent Art Nouveau silverware, which was frequently featured in *The Studio* (q.v.) and other art journals of the period. Much of the silver produced by Jones was destined for church use. The firm of A. Edward Jones Ltd continues to this day, under the direction of the founder's son, Major A. K. Crisp Jones.

Jugend

German weekly periodical, devoted to the arts and crafts, which made its debut in June 1896. As its title implied, the accent was on youth, and young artists and designers were given the chance to air their views and give expression to their ideas, unfettered by the conventions of the older-established art journals. It was from the title of this magazine that the term *Jugendstil* (q.v.)—youth style—was derived. The motto of *Jugend*, expressed in the first number, was:

Cover for *Jugend*, designed by Otto Eckmann.

'Everything pertaining to old-established style is excluded'. Ernst Barlach designed covers for *Jugend*; Felix Valloton and Theodore Steinlen contributed several vignettes. The influence of Toulouse-Lautrec and Walter Crane (qq.v.) was discernible from the very outset. Many of the illustrations, especially those by J. R. Witzel, echoed those of Aubrey Beardsley (q.v.). *Jugend* stimulated the development of the graphic arts and typography in Germany at the close of the nineteenth century, and also offered a forum for craftsmen and designers in every branch of the applied arts. Like *Pan* before and *Simplicissimus* later, it provided an accurate weather-gauge of prevailing fashions and developments in the arts.

Jugendstil

The German equivalent of Art Nouveau (q.v.), it was the distinctive style publicized primarily in the pages of *Jugend* (q.v.). Although the name was derived from the title of the magazine, its literal interpretation as 'youth style' ensured its popularity and permanency. The term is used to this day in Germany to denote the manifestations of the new styles in the applied arts at the turn of the century in every part of the world, but, for writers in the English language, it is a convenient term for describing those specifically German aspects. Like many other stylistic terms, it was not widely used at the time, but has gained currency in later years. Michalski (1925), Schmalenbach (1935) and Pevsner (1936) were the first art historians to bring it before an international audience. In Germany itself, the term *Neue Stil* was widely used in the 1890s and even later. Like the parallel developments elsewhere in Europe and America, *Jugendstil* owed much to the writings and teachings of Morris

(q.v.) and Ruskin. *Jugendstil*, more than Art Nouveau, derived inspiration from the architects and designers of the Glasgow Style (q.v.). Henry Van de Velde (q.v.) also exerted an enormous influence on the development of *Jugendstil*. The Dresden Exhibition of 1897 brought the style to prominence among the general public and, subsequently, colonies of artist-craftsmen developed in Munich, Darmstadt, Dresden and Scherrebek. The principal exponents of *Jugendstil* included Peter Behrens, Otto Eckmann, August Endell, Hermann Obrist, Bernhard Pankok, Richard Riemerschmid and Hans Schmithals (qq.v.). The term is also used to describe the contemporary developments in Austria but, because of the more dramatic beginnings of the modern movement in that country, the term *Sezession* (q.v.) is preferred. As with similar developments in other parts of Europe and America, *Jugendstil* found practical expression and outlet through the *Deutscher Werkbund* and the *Wiener Werkstätte* (q.v.), where artists, designers and craftsmen came together to pool their ideas and resources. *Jugendstil* had the same characteristics as Art Nouveau, but was more restrained in the use of the curved line. For all the principles laid down in *Jugend*, the style was eclectic and derived inspiration from Gothic, medieval, Renaissance, Japanese and traditional Germanic art forms, as well as from nature. *Jugendstil* found expression in every medium, but it was probably in the field of textiles that it had its most distinctive manifestation. Carpets (q.v.), upholstery, tapestry and wall-hangings were the speciality of the *Jugendstil* designers and, in a broader sense, this may be said of other two-dimensional media: posters (q.v.), wall-plaques, book-binding (q.v.) and the graphic arts.

See *Art Nouveau, Brussels School, Sezession, Stile Liberty*

Kazumasa, Numata

Japanese potter (1873–1954). Kazumasa studied at the Tokio Fine Art School in Ueno and later went to Europe, where he studied western techniques at Sèvres. He was subsequently responsible for introducing a sculptural approach to Japanese ceramics in the early 1900s.

Khnopff, Fernand

Belgian painter and graphic artist, born in West Flanders in 1858. Although trained as a lawyer, Khnopff switched to art in 1878 and studied at the Brussels academy of arts. Subsequently he was a pupil of Lefebre in Paris. He joined the arts and crafts union known as *L'Essor* and later became one of *Les Vingt*. From 1894 he was a member of *La Libre Esthétique*. Apart from his paintings, Khnopff is best known for his lithographs, posters, book designs and illustrations. He died at Brussels in 1921.

Heading for a catalogue of the Seventh Annual Exhibition of *Les Vingt*, 1890, designed by Fernand Khnopff.

Kleinhempel, Erich

German architect, painter and designer, born at Leipzig in 1874. He was a student, and subsequently a lecturer, at the Dresden art school. Here he founded, in 1900, the Dresden *Werkstätte*, with his brother Fritz (1860–1910) and sister Gertrud (later lecturer in textiles at the Bielefeld art school). This workshop quickly established a reputation for its advisory capacity in German household design. From 1912 onwards, Kleinhempel was Director of the school

Sketch of an extending table by Erich Kleinhempel.

of arts and crafts in Bremen. He was exceptionally versatile as a designer, working in the media of furniture, textiles, carpets, tapestry and ceramics, interpreted by students and craftsmen of the Dresden *Werkstätte*.

161

Klimt, Gustav

Austrian painter and designer, born at Baumgarten (Vienna) in 1862. Klimt studied at the school of arts and crafts in Vienna and became a founder-member of the *Sezession* (q.v.) in May 1897. Klimt was the leader of the artists in this group and was the first president of the *Sezession*. Disagreement with Hoffmann (q.v.) led to Klimt and his followers breaking away from the original *Sezession* in 1905, though subsequently he joined the *Wiener Werkstätte* (q.v.). Klimt died in Vienna in 1918. Though best known as a painter, Klimt wielded enormous influence over the interior decorators and furniture designers of *Jugendstil*. For the fourteenth exhibition of the *Sezession*, held in 1901, he designed his magnificent Beethoven frieze and later he collaborated with Hoffmann in designing the interior of the Villa Stoclet in Brussels. He evolved a highly personal style of decoration known as *malmosaik* (painted mosaic), using a grid-system originally devised by Hoffmann. His friezes combined metalwork, glass and ceramics and the severity of the geometric patterns was alleviated by the use of floral and plant ornament. His paintings, posters (q.v.), book-illustrations and friezes all have a richly jewelled quality.

Title page of *Ver Sacrum* designed by Gustav Klimt, 1898.

Komei, Ishikawa

Japanese wood-carver (1853–1913). Komei turned from *netsuke* to *okimono* and other decorative figures and panels in ivory and bone, after the Westernization of Japanese dress brought about the decline in *netsuke*. Komei also produced the exquisite bamboo bowls and vases for flower arranging and the tea ceremony, using traditional Edo styles.

König, Josef Pallme

Austrian glassmaker, prominent at the turn of the century. König worked at Steinschönau and Kosten in Bohemia and produced excellent lustre glass which is often confused with that manufactured by Lötz (q.v.). König also manufactured glassware with string-like trails of contrasting colour, the meshes of the net effect being generally wider and less well-ordered than that in the similar Lötz wares. This firm was also one of the pioneers of *Kristallglasschnitt* work, in which low relief decoration was achieved by chipping away the surrounding glass.

Köpping, Karl

German designer and craftsman in glass, born at Dresden in 1848, died in Berlin in 1914. Köpping trained as a chemist but began studying painting and etching under J. L. Raab of Munich in 1869 and subsequently studied art under C. A. Waltner in Paris. In 1890, he was appointed director of the master studio for etching and copperplate engraving at the Berlin Academy. From this period date his elegant blown-glass cups, beakers, vases and drinking-glasses, distinguished by their delicate ornamental stems and many-coloured bowls. Similar glassware was blown by Köpping's disciple Zitzmann (q.v.).

Lalique, René

French glassmaker and jeweller, born at Ay in Champagne in 1860. Lalique received his formal art training at the *Ecole des Arts Décoratifs* in Paris and subsequently spent two years studying metal-working and silversmithing in London. During the last two decades of the nineteenth century, he concentrated on jewellery and produced many choice pieces. Gradually, however, he moved away from precious stones and began experimenting in enamels and glass-pastes. From 1895 onwards, he devoted himself entirely to working in glass, primarily for jewellery but eventually extending his activities to larger subjects. Around the turn of the century, he experimented with moulded glass. In these early experiments, he modelled his creations in wax. Plaster moulds were then formed round the wax, which was melted out and the molten glass run in. Since the mould was then destroyed, each piece of glass was unique. Very few of these experimental pieces appear to have survived.

In 1909, he purchased a small glasshouse near Paris and began to manufacture ornamental glassware in the form of lamps, vases and bowls. The breakthrough came in 1911 when Lalique won a contract from Coty to produce an exclusive range of bottles for perfume. This was the beginning of a long association and, incidentally, provided a rare example of the packaging being preserved for aesthetic reasons long after the contents have been exhausted. Lalique was forced to suspend operations during the First World War, but he re-organized his factory at Wingen-sur-Moder in 1921 and,

Frosted glass vase by René Lalique, *c.* 1905.

from then onward, dominated the Art Deco style in glassware. The factory was badly damaged during the Second Warld War but, after René's death in 1945, his son Marc rebuilt the glassworks and has continued the traditions of high-quality glassware down to the present day.

Lalique glass from 1909 to 1914 was strongly influenced by the sinuous lines and ethereal

163

qualities of Art Nouveau (q.v.) and ranks with the better-known products of Gallé and Daum (qq.v.) in the field of French art glass. It is as a jeweller, however, that he is of interest to the period under review. From 1881 to 1905, he worked mainly as a freelance designer for such jewellers and silversmiths as Cartier (q.v.), Hamelin and Destape and, in fact, took over the last-named business in 1886. He enjoyed the patronage of Sarah Bernhardt and it was largely due to her that he was encouraged to branch out on his own, both designing and manufacturing jewellery. He made his debut at the *Salon* in 1895, winning a third prize with a brooch featuring a female nude, the first occasion on which he had turned to this subject. Female figures and profiles were later to become almost a Lalique trademark in brooches and pendants. In 1896, he introduced horn into his jewellery and subsequently he experimented with other materials which had never before been used in jewellery. After he secured the Coty contract, Lalique gradually phased out the jewellery side of the business and abandoned it altogether in 1914.

Lalique was a brilliant innovator, not only in the materials he used, but also in the techniques he applied to jewellery. With startling disregard for convention, he experimented with both aluminium and platinum as alternatives to silver for his settings. He was also astonishingly versatile, not only in his mastery of the flowing line so popular in Art Nouveau jewellery, but also in his brilliant static compositions, used to great effect in belt buckles. His greatest *tour de force* was a dragonfly corsage, with a wing span of more than ten inches, in which the wings and tail were superbly jointed to resemble the living creature. This piece, in gold, enamel and chrysoprase, was purchased by Calouste Gulbenkian and is preserved by the Gulbenkian Foundation. Lalique inspired and gave example to an entire generation of French jewellers and, though he later turned to glass, his greatest contribution to the arts was his liberation of jewellery from the constrictions of commercial interests and its evolution as a distinct art form.

Lamps

The period from 1890 to 1910 marked a transition from oil and gas lighting to electric light in public and domestic housing and afforded great scope for artists and craftsmen using many different materials. The bowls and shades of oil lamps were produced in a wide range of pottery and porcelain, with brass or silver mounts. From about 1885 onwards, Burmese glass (q.v.) was popular in both America and Britain for the more decorative lamps. At the same time the fairy light made its debut, the ornamental counterpart of the night light which had been used in nurseries since 1857. Wax lights were ingeniously enclosed in glass bulbs of delicate hues and adapted for a variety of purposes: as bracket lamps, hung in clusters to form chandeliers, or hung from slender chains in gardens and conservatories. These lamps were patented by Samuel Clarke of Cricklewood, London and were known by various names which help to date them. The earlier types, from 1886 to the mid-1890s, were known as the 'Fairy', the 'Fairy Pyramid' and the 'Wee Fairy' in descending order of size. At the turn of the century, lamps bearing the

Austrian porcelain lamp in the form of a girl; the blossom conceals a light bulb, 1900.

164

symbol of the new form of lighting. Around the turn of the century, thousands flocked regularly to her tiny theatre in Paris to watch her perform her own inimitable version of the dance of the seven veils. The combination of diaphanous material and skilled lighting with the artistry and poise of this dancer made her performance a memorable one. She is particularly remembered for the climax of her dance, in which the veils swirled around her head. The wispy, sinuous lines of her dancing veils were ideally suited to the spirit of Art Nouveau and the interpretations of Loie Fuller and her

French table lamp, 1906.

American table lamp attributed to Handel, *c.* 1900.

impressed trade name 'Cricklight' were marketed with either clear glass or cameo glass (q.v.) shades. The wax fairy-light gradually disappeared from the scene as electric light-bulbs became more common.

Although Edison's first electric light-bulb was patented in 1878, it was surprisingly slow to catch on, mainly on account of the fact that a ready supply of electricity was not generally available until the 1890s. Many people complained that the quality of electric light was too harsh, while others objected to it on the grounds that electric lamps were immobilized by their wires and could not be moved around at will. Candles and oil lamps continued to outshine it, in popularity if nothing else, well into the twentieth century. In 1895, electric lighting was still a novelty, but it was this that attracted it to the artists and craftsmen of the Art Nouveau movement and inspired them to explore the aesthetic qualities of this new medium. In Loie Fuller, the celebrated American *danseuse,* the exponents of Art Nouveau found the perfect

dance were astonishingly varied. She had made her name in the 1890s at the *Folies Bergère* but, about 1900, opened her own theatre whose decor, both interior and exterior, was the work of Pierre Roche, one of the small but devoted band of admirers who immortalized her in

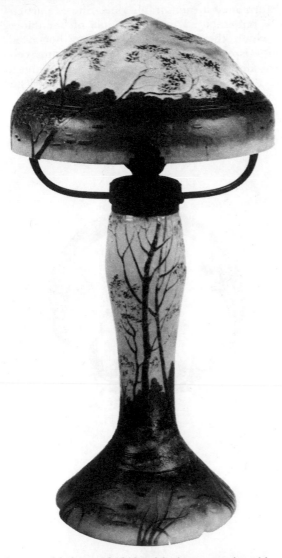

Cameo table lamp of 1910, with riverscape signed by Legros.

their art. Roche's theatre unfortunately is no longer in existence, but the many lamps, usually executed in gilt-bronze by Raoul Larche, are still around and fetch comparatively high prices.

Although the best-known of the designers of Loie Fuller lamps, Larche was by no means the

only one, and the dancer was also the subject of numerous bronze figures which were not necessarily wired as lamps. Other artists who specialized in these bronze lamps were Louis Chalon, Antoine Bofill and Leo Laporte-Blairsy. Chalon also produced gilt-bronze lamps featuring the ballet dancer Cleo de Merode, who was known as a great beauty although her strikingly simple hair style was said by jealous rivals to conceal a lack of ears. Laporte-Blairsy produced a large number of lamps using young women as models. Many of his lamps incorporated shades made by Daum (q.v.). The craze for female silhouettes utilized as lamps was all the rage for a few short years; the critics condemned it and the public soon tired of it, and there was little or no market for such pieces after 1905, until revived by the interest of collectors in recent years.

In the United States, where electric lighting was well established by 1900, the range of lamps was immense. The best of these exhibit the combined talents of many leading craftsmen as, for example, the lamps designed by Greene and Greene (q.v.) incorporating iridescent Tiffany (q.v.) glass in mosaic patterns, in both subject and style reflecting the fashion for *Japonaiserie* (q.v.). Lamps with isinglass shades and copper bases were the speciality of Dirk van Erp who worked in the San Francisco area until his death in 1933. Attractive lamps in pressed, moulded or cut glass, or in the various fancy styles popular in the late nineteenth century, were produced in great quantities by Hobbs Brockunier, Mount Washington (q.v.) and other leading American glasshouses.

Lamps were designed by all the leading architects and furniture designers of Britain and Europe at the turn of the century, as part of their total concept of interior decoration, and range from the gilt-bronze riot of twisting strands favoured by Horta (q.v.) to the relatively austere plated brass and coloured glass lamps designed by Mackintosh (q.v.).

Läuger, Max

German architect and designer, specializing in ceramics, born and died in Lörrach, 1864–1952. Läuger was educated at the Karlsruhe school of arts and crafts and was a lecturer there from 1885 to 1898. As well as designs for pottery, Läuger worked as a freelance designer of fabric-patterns for the Mannheim firm of H. Engelhardt.

Legros, Alphonse

Painter, etcher and medallist, born at Dijon in 1837 and died at Watford, England in 1911. At the age of fourteen, Legros left Dijon, to work as a wall-painter under the decorator Beuchot who was renovating the chapel of Cardinal Bonald in Lyons Cathedral. In 1852, he moved to Paris where he studied art under Cambon and Lecoq de Boisbaudran, and enrolled in the evening classes of the *Ecole des Beaux Arts*. He first took part in the *Salon* in 1857, exhibiting a portrait of his father, now in the Tours museum. Subsequently he concentrated on paintings with a quasi-religious motif. Legros came to England in 1863, becoming naturalized in 1881. He held appointments as teacher of etching at the South Kensington School of Art and as Slade professor

Tailpiece by Walter Leistikow, from *Pan*, 1897.

at University College, London from 1876 to 1892. As Slade professor, he exerted a tremendous influence on the developments of English art in the latter years of the nineteenth century, and contributed a great deal to the revival of draughtsmanship in Britain at the turn of the century. Among his outstanding pupils were C. W. Furse, William Strang, William Rothenstein and Harrington Mann.

After his retirement from the Slade school in 1892, Legros returned to the free and ardent manner of his early days, painting romantic landscapes with Spanish Castles and Burgundian farms. To this period belong his best-known etchings, such as the series of *The Triumph of Death*. He also experimented with sculpture, producing the fountains for the gardens of the Duke of Portland at Welbeck. His chief contribution to the decorative arts at the turn of the century, however, was in numismatics. He took an active part in reviving the art of the medal and, under his leadership, the English Society of Medallists flourished briefly. He rejected the mechanical techniques of the day and revived the Renaissance art of the cast portrait medal. Bronzes and medals by Legros are preserved in several museum collections, notably the British Museum and the Luxembourg in Paris. After his death in 1911, the English Society of Medallists languished and subsequent work in this medium did not live up to the early promise initiated by Legros.
See *Commemorative Medals*

Leistikow, Walter

German painter and graphic artist, born at Bromberg in 1865. Leistikow studied at the Berlin Academy in 1883 and subsequently under Eschke (1883–5) and Gude (1885–7). From 1890 to 1893, he was a lecturer in the Berlin art school. In the latter year, he spent some time in Paris where he made the acquaintance of the *Nabis*. He was a founder member of the *Eleven* (1892) and the Berlin *Sezession* (1899), and took a prominent part in the formation of the German *Künstlerbund* in 1904. He died in Berlin in 1908. Apart from his paintings, his best-known work consisted of illustrations for *Pan* and other contemporary art journals, and his prolific designs for wallpaper, produced commercially by Engelhardt of Mannheim.

Lemmen, Georges

Belgian painter, engraver and designer, born at Brussels in 1865. As a painter, he was influenced by Georges Seurat and took part in the Paris *Salon des Independants* from 1889 to 1892. Subsequently he became a member of the Brussels art circle *La Libre Esthétique*. From 1896 onwards, he was a versatile designer of mosaics, posters, wallpaper-patterns (qq.v.) and

Decorative heading for *La Libre Esthétique* by Georges Lemmen, 1894.

textiles for Samuel Bing (q.v.) and also contributed illustrations to the periodical *Die Insel* (1899). Lemmen died in Brussels in 1916.

Lenox, Walter Scott

American ceramicist, formerly art director of Ott and Brewer and largely responsible for the manufacture of the distinctive Belleek (q.v.) porcelain from 1882 onwards. Although originally designing porcelain in the classical tradition (especially the Rococo styles of the eighteenth century), Lenox later came under the influence of *Japonism* (q.v.). In 1896, he left Ott and Brewer to found his own pottery in Trenton, New Jersey. His Ceramic Art Company produced fine porcelain in a mixture of styles and rapidly developed into one of the leading American firms. Porcelain produced by Lenox bears his initials (and usually the date as well) on the underside.

Lethaby, William Richard

English architect and designer (1857–1931), author of several books on architectural theory and history. He was associated with Sir George Frampton in the foundation of the Central School of Arts and Crafts, of which he was director from 1893 to 1911. His best-known architectural designs include the Eagle Insurance Building in Birmingham and Brockhampton Church. He served under Walter Crane (q.v.) as professor of design at the Royal College of Art and, as such, exerted a great influence on the designers and craftsmen of the early twentieth century. The main theme of his teachings and writings was the concern he felt for the ways in which the arts should reflect the social order and the part which they ought to play in the integration of the individual and society. Lethaby held many important official appointments, ranging from the first inspector of Art Schools for the London County Council to the Surveyor of the Fabric of Westminster Abbey. Lethaby was a founder member of Kenton and Company, along with Gimson and the Barnsley brothers (qq.v.). He designed furniture using many different materials, from unstained oak to inlaid mahogany, subsequently manufactured by Morris (q.v.) and other commercial firms. His designs were strongly influenced by the Arts and Crafts Movement (q.v.).

Libbey Glass

In 1888, the New England Glass Company (q.v.) moved to Toledo, Ohio and changed its name. As the Libbey Glass Company, it specialized in 'Amberina' glass, bearing the name of the company etched on a comparatively large proportion of its output. A rare and short-lived variant of this art glass was called 'Plated Amberina', easily identified by its opaque lining and the presence of vertical ribbing on the outer layer. It is the latter characteristic which distinguishes it from the famous 'Peachblow' glass manufactured by Hobbs, Brockunier (q.v.). Libbey also manufactured excellent clear glass with elaborate wheel-engraving. For the Columbian Exposition (q.v.), Libbey produced a

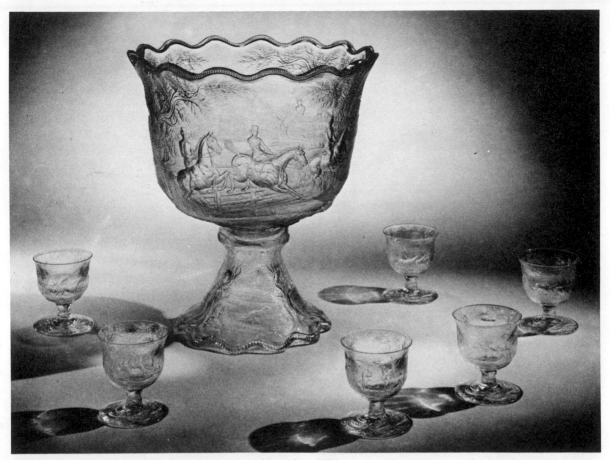

Engraved punch bowl and cups by the Libbey Glass Co., 1892.

punch bowl and set of matching glasses decorated with landscapes and hunting scenes derived from the British sporting prints which were popular in the early nineteenth century.

Liberty, Sir Arthur Lasenby

English merchant, born at Chesham in 1843, died at Great Missenden in 1917. Liberty was the son of a Nottingham lace manufacturer. In 1862, he became the manager of Farmer and Rogers Warehouse in Regent Street, London, which he soon transformed into an emporium specializing in the arts of the period, with emphasis on Oriental wares. In 1875, he established his own shop in Regent Street which prospered first on Oriental imports and then, in the 1890s, began adapting eastern motifs for fabrics and wallpapers (qq.v.). Liberty also sold Japanese porcelain and later gave encour-

agement to English potters to produce wares emulating Oriental styles. Similarly he dealt in Japanese metalwork and this, in turn, inspired the company to develop its own inimitable range of metalwares. Liberty was a personal friend of Rossetti, Dresser (q.v.) and other leading figures in both the Aesthetic and the Arts and Crafts Movements (qq.v.).

From 1899 onwards, the famous Liberty silverware known as 'Cymric' (alluding to its supposedly Welsh origins) was produced and three years later pewter, in the patterns known as 'Tudric', appeared. Liberty employed the best freelance designers of the period, such as Jessie M. King, Archibald Knox and Rex Silver, though the identity of the designers was kept secret at the time. Although the 'Cymric' and 'Tudric' patterns bore a close resemblance to the designs of the Guild of Handicraft, there was technically little contact between the designer and the manufacturer and, despite the 'craft'

169

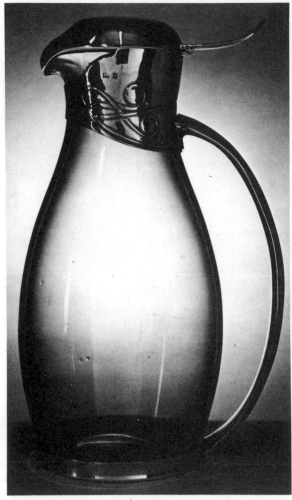

Green glass bottle with silver mount, in Liberty's
'Cymric' range, 1903.

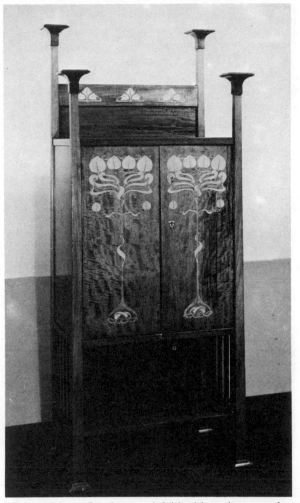

Music cabinet of mahogany inlaid with various woods,
by Liberty, 1897.

appearance of the finished articles, they were
produced in vast quantities using mechanized
processes. Liberty registered a silver mark
(LY & CO) as early as 1894 but production from
1901 onwards was entirely in the hands of
W. H. Haseler of Birmingham (q.v.) who also
produced the pewter (q.v.). The 'Tudric' and
'Cymric' patterns survived into the early 1920s.
See *Pewter*

Limoges Porcelain

Hard-paste porcelain was produced in the
Limoges district of Haute-Vienne, France from
1771 onwards. Since 1797, the principal factory
had been run by members of the Haviland

family which built up a thriving export trade
with America in the nineteenth century and
subsequently porcelain, known as 'Haviland'

Limoges enamelled box and cover, *c.* 1900.

ware, was manufactured in the United States. White wares, mainly dinner services, gilded and decorated with floral motifs, were the principal products of Theodore Haviland who controlled the company from 1860 to 1920, and such pieces bore the mark 'TH' in double-lined capitals. Several other potteries flourished in Limoges in the late nineteenth century: Montastiers & Prier, Gibus & Redon, Charles Ahrenfeldt (1894), Jules Teissonnière & Co. (1908), the Union Limousine (1908) and A. Vignaud (1911). These firms likewise produced good quality white wares, usually marked with the inscription 'LIMOGES FRANCE' and the initials of the individual company.

Presentation clock of 1883, with pottery mount designed by Christopher Dresser for the Linthorpe Pottery.

Hand-painted porcelain plate by Limoges, c. 1900.

Linthorpe Pottery

Company specializing in art pottery, established in 1879 by John Harrison, former owner of the Sun Brick Works in Linthorpe near Middlesbrough, Yorkshire, and Dr Christopher Dresser (q.v.). The brickworks was failing and there was considerable unemployment in the area. To alleviate economic depression, Harrison and Dresser embarked on a bold venture which, unfortunately, enjoyed only a limited measure of success and was forced to close down in 1890. Dresser secured the services of Henry Tooth, an artist from Ryde, Isle of Wight, as pottery manager although he had had no previous

experience in this field. Tooth took a crash course in pottery techniques in Staffordshire before joining the Linthorpe organization. He thus came to pottery with a fresh and original outlook which made up for his lack of practical experience. He applied himself enthusiastically to the practical side of the business and developed a flair for interesting colours and glazes, particularly the multicoloured flowing glazes which made Linthorpe pottery so distinctive. As early as 1880, the pottery was acquiring a reputation for excellent pottery in the prevailing Japanese style. Tooth left Linthorpe in 1882 to go into partnership with William Ault (q.v.) and, in the same year, Christopher Dresser severed his connection with the firm. In 1889, Harrison found himself in financial difficulties and the Linthorpe Pottery was liquidated the following year. Although it was in operation for barely a decade, the Linthorpe Pottery produced a wide range of art pottery based on Chinese, Egyptian, Greek, Roman, Indian, Islamic, Peruvian and Celtic originals as well as the Japanese

motifs. This eclecticism was excused by the company in its prospectuses of 1879–81 since its wares were 'in strict accordance with the principles of decorative art'. Jewitt, who disliked Dresser's designs, grudgingly admitted in his *Ceramic Art of Great Britain* (1883) that 'these works are characterized by a purity of art-treatment not found elsewhere'.

Lobmeyr Glass

The firm of J. and L. Lobmeyr manufactured good-quality glass in Vienna, Steinschönau and Haida from the early nineteenth century onwards. In 1873, Ludwig Lobmeyr, son of the original founder, began manufacturing the first iridescent glass in Europe, and it was this that L. C. Tiffany (q.v.) later developed in the United States. Lobmeyr's glassware was shown at the Vienna World Fair of 1873 and, from then on, this company was in the forefront of the European art glass movement. Lobmeyr restored cut and engraved glass to its former pre-eminence, employing the finest Bohemian engravers, such as Carl Pietsch, Franz Ullmann and Franz Knochel, all of Steinschönau. After 1900, Josef Hoffmann (q.v.) designed glassware for Lobmeyr, the best known being the distinctive *bronzitgläser*, matt-etched crystal glass with black bronzite decoration. Ornamental glass and drinking-glasses were also designed for the company by L. H. Jungnickel.

Lonhuda pottery jug designed by Sarah R. McLaughlin, 1893.

Lonhuda Pottery

American art pottery, established at Steubenville, Ohio in 1892 by William A. Long. Laura Fry, previously employed as a decorator by Rookwood (q.v.), was in charge of production at Lonhuda and prepared the wares displayed at the Columbian Exposition (q.v.). They came to the attention of Samuel A. Weller (q.v.) and, in 1894, he proposed a merger of his commercial pottery at Zanesville with the Lonhuda operation. The plant and machinery was transferred from Steubenville to Zanesville and thenceforward the art pottery was marketed under the name 'Louwelsa'. Subsequent styles were named 'Aurelian' and 'Eocean'. These styles were decorated with floral, fruit, ship, animal and American Indian motifs, slip-painted on a dark ground under a high glaze, emulating the

Rookwood wares of that period. Long and Weller soon parted company, Long going to the J. B. Owens Pottery Company, which subsequently marketed art pottery, under the name 'Utopian', resembling the 'Lonhuda' and 'Louwelsa' wares.

Loos, Adolf

Austrian architect and designer, born at Brünn (Brno) in 1870. Loos was a pupil of Otto Wagner (q.v.) in Vienna and subsequently studied in Dresden and the United States. He rebelled against the fussiness and derivative nature of late nineteenth century Austrian architecture and, in 1897, formulated his theories of 'practical' architecture, which uncompromisingly rejected ornament and the grand façades so beloved by the Viennese. He condemned Vienna as a

'Potemkin city', after the style of the Potemkin villages. His ideas were unpopular and few buildings designed by him have been preserved. His Steiner Haus in Vienna (1910) is the best example of his austere angularity, with large 'picture' windows. The Café Museum (1899) was his work also and here his ideas extended to the interior decoration and the furniture, which was almost entirely of bentwood (q.v.). Loos also designed solid, no-nonsense furniture which, in its totally functional approach, was diametrically opposed to the Art Nouveau works of his contemporaries and foreshadowed the styles popularized by the *Bauhaus* movement in the 1920s. Loos lived in Paris from 1922 to 1927 and died in 1933.

Extending table designed by Adolf Loos, 1898.

Lotusware

American translucent bone china with a distinctive soft, velvety glaze. 'Lotusware' was manufactured by Knowles, Taylor and Knowles of East Liverpool, Ohio from 1890 onwards. Previously this pottery had concentrated on Belleek (q.v.) type porcelain but a fire destroyed their kilns in 1889 and this unwittingly provided the opportunity for the products and techniques to be completely re-organized. This fine bone china bore a circular mark surmounted by a crown, with the word 'LOTUSWARE' outside and the initials 'KTK CO' inside. 'Lotusware' was a great success at the Columbian Exposition (q.v.) and was popular at the turn of the century. Both the shapes and the raised jewelled decoration were suggested by Oriental models, of a type which was also manufactured by Sèvres in the mid-nineteenth century.

Lotusware vase by Taylor, Knowles & Co., 1893.

Lötz Glass

A glassworks established at Klostermühle in Bohemia in 1830 by Johann Lötz. After his death in 1848, the company was run by his widow, hence the name J. Lötz Witwe by which it is often known. Johann's grandson, Max Ritter von Spaun, took over the control of the factory in 1879 and, within a few years, he had raised the company to a position of pre-eminence in Austrian glass. In the 1880s, Lötz specialized in glass imitating semi-precious stones such as agate and aventurine. A decade later, Lötz began producing iridescent glass, of the type which Tiffany (q.v.) had popularized. The technical secrets of the American glass

173

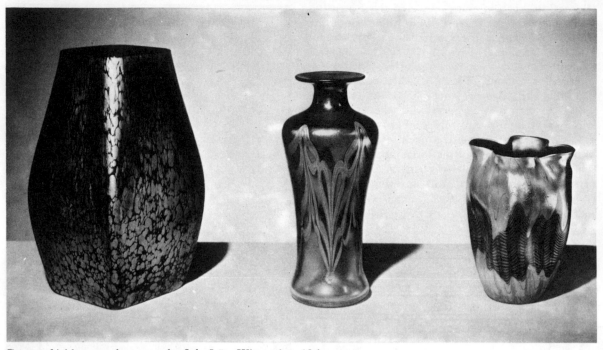

Group of iridescent glass vases by Joh. Lötz Witwe, late 19th century.

came to Lötz through a former employee of Tiffany, but Max von Spaun modified and refined it to suit his own purposes and took out his own patent in 1898. At the *Exposition Universelle* (q.v.), Lötz shared the *Grand Prix* with Tiffany, Gallé and Daum (qq.v.). Although the Tiffany wares were finer and more varied in style, those of Lötz were quite distinctive and often sumptuous. Lötz glass was exported to Russia and some of it was mounted by Fabergé (q.v.) for the Tsar and the leading Russian families.

Unlike Tiffany and Gallé, Lötz did not invariably sign their wares, though a fair proportion of glass will be found with the inscription 'LOETZ AUSTRIA' for export to Britain and America, or with crossed arrows in a circle and LÖTZ KLOSTERMÜHLE for home markets. It is thought that Lötz glass was only signed in those instances where it might otherwise have been confused with the inferior Bohemian competitors, though it has also been stated that the pieces marked in

English were thus inscribed at Tiffany's instigation because he did not wish his Austrian rival to pass off wares which might be taken by the public as the genuine Tiffany glass. After 1900, Lötz largely abandoned lustre wares and concentrated on the more austere black and white glass which was then becoming popular. By the outbreak of the First World War, however, Lötz had given up the manufacture of art glass altogether.

Luksch-Makowsky, Elena

German painter and designer, born at Hamburg in 1878, but educated in St Petersburg, Munich and Vienna before settling in Hamburg in 1907. From 1901 to 1907, she was a prominent member of the Vienna *Sezession* (q.v.), coming under the influence of Gustav Klimt (q.v.) and designing fabrics, wallpapers and posters (qq.v.) using his *malmosaik* technique.

Macdonald, Frances and Margaret

Scottish graphic artists and designers whose work gave rise to the distinctive Glasgow Style (q.v.). Frances (1874–1921) married Herbert McNair (q.v.) while Margaret (1865–1933) married Charles Rennie Mackintosh (q.v.). The Macdonald sisters studied embroidery, metal-work, jewellery and other aspects of the applied arts at the Glasgow School of Art where, in 1893, they were introduced to the architects McNair and Mackintosh. Their earliest work consisted of water-colours, with elongated, ghostly figures and mystical ornament redolent

Group of four panels, in beaten pewter with enamels and coloured glass, by Margaret Macdonald. (Below and over page)

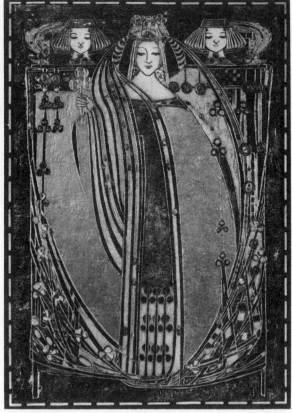

of Celtic mythology. Because of their distinctive style, they were dubbed the 'Spook School'. Subsequently the Macdonald sisters produced the decoration for the furniture designed by their husbands, and also designed beaten metal-work, embroidery, fabric patterns, jewellery and painted gesso panelling. Their style was on the fringe of Art Nouveau (q.v.) though quite distinct from it; more angular and less curvilinear in treatment. Their designs were hailed in Europe, especially in Germany, Austria, the Low Countries and Scandinavia, far more than they were in Britain. Retrospective exhibitions have resulted in a fresh appraisal of the work of the Macdonald sisters, and examples of their metalwork, jewellery and embroidery are now much in demand.

Mackintosh, Charles Rennie

Scottish architect and designer, born in Glasgow, 1868. Mackintosh worked in an architect's office and attended evening classes at the

176

Glasgow School of Art. He was an assistant, and later a partner, in the architectural firm of Honeyman and Keppie where he made the acquaintance of Herbert McNair (q.v.). In 1890, he travelled extensively in Italy and it was from that date that he began to evolve his distinctive Glasgow Style (q.v.) in design, later collaborating with McNair and the Macdonald sisters (q.v.). As an architect, his crowning achievement was the new Glasgow School of Art (1897–1905), but other buildings in the West of Scotland which deserve notice include Windyhill, Kilmacolm (1899–1901); Hill House, Helensburgh (1902–04) and the tea-rooms he designed for Miss Cranston between 1896 and 1911. Mackintosh's designs for interiors and furniture were quite distinct from those pro-duced by his contemporaries in the Arts and Crafts Movement (q.v.) and, after 1896, he ceased to take part in that movement's exhib-itions. His designs were enthusiastically ac-claimed on the Continent, however, and he

'Cymric' clock by Liberty, c. 1900. ▶

participated in the *Exposition Universelle* (1900) (q.v.) and the Turin Exhibition (1902).

Mackintosh was fortunate in having discerning patrons who allowed him a completely free hand with the design of their houses, down to the minutest detail of the furnishing and fittings and this enabled him to create total environments for his furniture. He is best known for his tall, angular chairs with low seats and Celtic panelling on white-painted wood. Decoration was always kept in check, complementing the form of furniture and never overwhelming it. Because of their delicate construction, his chairs have unfortunately not survived in any quantity, but his more robust tables and cabinets are lasting examples of fine craftsmanship.

From this period dated his interest in the graphic arts. In 1883, he designed and engraved the woodcut title-page for *Wren's City Churches* and in 1884 he founded the periodical *Hobby Horse* devoted to the arts and crafts. In the ensuing twenty years, he designed metalwork, fabrics, wallpapers and furniture, manufactured by Morris, Faulkner & Company or Simpson &

Mahogany hall-stand designed by Mackmurdo, *c.* 1890.

Cabinet in white-painted wood with metal handles and opaque glass inlay, by C. R. Mackintosh, 1902.

Mackmurdo, Arthur Heygate

English architect and designer (1851–1942). Mackmurdo travelled with John Ruskin in Italy and founded, with H. P. Horne and Selwyn Image, the Century Guild in 1882.

◀ Makinson lighting fixture designed by Greene and Greene for the Gamble House. (The Gamble House)

Godlee of Manchester. His furniture often combined traditional forms with the plant motifs of Art Nouveau, but some of it was startlingly functional in appearance, devoid of curving lines and relying on the quality of the wood for decorative effect.

McNair, Herbert

Scottish architect and designer, born at Glasgow in 1869 and trained in a Glasgow architect's office where he met Charles Rennie Mackintosh (q.v.) in 1889. Thenceforward his career was closely linked with Mackintosh and the Macdonald sisters (q.v.) and with them he evolved the distinctive Glasgow Style (q.v.) in 1893–4. In 1898, he was appointed a lecturer in design at Liverpool University and married Frances Macdonald the following year. McNair designed houses, interiors and furniture, usually in conjunction with Mackintosh. Insofar as his style may be said to differ from Mackintosh, it is in his greater degree of impetuosity. Ornament in furniture is less restrained and tends to weaken the effect of the form itself. McNair also designed posters (q.v.), characterized by angular lettering and elongated female figures in the *genre* established by his wife.

Maher, George W.

American architect (1864–1926) of the so-called Prairie School. Like Frank Lloyd Wright (q.v.), Maher was concerned with architecture which created a unified whole and thus paid attention to the design of every detail of the furniture and fittings of his ranch style houses. Maher served his apprenticeship first with Bauer & Hill and later with J. L. Silsbee, one of the largest architectural firms in Chicago. In 1887, he read a paper before the Chicago Architectural Sketch Club stating that 'originality in American architecture rests . . . upon . . . studying the necessities of labor and life, and meeting them. There is as much chance of a national style forthcoming in this country as elsewhere in the world. In most of our large cities a class of buildings can be seen which have no equal for interior arrangement . . . for nowhere are the wants of comfort and practicability so sought after as here.' Maher's furniture, like his houses, exhibited qualities of strength and mass, straight lines and plain

180

surfaces relieved by finely executed decorative detail. Nevertheless his furniture was eclectic in style, deriving inspiration from medieval European, Dutch seventeenth century and Chinese originals. Maher travelled extensively in Europe in the 1890s and undoubtedly imbibed the various traditions and influences which he subsequently utilized in his furniture. Nevertheless he was successful in combining these traditional elements with the simplicity which attained maturity in the furniture styles of the 1920s.

Majolica

Distinctive type of earthenware with coloured glazes, popular in Britain throughout the second half of the nineteenth century and much favoured for plates and tiles at the turn of the century. Majolica (not to be confused with the Italian tin-glazed earthenware of the sixteenth century

Late 19th century majolica urn showing Venus rising from the waves.

known as maiolica) was the invention of Léon
Arnoux (1816–1902), a French potter who was
appointed chemist and art director of Minton's
(q.v.) in 1848. Majolica was the most successful
of his inventions and was first shown to the
public at the Great Exhibition of 1851. Arnoux
received many awards in recognition of his
services to ceramics, among them the Order of
Franz Josef (Austria) and *Chevalier de la Legion
d'Honneur* (France). Although he retired in
1895, he continued his association with Minton's
until shortly before his death. He was only the
first of many European potters to gain employ-
ment at Minton's and other English potteries.
Christian Henk decorated pottery with land-
scapes after the manner of Watteau, but his son
John (1846–1914) modelled spirited animal fig-
ures in majolica. Majolica wares were also
produced by the Staffordshire potteries of George
Jones and Adams & Company. The latter in
particular popularized majolica in the late nine-
teenth century as a form of decorative pottery
for the masses. Wedgwood (q.v.) made majolica
wares from about 1860, but used a white instead
of a cane-coloured body, and clear rather than
opaque glazes. Majolica tiles (q.v.) were fashion-
able at the turn of the century, having been
popularized by the Aesthetic Movement (q.v.)
and subsequently used by many architects for
interior decor.

Majorelle, Louis

French furniture designer (1859–1929). After
studying art in Paris, he took charge of the
family ceramics factory but, from 1879 onwards,

Detail of a walnut chair designed and made by
Majorelle, *c*. 1900.

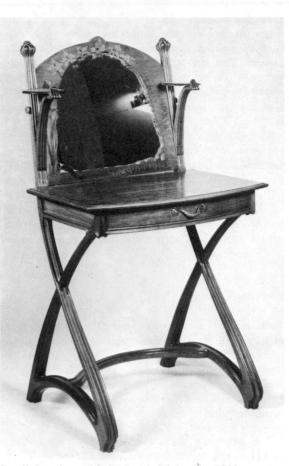

Small dressing-table by Louis Majorelle, 1900.

became more and more involved in the design
and manufacture of furniture. About 1890, he
came under the influence of Emile Gallé (q.v.)
but his training in conventional cabinet-making
prevented him from indulging in the flights of
fancy to which many of his contemporaries
were so prone. The furniture designed by
Majorelle in the 1890s, culminating in the work
which he displayed at the *Exposition Universelle*
(q.v.), laid emphasis on fluid sculptural forms
but was more practical and restrained than that
designed by Guimard (q.v.). Majorelle relied
heavily on the fine figure in walnut and more
exotic woods, such as tamarind and mahogany,
often used in contrasting bands or panels and
sometimes inlaid with marquetry (q.v.) or gilded
with ormolu.

What he practised, he also preached: 'The
first need in the construction of a piece of
furniture is to seek a healthy structure capable of
inspiring a sense of harmony and such that the

essential lines should have an architectural sense of elegant proportion. Whatever the function of a piece of furniture, the craftsman must ensure that the lines can exist without decoration . . . The richness of a piece of furniture should owe nothing to a surfeit of decoration; elegant lines and handsome proportions should suffice.' After 1900, when Majorelle's international reputation was at its height, he designed many suites of furniture characterized by flowing, naturalistic lines in mahogany. Ormolu mounts, mainly with lily motifs, were virtually the Majorelle trademark. Majorelle was less happy in his transition from Art Nouveau to Art Deco from 1907 onwards and much of his later furniture tends to be fussy in detail and massive in conception.

Marks, Gilbert

British silversmith (1861–1905), regarded as one of the strongest and most sensible metalworkers in the Arts and Crafts Movement (q.v.). Marks revived early English designs which he decorated in a rather heavy fashion, without falling into the worst excesses of Art Nouveau.

Marquetry

Technique of decorating the plain surfaces of furniture with patterns and pictures composed of veneers of different woods. Marquetry, popular in European furniture of the eighteenth century, was revived in the late nineteenth century and was used to great effect in the furniture designed for William Morris by George Jack (1855–1932) (qq.v.). Although plant motifs, such as the acanthus leaf which characterized other Morris products, were used extensively, a great deal of the marquetry derived inspiration from early Georgian, rather than medieval, forms. Mervyn MacCartney and W. A. S. Benson (q.v.) also designed furniture using marquetry decoration.

Marquetry was used extensively by Emile Gallé (q.v.) and his followers and often displayed great inventiveness with plant and insect motifs in relief. The French cabinet-makers often combined fruitwood veneers with mother-of-pearl and other materials. Victor Prouve (q.v.) designed marquetry panels for Gallé and

Tulipwood marquetry corner cabinet by J. Maubert, Paris, *c*. 1910.

Majorelle (q.v.). Marquetry was little used in Germany and the Low Countries and, among the American designers of the period, its use was restricted to occasional floral motifs found on the furniture of Greene and Greene (q.v.). It declined rapidly after about 1905, since the designers of subsequent years preferred to rely on the natural figure or graining of the wood, as well as the styling of the piece, for such decorative effect as they deemed to be necessary. Marquetry was out of place in the functionalism (q.v.) fashionable in the 1920s.

Martelé

French word meaning 'hammered' adopted by the Gorham Manufacturing Company (q.v.) of Providence, Rhode Island to describe their highly distinctive Art Nouveau silver, first

marketed in 1900. This technique was developed by William Codman, an English craftsman employed by Gorham from 1891 onwards. Hollow ware was hammered by hand, so that each piece was unique. The technique imparted a soft fluid look to the material. Stylistically the *martelé* silverware differed from 'mainstream' Art Nouveau in its symmetry and the absence of the elongated motifs popularized by the Macdonald sisters (q.v.). But the plant motifs and the flowing lines were characteristic of the style.

Loving cup with *martelé* decoration, by Gorham, c. 1900.

Pair of Martinware grotesque bird vases, signed and dated 1899.

Martinware

Distinctive, often grotesque, pottery manufactured by the Martin brothers between 1873 and 1914. There were four brothers: the eldest, Robert Wallace, trained as a sculptor and modelled under J. B. Philip whose advocacy of the Gothic Revival had a marked influence on the subsequent Martin designs. While associated with Philip, Wallace worked on the carvings and mouldings for the Houses of Parliament, which were then being rebuilt in the spirit of the medieval original. This period, in the early 1860s, coincided with the development of the Doulton (q.v.) enterprise at Lambeth which sought to beautify the applied arts. Through George Tinworth, a fellow student at the Lambeth School of Art evening classes, Wallace Martin made contact with Doulton's for whom he did a certain amount of modelling in terracotta. He turned away from stone-carving to modelling and worked full-time, between 1870 and 1873, at potteries in Devon and south-west London, perfecting the techniques of stoneware which Doulton's had recently revived.

In 1873, Wallace Martin decided to branch out on his own, and established a family pottery at Pomona House, King's Road, Fulham. He was assisted in this venture by his brother Charles and shortly afterwards was joined by his youngest brothers, Edwin and Walter, who had trained at the Lambeth School of Art and had worked in Doulton's studio. Initially the firm, known as R. W. Martin, was concerned

Pair of Martinware vases, dated 1889.

only with the decoration of pottery which was thrown and fired elsewhere. Subsequently Walter took over the entire production of stoneware pottery himself. Within a year, the company had become self-sufficient, as is evident from the wares shown at the South Kensington Exhibition of 1874. These included a stoneware fruit dish thrown by Walter Martin, and several ornamental pieces by Wallace Martin.

In 1877, the Martin brothers moved to new premises at Southall where both modelling and firing could be carried out in the one place. Wallace Martin continued as head of the company and specialized in the modelling of the grotesque and bizarre figures for which Martinware is best remembered. Edwin was the chief decorator while Walter attended to the production and research aspects of the firm. As the business expanded, the Martin brothers re-cruited Mark Marshall, a modeller who subsequently became even more famous in the employ of Doulton, and W. E. Willey, who was responsible for much of the decorative wares produced by the Martins in the 1890s. Although the grotesque figures have stolen the limelight, they represented only a small proportion of the firm's output. Most of their products consisted of vases, jugs, bowls and dishes and, apart from the distinctive glazes and styles of decoration, these items can be readily identified by the marks. The earliest items, from the Fulham period, have the mark 'R. W. Martin, London', while the earliest products of the Southall pottery are inscribed 'R. W. Martin, Southall'.

After the London showroom was opened, the mark was changed to 'R. W. Martin, London and Southall'; then, from 1883, either 'R. W. Martin and Bros' or simply 'Martin and Bros'

184

with 'London and Southall' underneath. Most Martinware bears the last of these marks, which was in use until 1914 when the shop was closed. A few items fired in that year, after the London showroom was closed, have the word 'London' omitted from the mark. Many of the figures and useful wares also bore the date of their manufacture. From 1900 onwards, the Martins were strongly influenced by Art Nouveau and this resulted in the so-called 'vegetable' ware, in which the exterior surfaces of vessels, in coloration and texture, were made to resemble vegetable skins. This highly novel facet of Art Nouveau is now in great demand. At the time, however, these wares failed to rouse much interest and led to the precarious financial state of the company, to which the First World War applied the *coup de grace*. Undoubtedly the most popular aspect of Martinware is, as it always was, the grotesque menagerie of birds and beasts for which Wallace Martin was mainly responsible. Jugs with gargoyle faces, birds with swivelling heads and disconcertingly human expressions, and a variety of useful articles such as watch-holders, candlesticks, inkstands and spoon-warmers in animal or human form, are among the subjects which Wallace modelled.

Meier-Graefe, Julius

French art dealer and principal rival to Samuel Bing (q.v.). In 1898, Meier-Graefe opened a shop, *La Maison Moderne*, in the rue des Petits-Champs, Paris, retailing work by the craftsmen and designers who specialized in Art Nouveau. In 1911, Meier-Graefe published a catalogue, *Documents sur l'Art Industriel au Vingtième Siècle*, listing the items for sale. With illustrations by Valloton, typography by Grasset and end-papers by Lemmen (qq.v.), the catalogue reflected the Franco-Belgian collaboration which Meier-Graefe encouraged. Meier-Graefe despised Bing for compromising on the issue of mechanization in production. He claimed in his *Documents*, that no one in France, before 1898, had pursued the ideals of William Morris (q.v.)— ignoring the activities of Bing for some years prior to that date. Art applied to everyday objects was his aim, and ornament was strictly contemporary without recourse to historicism. Meier-Graefe established a series of workshops, each one devoted to a specific craft or medium.

Among the designers and craftsmen employed by *La Maison Moderne* were Maurice Dufrene (furniture, jewelled fans), Paul Follot (jewellery, graphics and incised leatherware), Manuel Orazi (jewellery and posters), Abel Landry (furniture) and Felix Aubert (polychrome lace). George de Feure, Eugène Colonna and Henry Van de Velde (qq.v.) designed furniture and jewellery for Meier-Graefe at various times. Meier-Graefe's puritanical outlook and his uncompromising, but impracticable, fervour for the more socialistic ideas of Morris seem to have inhibited these artists, who never produced their best work for him. *La Maison Moderne* was never a financial success and went out of business shortly after 1900.

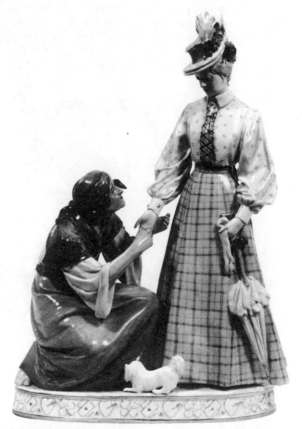

Meissen fortune-teller group modelled by Rehm, *c*. 1905.

Meissen Porcelain

Premier German porcelain factory, established in 1710. The period from 1870 to the end of the

185

nineteenth century was known as *Die Neuzeit* (the new time), but, despite this, traditional designs and models were fairly closely adhered to, though without the earlier splendours of the Baroque and Rococo periods of the eighteenth century. Apart from the rather heavy, conventional table wares, Meissen produced numerous figures and groups. The most important modellers in this period were Leuteritz, Hähnel, Ringler, Hirt and Schott. Hirt was the creator of the rather naïve and conventional groups of children, while Schott established a reputation with his Neo-classical groups. At the end of the century, however, the sculptor and modeller Andresen introduced *Jugendstil* (q.v.) to Meissen, and this was applied to a great variety of decorative and tablewares as well as figures and plaques. Especially prized are pieces bearing the familiar crossed swords mark, flanked by the dates

1710–1910, used during the bicentenary year of the factory.

See *Porcelain Plaques*

Meister, Emil

Swiss silversmith based in Zürich, founded by Emil Meister (1847–1921). Meister trained in the workshop of J. J. Hess in Horgen and subsequently worked for several years in England, the United States, France, Belgium and Germany before returning to Switzerland in 1874. He married Hess's daughter and inherited a share in that business but, after disagreements with his brother-in-law, founded his own business in 1881. After enduring many vicissitudes (his wife died in 1884, on the very day on which he lost an expensive court action in which his

Memorial jewellery: brooch, japanned iron bracelet, ear-rings and plaited hair ornament.

brother-in-law had involved him), he eventually succeeded and, in the 1890s, built up a reputation for fine jewellery and silverware. Emil Meister retired in 1909, entrusting the business to his son Eduard (1880–1954), who had trained as a silversmith in Geneva, London, Paris and Munich. The firm is still in existence, now headed by the founder's grandson, Walter Meister (born 1917).

Memorial Jewellery

Jewellery intended as an expression of mourning, seems to have been a peculiarly British institution which spread to America but never caught on to any extent in Europe. It is thought to have originated after the Restoration in 1660 when brooches and pendants commemorating the martyr-king Charles I became fashionable. Mourning jewellery went in waves of fashion, dying out by 1720, reviving in the late eighteenth century (in the form of small painted miniatures of the dear departed), dying out in the early nineteenth century, except for memorial rings, and reviving steadily from 1862 onwards, following the death of Prince Albert. Queen Victoria's protracted period of mourning for her Prince Consort, which continued until her own death in 1901, greatly stimulated the fashion for memorial jewellery which was, in itself, merely one aspect of the Victorian pre-occupation with death, ranging from mourning stationery to over-elaborate tombs.

Relatively few pieces from the turn of the century featured the rather gruesome skulls which distinguished the *memento mori* of the late eighteenth century, though some of these may be found incorporating watches. There was, however, a revival in the age-old custom of plaiting human hair into rings or brooches and this was conducted on a commercial scale, as is evident from an advertisement of the period which stated, 'Hair is at once the most delicate and lasting of our materials and survives us, like love. It is so light, so gentle, so escaping from the idea of death, that, with a lock of hair belonging to a child or friend, we may almost look up to heaven and compare notes with angelic nature—may almost say: "I have a piece of thee here, not unworthy of thy being now".' The Queen's long widowhood and lengthy period of mourning stimulated the popularity of lockets, brooches and rings portraying the

Group of memorial jewellery, comprising memory rings, brooch and jet necklace.

dead or depicting tombs and funereal scenes. Not all memorial jewellery was concerned with death, however, and quite a wide range of brooches and lockets may be found commemorating weddings, engagements or merely a loved one who had emigrated.
See *Jewellery*

Mendes da Costa, Josef

Dutch ceramicist, active at the turn of the century. He was trained originally as a sculptor, working for many years with Lambertus Zijl before turning to the modelling of figures and hollow ware in stoneware about 1898. He modelled family and biblical groups as well as devils, strange creatures and wild animals. His pottery was aptly described by the French critic Gabriel Mourey as 'a gothic cathedral built by a Javanese architect'. His figures and vases had a characteristic rough texture, with a dark grey glaze streaked with brown, yellow or blue. Many of his statuettes were subsequently edited commercially in terracotta or bronze. One of the best-known figures was of the painter Van Gogh. Mendes da Costa was associated with the architect H. P. Berlage (q.v.) and worked on the mouldings for the façade and interior of the Amsterdam *Bourse* in 1897.

Merton Abbey

Silk-printing factory on the bank of the River Wandle in Surrey which gave its name to a series of tapestries, fabric-designs and ceramics manufactured in the late nineteenth century by William Morris (q.v.). In 1880, Morris decided not to rely on outside firms any longer for the interpretation of his textile designs and the following year he purchased the Merton Abbey works, then in decline. Under his personal supervision, the Merton Abbey works were re-organized and, in the ensuing decades, built up a reputation for good-quality fabrics and sumptuous tapestries. It was at Merton Abbey that Morris supervised the weaving and printing of his distinctive textiles, the production of carpets and, above all, the design and production of the tapestries using medieval high-warp techniques. The most famous of the Merton Abbey tapestries were the Holy Grail series, designed by Burne-Jones (q.v.). The verdura backgrounds were contributed by Morris's chief assistant, J. H. Dearle (1860–1932), who became

Merton Abbey honeysuckle and corncrake cotton pattern by Morris & Co., 1915.

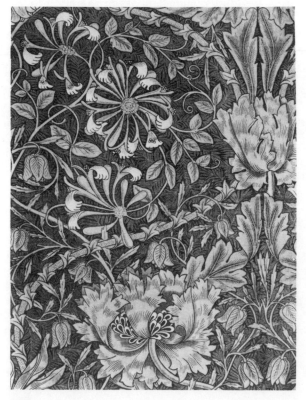

chief designer after Morris's death in 1896. Furniture, stained glass and pottery were also produced at Merton Abbey. From 1882 to 1888, William de Morgan (q.v.) had a pottery at Merton Abbey, next to the Morris workshops. The early lustre-painted tiles (q.v.) and hollow ware decorated in so-called Persian colours (blues, greens and turquoises) belong to De Morgan's Merton Abbey period.

Michelsen

Danish jewellery and silverware company, founded by Anton Michelsen in 1841. Seven years later, Michelsen was appointed Goldsmith and Jeweller to the Danish Court and, from then onwards, made jewellery and insignia for the Danish royal family, as well as many important government commissions. Much of the silverware was classical in design; in 1892, Michelsen's produced the largest piece of silver ever manufactured in Denmark—an epergne seventy-five inches long—part of a golden wedding gift to the King and Queen from the Danish gentry. Bindesböll (q.v.) designed modern silverware in the 1890s and Georg Jensen (q.v.) worked for Michelsen's in 1892–4.

Miniature Items

This is a vast field which, because of the small size of the individual pieces, has much to commend it to the collector with only limited space. Miniature items may be found in every medium and in every branch of the applied and decorative arts. In furniture, in particular, miniatures were produced since time immemorial as apprentice pieces: apprentices were not granted the freedom of their trade until they had served their time and proved themselves competent by performing a given piece of work known as a 'masterpiece' or 'test-work'. These masterpieces were intended as a symbolic form of practical examination by the various trade guilds and it is for this reason that miniaturized examples of the sort of work expected of a craftsman were called for. The would-be cabinet-maker was, in effect, showing his virtuosity by being able to produce accurate and detailed work on such a small scale. True masterpieces of this sort, dating around the turn of the century, are rare, since the custom had virtually

English miniature furniture, *c*. 1900.

died out. On the other hand, miniature items are often described loosely as apprentice pieces when they are, in fact, show-pieces or trade samples, dating from a period when travelling salesmen were expected to demonstrate their company's wares by means of small, three-dimensional pieces. In the era before glossy hand-outs and other forms of promotional material were commonplace, the miniaturized show-piece was a practical necessity. Although furniture is the most obvious category, miniaturization was applied from about 1890 onwards to a wide range of industrial products and included sectional or working models of engines and machines. Scale-models of ships, locomotives, automobiles and even aircraft were produced in considerable numbers from 1900 onwards, for the demonstration of inventions, for experimental purposes, or for sale promotion. The demand for accurate scale-models of all kinds developed in the 1890s as a side-effect of the great industrial expansion in the United States, Germany and Britain in particular. Model-making as a hobby also developed about the same time. Tiny steam engines and electric

dynamos were first marketed in quantity in the 1890s and the earliest of the constructional hobbies, such as Meccano, date from the beginning of this century.

Swift's reference, in *Gulliver's Travels* (1726), to a 'set of silver dishes and plates . . . not much bigger than what I have seen of the same kind in a London toy-shop for the furniture of a baby-house' indicates that, as long ago as the early eighteenth century, craftsmen were producing miniaturized versions of silverware, porcelain, glass and furniture for dolls' houses. Dolls' houses themselves (or baby-houses as they were more commonly known) originated in Germany and the Low Countries, but indigenous English and American examples were being manufactured by 1760 at least. They continued to be relatively scarce until the mid-nineteenth century, when they gradually increased in popularity. By 1890, what had originally been merely the side-line of craftsmen engaged in furniture and metalwork had developed into an industry in its own right. At the same time, the range in quality widened enormously to take note of the mass market. Miniature

189

tea and dinner services in china were produced
in vast quantities at this time by the German
manufacturers, notably Conta and Boehme of
Possneck. Kitchen equipment and bathroom
fittings were cast in lead or bronze and many of
the great glassworks turned out tiny glassware
for dolls' houses in addition to their standard
lines. Where money was no object, however, the
best craftsmen were commissioned to produce
special items, but these are now of the greatest
rarity since they were usually produced for a
specific order. The well-known Titania's Palace,
Queen Mary's dolls' house and the Russell
dolls' house (now on permanent loan to the
Bethnal Green Museum, London) are the best
known examples of sumptuously furnished
houses of this period.
See *Dolls, Model Soldiers, Toys*

Minton

English pottery established by Thomas Minton
at Stoke-on-Trent in 1793. During the nine-
teenth century, Minton's established a high
reputation for tablewares with floral and land-
scape decoration, but also produced the glazed
earthenware known as majolica (q.v.) and,
towards the end of the century, specialized in
pâte sur pâte (q.v.) decoration. Minton's also
produced some of the finest examples of parian
ware (q.v.), during the second half of the century.
The traditional forms of painted porcelain
services continued to be produced in the period
under review.

Minton's were especially fortunate in securing
the services of many Continental artists and
craftsmen. Henry Mitchell was a talented painter
of animal motifs working for the company from
the early 1860s to the end of the century. Richard
Pilsbury (1830–97) was one of the leading floral
artists of his day and he decorated the tablewares
for Minton between 1866 and 1892, specializing
in orchid motifs in the later period. Anton
Boullemier, an Alsatian artist, was employed
at the pottery from 1872 until his death in 1900
and excelled in portraiture and allegorical com-
positions. His sons, Henri and Lucien, carried
on this tradition at the turn of the century.
William Mussill was another French-trained
artist, formerly employed at Sèvres, who decor-
ated porcelain for Minton's between 1872 and
1906. His work in this field was carried on by
his able pupil, Henry Penson. J. E. (Teddy)

190

Late 19th century pilgrim bottle in earthenware by
Minton.

Dean worked at Minton's from 1882 to his
retirement in the 1920s and, though he was
extremely versatile, he is best-known for his
animal, fish and game studies. Herbert Wilson
Foster (1848–1929) joined Minton's in 1872
and from then until 1893, when he took up a
teaching appointment at the Nottingham School
of Art, he produced portraiture, bird and animal
subjects for reproduction in porcelain. Edmund
Reuter produced floral designs for Minton's
for about twenty years, before returning to his
native Switzerland, in 1895, to concentrate on
water-colour painting. Albert Wright, who joined
the firm in 1871, specialized in hunting scenes
and these were immensely popular in the United
States to which country many of his richly
gilded dishes were exported at the turn of the
century.

Minton's, however, were also fully conscious
of prevailing developments, having been asso-
ciated with the Arts and Crafts Movement
(q.v.) from the outset. The company sponsored
a short-lived experiment in the early 1870s,

when an Art Pottery Studio was established at Kensington Gore in London. The wares produced at this studio were marked 'Mintons Art-Pottery Studio Kensington Gore' and are now in great demand. Although the studio had a brief existence, many talented artists received their training there, including A. B. Donaldson, Edward Hammond, Edmund Reuter, Matthew Elden, John Eyre and J. D. Rockfort. While Marc Solon directed the traditional output of Minton's, his son Leon (1872–1957) concentrated on pottery and porcelain decorated in the style of Art Nouveau (q.v.). Solon was trained at the Hanley School of Art and the South Kensington School, working part-time for Minton's while still carrying on with his studies. As early as 1890, *The Studio* (q.v.) was taking note of Solon's work as 'an untiring experimenter and, with the resources at his command, likely to develop to its utmost the possibilities of the craft to which he is devoted'. As Art Director and designer at Minton's, he introduced many simple but pleasing designs and techniques involving coloured slips, sgraffito decoration and acid-etching.

Minton's was one of the few potteries which proved equally versatile in porcelain and earthenware, producing majolica and Palissy wares as well as fine china. The *Art Journal* (1896) summed this up: 'They have never been excelled by any firm at any time in resourcefulness leading to complete success in new departures of ceramics. There is scarcely a branch of pottery manufacture which they have not made their own.'

Model Soldiers

Though model soldiers were in existence in the eighteenth century, they did not appear in their present form until the late nineteenth century. The earliest soldiers were flat, two-dimensional figures in all shapes and sizes. In 1848, Heinrichsen of Nuremberg standardized his models on the 30mm scale which was subsequently adopted by other manufacturers. The French began producing *rond bosse* or three-dimensional figures about 1870 and many of these were subsequently manufactured in Germany for export, since Germany collectors continued to prefer 'flats'. The industry was revolutionized in 1893, when William Britain of London invented a process for hollow-cast, three-

dimensional figures. Britain's soldiers were not only more realistic than their German counterparts but, requiring far less metal, were considerably cheaper and rapidly captured the British market. These soldiers were standardized to the No. 1 model railway gauge and thus were relatively large, on the scale of 54mm. Although, in more recent years, the much smaller 'double 0' gauge has become popular, the original 54mm scale continues to be that used by model soldier collectors and war-gamers. Britain subsequently became the largest manufacturer of model soldiers in the world.

From the collector's viewpoint, the soldiers in greatest demand are those manufactured between 1893 and the end of the First World War, distinguished by their round, instead of square, bases with the name 'BRITAIN' stamped on them. Apart from the individual foot and mounted soldiers, Britain produced many sets, such as the Royal Engineers balloon and winch-wagon, the pontoon-bridge builders, the horse ambulance, the field-gun and carriage, and

Pair of model soldiers of the Napoleonic period, in Sèvres porcelain, 1900.

many others. Complete sets of these composite models are now highly prized, especially if preserved with the original boxes. Model soldiers, hitherto regarded as 'child's play', developed into a serious adult pastime after the publication of *Little Wars* by H. G. Wells in 1913. Wells and Jerome K. Jerome developed the art of *kriegsfiel* in the early 1900s and are thus regarded as the pioneers of war-gaming.

See *Toys*

Mohrbutter, Alfred

German graphic artist and designer, born at Celle in 1867. Mohrbutter trained at the Weimar art school between 1887 and 1890 and subsequently at the *Academie Julian* in Paris. From 1892 to 1900, he worked in Hamburg before taking up a teaching post at the art school in Berlin-Charlottenburg. He died at Neubabelsburg, Potsdam in 1916. Mohrbutter specialized in designs for wallpaper (q.v.), textile-patterns and, above all, wall-hangings. He was one of the first artists to produce designs for the Scherrebek weavers and pioneered a style known as *Schichtweberei* (layer-weaving) in which pictorial elements were rendered in geometric forms. Among his best-known designs for wall-hangings were 'Flamingos' (1899–1901) and 'Sunset' (1896–7), in which the influence of Japanese prints can be discerned. Mohrbutter also campaigned for reform in women's costume and produced a number of designs intended to liberate the female body from the restrictions and confinement of nineteenth century corsetry and underclothing.

Moore Brothers

English pottery company, originally established as Hamilton & Moore in 1830 at Longton, Staffordshire. In 1859, Samuel Moore became the sole proprietor of the St. Mary's Works, Longton and, when his brother Bernard became a partner in 1870, the name of the firm was changed to Moore Brothers. They followed the lead of Minton (q.v.) in experimenting with *pâte sur pâte* (q.v.) in 1878. Reference was made in the *Pottery Gazette* to these early experiments in slip decoration. Moore *pâte sur pâte* was, however, technically inferior to Minton's, often showing a badly crazed glaze and this is a fault which tended to mar their porcelain wares in

Bernard Moore vase decorated by Hilda Lindop, *c.* 1905.

general. Their chief decorator was H. Sanders, formerly of Minton's, and, under his guidance, Moore Brothers specialized in an updated model of the medieval pilgrim bottle. Examples were first shown at the Sydney International Exhibition in 1879 and thereafter became a speciality of this firm. Much of the porcelain produced by Moore Brothers was retailed by Thomas Goode of London, and such items were inscribed in gold to this effect. Towards the end of the century, Moore Brothers extended the range of their decorative porcelain, often using unusual bronze and other metallic pigments, and producing passable imitations of Chinese *cloisonné* enamelling (q.v.). Richard Pilsbury, formerly of Minton's, was art director of Moore Brothers from 1892 to his death in 1897 and, during this period, white porcelain decorated with floral motifs in his distinctive style were produced. Moore Brothers was sold in 1905 and thereafter Bernard Moore concentrated on wares with Oriental glaze effects which he produced at Wolfe Street, Stoke-on-Trent.

Morris, Talwin

Scottish architect and designer (1865–1911). Morris trained as an architect and later turned to the graphic arts, working on the staff of the magazine *Black and White* before becoming art director of Blackie & Sons in 1890. Morris was a member of the Glasgow group headed by

Mackintosh, McNair and the Macdonald sisters (qq.v.) and collaborated with them in the design of furniture, stained glass and metalwork. He was also a typographer of some note and a prolific designer of book-bindings (q.v.).

Morris, William

English designer, craftsman, interior designer, writer and political activist, born at Walthamstow in 1834. Morris was educated at Exeter College, Oxford where he met Edward Burne-Jones (q.v.) and studied ecclesiastical history, medieval poetry and the works of Tennyson and Ruskin. Morris was articled as a pupil in a London architect's office in 1856 and in the same year worked on the ephemeral *Oxford and Cambridge Magazine*, through which he made the friendship of Dante Gabriel Rossetti. In 1858, he published *The Defence of Guenevre,* virtually unnoticed at the time but now recognized as one of the gems of mid-Victorian poetry. In 1859, he married and began designing for himself a house which would embody all his theories on applied art. It was from this that his career as an interior designer sprang. With his friends, he formed a company in 1862, known as Morris, Marshall, Faulkner & Company with its offices

Rosewood cabinet designed by W. A. S. Benson for Morris & Co., 1899.

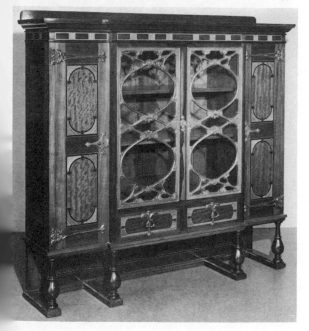

in Red Lion Square, London. The firm specialized initially in ecclesiastical furnishings—wood-carvings, stained-glass windows, embroidery and tapestry, but gradually it became more secular in scope. The business expanded rapidly and, by 1875, required drastic re-organization, with Morris becoming sole manager and proprietor. Incredibly, Morris was more interested in poetry at this time. He translated Icelandic sagas and Greek epics, as well as publishing his own works, and was offered the chair of poetry at Oxford in 1877, but declined it on the grounds of business commitments. In that year he founded the Society for the Protection of Ancient Buildings, originally to guard against the vandalistic 'restoration' of Tewkesbury Abbey. During the 1880s, he moved farther to the left politically. Originally a radical Liberal, he joined the Democratic Federation in 1883 and a year later formed the Socialist League, becoming editor of its magazine *Commonweal*. His socialism was intensely idealistic and, as the movement began to be dominated by anarchists, he adopted an increasingly negative role. His socialism was tinged with an enthusiasm for an inaccessible artistic ideal and, in the last years of his life, his energies were channelled more and more into expression of this artistic idealism.

His interest in the Arts and Crafts Movement (q.v.) attained its peak after 1881, when he took over the textile business at Merton Abbey (q.v.). The medievalism which inspired so much of his work, whether in poetry or in search of a socialist utopia, now projected itself in his tapestries and wallpapers-designs (q.v.). In 1887, he published his translation of the *Odyssey* and thereafter assumed a direct interest in typography by establishing the Kelmscott Press, which fully absorbed his last years. His crowning achievement as a printer was the great Kelmscott Chaucer, five years in the planning and two in the production. It was published in June 1896, a few months before he died.

Morris has been described as a child of the Gothic revival, a disciple of Ruskin and Pugin who was able to translate their theories into practice in a highly successful commercial venture. More than any other person, Morris wielded enormous influence on every facet of interior design, furniture, textiles, metalwork and the decoration of glass and ceramics. He was vehement in his denunciation of commercialism, yet he operated a lucrative commercial organization; and he was strongly opposed to

Ebonized dining chair by Morris & Co., *c.* 1900.

the use of machines in the applied arts, championing the cause of natural decoration and pure colour produced by hand-work and inspired by a passion for beauty regardless of cost or business efficiency. Inevitably his principles were substantially modified by many of his followers who had to compromise between craftsmanship and commercial viability.

The furniture produced by Morris falls into two distinct categories. The earliest was solid and simple in construction, joiner-made rather than cabinet-work, using oak and other traditional woods. The more expensive pieces were decorated with paintings of medieval subjects by Burne-Jones, Rossetti and Morris himself. Much of this early 'cottage' furniture was designed by Philip Webb (q.v.). Although this type of furniture continued to be made in the early twentieth century, more sophisticated furniture was also produced from 1890 onwards, with the emphasis on high-quality cabinet-work

using figured veneers and marquetry (q.v.). The chief designer of this type of furniture was George Jack (q.v.), a pupil of Webb.

In the 1890s, Morris acquired the Pimlico cabinet-making company of Holland and began turning out great quantities of 'reproduction' furniture. These pieces were of the highest quality, but somehow lacked the originality of the eighteenth century styles on which they were modelled. The design of this furniture was largely entrusted to the architect Mervyn Macartney (1853–1932), whose work was described by the company as 'following the ornate motifs of the eighteenth century'. At the turn of the century, the Morris company also produced some curious furniture to the designs of W. A. S. Benson (q.v.), ranging from pseudo-Georgian to pure Art Nouveau. Benson's forte as a metalworker is revealed in the strangely elaborate panel frames, lock-plates, handles, knobs and hinges.

Morris became interested in fabrics as early as 1857 when he took up embroidery as a hobby.

Trial page for *Sigurd the Volsung,* 1897. Vignette by Burne-Jones and border by William Morris.

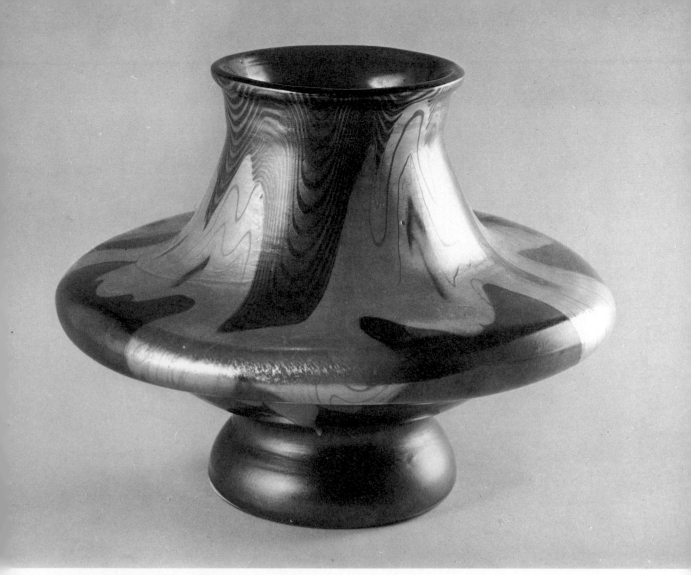

An iridescent glass vase by Lötz Witwe.

VEVER.　　PLAQUE DE COLLIER « CHÈVREFEUILLE » ÉMAIL VERT TRANSLUCIDE ET BRILLANTS　　*Reproduction interdite.*

LES MODES

ÉVENTAIL DUVELLEROY　　　　　AQUARELLE DE M. G. DARCY
FLEURS ANIMÉES　　　　　　　　EN DENTELLE AU POINT

REPRODUCTION INTERDITE

MANZI, JOYANT & C^{ie}, 24, Boulevard des Capucines, Paris. — PRIX NET : **2** fr.; Étranger, **2** fr. **50**

'Daffodil' chintz by William Morris, 1891.

The ecclesiastical tapestries for which the company was initially famous, were embroidered by Morris who also taught this skill to his wife and two daughters. Other wall-hangings were worked by Georgiana Burne-Jones, Lucy Faulkner (sister of his partner Charles Faulkner) and Morris's sister-in-law, Miss Burden. In the 1870s, many of Morris's textile designs were woven for him by other companies, but from 1879 onwards he began carpet-weaving in the coach-house of his home at Hammersmith, London and the acquisition of the Merton Abbey works, two years later, enabled him to expand this aspect of the business very considerably. As well as tapestries, rugs and carpets (q.v.), Morris produced chintzes and damasks, together with matching wallpapers.

Plain tiles (q.v.), imported from the Netherlands, were painted by Charles Faulkner and his sisters Kate and Lucy, using designs by Morris, Burne-Jones and Webb featuring fairytales, the four seasons and scenes from Chaucer. From 1876 onwards, tiles were also manufactured for Morris by William de Morgan (q.v.). Relatively little metalwork was produced and,

◀ Decorative cover for *Les Modes,* June 1901.

apart from a few bronze candlesticks, few pieces appear to have survived. Both Burne-Jones and Webb designed jewellery which was marketed by Morris, Marshall and Faulkner. Stained glass, mainly for church windows but latterly for private houses, was one of the company's principal products, personally supervised by Morris. After 1875, the designs became much more elaborate, under the sole direction of Burne-Jones who specialized in this field until his death in 1898. The firm also produced a sizeable amount of table glass, designed by Philip Webb and manufactured for Morris by Powell's of Whitefriars. The simple designs of the thinly-blown glass contrasted sharply with the over-elaborate cut glass which was popular at the time. Consequently Morris glassware found little favour with the general public, though it has a startling affinity with present-day glass.

Prior to 1865, all the interior designs produced by the company had been for churches, but thenceforward Morris received many secular commissions. The first important commission was for the decoration of one of the refreshment rooms at the Victoria and Albert Museum, and this has been preserved as the so-called

197

Green Dining Room. Subsequently Morris did much of the interior decoration for St James's Palace and the name 'St James's' was later used for a range of wallpapers and textiles commercially marketed by the firm. These and other important public commissions helped to popularize Morris patterns, especially in wallpaper and, by the turn of the century, no fewer than forty-one wall- and five ceiling-paper patterns were being printed for Morris by Jeffrey and Company of Islington.

The original policy of the company was continued after Morris's death, but, in 1905, it was transformed into yet another department store selling the commercial (and mechanically produced) goods of other companies. Thereafter the fortunes of the firm declined and it went into liquidation in October 1940.

See *Art Nouveau, Arts and Crafts Movement, Fabrics, Furniture, Glass, Merton Abbey, Private Presses, Studio Pottery, Wallpaper*

Moser, Koloman

Austrian artist and designer, born in Vienna in 1868. Moser studied art under various masters, principally Franz Marsch, and was a founder member of the Vienna *Sezession* (q.v.) in 1897. With Josef Hoffmann (q.v.) and Fritz Wärn-

Book-plate for Fritz Wärndorfer, designed by Koloman Moser.

dorfer, he founded the *Wiener Werkstätte* (q.v.) in 1903. From 1899 to his death in 1918, he was a lecturer at the Vienna school of arts and crafts. As a painter, Moser produced frescoes, theatrical sets and designs for stained-glass windows. As a graphic artist, he designed lettering and produced numerous posters (q.v.) and was also one of the few artists to design postage stamps (q.v.) in the *Jugendstil* (q.v.) genre. In the latter field, Moser designed the stamps issued by Austria in 1908 to mark the Diamond Jubilee of Kaiser Franz Josef, the eightieth birthday series of 1910, the Austro-Hungarian military stamps of 1915, as well as the definitive sets for Bosnia (1906 and 1912) and the early stamps of Liechtenstein (1912–18). Moser ranks as one of the most prolific designers in the applied arts at the beginning of this century, working in the media of furniture, textiles, book-binding, glassware, leatherwork, metalwork, jewellery and even toys.

Moser, Ludwig

A glasshouse founded by Ludwig Moser at Karlsbad (Karlovy Vary) in Bohemia in 1857. By the close of the nineteenth century, it was producing the finest carved and cameo glass (q.v.) in the Austrian empire. Moser and Sons did not follow the fashion of the time and produce iridescent glass like the other leading manufacturers, but concentrated instead on moulded and crystal glass. The moulded glass, in various shades of purple, was decorated with gilt friezes of plants or dancing figures. The crystal ware was often overlaid with green or purple glass which was then carved or etched. Many different techniques, such as etching, engraving, carving, faceting and enamelling, were often combined in a single vase with pleasing results. The iris was the most popular motif, lending itself admirably to the combinations of purple and green which Moser preferred. Moser emerged, after the First World War, as the leading glasshouse of Czechoslovakia and continued, until fairly recently, to produce heavy vases decorated in the *fin de siècle* style.

Mount Washington Glass

The Mount Washington Glass Works was founded by Deming Jarves in 1837, taken over by

'Crown Milano' cracker jar, 'Napoli' cracker jar, 'Royal Flemish' bottle, from the Mount Washington Glass Co., *c.* 1895. (Corning Museum of Glass)

William Libbey and Timothy Howe in 1856 and transferred to New Bedford, Massachusetts in 1869. Subsequently the company became known as W. L. Libbey & Co. Libbey (q.v.) was subsequently involved in the fortunes of the New England Glass Company (q.v.) after it moved to Toledo, Ohio in 1888. The Mount Washington Glass Works resumed its original name in 1871 and continued until 1894 when it was taken over by the Pairpoint Manufacturing Company (q.v.). Under Frederick S. Shirley, factory director from 1874 to 1887, Mount Washington became the leading manufacturer of art glass in the United States. Beginning with opalescent decorated wares in the 1870s, Mount Washington copied the 'Amberina' glass of its rival, the New England Glass Company, and, when legal action was threatened, changed the

name of its shaded glass to 'Rose Amber'. In 1885, Shirley was granted a patent for Burmese glass (q.v.), subsequently manufactured under licence by Thomas Webb (q.v.) in England. 'Peach Blow', shading from bluish white to deep pink, was another Mount Washington speciality, emulated by Hobbs, Brockunier (q.v.) and the New England Glass Company.

From 1886 onwards, Mount Washington produced great quantities of an art glass known as 'Pearl Satin Ware' on account of its matt finish, achieved by exposing the glass to hydrofluoric acid. In addition, this company produced a wide range of decorated wares known under such trade names as 'Albertine', 'Crown Milano', 'Napoli' and 'Royal Flemish'. The last-named achieved great popularity in the 1890s; its principal distinguishing feature was its finely

199

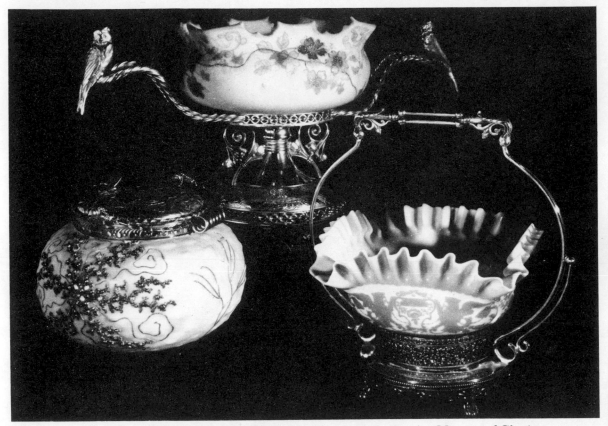

'Crown Milano' cut glass by the Mount Washington Glass Co., *c.* 1890. (Corning Museum of Glass)

painted enamels with designs in high relief, emulating the decoration on the porcelain known at that time as 'jewelled Sèvres'. The commonest motifs were classical medallions, but winged subjects, such as birds, cherubs and mythical creatures, were also depicted. This technique was patented by the Mount Washington foreman, Albert Steffin, in 1894 (though it was being used by the company as early as 1889). In this process, beige or brown enamel was applied to the acid-finished matt surface of the glass, and the design outlined in gold. French porcelain of the eighteenth and Islamic pottery of the fourteenth centuries strongly influenced this eclectic glassware in both decoration and shape.

See *Paperweights*

Mucha, Alphonse

Czech painter and graphic artist (1860–1939). Largely self-taught, Mucha left Bohemia to work in Paris in the closing years of the last century. His mastery of the sinuous fluidity of Art Nouveau has earned him the sobriquet 'dancing dervish of the graphic line'. He worked in straitened circumstances in Paris, but a rush job—a poster for the actress Sarah Bernhardt—gave him his first real break in December 1894. The work was executed within a few days and Paris woke up on New Year's morning 1895 to find the poster for *Gismonda*—an immediate success which established Mucha as a poster artist of the first rank. His use of soft, gentle colours—tender greens, faded yellows and pale reds—contrasted strangely with the vivid scarlets and vermilions favoured by Cheret (q.v.), but the effect of these so-called 'white colours' served to enhance the luxuriance and opulence of his drawing.

Bernhardt was enchanted with Mucha's work and employed him exclusively over the next six years, the hey-day of Art Nouveau. Probably the best-known poster which he designed in this period (and oft-reproduced in recent years)

Lithographic *panneau décoratif* by Mucha, 1897.

◀ Poster for Sarah Bernhardt, designed by Mucha, 1905.

was that depicting the great tragedienne in the role of *Lorenzaccio* by de Musset, which opened in 1896 at the *Theatre de la Renaissance*. This poster, depicting Sarah Bernhardt in her chocolate page's costume on a background of gold filigree, was enormously popular and established Mucha as the poster artist *par excellence*. He held his first exhibition the following February and, on the eve of the opening, Sarah wrote to him: 'The delicacy of your drawing, the originality of your compositions, the lovely colours of your posters and pictures—all this will charm them the Parisian public and after your exhibition I predict fame for you.'

Fame certainly came his way; the poster artist of the 1890s maintained his distinctive style long after Art Nouveau was on the wane and the first postage stamps and banknotes of an independent Czechoslovakia in 1918 were the last flowering of Art Nouveau. Examples of Mucha's other-worldly long-haired girls are to be found in jewellery, interior decoration and textile patterns as well as lithographs and posters. These girls, with their meditative, dreamy expression, great masses of intertwining tresses and a sumptuous dress that is at once Oriental, barbaric and refined, were the hall-mark of Mucha's work and more than anything else symbolized Art Nouveau.
See *Posters*

Munthe, Gerhard

Norwegian painter and designer, born at Elverun, in 1849. Munthe studied art in Düsseldorf (1874), Munich (1877) and Paris (1883). His style of painting was initially realistic but later he turned to Impressionism. By 1890, however, he had evolved a distinctive decorative style, based on old Norwegian and medieval forms of folk art, and this he applied to various branches of the applied arts, principally wall-hangings, of which his 'Daughters of the Northern Lights' is the best known. Munthe died at Elverun in 1929.
See *Carpets and Tapestry*

Musical Boxes

The Victorian musical box developed out of the elegant toys produced by the Swiss manufacturers of Chaux de Fonds in the eighteenth century. From then until about 1830, snuff-boxes, ele-

Late 19th century French 'bird-in-a-cage' automaton.

gantly jewelled and enamelled cases and even pistols were produced, containing a miniature clockwork mechanism playing anything up to ten or twelve popular melodies. A similar device was used on a simpler basis in watches of the period, playing a melody when the lid was opened. Musical boxes, often accompanied by figures operated by clockwork, spread to other parts of Europe and America in the nineteenth century. By 1890, the art had deteriorated and the boxes themselves are seldom as well-fitted or finished as the earlier examples, but technically they had greatly improved. In quality, tone and range, the music was often more ambitious and more complex than in the mid-century boxes, and some attempts were made to simulate

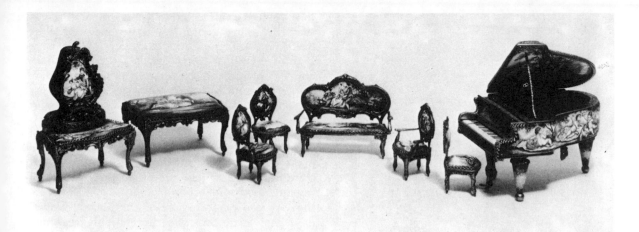

Collection of Viennese musical boxes in furniture form, early 1900s.

various instruments; a far cry from the simple, tinkling tones of the Swiss originals. As cabinet-work declined, the style of boxes expanded enormously in scope. Shell-decorated boxes first became popular in the 1890s, and novelty boxes, in the form of houses, castles and money-banks, were all the rage. The most desirable boxes are those with beaten metalwork, decorated with enamelling and semi-precious stones and exhibiting the characteristic lines and plant motifs of Art Nouveau.

Rare Nicole Frères percussion cylinder musical box. Swiss, *c.* 1900.

Musical Instruments

The most popular musical instrument at the turn of the century was undoubtedly the piano, and few homes in Western Europe and America would have been without one. In the era before radio and television, the piano was the focal point of most home entertainments, a position which it maintained until after the First World War. Consequently there was a wide range of pianos available to the public in the late nineteenth century, both upright and grand. The finest pianos were made in Germany and, to this day, such names as Bechstein, Steinweg and Blüthner command a high premium. Ludwig Bösendorfer made pianos for the *nouveaux riches* of Austria. Theodore Steinway brought the art of piano manufacture to the peak of perfection in the United States, while Collard and Collard of London, then as now, provided sumptuous pianos for the upper classes of England. Although these are the most important names of the period, there were many other manufacturers producing excellent instruments. In Germany and France, designers concentrated on the tone of the instrument and the quality of the case, whereas British and American manufacturers concentrated on novelty of shape, technique and the invention of mechanical aids. From England, for example, came the patented 'expanding and collapsing pianoforte for gentlemen's yachts' and, no doubt with the storm-tossed yacht in mind, there was even a piano mounted on rockers which kept upright in any weather! The British and Americans obviously

So-called Manx piano, designed by Baillie Scott for John Broadwood & Sons, 1898.

in it rotated against a tracker bar in such a way that the piano action could be operated. The best-known names in the early 1900s were Pianola, Ampico, Angelus, Duo-Art (Aeolian) and Welte-Mignon. Player-pianos were an American invention, but large numbers of them were exported to Europe up to the Second World War.

The late nineteenth century was also a time of great invention in stringed instruments and many variations on the harp, zither and guitar were marketed. They combined the features of several instruments and aimed at improving the virtuoso performance of the player, Nowadays, however, they are more highly regarded on account of their decoration, fine marquetry (q.v.), gilding, japanning and carving in the prevailing Art Nouveau style.

Pianola invented by Edwin S. Votey, 1896.

delighted in instruments which were not always quite what they seemed. In England, Richard Hunt patented the tavola, which looked like a dining-table but in fact concealed a piano operated by clockwork. Conversely the Americans produced the piano-bed, which looked like a piano but which, in fact, opened out to form a bed. This was the ancestor of the collapsing or folding beds favoured in bed-sitters and small apartments at the present time, and the fact that it was necessary to disguise such a useful piece of furniture as a piano, complete with fretted front and pedals, is a commentary on late-Victorian ideas on propriety.

The turn of the century was also the hey-day of the pianola or player-piano, fitted with a mechanism for automatically playing written music or for reproducing the playing of a pianist. This device operated on the principle of air pressure. A roll of paper with holes punched

Nancy School

Name given to the artists and craftsmen working in Nancy which, with Paris, was the leading French centre of the applied arts in the late nineteenth century. The Nancy School was grouped around Emile Gallé (q.v.) who was its theorist and guiding light, especially in the fields of glass and furniture. It was the declared aim of the Nancy School to reject 'the imitation of old styles in favour of a new principle, that of the scientific observation of live models'. By the 1890s, however, the former rejection of mechanical aids to production had been substantially watered down. Apart from Gallé, the principal exponents of glass in the Nancy School were Daum Frères (q.v.), Delatte, Arsall, Muller Frères, D. Christian and Michel. The furniture produced at Nancy was generally more robust than that produced in Paris, with a distinct provincial appearance and stronger, heavier and more imposing forms. Whereas the Parisians preferred to model the legs and other parts of a piece as an abstraction or stylization of a plant, the Nancy craftsmen would often carve these components in a realistic manner, close to the natural form of the plant. Marquetry (q.v.), seldom practised at Paris, was very popular at Nancy where local fruitwoods could be utilized. The thistle and cow-parsley were favourite motifs of the Nancy craftsmen. Gallé himself designed an entire bedroom suite with cow-parsley decoration. The best of the Nancy furniture-designers was Louis Majorelle (q.v.), but Eugène Vallin and Victor Prouvé (qq.v.) both designed furniture and decorative panels for Gallé and Majorelle.

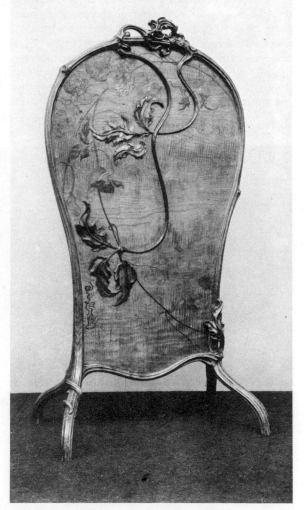

Ash screen designed by Emile Gallé, shown at the *Exposition Universelle*, 1900.

Newcomb Pottery

The Sophie Newcomb Memorial College for Women, an adjunct of Tulane University, New Orleans, established a pottery in 1895 to give practical training in art and design, as well as experience, in a field which was at that time open to women. Mary Sheerer, a graduate of Cincinnati Art Academy, was appointed by Professor Woodward to direct the pottery. From the beginning, the Newcomb Pottery produced fine, simple wares which found a ready market. At first strongly influenced by the Rookwood (q.v.) glazes, Newcomb failed to match up to their quality and turned instead to totally new styles of decoration, in which light green glazes covered the upper part of the vessel and the lower portion was left an unglazed reddish-brown. This style of decoration, common in the studio pottery of the present day, was quite novel at the turn of the century. Miss Sheerer and her students experimented continually with new shapes and glazes and, because they did not have to concern themselves with a commercial market, they were able to concentrate

on good, honest functional designs. Plant motifs —cotton, magnolia, rice and other plants found in the Louisiana area—were carved or incised and then delicately sponged to expose a fine sand on the surface, which gave a misty effect under the glaze. After 1910, motifs became more naturalistic, less stylized, and new matt glazes were developed in place of the earlier glossy glazes. Newcomb Pottery was marked with an 'N' within a 'C' and often bore the initial of the individual potter within a lozenge.

New England Glass Company

American glassworks operating in Cambridge, Massachusetts from 1818 to 1888, and thus strictly outside the scope of this book. In 1888, however, the firm was taken over by Edward D. Libbey and transferred to Toledo, Ohio where it was subsequently known as the Libbey Glass Company (q.v.). The New England Glass Company was in the forefront of the American art glass movement of the 1880s, under the direction of an English immigrant, Joseph Locke, who

Three pieces of 'Agata' glass by the New England Glass Co., *c.* 1888. (Corning Museum of Glass)

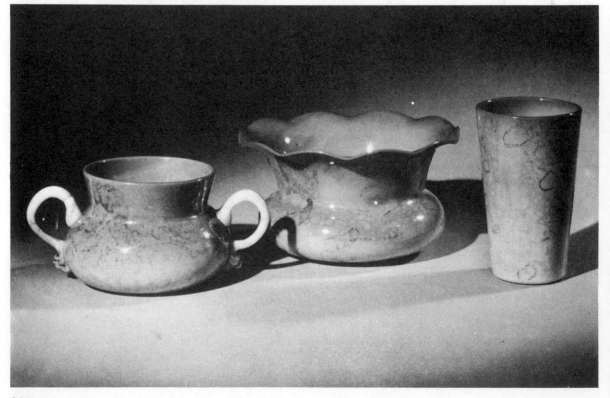

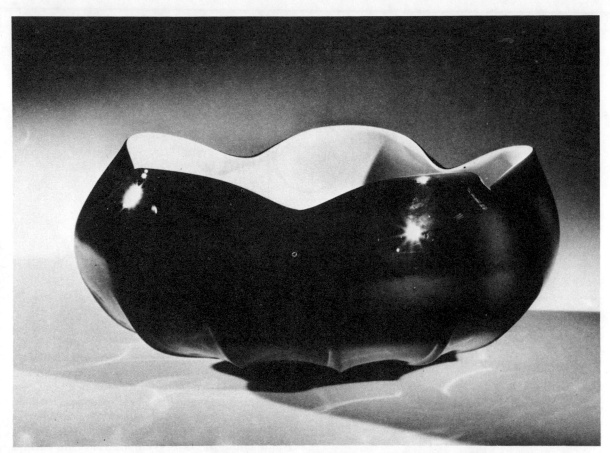

Plated Amberina bowl by the New England Glass Co., *c.* 1890. (Corning Museum of Glass)

produced the first bi-partite or shaded art glass, known as 'Amberina', in 1883, and went on to develop 'Wild Rose', 'Agata' and 'Plated Amberina', the last-named being 'Amberina' glass encasing an opaque-white glass and invariably pattern-moulded. These forms of art glass were subsequently produced by the Libbey Glass Company.

Nicholson, William

English painter and graphic artist, born at Newark-on-Trent in 1872. For a short time in the early 1890s, he studied art at the *Academie* *Julian* in Paris but was mainly self-taught. In 1896, he began producing wood-cut portraits of famous personalities for book- and magazine-illustration and these included Sarah Bernhardt, Prince Bismarck and Queen Victoria. From 1898 onwards, he was a contributor to *The Studio* (q.v.). His woodcuts were typified by their square format with heavy outlines, simple line backgrounds and relatively solid figures, with sharp contrasts between light and dark. With James Pryde (q.v.), he formed the partnership known as the Beggarstaff Brothers (q.v.) and, under this pseudonym, they won a high reputation for their wood-cut posters.
See *Posters*

Obrist, Hermann

Swiss sculptor and designer, born at Kilchberg, near Zürich, in 1867. Obrist studied natural history at Heidelberg and attended the art school in Karlsruhe in 1888. Subsequently he studied ceramic design and modelling in Weimar and then worked at Bürgel in Thüringia for the Grand Duke of Saxe-Weimar. Later he turned to sculpture, a medium in which he was largely self-taught. In 1892 he founded, with Berta Ruchet, a weaving workshop in Florence, transferred to Munich two years later under the name of *Der Peitschenhieb* (the whip-lash). In 1897 he was a founder member of the *Vereinigte Werkstätten* (q.v.)—united workshops—in Munich and collaborated with them until his death in 1927. Obrist was a prolific designer of memorials, furniture, ceramics and textile patterns.

Olbrich, Joseph Maria

Austrian architect, painter and designer, born at Troppau in 1867. Olbrich studied at the Vienna Academy and was a pupil of Hasenauer and Otto Wagner (q.v.). With Hoffmann (q.v.) he ranks as the leader of the Vienna *Sezession* (q.v.) which they founded in 1897. As an architect, Olbrich was responsible for the designs of the Hofpavillon and the Karlsplatz Bahnhof in Vienna as well as many of the structural features of the Vienna Metropolitan Railway. Following

Sketch for a tower, by Hermann Obrist, *c.* 1902–5.

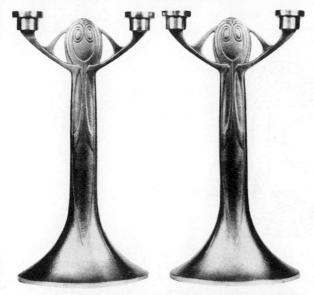

Pewter candle-holders by Joseph Maria Olbrich, 1902.

on the foundation of the *Sezession* movement, he was entrusted with the design of its special exhibition building, whose opening was planned to coincide with the celebrations marking Emperor Franz Josef's golden jubilee. In 1899, Olbrich joined the artists' colony formed at Darmstadt under the aegis of the Grand Duke Ernst Ludwig of Hesse. Here he designed the Matildenhöhe palace, his most important commission, but also designed furniture, metalwork and jewellery in the prevailing *Jugendstil* manner. Olbrich died at Dusseldorf in 1908.

Owens Pottery

American art pottery which flourished at the turn of the century. The pottery was founded at Zanesville, Ohio by J. B. Owens and originally concentrated on commercial and domestic wares. In 1895, however, William A. Long, who had previously organized the Lonhuda Pottery (q.v.) at Steubenville, joined the Owens company and directed its activities in art pottery, using the slip decoration and glazes formerly used in the 'Lonhuda' and 'Louwelsa' ceramics. Art pottery manufactured by Owens at the turn of the century went under the name of 'Utopian' ware. Other 'brand names' were used, but these were never inscribed on the pottery. At the peak of their output, the Owens Pottery employed more than forty artists to decorate their wares, of whom Albert Haubrich is probably the best known. The factory was badly hit by the economic depression of 1907 and was forced to close down. Owens pottery is characterized mainly by its dark brown glazes with bird and floral motifs, borrowed from Japanese originals, in contrasting lighter colours.

Pairpoint Glass

The Pairpoint Manufacturing Company was established at New Bedford, Massachusetts in 1880, next door to the Mount Washington Glass Works (q.v.). It produced a wide range of decorative and domestic wares in silver and electroplate (q.v.). Glass for lamps (q.v.), cookie jars, cake-stands and other objects was supplied by Mount Washington and the two firms had a very close connection. In 1894, the glassmaking operation of Mount Washington was taken over by Pairpoint. Although the Mount Washington name was often retained in certain instances, new lines of glassware came to be known as Pairpoint. Pairpoint specialized in brilliant over-lay glass with deep cutting in the prism and bulls-eye pattern patented in 1898. Deep cutting in fan, hobnail, star and diamond motifs was also practised on colourless glass. Novelty wares in opal glass, such as salt and pepper shakers in the form of eggs or tomatoes, were another popular line in the early 1900s. Paperweights (q.v.) were produced in the Mount Washington tradition, but also included the so-called Pairpoint weights, large footed spiral weights produced in the period up to the First World War. After many vicissitudes and changes of name, the Pairpoint Glass Works closed down in 1958.

Pankok, Bernhard

German architect, sculptor, painter, graphic artist and designer, born at Münster in 1872. Pankok studied in the Academies of Düsseldorf and Berlin and worked in Munich from 1892 to 1902 where he collaborated on *Jugend* (q.v.) as an illustrator. He was a founder member of the *Vereinigte Werkstätten* (q.v.) and also helped to compile the German catalogues for the *Exposition Universelle* of 1900 (q.v.). From 1902 onwards, he lived in Stuttgart and was Director of the state school of arts and crafts from 1913 to 1917. He died in Baierbrunn, Upper Bavaria, in 1943. As an architect, he was strongly influenced by Van de Velde and Mackintosh (qq.v.) and believed in the total concept of a house, down to the last detail. The so-called Alcove at the Paris exhibition was an excellent example of his theories put into practice, in which the panelling, ceilings, lighting, floor-covering, furniture and even the embroidered cushions, were designed by him. The fluid lines of this room, especially in the beams and wall panelling, were inspired by the interior of a medieval Hanseatic *kogge* or caravel. Medieval shipping provided Pankok with the inspiration for much of his subsequent interior design. For the St. Louis International Exposition in 1904, he designed a music room, strongly reminiscent of a marine aquarium, with its coral and shellfish motifs, and lamps like fronds of seaweed. Nautical motifs decorated the plane surfaces of the furniture, the principal feature of which was a grand piano, but the smaller items—chairs and stools—were very much ahead of their time and would not be out of place in a contemporary setting. Pankok was one of the most versatile designers of *Jugendstil* (q.v.) working in the fields of theatrical settings, book-illustration and book-binding, metalwork and jewellery as well as furniture.

Paperweights

Small bibelots remained popular at the turn of the century, although the classic period of production (1842–70) was long past. The majority of paperweights were made of glass, but it should be noted that a few were made of pottery, and in this group the Doulton and Minton majolica (qq.v.), oblong paperweights deserve notice. Glass paperweights, at the turn of the century, fall into two broad categories. At the lower end of the price scale were the flat, oblong weights with prints or photographs of seaside resorts, scenery, landmarks and tourist attractions affixed to their base. Similar paperweights, portraying Queen Victoria, celebrated her golden and diamond jubilees (1887–1897). These weights were mostly of German origin, exported in large quantities to other countries where the decoration could be added. Long despised by the paperweight *aficionado,* these tourist weights have now caught the attention of collectors and have consequently risen greatly in value.

Paperweights in the classic *genre* of Baccarat, Clichy and St Louis continued to be produced in France around the turn of the century, but this was a sporadic business and such weights (attributed to the Pantin and other factories) are now thought to have been 'end of day' wares made by individual craftsmen and not intended for the commercial market. The revival of paperweight manufacture in France was due to the *Exposition Universelle* of 1878 at which Pantin weights were exhibited. It is possible, though by no means certain, that a few weights were being made at Baccarat at the beginning of this century, by a craftsman named Dupont. These Dupont weights have Baccarat characteristics, but the *millefiori* canes are smaller. In England, the production of paperweights was conducted intermittently by the Whitefriars glassworks, using traditional *millefiori* patterns. Large bottle-glass weights, containing floral or plant motifs composed of fine bubbles, were produced by J. Kilner & Sons of Yorkshire from 1830 to the 1920s and undoubtedly the

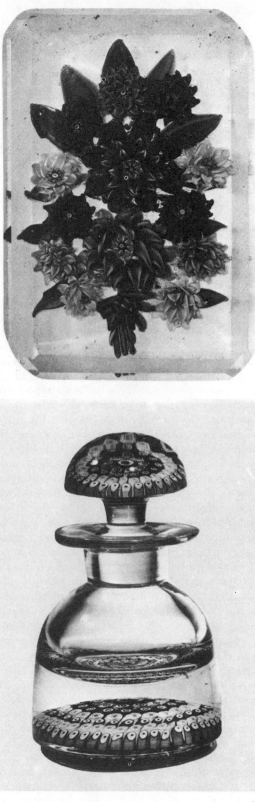

Above A very rare, large, rectangular floral plaque by the Mount Washington Glass Works, late 19th century. The bunch of flowers is tied with a red bow.

Right A large *millefiori* inkwell and stopper from the so-called 'Stourbridge' factory, English, late 19th century.

majority of those now in existence date from the late nineteenth century. These comparatively crude, 'door-stop' weights were a form of folk art, produced by the workmen in the bottle-glass factories of Yorkshire as 'end-of-day' ware. A few of these weights contain sulphides of Queen Victoria or King Edward VII, celebrating the diamond jubilee (1897) of the former and the coronation (1902) of the latter. In Scotland, sulphide paperweights portraying Robert Burns, William Shakespeare, the Duke of Wellington, Lord Byron and other personalities, were produced by John Ford of Edinburgh and the Holyrood Glassworks, but paperweights in the *millefiori* pattern or bottle-glass types of the Yorkshire glassworkers seem to have been neglected.

In Europe itself, the bulk of traditional paperweight production at the turn of the century took place in Belgium and Scandinavia. The Val St Lambert company of Belgium made *millefiori* weights and a few flower and fruit weights as late as the 1920s. A few weights are known to have been made in Sweden and Denmark between 1880 and 1920, but the evidence is so sparse that exact attribution has not so far been possible. The bulk of paperweight production at the beginning of this century took place in the United States. Traditional *millefiori* weights were produced by the New England Glass Company from 1850 to 1880, but flower-basket weights and fruit weights on a distinctive 'cookie' base were also manufactured towards the end of that period. Large footed spiral weights were produced by the Mount Washington Glass Works and its successor Pairpoint (qq.v.) at the turn of the century. These highly distinctive weights consist of a large solid globe mounted on a base. Within the globe is a spiral arrangement in opaque white with deep blue or red contrasting ribbons interspersed with bubbles which form a regular, spaced pattern. The bases of these so-called Pairpoint weights were intricately engraved. 'End-of-day' weights, often incorporating crude patriotic motifs, were produced in the Millville glassworks, New Jersey. In contrast are the beautiful Millville rose weights produced by individual artist-craftsmen, such as Ralph Barber, Marcus Kuntz, John Rhulander and Emil Stanger in the period down to 1912. Other Millville weights from this period featured tulips, lilies, ships, hunting scenes and the American eagle. The picture weights were largely the work of

212

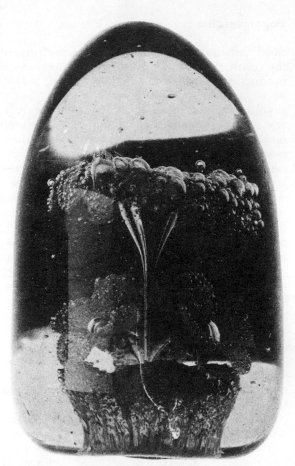

English flower weight by Kilner, *c*. 1890.

Michael Kane. Beautiful flower weights, by Tobias Hagberg and Ernest von Dohln, were produced intermittently by the Dorflinger Glass Works (q.v.) up to 1921 when this firm went out of business. Butterfly, fruit and flower weights were made by Nicholas Lutz at the Union glassworks, Somerville, Massachusetts between 1895 and 1904, but other craftsmen of this factory also produced relatively large weights intended as gifts to relatives and friends. Emil Avinwell and Philip Bunamo carried on the Lutz tradition, making floral, anniversary, strawberry, animal and patriotic weights (the last dating around 1917–18 when the United States entered the First World War). A few very large weights were made by Tiffany (q.v.) in his distinctive Favrile glass, with motifs derived

'The Angel of the Night': decorative panel in mother-of-pearl and opal-decorated gesso by Frederick Marriott, 1904.

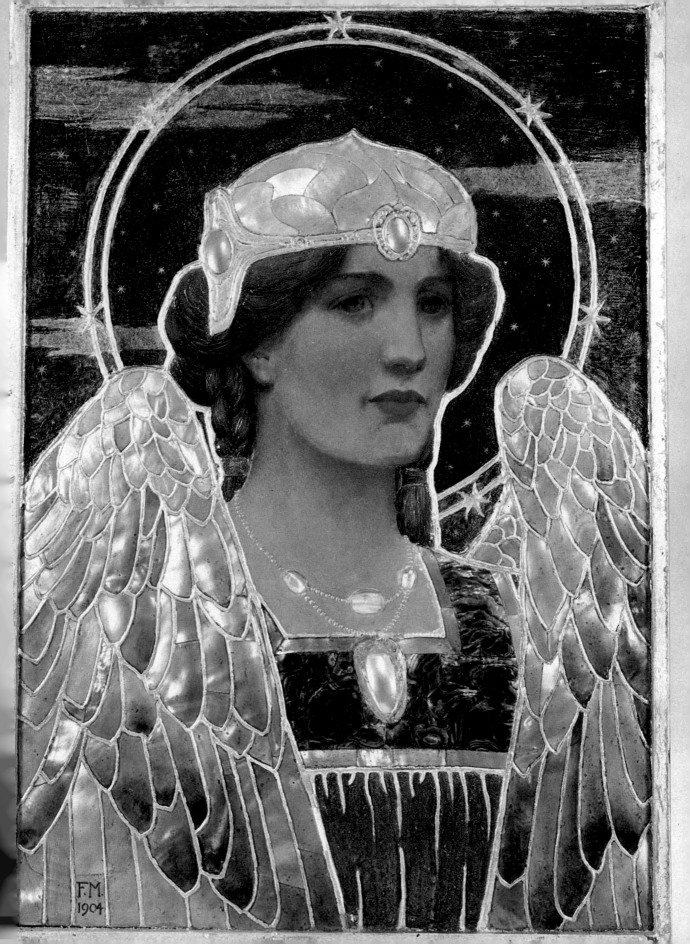

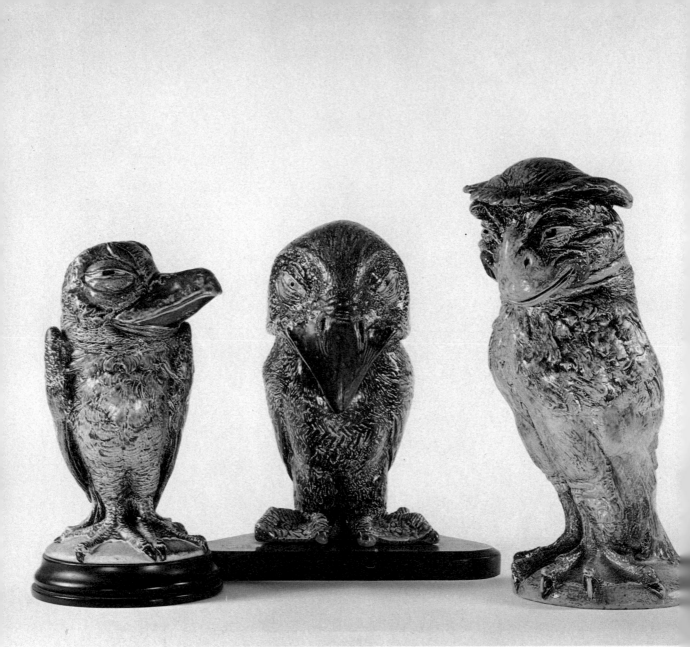

Martinware birds, signed and dated (left to right),
1897, 1881, and 1901.

from marine life. Other companies which are known to have made paperweights in this period include the Fostoria, Ravenna, Hendrix and Tiffin glassworks (all of Ohio).

Parian Ware

A white, matt porcelain, sometimes known as statuary porcelain, invented in England in the

Parian ware figure modelled by R. J. Morris, 1884.

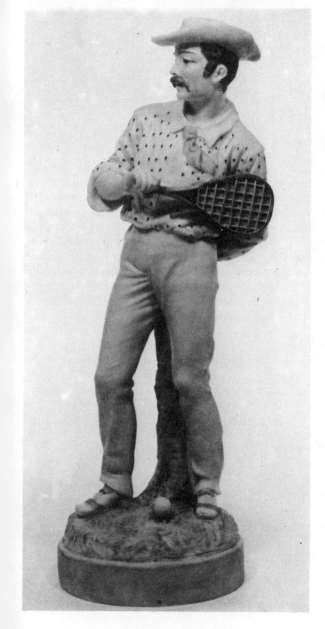

1840s and used in the manufacture of busts and figures simulating marble. Parian ware was first produced commercially by Copeland and Garrett and this firm preferred the term 'statuary porcelain' to describe their wares. Minton's (q.v.) popularized the term 'parian' which they had first used for a similar substance as early as 1831, while Wedgwood preferred the term 'Carrara', alluding to the fine statuary marble quarried there. The general public, and subsequent generations of collectors, however, have found the name 'parian' more convenient. Parian ware was shown by several firms at the Great Exhibition of 1851 and, in the ensuing half century, it was produced in great quantities by many English potteries, varying considerably in quality and design. It has been estimated that well over a hundred companies produced parian figures and busts in this period, though many of the smaller manufacturers did not bother to mark their wares. One of the outstanding manufacturers of parian ware was Robinson & Leadbetter, who produced nothing else between 1850 and the 1920s. Unfortunately the bulk of their products were unmarked, though a few late nineteenth century examples are known with the initials 'RL' impressed on the base, with 'Ltd' added after 1887. Many pieces by this firm were gilded and coloured, whereas most examples of parian ware by other potteries were left uncoloured.

Pâte de Verre

French term meaning literally 'glass-paste'. It is sometimes found in French auction catalogues or art dealers' lists, used erroneously to describe cameo glass (q.v.). True *pâte de verre* was a process in which crushed glass was mixed with coloured oxides, placed in a mould and slowly fired. After being allowed to cool gradually, the paste was taken from the mould and modelled with a spatula. Each artist had his own individual technique and the resulting range of *pâte de verre* was diverse. The first craftsman to experiment with *pâte de verre* was Henri Cros in the late nineteenth century, but he was surpassed by G. Argy-Rousseau and ceramicists such as François Decorchemont and Albert Dammouse (qq.v.). Other artists in this field were Georges Despret who produced figures, fish and grotesque masks in rather sugary colours in the 1890s, and Ringel d'Illsach who also specialized

215

in masks. George de Feure (q.v.) modelled figures which are often thought to be *pâte de verre* but were really in ordinary moulded glass. Amalric Walter (q.v.) modelled figures in *pâte de verre* of the *danseuse* Loie Fuller, but also produced ash-trays, inkstands and other useful wares decorated with insects, frogs, lizards and birds.

Pâte sur Pâte

Distinctive nineteenth century form of porcelain decoration which derives its name (paste on paste) from the painstaking technique of building up thin washes of white slip on a tinted ground to produce a cameo effect. Plaques (q.v.) decorated in the *pâte sur pâte* manner were produced by Marc Louis Solon, under the pseudonym 'Miles' in the 1860s and retailed by the Parisian art dealer, E. Rousseau. Following the Franco-Prussian War, Solon emigrated to England where he found employment with

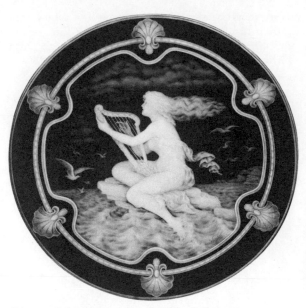

Pâte-sur-pâte dish by George Woodall.

Minton *pâte-sur-pâte* vase by Alboine Birks, 1902.

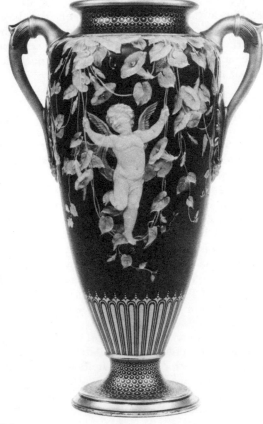

Minton (q.v.) and introduced the *pâte sur pâte* technique to that firm. The process was slow, complex and hazardous, requiring great skill and patience on the part of the craftsman and, for these reasons, *pâte sur pâte* wares were always very expensive. Nevertheless its popularity increased and, in order to step up output, Solon was forced to share his secrets with a number of pupils whose work was current at the end of the century. Their early work consisted mainly of floral subjects and was unsigned; later, however, they progressed to more ambitious pieces and many of these can be identified.

The most important craftsman was Alboine Birks (1861–1941) who continued to produce fine *pâte sur pâte* vases and borders on dishes until his retirement in 1937. Panelled plates in the same style were produced by Richard Bradbury and examples by these craftsmen were signed 'A.B.' and 'R.B.' respectively. Much of their output was exported to the United States where it was highly regarded. Alboine's cousin, Lawrence Birks, also worked in *pâte sur pâte*, but wares signed 'L.B.' are comparatively scarce. Frederick Rhead (q.v.) trained at Minton's but later worked for W. Brownfield & Sons and executed a number of fine vases in this manner for them in the late 1880s and 1890s. H. Sanders took the technique from Minton's to Moore Brothers (q.v.) and decorated their distinctive pilgrim bottles in this fashion. His work bears

the initials 'H.S.'. Solon himself continued to work for Minton's until 1904 and, from then until his death in 1913, he continued to produce *pâte sur pâte* plaques on a freelance basis. His wares were signed 'L. Solon'. *Pâte sur pâte* ware was also produced by Royal Worcester (q.v.), the Grainger Worcester pottery and the Trent Pottery but, with the exception of Minton's, these potteries had ceased production of this line by 1890, on the grounds that it was impracticable and economically unsound for the average manufacturer. As Solon himself has written, in his customary flamboyant manner: 'They discovered to their cost that it did not bear mediocrity of execution'.

Paul, Bruno

German graphic artist and designer, born at Seifhennersdorf, Saxony in 1874. He studied at the Dresden school of art from 1886 to 1894 and subsequently at the Munich Academy.

In 1897, he became a founder member of the *Vereinigte Werkstätten* (q.v.). Later he held appointments at the museum of arts and crafts in Berlin (1907) and, from 1924 to 1932, was director of the united state school for liberal and related arts in Berlin. As a furniture designer, Paul was influenced by his fellow members in the Munich circle: his style was as polished as Pankok (q.v.), but later he moved away from the fantasies of Endell (q.v.) and came closest to the style evolved by Riemerschmid (q.v.). His chairs and tables were distinguished by their clean lines, clarity of form and discipline. Paul also designed silver and other metalwork, but he is best remembered as a designer of posters and a regular contributor to *Jugend* (q.v.) for which he designed several covers.

Penfield, Edward

American graphic artist, born at Brooklyn, New York in 1866. From 1893 to 1903, Penfield

Poster by Edward Penfield for *Harper's March*, 1897. (Museum of Modern Art, N.Y.)

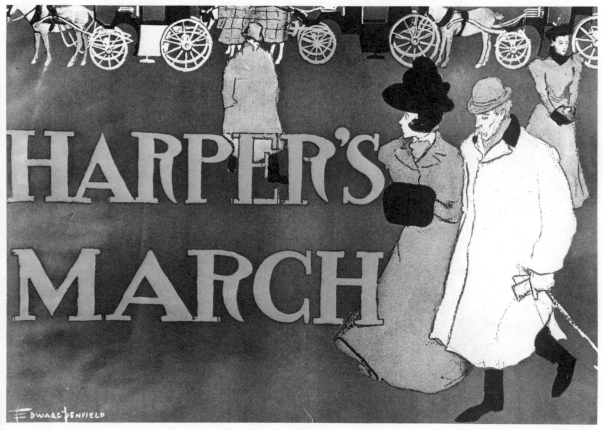

designed covers and posters (q.v.) for Harper Brothers, and produced designs and illustrations for other publishers after that date. Penfield died in Beacon, New York in 1925. His posters, with monochrome backgrounds and clean-cut, almost silhouette, figures, pioneered a distinctly American style of graphic art.

Pewter

This alloy of tin and copper, traditionally used as the poor man's substitute for silver, declined sharply in the early nineteenth century following the development of Sheffield plate, electroplate (q.v.) and other *ersatz* materials which more closely resembled silver and were easier to clean and maintain. Pewter, however, accorded with the medievalism of William Morris (q.v.) and he made some attempts to revive interest in it. It had little appeal to the followers of the Aesthetic Movement (q.v.): significantly pewter was conspicuous by its absence from the Aesthetic Movement Exhibition, held in London in 1973. Nevertheless interest in pewter was revived in the 1880s by C. R. Ashbee's (q.v.) Guild and School of Handicraft and, gradually, artists and craftsmen in metalwork rediscovered the subtle qualities of this substance. It lent itself admirably to the *martelé* (q.v.) technique, and hammered panels in pewter were a speciality of the Macdonald sisters (q.v.) at the turn of the

century, either incorporated in furniture designed by their husbands or used in lamp-shades, jewel-boxes and decorative caskets. Herbert McNair (q.v.) designed mirrors and picture frames, using the Glasgow Style (q.v.) of Art Nouveau in pewterwork. Designs by Sir Edward Burne-Jones (q.v.) in 'late-Gothic' were subsequently interpreted by many craftsmen at the turn of the century in this metal.

In Holland, F. Zwollo (q.v.) worked in both pewter and brass in the late 1890s and, in Denmark, Mogens Ballin and Siegfried Wagner used pewter extensively in tableware, lamps (q.v.) and decorative panels for furniture and interiors. As a medium for lamps, candlesticks (q.v.) and wall sconces, pewter was employed to some extent by the Parisian architect Tony Selmersheim and also featured in some of the furniture designed by Gaillard, Colonna, De Feure and Van de Velde (q.v.). In Germany, forms of pewter known as *Hartzinn* or *Neusilber* had a limited popularity in jewellery and metalwork, mainly lamps and light-fittings, and, in this context, featured briefly in the work of Peter Behrens, Bruno Paul, August Endell and Bernhard Pankok (qq.v.).

Apart from this somewhat dilettante approach, the only attempt to exploit pewter on a large scale was mady by Liberty (q.v.) who marketed articles from 1902 onwards in the range known as 'Tudric'. These pewter services, cake-stands, vases, bowls, plaques and boxes were manu-

Late 19th century English tea-set in beaten pewter.

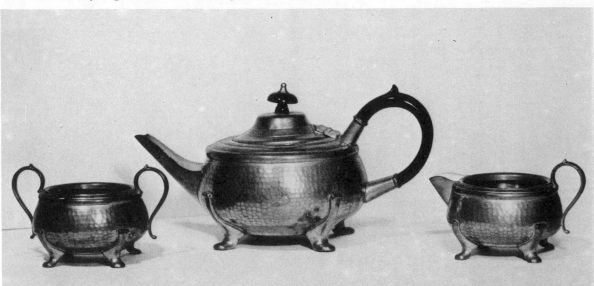

factured for Liberty by the Birmingham firm of W. H. Haseler (q.v.). The 'Tudric' patterns continued into the early 1920s.

Picture Postcards

Postcards were invented in Austria, making their debut in 1869. Britain adopted them in 1870 and the United States in 1873. By the 1880s their use had extended to virtually every country in the world. At first postal administrations held a monopoly of postcards which had to bear an impressed postage stamp, and regulations governing the embellishment of cards were strict. Gradually these rules were relaxed and first commercial advertising and then more pictorial elements were permitted. Finally unstamped postcards were allowed to compete with the government issues, though Britian did not permit this until 1894. Initially one side had to be reserved solely for the name and address of the recipient, and the message was confined to the other side. When pictures were eventually permitted, they were restricted in size, in order to allow room for the message. As the 1890s wore on, the pictures grew in size until no more than a broad horizontal margin was left for the message. Finally even this rule was relaxed and cards with a division on the reverse permitted the message on the left-hand side and the address on the right.

Picture postcards, depicting scenery and landmarks, with a conventional greeting from the place of posting, developed gradually during the 1880s, but they did not attain universal popularity until 1890. Thenceforward, picture postcards developed rapidly, attaining their peak in Edwardian times. The First World War and increased postal charges checked this mushroom growth. Though still immensely popular as an adjunct to tourism, modern postcards lack the charm and artistry of those produced at the turn of the century, and, from the collector's viewpoint, these are the cards which are most highly regarded at the present time. Tourism accounted for the bulk of the cards posted in the 1890s and 1900s and the more remote or spectacular a place, the more popular were its postcards: the summits of Ben Nevis and Snowdon, the Swiss Alps, even the Eiffel Tower, remote places like Spitzbergen or St. Kilda, or places which caught the popular imagination, like Land's End and John o' Groats,

Picture postcard by Raphael Kirchner, Paris, 1902.

account for a fair proportion of the cards which have survived, often embellished with distinctive cachets provided by enterprising stationers or souvenir shops. Outstanding events such as the great international exhibitions; the jubilees of Queen Victoria, Emperor Franz Josef of Austria, King Ferdinand of Bulgaria or Prince-Regent Luitpold of Bavaria; royal weddings; royal visits; congresses and fairs; were faithfully recorded in postcard form, but even parochial events were immortalized in this way, and the picture postcard is thus a valuable, if often overlooked, source of material for the social historian.

Picture postcards also had pretensions as an art form, designed to inculcate taste and discernment among the masses. Raphael Tuck introduced the 'Connoisseur' series in 1903 and also held annual exhibitions of the season's new

219

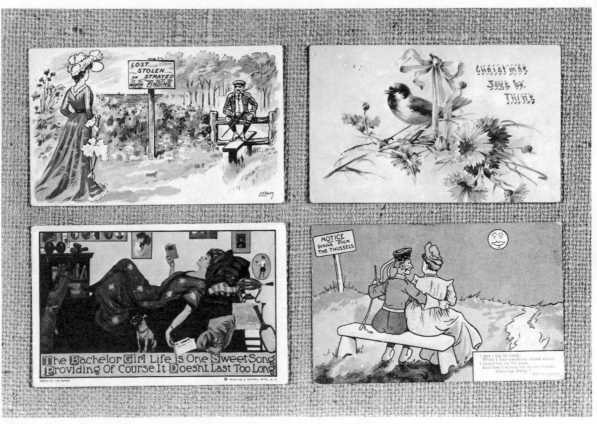

Christmas and humorous postcards from Britain and America, *c*. 1900.

designs. The reproduction of works of art was at first strenuously opposed by museums and art galleries, but later they relented and began to publish their own cards. By the mid-1890s, the spirit of Art Nouveau had permeated picture postcards, and artists, who had made their name in posters (q.v.), now turned to this medium. Cheret, Mucha and Grasset (qq.v.) were pioneers of the art postcard, often adapting designs which they had previously produced as advertising posters. By the end of the century, however, certain artists were emerging who specialized in this field. The outstanding figures included Raphael Kirchner, a Vienese artist domiciled in Paris who also worked for Tuck's Connoisseur series. Kirchner is best known for his romantic postcards featuring beautiful women in various poses—forerunner of the modern pin-up. Harry Paine, Lance Thackeray and Tom Browne were early British exponents of artistic postcards. Humorous postcards developed after 1900 and, in this field, Bert Storey, Phil May and Donald McGill are the outstanding names. McGill

later formed his own company and dominated the seaside-joke postcard industry between the world wars. Louis Wain specialized in whimsical cards in which cats performed human roles. Humour of a more restrained, sophisticated kind is associated with Charles Dana Gibson, inventor of the 'Gibson girl', whose work was reproduced in postcard form on both sides of the Atlantic at the turn of the century.

This was a period when new techniques in printing and production were being combined with the traditional lithography and letterpress. Photography became increasingly popular after 1900 and various techniques of photo-montage were used effectively in greetings, art and humorous postcards before, and during, the First World War. Novelty cards, printed on leather, silk or even wood, enjoyed a certain vogue in the Edwardian era. Tinselling and the use of scraps of cloth, heather or dried flowers also became popular in this period, though postal regulations originally forbade such adornment. Pull-out postcards, containing tiny photo-

220

Group of postcard views of New York, 1903–12.

graphic views, concertina-fashion, also developed in the early 1900s. Trick effects were developed in France and Germany and the best-known consisted of innocuous portraits of young ladies which, when held at a certain angle to the light, stripped them of their clothes and revealed them in all their glory.

Propaganda postcards outstripped the commemorative medal and the broadsheet as media for disseminating political viewpoints in an era before motion pictures, radio or television could fill this role, and political cartoons in the popular press were not yet fully developed. A large number of anti-British postcards were produced in France, Germany, Austria and the Low Countries between 1899 and 1902, highly critical of Britain's conduct of the Boer War. Conversely many cards were published in Europe publicizing President Kruger and his generals, who were great popular heroes at that time. The Spanish-American War had relatively little impact on picture postcards, but the Boer War was commemorated in this way, not only in Britian but also in Canada, Australia and New Zealand to a surprising extent, demonstrating the imperial sentiment of the British colonies and overseas dominions at that time. Women's suffrage and the temperance movement were other popular subjects for political postcards. The development of photographic techniques after 1900 also made the postcard an ideal vehicle for promoting actresses, and thousands of cards were produced in the early 1900s portraying the beauties of the stage, the vaudeville hall and the silver screen, then still in its infancy.

Many greetings cards at the turn of the century were produced in the form of picture postcards. Christmas cards and Valentines (qq.v.) are those most frequently met with, but New Year cards, birthday cards and Easter cards may also be found.

Pictures composed of unusual materials

An unusual manifestation of the craze for amateur decorative arts was the picture composed of the most unlikely materials. This craft began in the mid-nineteenth century and reached its peak in the 1880s but there are still plenty of examples extant from the turn of the century. Cork pictures (q.v.) reflected the influence of the Orient and the Middle East in Western Europe and America, but other forms seem to

Verre eglomisé portrait of a Maharajah in giltwood frame. Indian, *c.* 1900.

have developed quite spontaneously. Shell mosaics became popular in the 1850s and, by the end of the century, had developed into a flourishing folk art on both sides of the Atlantic. Floral compositions made from shells have been traced back to the late eighteenth century but they did not attain widespread popularity until after 1870 and some very elaborate pictures, using thousands of tiny shells of different colours, are known to have been shown at the great international exhibitions of the period. Feather pictures sometimes simulated flowers and foliage, but more often represented birds, like a form of two-dimensional taxidermy, with glass beads for eyes and beaks and feet merely painted in.

The late Victorian pre-occupation with death expressed itself in the rather morbid 'still life'

Picture by R. Arroyo composed of humming-birds' wings. Late 19th century.

before the First World War. Tinsel pictures were produced on a commercial basis from 1890 onwards and this somewhat garish art form survived until the Second World War, portraits of royalty and popular heroes being the favourite subjects. Sand pictures were a German invention, and this art was practised in a desultory fashion in many other parts of Europe, but commercially it is usually connected with the Isle of Wight, where the many hues and colours of the sands of Alum Bay stimulated this form of tourist memento. Most of the surviving examples of sand picture seem to depict views in that island, and they are even known in the form of picture postcards (q.v.).

Pilkington Pottery

The Pilkington Tile and Pottery Company, of Clifton Junction near Manchester, was founded in the mid-1890s, under the direction of William and Joseph Burton. Initially the firm's main product was tiles (q.v.), but decorative wares were also produced from 1897 onwards. About 1903, the company began marketing its famous lustre ware which became known, a decade later, as 'Royal Lancastrian' ware and continued until shortly before the Second World War. The Pilkington pottery produced in the early years of this century was of a very high quality

feather pictures which can best be described as resembling a chicken victim of a hit-and-run accident. Leather pictures had the decoration applied by poker work or with blunt tools, but a few were ingeniously cut and mounted to resemble ferns and foliage. Leather pictures, unfortunately, have not survived in pristine condition as a rule, because of the fragile nature of the material. Various forms of embroidery were also popular in pictorial form, ranging from fine needle-point to Berlin wool-work and the relatively coarse form of stump-work. Pressed and dried flowers and leaves could be arranged in figurative or landscape pictures, mounted and framed. Marquetry (q.v.) also became popular at the end of the century as a medium for pictures and, at the same time, fret-work (also known as Sorrento work or jigsaw work) was widely practised, often being combined with embroidered panels and bead-work. More bizarre materials ranged from match-sticks to porcupine quills. Butterfly wings and used postage stamps were also used, with infinite patience and a great deal of ingenuity, to produce elaborate pictures.

Although pictures from unusual materials usually have a folk-art character, it should be noted that poker-work on wood or bone panels was a flourishing branch of the tourist souvenir industry in many parts of Europe and America

Pilkington's Royal Lancastrian dish with lustre decoration by Richard Joyce, c. 1910.

223

technically and artistically and several well-known artists designed and decorated wares for the company. Walter Crane (q.v.) was a prolific worker in the early 1900s and his designs may be recognized by the tiny crane-bird which was his personal trade-mark. Other artists who decorated 'Royal Lancastrian' and Pilkington lustre ware included Richard Joyce, Charles Cundall, Gordon Forsyth and William Mycock. Lewis Day and C. F. A. Voysey (q.v.) designed tiles produced by the company in the late 1890s.

Pins and Pin-trays

The turn of the century was a period of great ornamentation in the minor accessories of dress for both sexes. Hatpins (q.v.) were an obvious object of decoration, but many different types of hairpin, tie-pin, stick-pin and lapel-pin may be found, with heads ornamented with semi-precious stones, or cast or die-stamped in diverse novelty shapes. Good luck symbols, such as four-leafed clovers and horse-shoes, were favourite subjects but many different animal, bird, insect and floral motifs may be encountered. Elaborate pins were used by ladies to secure scarves and shawls. Often pins in varying sizes may be found in matching sets. Pin-cushions, pin-holders, pin-cups and pin-trays are some of the associated collectables which were produced in the late nineteenth century in a wide variety of different forms and materials.

Pliqué-à-jour

A transparent form of enamelling on glass or metal, in which thin strips of metal are used to keep the various colours apart and the backing is removed to achieve translucency. This technique probably originated in China and Japan, where it was widely practised in the seventeenth and eighteenth centuries. It spread to Russia where it was popular in the eighteenth and nineteenth centuries, but attained perfection in the *atelier* of Pavel Ovtchinnokov in the 1870s. *Pliqué-à-jour* enamelling was also practised by Khlebnikov and Fabergé (q.v.). Fernand Thesmar, inspired by Chinese work in this *genre,* practised this technique in France at the turn of the century and produced bowls and vases in Art Nouveau floral designs. Thesmar's enamel-

224

ling resembles stained-glass in miniature. The technique involved the use of a metal base as a support to the honeycomb of cells but, when the piece had cooled sufficiently, the base was removed to achieve the stained glass effect. See *Cloisonné*

Examples of *pliqué-à-jour* enamelling. Late 19th century.

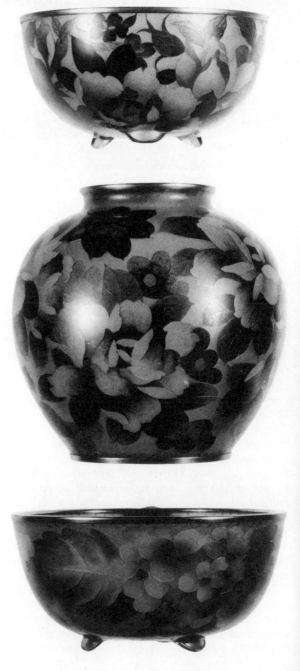

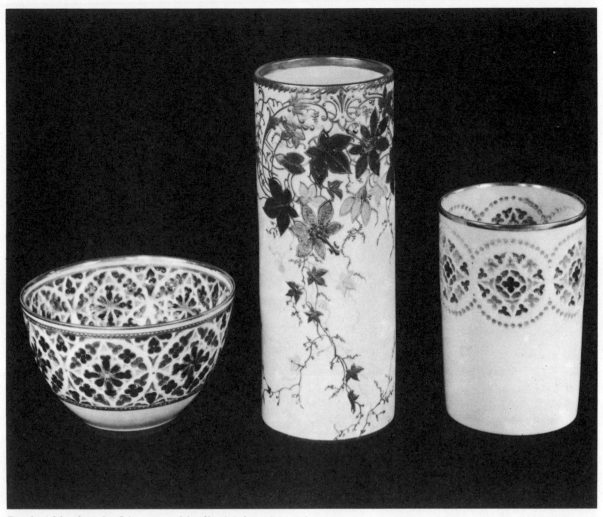

Bowl and beakers by Limoges, with *pliqué-à-jour* decoration.

Pole Screens

Although it was the earliest type of fire-screen
used in England, in the latter half of the seven-
teenth century, the pole screen was widely
popular until the end of the Victorian era.
Walnut, beechwood, mahogany and oak were
used for the central pole and the framework
of the screen itself, though latterly metal frames
became popular. *Papier mâché* screens first
appeared about 1825 and continued to be popular
until the turn of the century. The best of these
screens were manufactured by Jennens and
Bettridge of Birmingham, using mother-of-
pearl inlays on a black lacquered ground. Glass
mounts were used for embroidery, but, towards
the end of the century, die-stamped scraps,

pictures cut out of magazines and other ephemera,
such as postcards and Christmas cards (qq.v.),
became fashionable decoration. Morris and Com-
pany (q.v.) designed textile-patterns for incor-
poration in these screens, but tile (q.v.) panels
representing the four seasons and other alle-
gorical compositions were also popular.

Porcelain Plaques

Hand-painted porcelain plaques were produced
by many British and European potteries in the
late nineteenth century, either for home markets
or, more usually, for export to the United States.
Most of the leading French, German and Aus-

Berlin porcelain plaque, with painting after Titian, early 1900s.

trian porcelain factories produced these plaques, usually depicting landscapes, pastoral or classical scenes or portraits of young ladies, in a style which clung rigidly to the traditions of the eighteenth century, but without the splendours for which the Baroque and Rococo periods were renowned. These plaques were either incorporated in the panelling of furniture or were used individually as wall-decoration, and as such they accorded with the Beaux Arts (q.v.) tradition in American interior decoration at the turn of the century. The King's Porcelain Manufactory in Berlin (q.v.) was one of the leading exponents of this art and plaques with allegorical compositions, denoting the elements of the four seasons, were especially popular. In Britain, both Minton and Worcester (qq.v.) excelled in this field, exporting the bulk of their products to America. The English plaques tended to concentrate on flowers, birds and animals rather than figurative work. Wedgwood (q.v.) continued to manufacture Neo-classical plaques in their celebrated jasperware and this has continued undiminished and undiluted over a period of two centuries to the present day. No concession appears to have been made to the prevailing Art Nouveau style at the turn of the century.

More modest in appearance, but highly popular in the late nineteenth century, were the small porcelain plaques moulded with a recessed pattern on the same principle as a watermark in paper. Where the porcelain was thinner an impression would be discernible when the plaque was held up to the light. These plaques, known variously as lithophanes or Berlin transparencies (alluding to their origin) were produced by Minton's and a number of European potteries. They featured allegorical subjects, portraits, landscapes and copies of well-known Old Masters. They were intended to be mounted in frames set against the light, either in windows, fire-screens of lampshades. The majority of these lithphanes belong to the period from 1850 to 1880, but they continued to appear down to the end of the century.
See *Berlin Porcelain*

Poschinger Glass

Iridescent glass, similar to that produced by Lötz (q.v.), was manufactured at the turn of

226

the century by Ferdinand von Poschinger at Buchenau and Theresienthal in Silesia. Decorative wares, mainly vases and bowls, were marked on the base 'Ferd. von Poschinger Buchenau'.

Postage Stamps

The two decades at the turn of the century witnessed an unprecedented growth in the number of new stamp-issuing countries. Between 1890 and 1910, no fewer than 112 new names found their way into the stamp album—compared with a grand total of 840 countries or postal administrations since 1840, or the present number of around 250. The benefits of postage stamps were extended mainly to the area now known as the Third World, but which was, at that time, almost entirely under the imperial rule of the major European powers. Although the 1890s began with the extension of stamps to British East Africa (Kenya), British South Africa (Rhodesia) and British Central Africa (later Nyasaland and now Malawi), comparatively few British colonies and protectorates

Dresden porcelain plaque signed by E. Boerschneider, *c.* 1900.

were left without the benefits of a postal service by that date. In the ensuing decades, postage stamps were introduced in the Malay States and the scattered island possessions of the Pacific. Prior to the 1890s, with few exceptions, the French colonies had got by with a general series, but, in 1892, ten French territories were granted their own stamps and the spate of additions continued until 1894. At the same time, the individual islands of the Azores group were each given their own stamps. Conversely Britain withdrew this privilege from the various presidencies of the Leeward Islands in 1890, substituting a single series thus inscribed. Complaints from the individual islands that their revenue had suffered as a result, led to the re-introduction of distinctive stamps in the respective islands in 1903, though the Leeward Islands general series was retained. Germany was a latecomer in the colonial game but rapidly caught up with Britian and France. Five German colonies began issuing stamps in 1897 and a further three in 1900. The turn of the century was also the heyday of European interference in Turkey and the Near East, manifest in the issues of stamps for the postal agencies established by Britain, France, Austria, Germany, Italy and Spain in various parts of the Ottoman Empire from North Africa to the Balkans and the Holy Land, and, in each case, special stamps were produced, usually consisting of the stamps of the country concerned suitably overprinted. In China, the situation was more extreme; Britian, France, Germany, Russia, Italy, the United States and—significantly—Japan all opened post offices in China at this time and issued special stamps. In addition, many of the treaty ports and commercial cities which had European communities, operated municipal or local postal services, because the Chinese Imperial Posts were inefficient.

Political events had their repercussions on the philately of the period. The long simmering revolt of the Cretans against Turkish rule exploded in 1897 and led to the island being declared autonomous, still nominally under the Turkish sultan but in fact self-governing, under the supervision of the European powers. Philatelically this resulted in stamps issued by the Cretan authorities and also the Austrian, Russian, British, French and Italian occupying forces. The situation was complicated by the stamps issued by a rebel group (1905) and the overprint of Cretan stamps from 1908 onwards to signify

227

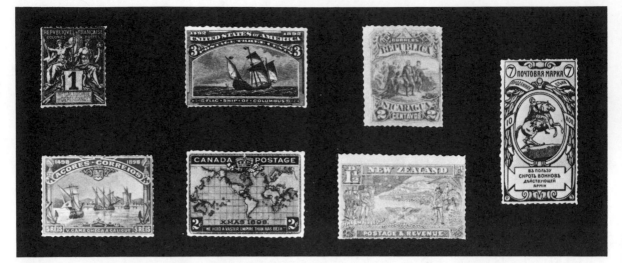

Selection of postage stamps: 'Peace and Navigation' design used by the French colonies, 1892; one of the series issued by the United States to mark the quater-centenary of Columbus, 1892; Nicaragua was one of the many Latin American states to honour the same event; Vasco da Gama quater-centenary design for the Portuguese colonies, 1898; Canada's jingoistic 2 cents marking Imperial Penny Postage, 1898; New Zealand 1½ pence stamp of 1901 echoing the sentiments of the Boer War; one of a series of semi-postal stamps issued by Russia to raise funds during the Russo-Japanese War, 1905.

union with Greece, a fact which was not recognized by the European powers until 1913.

The Spanish-American War of 1898 brought changes as well. The 'Curly Head' colonial key-type stamps of Cuba, Puerto Rico and the Philippines were replaced by contemporary American stamps suitably overprinted, followed by distinctive sets in Cuba and the Philippines when civil government was restored. Puerto Rico lost its philatelic identity and has used ordinary American stamps since 1900. The Boer War of 1899–1902 resulted in a spate of siege stamps from no fewer than seven towns, the Baden-Powell issues of Mafeking being the best known. As the tide of war turned, stamps of the Orange Free State and the South African Republic were first overprinted with the royal monogram 'v.r.i.' or 'e.r.i.' and then emerged with new names; Orange River Colony and Transvaal respectively. The separate issues for the four South African provinces continued until 1910 when stamps of the Union of South Africa were gradually introduced. The Boxer Rebellion in China (1900) resulted in little that was new, since the belligerents made use of their existing postal services in that country, but Indian stamps were overprinted 'c.e.f.' for the use of the China Expeditionary Force. Protracted civil wars in Venezuela and Colombia at the beginning of this century threw up a

number of ephemeral issues, but the chief result of these conflicts was the suppression of the departmental (states) issues of Colombia in 1904, the secession of Panama in 1903 and the emergence of the United States Canal Zone at the same time, all replete with their own stamps. The Anglo-Egyptian reconquest of the Sudan (1897) and the Turkish invasion of the Thessaly district of Greece (1898) both produced new stamp-issuing territories.

Two of the most important phenomena in philately made their appearance in this period. In 1888, New South Wales celebrated its centenary as a British colony by releasing a long set inscribed 'ONE HUNDRED YEARS'. The stamps remained in use for twenty-five years and underwent many changes of watermark, perforation and even colour, so they were, to all intents and purposes, no different from an ordinary definitive series. Nevertheless, on account of the inscription, they are regarded as the world's first government-issued, adhesive, commemorative stamps. Stamped stationery had been released by the United States in 1876 to mark the centenary of independence and, in 1887, a private postal service in Germany had produced special stamps in honour of the Ninth Federal Shooting Contest, but these were isolated examples. The concept of the commemorative stamp was slow to catch on, but it received

a tremendous boost in the 1890s when many countries in the New World celebrated the quatercentenary of the voyages of discovery by Christopher Columbus. The United States issued sixteen stamps, ranging from 1 cent to 5 dollars, for the Columbian Exposition (q.v.) and, having established a dangerous precedent, continued to produce long and expensive sets for other world's fairs and expositions up to 1915. In 1897, the Diamond Jubilee of Queen Victoria was celebrated by stamps from six British territories: Canada, New South Wales, Victoria, Newfoundland, Leeward Islands and Barbados; and two more, Mauritius and British Guiana, belatedly marked the event the following year. Commemorative stamps spread to Europe (Montenegro), and Asia (China and Japan) in 1894 and to Africa (South African Republic) the following year. In 1896, the Olympic Games were revived and Greece issued a long series (from 1 lepton to 10 drachmae): the first of many stamps honouring sporting events. Though commemorative stamps were ignored by many countries—Germany did not adopt them until 1919 and Britain ignored them until 1924—the steady stream alarmed collectors who banded together in the 1890s to form the Society for the Suppression of Speculative Stamps. Their attempts to boycott commemorative stamps were short-lived.

In 1890, Britain issued a stamped envelope to mark the jubilee of Penny Postage. The envelope was sold for a shilling, but was valid for only a penny's postage, and the remaining elevenpence was given to Post Office charities. Fortunately this idea was never repeated, but it may have encouraged New South Wales and Victoria to celebrate the Diamond Jubilee in 1897 by issuing two stamps apiece with exorbitant charity premiums in aid of hospitals and sanatoria. In this way the charity, or semi-postal, stamp was born. Stamps with charity premiums were issued by Russia at the time of the Russo-Japanese War (1904–5) and Rumania issued no fewer than four charity sets in 1906 alone, but this idea did not gather momentum until the First World War when many countries issued stamps on behalf of the Red Cross and orphans' funds.

After the turn of the century, fashions in stamp-collecting changed drastically. In the nineteenth century, the average collector took anything that remotely resembled a stamp, and included local stamps, fiscal (revenue) stamps, commemorative labels and postal stationery. The spate of German, Chinese and Russian locals killed interest in these stamps, while the sheer bulk of envelopes, wrappers and stamped postcards led to the decline in this branch of the hobby after 1900. Label-collecting, or erinnophily (q.v.), survived rather longer, but was gradually supplanted by the officially-issued, commemorative, postage stamp. The increased output in postage stamps, which began in the 1890s, forced philatelists to narrow their aims and it was from this period also that more specialized, one-country collecting gradually took the place of whole-world collecting.

See *Ephemera, Erinnophily*

Poster by Dudley Hardy for *The Rose of Persia*.

Posters

The poster, as a distinct art form, attained its apogee in the 1890s. Improved lithographic

Undated poster by Louis Rhead for Lundborg's perfumes.

few were actually produced in the Low Countries until the 1890s. George de Feure, a Dutchman domiciled in France, designed a number of important posters for the Belgian and Dutch market in the 1890s. Subsequently several local artists produced posters in the prevailing French idiom, notably T. Privat-Livemont (q.v.) whose maidens were first cousin to those of Alphonse Mucha. Among the Belgian artists whose posters are now highly regarded are Fernand Toussaint, Armand Rassenfosse and Victor Mignot. Dutch posters tended to be more utilitarian but provide many striking examples of the art nonetheless. The designs by Jan Toorop (q.v.) are much closer to the German *Jugendstil* than the Parisian

techniques revolutionized the advertising industry from 1868 onwards, but it was with the work of Toulouse-Lautrec, Cheret, Grasset and Mucha (qq.v.) in *fin de siècle* Paris that the poster reached the peak of perfection. The colourful, well-designed posters of the 1890s turned the boulevards into open-air art galleries. Often these magnificent posters defeated their own ends; they were carefully removed from the hoardings by collectors, almost as soon as the bill-posters had put them up. Fortunately these otherwise ephemeral pieces were treasured and many of them have survived to delight present-day collectors. Many of the better-known *affiches* have been reprinted for collectors in recent years. Other French artists, whose posters of this period are much admired, include Manual Orazi, Theodore Steinlen and George de Feure (q.v.). Regrettably this street art was short-lived and the quality of French posters declined sharply after 1900.

Chromolithographed posters spread from France to the Netherlands in 1879, but very

Advertisement for Van Houten's Cocoa, by V. Caspel.

Bronze bust by Alphonse Mucha, 1900.

230

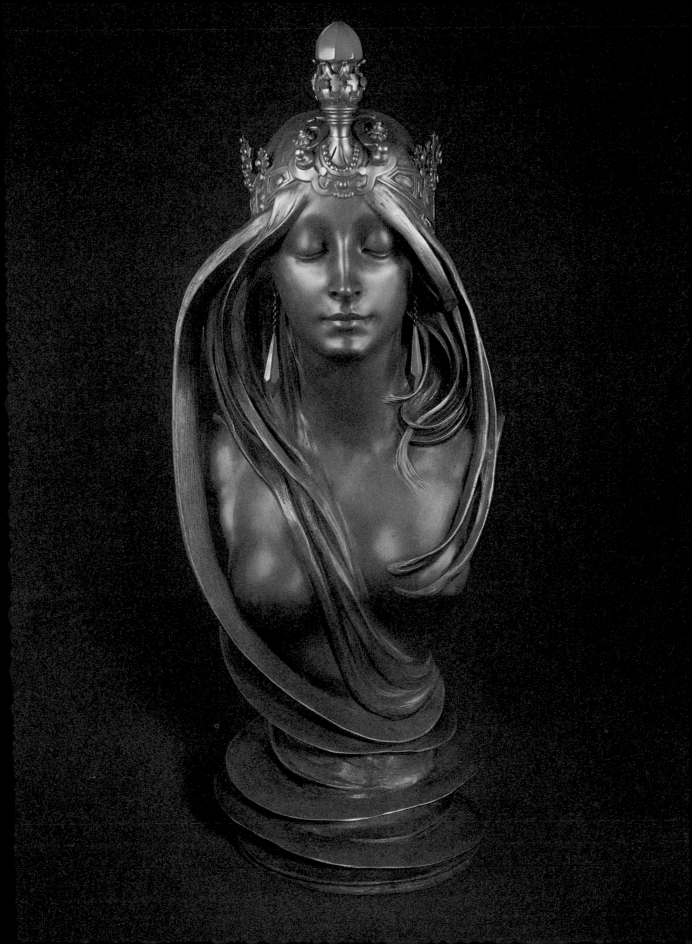

◀ Minton pot-pourri bowl, 1890.

Art Nouveau of the Belgian artists. Even more austere in form were the poster designs by Thorn-Prikker (q.v.), who returned to a more typographical style, in which the pictorial element was strictly subordinate.

The year 1894 marked the turning point in the history of the English poster, though it can be argued that the advent of the large-sized, colourful, American circus posters, introduced to Britain in 1889, helped to revolutionize the English poster. The new style posters were linked with William Morris's belated interest in typography and the establishment of the Kelmscott Press. Morris encouraged the development of a distinct branch of poster art depending on the wood-cut, but this was not really suited to the large format of the poster. Photo-mechanical techniques, developed in the early 1890s, however, had a strong influence on the art of Aubrey Beardsley (q.v.), enabling him to apply his idiosyncratic brand of design to the poster. The first Beardsley poster, for *A Comedy of Sighs* at the Avenue Theatre, appeared on the hoardings in March 1894, combining the orthodox typographical approach of previous theatrical posters with a pictorial motif reminiscent of the Japanese print. The poster never developed into the same open-air art form found in Paris. There were fewer opportunities for this type of advertising in England and it was largely confined to theatrical productions, art exhibitions and announcements for magazines. The leading exponents of the English poster were the Beggarstaff Brothers—William Nicholson and James Pryde (qq.v.), Dudley Hardy (whose Gaiety girls were reminiscent of Cheret's languid ladies) and Maurice Greiffenhagen. In Scotland, the distinctive Glasgow Style (q.v.) was to be seen in the posters designed by Herbert McNair and the Macdonald sisters (qq.v.).

In other parts of Europe, the poster developed fitfully. In Denmark, for example, Thorvald Bindesböll (q.v.) was virtually the only designer of note in this period, but he produced quite a number of excellent posters from 1888 onwards. In Germany and Austria, however, the disciples of *Jugendstil* (q.v.) developed their own brand of poster-design, more angular and geometric

Pâte-de-verre 'chameleon' dish by Amalric Walter, *c.* 1910.

Art Exhibition poster by Oskar Kokoschka, Vienna, 1908.

233

than the French, less frivolous, more mystical, less narrative and more symbolic. Joseph Sattler (q.v.), who designed covers for *Pan,* pioneered the art of the poster in Germany, relying on solid backgrounds against which the lettering and linear ornament appeared starkly in white. Other German artists who produced posters in this period included Thomas Theodor Heine (q.v.), Emil Rudolf Weiss and Edmund Edel. The formation of the *Sezession* movement (q.v.) in Vienna gave tremendous impetus to poster-design, influenced by the Glasgow group. The finest Austrian posters were designed by Koloman Moser and Alfred Roller (qq.v.).

In the United States, a vigorous, home-spun style of poster art had developed throughout the nineteenth century, to advertise fairs, exhibitions and circuses. The style was essentially typographical, but variety was created by the use of different founts of lettering, including some very ornate styles, and the liberal use of

Design for the Grafton Gallery poster by Eugène Grasset, 1893.

colour. The art poster, on the other hand, can be traced back to 1889 when Harper and Brothers commissioned Grasset to design a cover for the forthcoming Christmas number. In America, there had developed, in the 1880s, a distinct type of poster, small in size, which was used by booksellers and stationers to advertise periodicals, and Grasset's cover design was subsequently reproduced in this form. Posters in the same *genre* were soon produced by Harpers' rivals; Lippincott, Scribner and *The Century*. For later posters, Harpers chose a young staff artist, Edward Penfield (q.v.) and he quickly established a reputation as the leading American poster artist of the day, with his characteristic pictures of clean-cut all-American boys and their female counterpart, a slightly up-dated version of the Gibson girl. Lippincott chose Will Carqueville whose style was derived from contemporary French models. In 1896, Carqueville went to France to study art further and his place was taken by J. J. Gould whose work was quite derivative, alternately emulating Carqueville and Penfield. Apart from Penfield, the most outstandingly original poster artists at the turn of the century were Maxfield Parrish and Louis Rhead (q.v.) who worked for Scribner's and *The Century* respectively. Will Bradley (q.v.), better known as a freelance book- and magazine-illustrator, also produced some interesting posters in the style of Beardsley; and Ethel Reed, in her all too brief artistic career, produced some distinctive Art Nouveau designs in the 1890s. The art poster in America, however, enjoyed only ephemeral popularity. Standards declined sharply after 1900 and there was a return to traditional narrative or purely typographical styles, while the artists, who had raised the art poster to the heights, turned their attentions to other fields such as the fine arts or book-illustration.

Pot Lids

Pictorial potlids were produced in England and America from 1850 to the end of the nineteenth century, as part of the packaging for pomade, cosmetics, tooth-powder, fish-paste and potted shrimps. They came to prominence in 1851, when they were displayed at the Great Exhibition, but their use declined in the 1880s as marketing costs became more competitive. Paradoxically their popularity with collectors began about

this time, and it is significant that the last pot-lids, from 1878 to 1894, were more consciously artistic in conception, aiming deliberately at the collectors' market. The vast majority of potlids were produced by four Staffordshire potteries: Mayer Brothers and Elliott, Ridgway of Cauldon, Ridgway of Shelton and F. and R. Pratt of Fenton. Of these, Pratts made the lids most highly prized by collectors today.

The finest potlids were produced to commemorate the great international exhibitions from 1851 onwards and a fitting swan song for this ephemeral art form consisted of the splendid Prattware potlids, decorated with scenes from American history, which were produced in connection with the Columbian Exposition of 1893 (q.v.). Other lids dating from the final decade of their existence featured prominent nineteenth century personalities, from Queen Victoria to Jenny Lind, the 'Swedish nightingale'. The production of pictorial potlids dropped abruptly after the death of Jesse Austin, production manager for Pratts, in 1879, but the boom in collecting potlids began in 1894 when a vast number of them were released to collectors, following the death of Felix Pratt in that year.

Presentation Silver

Silverware was the most popular medium for rewarding the long and faithful service of

A selection of late 19th century potlids.

Punning dessert dish and stand in silver, presented to Harry Head in 1903, made by the Guild of Handicrafts. The dish, when lifted off the stand, is in the shape of a hat—for Mr Head!

employees, for marking outstanding individual achievements, and celebrating anniversaries and jubilees throughout the nineteenth century; and the practice continued well into the present century. Some of the most tastelessly elaborate confections in silver were produced as testimonials of this nature and the more important the occasion, the more ornate and fussy the decoration. For many years, there was little market for these monstrosities and most of them were destined for the melting pot whenever they parted company with the family which had originally treasured them. The somewhat perverse vogue for Victorian silver in recent years has saved many of these monuments in metal from destruction and the human interest of these pieces—the life and background of the person honoured—has provided a fresh angle for the collector. Apart from the elaborate centrepieces; caskets, cake-baskets, salvers, bowls and vases are the objects which were most favoured for presentation purposes. Unless the recipient is of interest, these pieces have little to commend them to the collector as a general rule, since the majority of such items were standard designs, virtually mass-produced for the testimonial trade. From time to time, however, individual pieces, specially designed and decorated, come on the market, but they usually command a high pre-

Two-handled silver cup, by Barnard, 1892. Her
Majesty's Cup, Jersey Races, 1892 won by Jersey Lily.

mium. There are, however, plenty of more
modest pieces within the range of the average
collector, from snuff-boxes to turnip watches;
and these can be collected thematically, according
to the circumstances or profession of the recip-
ient. Popular fields include testimonial silver
awarded to railroad employees, regimental or
military items named to individual soldiers or
sailors, trophies connected with certain sports,
or items presented to people from a particular
locality.

See *Association Items, Railway Relics*

Privat-Livemont, T.

Belgian graphic artist and poster-designer, born
in Brussels in 1861. Privat-Livemont won a
government scholarship in 1879 which enabled
him to study art under Lamaire in Paris. Subse-
quently he worked on theatrical sets with
Lavastre for the *Theatre Français*. In the mid-
1880s, he returned to Brussels, where he settled
in the artists' colony in the suburb of Schaerbeek,
and thenceforward he worked as an interior
decorator and mural painter for various archi-
tects. Among his best known commissions were
the ceramic figures adorning the exterior of the
Maison de Blanc in Brussels and the allegorical
portrait roundels in the Hasselt Town Hall.
He turned to poster-design in 1890–1 and,
from then onwards, he produced the poster

(q.v.) for the annual exhibition of the *Cercle
Artistique de Schaerbeek*. In the 1890s, he
produced a number of famous commercial
posters, using Art Nouveau motifs and long-
haired maidens to extol the delights of Robette
absinthe, Van Houten cocoa, Boldoot perfumes
and Dutoict corsets. Several of his posters in the
same vein advertised Belgian tourist resorts,
but the designs were other-worldly, having
more in common with the Japanese prints of
Hokusai than the *plages* of Ostend or Cabourg.
Art historians are divided as to the origin of
his flower-girls, some claiming that he followed
Mucha (q.v.) and others stating the reverse.
As the Hasselt roundels and the earliest Privat-
Livemont posters were produced long before
Mucha's first Bernhardt posters (1894), the
Belgian artist is now belatedly receiving recog-
nition as one of the pioneers of Art Nouveau.

Private Presses

It is said that a lecture on medieval letter-forms
by Emery Walker in 1888 inspired William
Morris (q.v.) to turn his attention to printing.
Three years later, the Kelmscot Press was
established and, though Morris died in 1896, it
continued to produce limited editions of fine
books until the First World War disrupted its
operation in 1914. Morris designed the type
used by the Kelmscott Press, basing it on
Venetian lettering of the late fifteenth century.
Two type faces were used and given distinctive
names: 'Golden' (roman), 'Troy' and 'Chaucer'
(two sizes of black-letter). Morris produced
small editions (of 200 to 300 copies in most
instances) of the works of English poets. His
greatest work, the Kelmscott Chaucer, was
completed barely a few months before his death.

Morris's example inspired others to found
private presses in England at the turn of the
century. The Doves Press was established by
Thomas Cobden-Sanderson (1840–1922) and
produced fine editions of Milton and other
classical English writers, using a single type-face
in various sizes and printed in black and red.
The *magnum opus* of the Doves Press was the
magnificent folio Bible in five volumes. Cobden-
Sanderson also designed book-bindings (q.v.)
at the Doves Bindery which bound works for
the Kelmscott Press. The third great English
private press was the Ashendene, founded by
St. John Hornby in 1895 and named after his

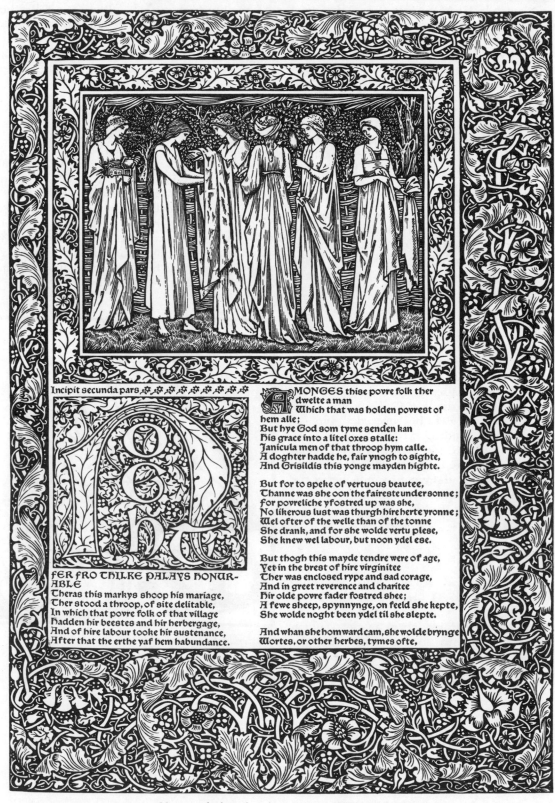

Incipit secunda pars ❧ ❧ ❧ ❧ ❧ ❧ ❧ ❧

AMONGES thise povre folk ther
dwelte a man
Which that was holden povrest of
hem alle;
But hye God som tyme senden kan
His grace into a litel oxes stalle:
Janicula men of that throop hym calle.
A doghter hadde he, fair ynogh to sighte,
And Grisildis this yonge mayden highte.

But for to speke of vertuous beautee,
Thanne was she oon the faireste under sonne;
For povreliche yfostred up was she,
No likerous lust was thurgh hire herte yronne;
Wel ofter of the welle than of the tonne
She drank, and for she wolde vertu plese,
She knew wel labour, but noon ydel ese.

But thogh this mayde tendre were of age,
Yet in the brest of hire virginitee
Ther was enclosed rype and sad corage,
And in greet reverence and charitee
Hir olde povre fader fostred shee;
A fewe sheep, spynnynge, on feeld she kepte,
She wolde noght been ydel til she slepte.

And whan she homward cam, she wolde brynge
Wortes, or other herbes, tymes ofte,

OGht
FER FRO THILKE PALAYS HONUR-
ABLE
Theras this markys shoop his mariage,
Ther stood a throop, of site delitable,
In which that povre folk of that village
Hadden hir beestes and hir herbergage,
And of hire labour tooke hir sustenance,
After that the erthe yaf hem habundance.

A page from the Kelmscott *Chaucer*, designed and printed by William Morris.

237

father's house in Hertfordshire. The Ashendene Press was later transferred to Chelsea where it continued to function until shortly before the Second World War. Other presses, whose works are now eagerly sought after, include the Daniel Press, founded by Henry Daniel, Provost of Worcester College, Oxford; the Eragny Press operated by Lucien Pissaro; and the Vale Press run by Charles Ricketts between 1900 and 1907. The Vale Press produced the works of Shakespeare in thirty-nine volumes, and Pissaro likewise concentrated on the classics, but Daniel produced editions of contemporary writers, including Lawrence Binyon and Robert Bridges. C. R. Ashbee's (q.v.) Guild and School of Handicraft operated its own printing press, first in London and latterly in Gloucestershire. Known as the Essex Press, it excelled in fine two-colour printing.

See *Book-bindings*

Prouve, Victor

French painter, engraver, sculptor and interior designer (1858–1943). Prouve studied in Nancy and Paris and subsequently worked as a designer of glass and furniture for Gallé (q.v.). After Gallé's death in 1904, he succeeded him as President of the Academy of Nancy and was an influential figure in the transition of French design in the applied arts from Art Nouveau to Art Deco. Glass designed by him bears the Gallé signature, with the addition of a tiny asterisk to the left of the 'G'.

Pryde, James

Scottish painter and graphic artist, born at Edinburgh in 1869. He trained at the Royal Scottish Academy and then studied at the *Academie Julian* in Paris, where he met William Nicholson (q.v.) and formed with him the partnership known as the Beggarstaff Brothers (q.v.), to produce art posters at the turn of the century. Pryde is regarded as the founder of the wood-cut technique applied to poster-design.

Putz, Leo

German painter and graphic artist, born at Meran in 1869. Between 1886 and 1889, he studied under Poetzelsberger in Munich and subsequently trained at the Munich Academy. In 1891–2, he travelled abroad, working for a time in Paris, and then resumed his studies in Munich. In 1899, he joined the *Scholle* group and was also a member of the *Sezession* (q.v.) movement in Berlin, Munich and Vienna. As an illustrator, he is best known for his contributions to *Jugend* (q.v.). Putz died in 1940.

Mutterglück, wood-cut by Leo Putz.

Railway Relics

Although interest in railway relics, as a branch of industrial archaeology (q.v.), is to be found all over the world, it has attained its greatest popularity in the United Kingdom. It has been said, with a great deal of truth, that the British are never so keen on keeping something as when they have lost it. This paradox explains the growing popularity for anything to do with the steam locomotive. With the rapid replacement of steam by electric or diesel trains, there has been a drastic pruning of services which were deemed to be uneconomic. This, in turn, has led to the mushroom growth of railway preservation societies, to raise funds to save obsolete locomotives from the scrap-heap, and restore them to full working order on one of the many private railways now operating in Britain.

In a less highly mechanized age than the present, the steam locomotive must have seemed the ultimate in power, speed and noise; attributes which endeared it to countless small boys, whose ambition it usually was to be an engine-driver. These huge, noisy, dirty, clanking monsters had an irresistible attraction which their diesel and electric descendants somehow fail to posses. Enthusiasm for steam locomotives has become tinged with nostalgia, and acquired a new maturity with the passing of the steam-engine from the railway systems of the world. As many a fine Jubilee, Castle or Bulleid Pacific passes to the scrapyard, certain parts are salvaged as mementoes.

Nameplates and crests form the most expensive class of railway relic, up to £200 being paid for a nameplate, depending on the importance of the locomotive. In a humbler class

Railway models: 3½″ gauge model of a 2-4-0 locomotive, 1900; 1¾″ gauge model of a 4-4-0 locomotive, c. 1900.

239

Relic of the Great Northern Railway: ½d newspaper stamp, *c.* 1900.

are coach-destination-boards and head-boards, and lower down the scale are the number-plates from cabsides and smoke-boxes. Other plates which are still relatively inexpensive are the builders' or works' plates formerly mounted on locomotives, wagons and c rriages. There are also lamps, engine-whistles, signs of various kinds, furniture and fittings, relating not only to the rolling stock but to the stations and goods-yards. Crockery and cutlery from the pre-grouping days (up to the early 1920s) was often smashed up or melted down at the time of the big mergers, since there was little use for it then; nowadays such items as plated tableware with the crests of long-forgotten railroad companies, or even such mundane articles as a chamber pot with the initials of the London and North Western Railway, are keenly sought after by the railway enthusiast. Railwaymen's hats, uniforms and watches, station-signs and notices, office rubber-stamps and ticket machines—not to mention the tickets themselves—are all within the province of the railway collector. For the student of ephemera (q.v.), there are posters, postcards, signal diagrams, working time-tables and vintage Bradshaws, company regulations, lithographs and prints of early locomotives, railway letter stamps (introduced in 1891), envelopes with embossed crests, headed notepaper and other stationery items.

See *Ephemera, Industrial Archaeology, Presentation Silver*

Ranson, Paul

French painter and designer, born in 1862 at Limoges. He studied at the *Academie Julian* in Paris and became a founder member of the group known as the *Nabis*. He contributed illustrations to the periodical *Revue Blanche*,

but is best known for his interior designs, textile-patterns and wall-hangings. In 1908, he founded the *Academie Ranson* for the promotion of the arts and crafts in France, and employed Denis (q.v.) and Serusier as lecturers. Ranson died the following year.

Reed and Barton

American silversmiths, founded in Taunton, Massachusetts in 1824. From 1840 onwards, this company specialized in the production of Britannia metal, a cheap substitute for silver, and later developed the electroplate industry. At the turn of the century, Reed and Barton were responsible for a large proportion of the sterling silver and plated ware used in mountings for toilet sets, dress accessories, inkstands (q.v.) and the like.

Parcel-gilt table lamp by Reed & Barton, *c.* 1890.

Bechstein piano advertisement designed by Louis Rhead.

Rhead, Louis John

English painter, graphic artist and designer, born at Etruria, Staffordshire in 1857. Rhead worked in London and Paris before emigrating to the United States in 1883, where he obtained employment with the Appleton publishing company in New York as a book- and magazine-illustrator. He designed covers and posters for *The Century Illustrated Monthly Magazine*, Scribner's and other newspapers and magazines as well as various manufacturing companies. From 1891 to 1894, Rhead was again working and studying in London and Paris and the results of this experience may be seen in his famous design for *Century's* Midsummer Holiday number of 1895, with a dreamy girl in the style of Mucha (q.v.) and lettering after William Morris (q.v.). A one-man exhibition of his poster-designs was held at Wunderlich's in New York following his return to the United States and, at the turn of the century, he was being hailed as the leading graphic artist in America at that time. Rhead also designed book-jackets and book-bindings and, to a limited extent, worked in ceramics. He died in 1926.

Exhibition poster by Louis Rhead, *c*. 1893.

241

Ricketts, Charles

English painter, sculptor, graphic artist and designer, born at Geneva in 1866 and brought up mainly in France. In England, Ricketts came under the influence of Morris (q.v.) and the Pre-Raphaelites. Between 1889 and 1897, he edited, with Charles Shannon, the periodical, *The Dial*, which promoted the Art Nouveau style in graphic design. In 1896, he founded the Vale Press, one of the leading private presses (q.v.) which flourished in England at the turn of the century. In 1922, he was elected a member of the Royal Academy and died in 1931. Apart from his designs in the two-dimensional media,

Title page for *Nimphidia and the Muses Elizium* by Charles Ricketts, 1896.

Ricketts worked on theatrical settings, bronze figures, metalwork and jewellery in the style of Art Nouveau. His illustrations may also be found in the magazine *Hobby Horse*. His designs were eclectic, combining the contemporary S-line and plant motifs with Rococo and Gothic styles. As a book-designer, he is best remembered for the cover, produced in 1892, for a volume of poems by Oscar Wilde and published by Elkin and Matthews, before Ricketts embarked on his own printing and publishing ventures.

Riemerschmid, Richard

German architect, painter and designer, born in Munich in 1868. He was a student of the Munich Academy from 1888 to 1890 and became a founder-member of the *Vereinigte Werkstätten* (q.v.) in 1897. As an architect, one of his earliest and most important commissions was the Munich *Schauspielhaus* (theatre). Subsequently he held various appointments, including lecturer at the Nuremberg school of art (1902–5), director of the Munich school of arts and crafts (1912–24) and director of the Cologne crafts school from 1926. He died in Munich in 1957. Riemerschmid was one of the most talented designers of the Munich circle, working with equal skill in such unrelated media as furniture, metalwork, stoneware, porcelain, glass, textiles and wallpaper; and he exerted great influence on the development of design in all these fields. In cutlery (q.v.), he produced highly distinctive designs, but it was in the realm of furniture that he had his greatest impact. He belonged to the 'organic' school which believed that the grain and quality of the wood alone should serve as decoration, and concentrated on the form of the piece. His designs for cabinets, tables and—above all—chairs, were always highly original. His chairs were characterized by lightness and strength, and it was he who devised diagonal struts, linking the back of the chair to the fore-legs, for greater durability.

Rodgers Knives

In his book *Hindoo Holiday* (published in 1932), J. R. Ackerley recounted the following anecdote: 'As Babaji Rao and I were walking in the outskirts of the village this evening, two old peasants,

Pair of candelabra on curved tusk stems, by Rodgers of Sheffield, *c.* 1890.

a man and a woman, begged of me, the old woman was ill it seemed; she squatted on the ground at my feet and moaned and rocked herself, holding out her clawlike hands, while the old man, who was thin and hairy, and almost entirely naked, begged for medicine for her. "Good medicine," he kept saying, "Rodgers medicine." Babaji was very amused and explained to me that there were some steel articles of recognized excellence, marked "Rodgers" being sold at the fair, and the old man wanted some medicine as good as this steel. "Of course he thinks you are a doctor," he said; "the poor people think that all white men are doctors." I asked him to explain that I was unfortunately not a doctor and I gave the old man a rupee to buy some "Rodgers medicine".' Few manufacturers could ever have received a finer testimonial than that, and so completely unsolicited in such a remote part of the world.

This anecdote symbolizes the wide reputation enjoyed in the late nineteenth century by the Sheffield cutlers, Joseph Rodgers and Sons, whose family had been engaged in the production of fine steel knives as far back as 1682, when their earliest marks were recorded. Although the name of Rodgers is not perhaps as well-known today as it was a century ago, one of their products is still a household word to fans of the Wild West. The famous Bowie knife, invented by Jim Bowie of Alamo fame, was for many years manufactured by Rodgers, using only the very best-quality steel. Buffalo Bill visited the Rodgers works in the 1860s and showed off his blood-stained Bowie knife. At the turn of the century, however, the main output of Rodgers was household cutlery (q.v.) of a very high quality and many of the styles then current, have become collectors' pieces today. In particular, the company was renowned for knives whose blades

243

were delicately etched or engraved with pictures or ornamentation, and a great amount of fine craftsmanship lavished on the handles and mountings.

Rodgers also specialized in multi-blade knives. In 1822, they produced a knife with 1822 blades, one for each year of the Christian era, and added a blade to it every year until 1968. Each blade added in recent years was exquisitely engraved with pictorial vignettes and commemorative inscriptions. Apart from the highly elaborate year knives, Rodgers produced multi-blade sporting knives at the turn of the century, with up to forty blades including can opener, flower-gatherer's scissors, castrator, cigar fork, spanner, cartridge extractor, ear scoop, lancet, forceps and that item beloved of Boy Scouts, a hook for getting stones out of horses' hooves. Among the other late-nineteenth century products, for which Rodgers were famous, were cut-throat razors and scissors, the latter being ornamented with hunting and racing scenes.

Rohde, Johan

Danish painter and designer (1856–1935), trained under Maurice Denis. Rohde travelled extensively in western Europe in the 1890s, coming in contact with Van Gogh in Holland, Rops and Rijsselberghe in Belgium and Gauguin, Toulouse-Lautrec (qq.v.) and the *Nabis* in Paris. In 1893, he organized an exhibition of works by Gauguin (q.v.) and Van Gogh in Copenhagen. As a painter, he was not of the first rank himself, but he had an affinity with the modern movement in the applied arts and produced furniture-designs which were far ahead of their time and would not be out of place in an ultra-modern setting. His streamlined, mahogany furniture (q.v.) was manufactured by the brothers H. P. and L. Larsen. The same clean, simple lines distinguished his cutlery (q.v.) and silverware which he designed for Georg Jensen (q.v., Rohde collaborated with Jensen in metalwork from 1907 onwards, after Jensen progressed beyond his early experiments with jewellery. Together they managed to translate the forms of post-Impressionist painting into metalwork without resorting to the facile imitation of motifs. This fruitful partnership lasted until their deaths, within months of each other, in 1935.

Roller, Alfred

Bohemian painter, graphic artist, theatrical designer and craftsman, born at Brno in 1864. Roller studied at the Vienna Academy and subsequently held a professorship at the school of applied arts in that city. Roller favoured a greater degree of angularity and designed posters (q.v.) notable for their geometric stylization, heralding the fashion of the 1920s. He also designed stage sets for the *Wiener Staatstheater*.

Rookwood Pottery

Foremost American art pottery, from its foundation in 1880 until the 1930s. Thereafter production declined, but it continued to maintain the

Rookwood earthenware bottle decorated by K. Shirayamadani, 1899.

same high standards of quality until it finally closed down in 1967. The Rookwood Pottery was founded in November 1880 by a wealthy socialite, Maria Longworth Nichols, in a converted schoolhouse on her father's estate in Cincinnati. The venture began in a modest way with Laura Fry, a china decorator, and Joseph Bailey, an English immigrant potter, providing the only practical experience. From this small beginning, Rockwood developed in the 1880s to become the leading art pottery and, indeed, the only one of the many art potteries in Ohio to survive the vicissitudes in the fashion for studio ceramics until recent times. The production of art pottery was expanded in 1883 and, by the end of the decade, Rookwood was beginning to show a profit. In the initial decade, various domestic and useful wares were also produced, mainly in order to offset the losses incurred on the art pottery which was still in its experimental stage, but, from 1890 onwards, the major part of the output was concentrated on decorative wares.

Rookwood experimented boldly with new glazes and shapes, and in the 1890s, was renowned for its rich brown, orange and yellow blended backgrounds with contrasting floral, plant, dragon and insect motifs. Rookwood wares won high praise at the Columbian Exposition (q.v.) and thenceforward their success was assured. The decorative wares may be grouped in categories according to the brand names applied to them. The earliest, known as 'Cameo', had floral decoration on cool pink or white grounds; from the middle 1890s, 'Iris' (light blue, grey and white blended under a high glaze), 'Sea Green (described as 'a limpid opalescent effect' with fish motifs) and 'Aerial Blue' (bluish glaze on light blue and grey blended backgrounds) were added to the range. At the turn of the century, Rookwood also produced vases decorated with human figures and animals, reproductions of Old Masters and slip-painted portraits of American Indians. Experiments in sculptural forms in the style of European Art Nouveau were unpopular with the American public and were consequently short-lived. Many prominent designers and artists worked for Rookwood at one time or another, including Artus Van Briggle (q.v.) who subsequently established his own art pottery in Colorado Springs. In 1904, the premises were further expanded to cope with the production of decorative tiles (q.v.) with a matt finish, but this line

Rookwood earthenware vase by Matthew A. Daly, 1890.

was discontinued before the First World War. The decorative wares up to 1910 were invariably signed by the individual artists, in addition to the standard Rookwood marks and the date, a feature which enables the collector to assign his pieces to the proper period.

Roseville Pottery

American art pottery, established at Roseville, Ohio in 1892. Originally only useful wares were manufactured but, in 1900, additional premises

were acquired in nearby Zanesville and, under the direction of George F. Young, Roseville began producing art pottery, emulating the products of the Lonhuda and Owens potteries (qq.v.). The art pottery was distinguished by the name 'Rozane', usually found incised on the base of each piece. Artistically, Roseville was not as fine as its immediate rivals, but this was balanced by the originality and diversity of its styles, subsequently known by such brand names as 'Rozane Royal', 'White Rose' and 'Egypto'. The early Roseville pottery was slip-painted on a dark ground, but the later wares had modelled designs with a matt glaze. Later wares were marked 'Roseville', either impressed or embossed, and these are still relatively plentiful.

Royal Relics

The turn of the century marked the zenith of royalty as a world-wide institution. Even the United States could boast a recent connection with royalty, both Samoa and Hawaii having had monarchical forms of government until shortly before they came under American rule, in 1889 and 1898 respectively. It was in Europe, however, that monarchy seemed at its height, though even there the thrones of ancient dynasties no longer seemed as safe as they once were. Portugal became a republic in 1910 and, in the same year, the ancient empire of Korea came to an end. Two years later, China opted for republicanism and then came the First World War which toppled the great Central European empires of Austria, Germany and Russia, with the thrones of Bavaria, Württemberg and Montenegro in their wake, not to mention a host of petty German duchies and principalities, whose reigning families were forced into exile.

Now that monarchy is virtually confined to Scandinavia, the Low Countries and Britain, there is a nostalgic element in the current craze for relics and memorabilia of royalty. The most highly prized items are those which were personally associated with king and queens, princes and emperors, but there is infinitely greater scope in the commercial souvenirs produced in many countries to commemorate jubilees and other royal events. Among these events celebrated in this period were the Diamond Jubilee of Queen Victoria (1897), the millennium of the Kingdom of Hungary and the Golden

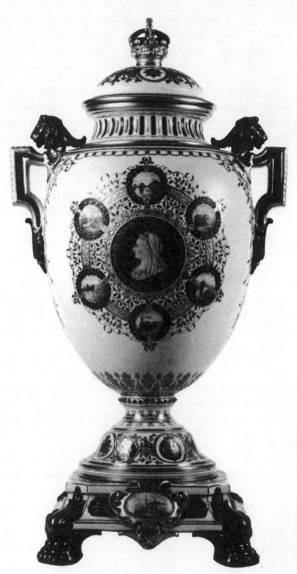

Coalport Diamond Jubilee vase and cover; limited edition of 50, 1897.

Jubilee of Emperor Franz Josef (1898), the Silver Jubilee of the German Empire (1896), the centenary of King William I of Prussia (1897), the Coronations of Edward VII and George V in Britain (1902 and 1911 respectively), the accession of Victor Emmanuel III of Italy (1900), the centenary of Württemberg and the Silver Jubilee of Rumania as kingdoms (both 1906), the Diamond Jubilee (1908) and 80th birthday of Emperor Franz Josef (1910), the Golden Jubilee of Prince Nicholas of Montenegro (1910), the investiture of the Prince of Wales—later King Edward VIII and Duke of Windsor

246

Ticket for the Coronation Durbar, Delhi, 1911.

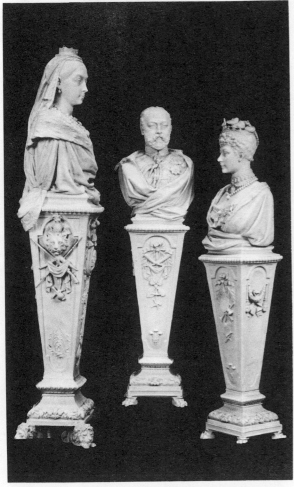

Busts of Queen Victoria, King Edward VII and Queen Alexandra, in parian ware by Royal Worcester.

(1911), the Silver Jubilee and ninetieth birthday of Prince Regent Luitpold of Bavaria (1911), the Silver Jubilee of Tsar Ferdinand of Bulgaria (1912), the Silver Jubilee of Kaiser Wilhelm II of Germany and the Tercentenary of the Romanov Dynasty (both 1913).

All of these major events, and a galaxy of lesser anniversaries and celebrations, produced innumerable mementoes in the form of coins, particularly in the German states and Central Europe; picture postcards; commemorative pottery and porcelain (qq.v.); medals in great profusion; printed silk scarves and handkerchieves; souvenir albums and picture books. Postage stamps (q.v.), though still in their infancy as commemorative items, were an obvious medium for royal celebration. By contrast, commemorative labels were at the height of their popularity and remedied the deficiency of proper postage stamps, being frequently sold in aid of charities and other deserving causes.

One aspect of royal memorabilia, hitherto neglected but now attracting the attention of collectors, consists of gifts made to schoolchildren by civic and national authorities in connection with royal events, and ranging from the Doulton (q.v.) Diamond Jubilee mug to confectionery boxes, presented in connection with the 1911 Coronation. Allied to this are the boxes of tobacco, sweets and other 'comforts' supplied to troops on active service in the Boer War and the First World War, usually embellished with patriotic motifs and profiles of the reigning monarch. King Edward VII revived the royal franking privilege in 1902 and examples

247

of mail from the royal household bearing his monogram are now highly prized. European royalty, especially the myriads of kings, princes and dukes of the German Empire, had large scalloped seals to denote their franking privilege and examples of these, preferably with the royal autograph, are also eminently collectable. See *Association Items, Ephemera, Erinnophily*

Roycrofters

The name given to the community of artists, designers and craftsmen, established by Elbert Hubbard (q.v.) at East Aurora, New York, emulating William Morris and the Arts and Crafts Movement (qq.v.) in England, in the production of fine hand-made furniture, pottery, textiles and books.

Armchair by the Roycroft Shops, *c.* 1903.

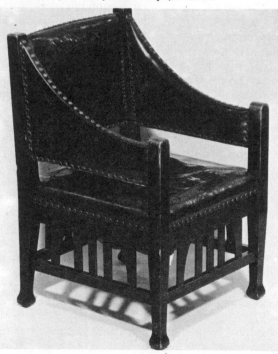

Rozenburg Pottery

Dutch art pottery established at The Hague in 1885 by the German potter, W. W. von Gudenberg. The *Rozenburg Plateelbakkerij* was under the direction of Theodorus A. C. Colenbrander, one of the outstanding figures in the ceramics of the Low Countries in the late nineteenth century. Rozenburg specialized in light, elegant faience (q.v.) wares and egg-shell china. Colenbrander's early faience pieces were decorated in pale shades of yellow, pink and blue with large white areas. Scrollwork and stylized clouds were the favourite motifs. Many Dutch artists worked as decorators for Rozenburg at the turn of the century, painting the fine, translucent porcelain with realistic birds, animals and flowers, as well as geometric patterns derived from traditional Javanese batiks. The colouring of these later pieces is harsher and more strident: brick-red, black, mauve and green, usually on a bottle-green ground. Colenbrander subsequently headed two other potteries, Zuid-Holland and Den Ram, and both factories produced faience in the Rozenburg style.

Cup and dish by Rozenburg Plateelbakkerij, *c.* 1900.

Ryushin, Umezawa

Japanese metalworker (1874–1955), specializing in *maki-e* (lacquer ware). Ryushin experimented with new colours and textures of lacquer and applied them to many objects which had not previously been subjected to this decorative treatment. Lacquerware by this craftsman was exhibited at the *Exposition Universelle* (q.v.).

Three-colour *pâte-sur-pâte* flask by Minton, late 19th century. ▶

'Cymric' tray with tea and coffee service, made by
Haseler, 1902.

Sattler, Joseph

German graphic artist, born at Schrobenhausen in Upper Bavaria in 1867. From 1886 to 1891, he studied art in Munich, securing an appointment in the latter year as lecturer in the Strasbourg school of arts and crafts. From 1895 to 1904, he worked in Berlin and then returned to Strasbourg, but moved to Munich in 1918 and died there in 1931. Sattler was a prolific book- and magazine-illustrator whose changing styles reflected the fashions of the period. Beginning in the romantic style, he turned to wood-cut illustration in the manner of Albrecht Dürer and, in the 1890s, applied these techniques to *Jugendstil* (q.v.). Sattler designed posters (q.v.) and also produced covers and illustrations for *Pan*.

Schmithals, Hans

German architect, painter and designer, born at Bad Kreuznach in 1878. From 1902 to 1909, he attended the Obrist-Bebschitz school of applied arts in Munich, first as a pupil and subsequently as a lecturer. From 1909 to 1911, he worked in Paris and then returned to Munich where he built up his architectural practice and specialized in interior design. He is best remembered for his textile-patterns and wall-hangings in the *Jugendstil* manner.

Schmuz-Baudiss, Theodor

German painter, engraver and designer, born at Herrnhut in 1859. He studied art under Lindenschmit at the Munich Academy, but turned to pottery in 1896, working as a freelance illustrator for the King's Porcelain Manufactory in Berlin (q.v.). At first he painted landscapes and views of towns, using soft green, grey and rose tones. In 1897, he became a founder member of the *Vereinigte Werkstätten* (q.v.) in Munich and thereafter developed art pottery in the prevailing *Jugendstil* (q.v.). From 1898 onwards, he headed the art pottery section at the Berlin factory.

Screens

In an era before patent draught-excluders and door-strips, the screen was a necessity for shutting out—or at least deflecting—draughts from ill-fitting doors and windows. Modern ideas of Victorian prudery and false modesty have spawned the fallacy that screens were designed primarily for ladies to undress behind, but this seems to have been a latter-day invention, promoted by Hollywood in countless light romantic movies of the 1930s. Door-screens extended right down to the floor and were made of folding panels of wood, canvas, leather or embroidered fabric over a wooden frame. Lighter, more elegant screens in silks and damasks might be used in the boudoir, more for decorative effect. In the 1880s and 1890s, there was a fashion for screens with fretted strapwork at top and bottom, with Oriental silk-printed panelling. Shorter screens, with their panels a foot or more above floor level, were intended to stand in front of those large, blazing fires so beloved by the Victorians, to keep the fierceness

of the heat from desiccating the complexions of the ladies. Pole screens (q.v.) were even smaller; mounted on a pole or narrow tripod, they could be moved around the fireside more easily.

Nursery screens were generally utilitarian in design—canvas on wooden frames—but their severity was alleviated by the widespread practice of decorating the broad panels with pictures cut out of magazines; or with die-stamped paper scraps, picture postcards, trade cards, cigarette cards (qq.v.) and other forms of gaily coloured, pictorial ephemera (q.v.). When the pieces had been laboriously pasted into place, they would be varnished over in order to preserve them. Late Victorian screens of this type, with their panels intact, are now in great demand on account of the rich treasure of ephemera preserved thereon. Postage stamps (q.v.), applied in a form of mosaic, were another popular medium for screen decoration, and countless thousands of Penny Lilacs or American 2-cent Washingtons were put to this secondary use.

French giltwood firescreen, c. 1900.

Chinese carved hardwood screen, 1900.

The artistic tiles (q.v.) produced by William Morris, William de Morgan, Doulton's (qq.v.) and others were often, mounted in panels for incorporation in screens.

Serrurier-Bovy, Gustave

Belgian architect and interior designer, born at Liège in 1856, died in Antwerp in 1910. Serrurier-Bovy travelled frequently to Britain where he was strongly influenced by Ashbee and Voysey (qq.v.) and subsequently imported English Arts and Crafts furniture and fabrics to Belgium. Later he operated a shop in Liège which marketed the products of Liberty (q.v.) but, from 1895 onwards, he designed his own furniture which was austere by comparison with the English Art Nouveau styles of the period. Like Horta and Van de Velde (qq.v.), Serrurier-Bovy designed furniture for a specific purpose, to

complement the architecture of a house, and consequently individual pieces do not often stand on their own merits. His style attained maturity in 1900 when he decorated the *Pavillon Bleu* at the Paris *Exposition Universelle* (q.v.). Serrurier-Bovy pioneered the design of 'collapsible' furniture in units, with his 'Silex' range of birchwood furniture.

Sezession

German word for 'secession', used to describe the breakaway of younger artists and craftsmen from the traditional mainstream of the applied arts. Though strictly applied to the movement in Vienna in 1897, it was a convenient appellation for the groups of artists in Berlin, Dresden and Munich who broke away from the classicism that dominated the decorative arts of the nineteenth century. The *Sezession* movement began in Vienna in 1896 when a number of artists became disgruntled with the *Genossenschaft der bildenden Künstler* (Society of Visual Artists). Matters came to a head in May 1897 when the Vienna Municipal Council, advised by Alderman Rudolf Mayreder, approved a design for an exhibition pavilion submitted by the brothers Julius and Karl Mayreder, members of the 'traditionalist' wing of the Society. Disgust at this move led to the resignation of several members, who formed the *Vereinigung bildenden Künstler Österreichs* (the Association of Austrian Visual Artists). Influential figures in the new Association were the architect Otto Wagner and the painter Gustav Klimt (qq.v.), and their respective followers formed two of the important groups within the Association. Felicien Freiherr von Myrbach, Director of the department of graphic arts at the School of Applied Art and Industry, was a founder member of the *Sezession* and he subsequently secured important teaching posts for other members, including Olbrich, Hoffmann, Roller and Moser (qq.v.). In turn, many of the students at the School were won over to the *Sezession*. The *Sezession* designed and built its own art centre and, from 1898 onwards, staged exhibitions of the work of its members.

The members of the *Sezession* were mainly influenced by the Arts and Crafts Movement

Sezession poster designed by Alfred Roller, 1903.

(q.v.) in England, and their activities were closely modelled on work of Ashbee and Crane (qq.v.). Stylistically, however, they developed their own brand of Art Nouveau, more controlled and more severe than the English, but owing a great deal to the inspiration of Mackintosh and the Glasgow group (q.v.). Following the example of Ashbee's Guild and School of Handicraft, they founded the *Wiener Werkstätte* (q.v.) in 1903, to give practical expression to artistic design in the widest possible range of articles. The rift between Hoffmann and Klimt widened thereafter and culminated with the secession of Klimt and his followers from the *Sezession* in June 1905. Like the new styles elsewhere in Europe, the *Sezession* gradually moved away from curvilinear forms to a more angular, geometric style; severity and simplicity became the keynotes and heralded the work of the *Bauhaus* movement of the 1920s.

See *Art Nouveau, Brussels School, Jugendstil, Stile Liberty*

Shaw, Richard Norman

British architect and interior-designer, born at Edinburgh in 1831. In 1847, he went to London where he was apprenticed to William Burn and also attended the architectural classes of the Royal Academy where, in 1854, he won the gold medal and a two years' travelling scholarship. His travels abroad resulted in his book *Architectural Sketches from the Continent,* published in 1856. His first practical job was as an assistant in the drawing office of George Edmund Street, where William Morris and Philip Webb (qq.v.) were also employed. Subsequently Shaw became Street's chief assistant and, in 1863, he formed his own architectural practice in partnership with W. E. Nesfield, a former colleague in Burn's office. Shaw was elected an Associate of the Royal Academy in 1872 and a full member five years later. He was responsible for the design of many outstanding buildings in London, Liverpool and other parts of England in the late nineteenth century. Among his more important works were the New Zealand Chambers in Leadenhall Street and New Scotland Yard (the former headquarters of the Metropolitan Police); the latter being regarded as his finest and most complete work. Shaw also designed numerous private country houses, including Preen Manor, Shropshire; Pierrepoint, Wispers

and Merrist Wood in Surrey; Lowther Lodge, Kensington; Flete House, Devon; Greenham Lodge, Berkshire; Dawpool, Cheshire and Chesters, Northumberland. He also designed three houses for himself, in Kensington, Chelsea and Hampstead.

Shaw revolutionized English domestic architecture, by going back to medieval models, techniques and traditions. His revival of the half-timbered house was subsequently vulgarized by the speculative builders of the 1930s and it is a far cry from his fine Elizabethan house at Banstead, Surrey (1884), to the suburban mock-Tudor semi-detached, which is to England what the ranch house is to America. Shaw's style changed dramatically about 1890, when he abandoned classicism and traditionalism in favour of the prevailing *fin de siècle* fashions. Chesters (1891) and the Piccadilly Hotel (1905) are good examples of his later work. Shaw was a founder member of the Arts and Crafts Movement (q.v.) and believed, like Voysey (q.v.), in designing the interiors of his houses down to the humblest object. He produced designs for decorative wood panels, textile-patterns, wrought-iron grills and fire-dogs, rather than for furniture in the accepted sense. Shaw died at his Hampstead home in 1912.

Shomin, Unno

Japanese metalworker (1844–1915), specializing in the techniques of metal-chasing. With Kano Natsuo (1828–98) and Tsukada Shukyo, he led the revival in the art of metal-chasing, and its application to small boxes and other decorative articles after the traditional market for *tsuba* (sword fittings) declined.

Silver

In the second half of the nineteenth century, there was a boom in the silver industry, reflecting the rapid rise in material wealth of the countries of western Europe and North America. Unfortunately the tendency to equate wealth with ostentatiousness in silver, virtually the only material for applied art which possessed intrinsic value, resulted in pieces becoming increasingly massive and elaborate. Centrepieces resembled war memorials in their monumental construction, but even lesser pieces were so heavily

254

Silver back of a hand-mirror by W. S. Hadaway, 1904.

satirized it, referring to the Podsnap plate in *Our Mutual Friend*: 'Here you have as much of me in my ugliness as if I were only lead; but I am so many ounces of precious metal worth so much an ounce—wouldn't you like to melt me down?' In Germany, fussy, over-ornamented silverware was derided as *der Kunst des Jockey-clubs,* alluding to the predilection of sporting clubs for trophies in this ebullient style.

Right down to the end of the nineteenth century, the bulk of the silverware manufactured in Europe was eclectic, drawing on the styles of the Renaissance, Gothic, Baroque, Rococo and Neo-classical periods of earlier centuries, not to mention the motifs and forms borrowed from Japan, Peru, Egypt, Greece and Rome, and all mixed up with a penchant for scrollwork, heraldic or pseudo-heraldic devices, putti in profusion and foliage in great luxuriance. It was against this that Matthew Digby Wyatt, in *Metalwork and its Artistic Design* (1852), struggled: 'The object must be so formed as to fulfil the purpose for which it is intended; that object must in no way be disguised, but, on the contrary, should be apparent on the first cursory inspection; the general outline should be symmetrical and the disposition of the various parts as proportioned as to appear strong . . . the amount of ornament should be proportioned to the purpose of the object . . . there should be no direct imitation of nature, and yet no perversion of her forms; and lastly, it would be well if a system of judicious contrast of plain surfaces and enrichment were carried throughout such works, and each ornament applied only to those points where the general form appears to demand accentuation.'

Wyatt's dicta had little influence at the time but, a generation later, they inspired Christopher Dresser and Charles Ashbee (qq.v.) to pioneer a simpler style in English silver which gathered momentum towards the end of the century. Silver was one of the principal media which captured the attention of the Arts and Crafts Movement (q.v.). Elkington, Liberty (qq.v.), James Dixon of Sheffield and W. H. Haseler (q.v.) of Birmingham produced silverware on a commercial basis at the turn of the century, making use of designs by Dresser and others, such as R. C. Silver, William Burges, Archibald Knox and Jessie King. Morris and Company (q.v.) employed Philip Webb (q.v.) to design silverware in a robust style with medieval overtones. From 1899 to the early 1920s,

ornamented and overlaid with Rococo excrescences that the form was often completely engulfed. The florid vulgarity of late-Victorian silver was not without its critics. Charles Dickens

255

Liberty 'Cymric' silver and enamel clock, 1900.

Liberty (q.v.) produced their distinctive 'Cymric' range of table silver, though actual production was delegated to W. H. Haseler from 1901 onwards.

Until the discovery of the Comstock Lode in 1858, silver was comparatively little used in the United States and it is significant that electroplate and other silver substitutes made greater headway in America in the mid-nineteenth century than anywhere else. From 1860 onwards, however, the market for silverware expanded enormously and companies, such as Gorham, Pairpoint and Charles Louis Tiffany (qq.v.) produced a growing volume of silverware in the contemporary European eclectic styles. Reed and Barton (q.v.), one of the pioneer firms in the field of electroplate, turned to solid silverwares in the late 1880s and went back to the simple colonial styles of the early eighteenth century, producing surprisingly restrained hollow ware, contrasting with the heavily encrusted ornament which characterized so much of their electroplate.

256

From the late 1860s onward, Charles Louis Tiffany produced an enormous range of silverware, much of it in the prevailing florid styles. Significantly, it was his simpler wares which won him an award of merit at the Paris Exposition of 1867 and, thenceforward, this vast organization (the largest silversmiths in the world by 1890) manufactured all manner of silverware from small boxes and dress accessories to enormous centrepieces. Unfortunately it is usually for the latter that Tiffany's are remembered. By 1893, Tiffany held appointments to no fewer than twenty-three crowned heads, including Queen Victoria, the Shah of Persia and the Tsar of Russia, and the bulk of the silver, produced as royal commissions, was in the classical and exotic *genre*. Lucien Falize and Peter Carl Fabergé, in Paris and St. Petersburg respectively, produced costly confections in silver. Falize was a traditionalist to the end of his life (1897) and enjoyed the patronage of the royalty and nobility of Europe. Fabergé (q.v.),

Silver dressing-table mirror by Walker & Hall, *c.* 1905.

Pair of parcel-gilt *repoussé* vases, by Wakley and Wheeler, 1900.

though best known for his exotic trinkets and jewelled Easter Eggs, produced some astonishingly modern styles of decoration in silver, used mainly on powder-compacts and cigarette-cases (q.v.).

Truly modern styles in silverware began to emerge with the work of the Glasgow group (q.v.) led by Herbert McNair. The somewhat austere and more angular lines of the metalwork, designed by McNair and the Macdonald sisters (qq.v.), paved the way for the more streamlined design practised in the Low Countries, Germany, Austria and Scandinavia in the early years of this century. The outstanding designers of silverware were Georg Jensen in Denmark, Joseph Maria Olbrich and Josef Hoffmann in Austria, Frans Zwollo and Jan Eisenloeffel in Holland and Henry Van de Velde in Belgium (qq.v.). Art Nouveau silver, in its more decadent floral aspect, appeared in the silverware of the old-established Parisian firm of Christophle (q.v.) in the mid-1890s. As well as solid silver, Christophle applied Art Nouveau decoration increasingly to electroplate, and much of their so-called Gallia metal, a more sumptuous sub-

stance than mere electroplate, was decorated in this manner between about 1903 and 1910.
See also *Cutlery, Electroplate, Jewellery, Presentation Silver*

Silver bowl designed by C. R. Ashbee and made by the Guild of Handicrafts, 1893.

Sosuke, Namikawa

Japanese metalworker (1847–1910) who led the revival in the use of *cloisonné* (q.v.) in Japan at the turn of the century, after a long period of decline. *Cloisonné* enamelling had been practised in Japan for centuries but, like other aspects of the applied arts, declined in the face of Westernization from 1868 onwards. Sosuke re-introduced the technique from Europe where it had been given new stimulus, especially in France and England. Sosuke established a new *cloisonné* factory in Tokio, where the best elements in traditional and western methods were combined.

Sozan, Suwa

Japanese potter (1852–1922) of the Tokio School. With Takemoto Hayata (1848–92), Sozan intro-

257

duced Western techniques of pottery and combined them with traditional Japanese styles. Sozan's best work in this *genre* was produced up to 1912; thereafter his pottery tended to become increasingly formalized.

Spanish Mission Furniture

Type of simple, well-made furniture which originated around the end of the nineteenth century in the United States and has remained popular ever since. The name derived from the Franciscan missions in California in the eighteenth century, and the style was thought to be associated with the distinctive architecture and interior design pioneered by these Spanish missionaries. In fact, the name seems to have evolved erroneously. The earliest reference to 'mission' furniture dates from 1898, when Hubbard and Stickley (qq.v.) used the term to imply functionalism (q.v.): a chair had a mission to be used, a book-case had a mission to hold books, and so on. Be that as it may, the romantic connotation of the old *misiones* has stuck to these pieces of simple oak furniture ever since.

Staffordshire Pottery Figures

Although the hey-day of the Staffordshire pottery figure was from 1780 to 1870, they continued to be produced well into the twentieth century: William Kent of Burslem was producing figures from nineteenth century moulds as recently as 1962. Production at the turn of the century was largely in the hands of this company, founded in 1878 as Gaskell, Kent and Parr and changing its name to William Kent Ltd in 1894. The late nineteenth century figures can readily be distinguished from the earlier ones by their comparative lack of colouring. The figures were often left completely white, with only the lightest amount of colour to the background. Equestrian figures, for example, might have a coloured horse, but the riders would be albino, apart from minor details such as gold buttons and facial features. The bulk of the figures consisted of standard heroes and heroines—members of the royal family, the Duke of Wellington, Garibaldi, Jenny Lind and Florence Nightingale, but a topical note was struck by General Gordon and the generals of the Boer War period such as Roberts, Kitchener, Buller and French.

Earthenware bust of Voltaire; Staffordshire pottery, *c.* 1890.

Steuben Glass

The Steuben Glass Company was formed at Corning, New York in 1903, under the management of L. G. Hawkes and Frederick Carder. Carder, an English immigrant, had served his apprenticeship with Stevens & Williams of Brierley Hill, Staffordshire and came to the United States in 1903. Subsequently he became one of the most influential figures in the later history of American art glass. In 1918, the Steuben company was taken over by the Corning Glass Company (q.v.), but Carder continued to direct operations until the 1930s. During this period, he was responsible for the production

Bowl and vase by Frederick Carder for the Steuben Glass Works, *c.* 1904.

of coloured glass, running to over sixty major colours in several thousand shades. Among his best-known creations were *'Verre de Soiz'*, a pearly, iridescent and slightly metallized glass, and 'Intarsia' glass, distinguished by the solid particles trapped in it. Other brands of art glass produced by Steuben were 'Aurene', 'Cluthra Ivrene' and 'Rosaline'. 'Aurene' was a particularly distinctive glass, patented in 1904. It had a fine gold lustre and may be found in shades of gold, red, green and brown, either plain or with characteristic Art Nouveau motifs in contrasting colours. Although the bulk of Steuben glass was not marked, a few pieces were marked 'Steuben' or even bore Carder's name, and these are the items most highly prized nowadays. A few pieces are marked with a date.

Stickley, Gustav

American furniture designer and manufacturer, (1857–1942). Stickley was the outstanding innovator in American furniture at the turn of the century, translating the aims and ideals of William Morris and the English Arts and Crafts Movement (qq.v.) into the American idiom. Stickley was raised on a Wisconsin farm and later worked in furniture stores and factories where he gained a great deal of practical experience, both in the manufacture and in the marketing of furniture. He rebelled against the cheap, fussy furniture which was mass-produced in the factories of Chicago, Cincinnati and Grand Rapids and argued that the quality could be raised immeasurably without increasing the cost. The result was his simple 'Craftsman' furniture, well made in the craft workshops which he established at Syracuse, New York in the 1890s.

The name given to this style of furniture came from the magazine *The Craftsman* which Stickley edited and used to publicize his ideas. The first number of this periodical, in October 1901, proclaimed Stickley's aims 'to substitute the luxury of taste for the luxury of costliness; to teach that beauty does not imply elaboration or ornament; to employ only those forms and materials which make for simplicity, individuality and dignity of effect'. He began designing his furniture at Eastwood, New York, in 1898 and first brought it to the attention of the general public at the furniture exhibition, held at Grand

259

Oak and leather settle designed and manufactured by Gustav Stickley, 1908.

Rapids, Michigan in 1900. Later Stickley claimed that he had had no intention of creating a new style; he merely wanted to replace the false taste of the Beaux Arts (q.v.) style of furniture with something simple, durable, comfortable and 'fitted for the place it was to occupy and the work it had to do'.

Stickley used oak and native American woods, with simple upholstery in leather or canvas and metal fittings of copper or iron. The furniture had a startlingly modern appearance for the early 1900s, especially the reclining chair which he patented in 1901 and is still popular generations later. The enduring qualities of Stickley's style were summed up, rather complacently, in his catalogue of 1913: 'Most of my furniture was so carefully designed and well proportioned in the first place, that even with my advanced experience I cannot improve upon it'. By this time, however, Stickley was facing fierce competition and he tried in vain to protect his Craftsman brand by using no fewer than three trademarks on each item: the word 'Craftsman', the shop mark showing joiner's compasses with the Dutch motto '*Als ik Kan*' ('as I can'—first used by Jan van Eyck) and the written signature 'Stickley'. Inferior imitations

so drastically undercut him that Stickley was forced into bankruptcy by 1916. Stickley had a greater influence on the development of American—and subsequently Western European—interior design that any other furniture-maker of this century. He was a prolific propagandist for his Craftsman style of furniture, publishing the best-selling *Craftsman Homes* in 1909, embodying, in book form, his preaching in *The Craftsman*.

Stile Liberty

The name given to Art Nouveau in Italy. The allusion to the English firm of Liberty (q.v.) is highly significant. It is surprising that there were no original developments in the new style in the Mediterranean area (the architecture of Gaudi (q.v.) is a solitary example) and such manifestations of Art Nouveau as appeared in Italy were largely imported from England. Carlo Bugatti (q.v.) designed furniture and a certain amount of silverware in the *Stile Liberty* but he seems to have been quite alone in this respect.
See *Art Nouveau, Jugendstil, Sezession*

The Studio

English art journal, founded in April 1893 and, under the name *Studio International,* still in existence. *The Studio* is an invaluable source of information regarding trends and developments in the fine and applied arts at the turn of the century; even the emphasis on certain aspects, and the total omission of others, reveal significantly the attitudes of artists and craftsmen of the period to developments in other countries at the time. The first volume carried the earliest published work of Aubrey Beardsley (q.v.), but was accompanied by a highly critical account of the man and his work by Joseph Pennell. One of the earliest controversies publicized in *The Studio* concerned the effects, harmful or otherwise, of photography to painters. Then, as now, *The Studio* maintained a high standard of provocative journalism and possessed that lively, up-to-date quality which was necessary to a journal of contemporary art. An early development was the production of *Studio* special numbers, exploring some aspect of the arts in depth. Among the early subjects were modern book-bindings (q.v.) and their designers (1899),

Vignettes for story endings; a competition page from *The Studio,* 1900.

Christmas cards (q.v.) and their chief designers—the best source for the work of Kate Greenaway (q.v.)—written by Gleeson White (1894), and Charles Holme's accounts of modern British domestic architecture (1911) and the art revival in Austria (1916).

Studio Pottery

Ceramics produced by individual craftsmen-potters, as opposed to the mass-produced wares of the great commercial potteries, also known as art pottery. Reaction against the lack of creativity or individuality in the industrial processes favoured by Sèvres, Meissen, Limoges, Worcester, Minton (qq.v.) and the other well-established factories of Europe induced certain potters to turn their backs on useful wares and even the standard repertoire of decorative wares, and strive to create something which was likely to reflect the intellectual 'aesthetic' approach of the period. Art pottery had many origins in many countries. In Britain, the Art Unions, which aimed at bringing Art and Manufacture closer together, fostered the design of everyday wares by artists in the 1840s. In 1846, Henry Cole, under the pseudonym of Felix Summerly, won a Society of Arts prize for a tea set, subsequently manufactured in earthenware by Minton (q.v.). Later Cole founded Summerly's Art Manufactures which tried to wed the High Art of the aesthetes to the Low Art which was fashionable in the second half of the nineteenth century. The Summerly experiment, however, lasted barely three years. Cole was criticized by the *Art Union* magazine for his dictatorial approach, his products did not enjoy a ready sale and, by 1850, he was more preoccupied with the plans for the forthcoming Great Exhibition. Nevertheless the importance of Cole and his experiments of 1847–50 cannot be over-emphasized for the part they played in laying the foundations of the late-Victorian art pottery movement.

A parallel development on the other side of the English Channel coincided with the strong Far Eastern influence in the French applied arts. Theodore Deck (1823–91) opened his studio pottery in Paris in 1856 and pioneered the art pottery movement in France. Unlike Cole, Deck persevered and his superbly decorated vases and dishes won wide acclaim at the Paris Exhibition of 1867. Thereafter the vogue for studio pottery

English studio pottery; Ruskin vase, 1908.

rebuilt, but the craze for 'do-it-yourself' decorated pottery and porcelain swept the country. From 1876 onwards, the London retailers, Howell & James, held annual exhibitions of pottery decorated by amateurs. Much of this material has a decidedly amateurish appearance, lacking the technical excellence or finish of the professional wares and often painted in muddy colours. But out of these often crude experiments, there developed the artist pottery of the 1880s and 1890s. Working on the principles of Ruskin and Morris and often without professional training, the artist-potters of the late nineteenth century brought a new approach to ceramics, compensating for a lack of sophistication in the freshness and vitality of their wares.

The outstanding figures in English studio pottery were William de Morgan (q.v.), first at Merton Abbey (q.v.) and latterly at Sand's End; Harold Rathbone who founded the Della Robbia Pottery (q.v.) at Birkenhead; and the Martin brothers who gave their name to the highly distinctive Martinware (q.v.). The commercial factories did not entirely disregard the vogue for studio pottery. Doulton of Lambeth (q.v.) took up where Minton left off and encouraged such artist-potters as Hannah and Florence Barlow.

Studio pottery developed rapidly in the Low Countries from 1885 onwards, inspired by such

Samson imitation of Japanese 'Kakiemon' bottles, c. 1900.

was truly established in France and spread rapidly to other parts of the continent. Deck continued to produce finely glazed earthenware right up to the time of his death. Many of his later pieces derived inspiration from Moorish originals and were, in fact, destined for the Arab market of the Near East. The French studio pottery attained its peak in the 1890s, with the work of Dammouse, Dalpayrat and Delaherche (qq.v.) who were all primarily concerned with the effects of various glazes and their elaboration on pottery and porcelain.

In England, Minton revived Cole's ideas in 1870 by establishing the Art Pottery Studio in Kensington Gore, London. Here artists and art students were encouraged, under the aegis of W. S. Coleman, to decorate Minton wares. The studio was burned down in 1875 and never

Tile from the J. & J. G. Low Art Tile Works, Chelsea, Mass., *c.* 1890.

Vase by Hanna Tuft for the Marblehead Pottery, *c.* 1908.

diverse influences as early Dutch delft, the English Arts and Crafts Movement (q.v.), Javanese batik patterns and local folk traditions. The *Rozenburg Plateelbakkerij* (q.v.) founded in 1885, pioneered studio pottery in the Netherlands and was quickly emulated by a host of lesser potteries, of which Amstelhoek (q.v.) is the best known. Individual artist-potters whose work is now attracting the attention of collectors, include Joost Thooft, W. C. Brouwer and Josef Mendes da Costa (qq.v.). In Belgium, reaction against the conservatism of the porcelain and faience factories was led by *Les Vingt*, a group of twenty *avant-garde* artists including the Englishman A. W. Finch (q.v.) who subsequently taught in Helsinki and had a great influence on the development of Scandinavian ceramics.

Apart from the short-lived Chelsea Keramic Art Works of the 1860s, studio pottery did not exist in the United States prior to the Centennial Exposition of 1876, but the Oriental wares displayed on that occasion inspired artist-potters, centred on Cincinnati, Ohio, to develop their own distinctive styles. Of the six potteries in Cincinnati, only one survived the initial decade, to reach its zenith at the turn of the century and exert a tremendous influence on the studio pottery of that period. The Rookwood Pottery (q.v.) set the trends and trained the artist-potters who branched out in the 1890s. Laura Fry, for example, left Rookwood in 1892 to help inaugurate the Lonhuda (q.v.) art pottery at Steubenville, Ohio. Subsequently Samuel Weller's Louwelsa and the Roseville Pottery (qq.v.) developed the techniques of slip-painting and high glazes pioneered at Rookwood. After 1910, American

263

Watcombe jardiniere and stand, *c.* 1900.

studio pottery departed from the characteristic glossy finish and used matt glazes with a more naturalistic decoration. At East Boston, Massachusetts, the Grueby Faience and Tile Company (q.v.) copied the dull glazes which Delaherche exhibited at the Columbian Exposition of 1893. Another former Rookwood employee, Artus Van Briggle (q.v.) founded his own studio pottery in Colorado and produced excellent wares in the styles of Art Nouveau. The former Chelsea Keramic company was revived in 1895 as the Dedham Pottery (q.v.) which specialized in heavy stoneware with a distinctive crackle glaze.

See *Bailey, J. C., Bindesböll, Thorvald, Bretby Pottery, Brouwer, W. C., Burmantofts Pottery, Dalpayrat, Adrien, Dammouse, Albert, Dedham Pottery, Delaherche, Auguste, Della Robbia Pottery, De Morgan, William, De Rudder, Isidore, Doulton Pottery, Finch, Alfred William, Greenpoint Porcelain, Grueby Faience, Laüger, Max, Linthorpe Pottery, Lonhuda Pottery, Louwelsa, Lotusware Pottery, Majolica, Mendes da Costa, Josef, Moorcroft Pottery, Owens Pottery, Rookwood Pottery, Roseville Pottery, Rozenburg Pottery, Schmuz-Baudiss, Theo, Thooft, Joost, Van Briggle, Artus*

Sullivan, Louis

American architect (1856–1924) and pioneer of the modern movement in architecture. Sullivan was trained under Vaudremer at the *Ecole des Beaux Arts* in Paris. Subsequently he practised as an architect in Chicago, designing the Auditorium Building (1887–9), the Wainwright Building in St. Louis (1890) and the Guaranty Building in Buffalo (1894–5). The high point of his architectural style is seen in the Carson Pirie Scott department store in Chicago (1899–1904). Sullivan's concepts of simple masses, enhanced by a modicum of integrated organic ornament, had a profound influence on his contemporaries and pupils, such as Frank Lloyd Wright, George Maher and George Grant Elmslie (qq.v.). Though Sullivan did not himself design furniture, his ideas rubbed off on the Tobey Furniture Company (q.v.) and there are striking parallels between Sullivan's buildings and the salient features of Tobey custom-built furniture. His concern with the interior design of his buildings was shared by his colleagues who went farther and actually designed furniture and fittings.

Schlesinger & Mayer Department Store (now Carson, Pirie, Scott & Co.), designed by Louis Sullivan, 1899.

Thonet Furniture

Austrian furniture company, known as Gebrüder Thonet A.G., which specialized in bentwood furniture (q.v.). The firm was founded by Michael Thonet (1796–1871), a craftsman, technician and designer extraordinary, who revolutionized European furniture in the mid-nineteenth century and evolved techniques and designs which fore-shadowed the tubular steel and plastics of the present day. Thonet was born in Boppard am Rhein and was apprenticed to a carpenter. By 1819, he had established his own workshop where he produced furniture in traditional designs and using conventional methods. A brilliant innovator, Thonet began experimenting in 1830 with techniques for laminating wood and devising ways of making it pliable, so that the expensive techniques of carving and jointing could be dispensed with. By 1841, he had taken out his first patents for bentwood and the following year he transferred operations to Vienna. The present Thonet company was founded in Gumpendorf, Vienna in 1849, being re-organized some years later as Gebrüder Thonet. In addition to premises in Vienna, Thonet had a large modern factory at Koritschan in Moravia (now Czechoslovakia), utilizing the beechwood of that district. Though Thonet was producing his distinctive bentwood furniture on a large scale from the 1850s onward, it was in the 1890s that it became internationally popular. Moreover Thonet's influence on furniture design in the twentieth century was considerable, and certainly far greater than any of his contemporaries. Above all else, he successfully countered Morris's (q.v.) ban on mechanization and demonstrated that industrialization could be harnessed for pleasure as well as profit, and that things of beauty could be produced mechanically as well as manually.

Thonet bentwood smoker's chair, late 19th century.

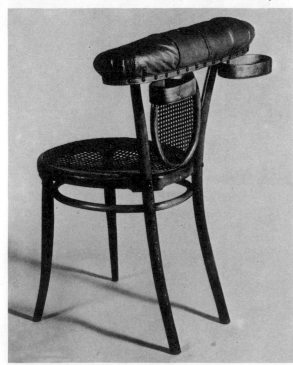

American studio pottery: (left to right) Newcomb College vase by Maria Hoe le Blanc; Rookwood Pottery vase, 1901, designed by Frederick Rothenbusch; vase by the Van Briggle Pottery Co.; Grueby faience vase by Ruth Erickson.

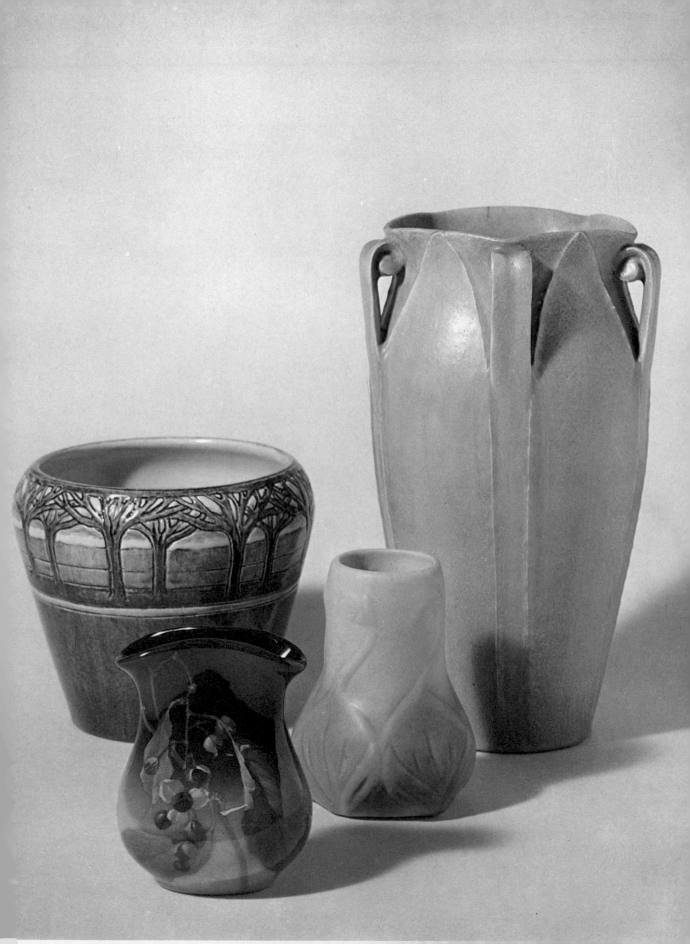

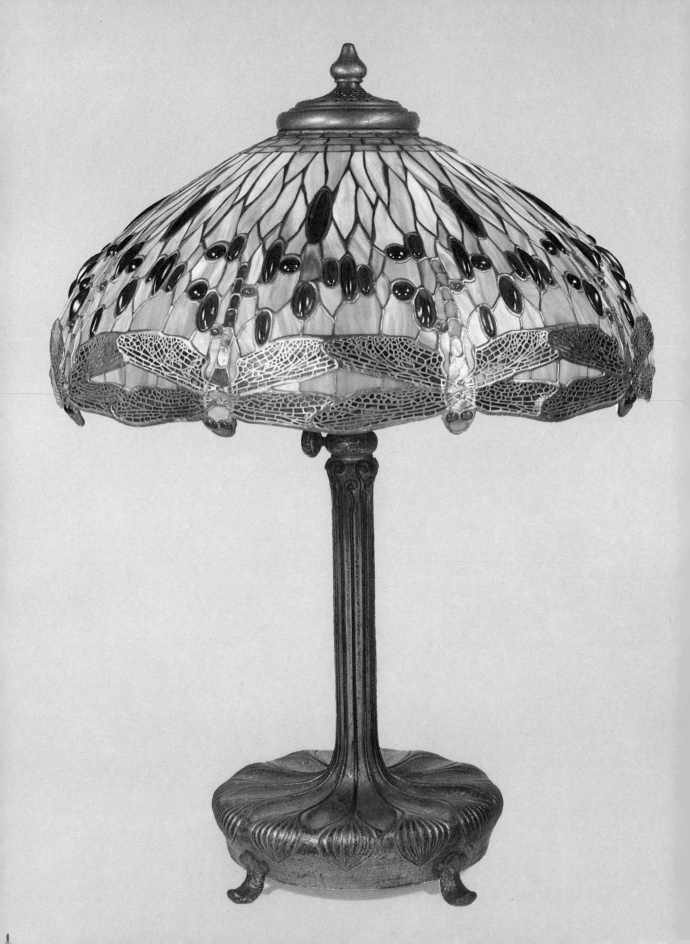

Thooft, Joost

Dutch potter active at the turn of the century. Thooft revived the art of hand-painting on white earthenware at the old-established Delft factory, *De Porceleyne Fles,* which changed its name in 1890 to Thooft and Labouchere. Under new management, the firm specialized in white biscuit earthenware, decorated with geometrical designs heightened with green slip and outlined in gold. Another speciality was 'Jacoba' faience (q.v.), under-glaze painted faience with red and green lustre, used mainly in the production of simple vases. Tiles (q.v.), decorated by such leading Dutch painters of the period as Bisschop, Israels and Mauve, were produced at the turn of the century. The motifs in faience were traditional for the most part, but an outstanding exception were the vivid witches, devils and animals in mosaic techniques by Adolphe le Comte who also designed vases with stylized scrollwork.

Thorn-Prikker, Jan

Dutch painter and graphic artist, born at The Hague in 1868. Thorn-Prikker studied at the Academy in The Hague and also under Maurice Denis (q.v.). In 1904, he emigrated to Germany where he concentrated on ecclesiastical painting in the style later known as 'Rhenish Catholicism'. At the same time, he held an appointment as lecturer at the Krefeld school of art and subsequently lectured in art at Essen (1910), Munich (1919), Düsseldorf (1923) and Cologne, where he was professor at the school of arts and crafts from 1925 to his death in 1932. Apart from murals and frescoes for churches, Thorn-Prikker designed stained-glass windows, mosaics and painted-glass panels. His posters (q.v.) and book-illustrations have an ascetic quality reminiscent of the Macdonald sisters (q.v.).

Tiffany, Louis Comfort

American artist, designer and manufacturer, born in New York City in 1848, the son of Charles Lewis Tiffany (1812–1902), the jeweller and silversmith. As the scion of the most famous American manufacturing and retailing business

Tiffany 'dragonfly' lamp, *c.* 1900.

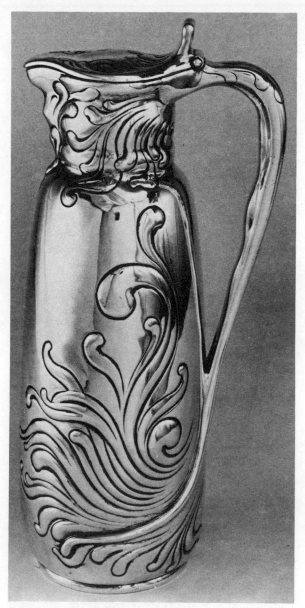

Silver claret jug by Tiffany, 1887.

in silver, it was inevitable that Louis C. Tiffany should be interested in the decorative arts from the earliest age, but his career took quite a distinctive line from that of his father, and his own contribution to the arts and crafts of the late nineteenth century was impressive. Louis began as a painter, studying under George Inness and Samuel Coleman in New York, and Leon Bailly in Paris. He travelled extensively in Europe, painting in both oils and water-colours, but eventually he concentrated on

269

decorative-glass work. His interest in the applied arts took a practical turn when, in 1879, he founded a decorating business known as Louis C. Tiffany and Associates. Tiffany's early collaborators in this venture were the painters, Samuel Coleman and Lockwood de Forest (brother of Robert de Forest, President of the Metropolitan Museum of Art from 1913 to 1931), and the textile designer, Candace Wheeler. This company was short-lived but it nevertheless made a tremendous impact on the applied arts of the early 1880s. Tiffany and his partners specialized in wallpapers and fabric-designs and gradually extended their activities into every aspect of interior decoration. In 1882–3, they were responsible for redecorating the White House, perhaps their most memorable commission.

Even before Associated Artists, as the firm was later known, was dissolved, Tiffany was turning his attention to glass. The crowning glory of the Tiffany décor in the White House was a huge opalescent glass screen, for long one of the outstanding sights of the executive mansion until Teddy Roosevelt ordered its destruction in 1904. Tiffany's glass mosaics were also beginning to attract a great deal of attention about this time. Glass tiles, stained-glass windows and coloured glass ornaments became increasingly common features of Tiffany's schemes for interior decoration until, in the 1890s, his interest in art glass became predominant. In 1885, the Tiffany Glass Company was incorporated, becoming the Tiffany Glass and Decorating Company in 1892 and Tiffany Studios about 1900. These comparatively small firms produced highly individualized and often experimental work, either directly by Tiffany and his artist-associates, or supervized by them. Thus these companies were entirely different, in concept, size and organization, from the vast, traditional and wholeheartedly commercial enterprise run by Charles L. Tiffany.

In 1893, Louis established his own glassworks at Corona, Long Island, employing the best glassblowers and workers in England and America to carry out his designs. The fruits of the first glassblowing experiments at Corona were shipped by Tiffany to his friend, Samuel Bing (q.v.), in Paris in 1895 in time for the grand opening of Bing's famous shop *La Maison de L'Art Nouveau*.

One of the most familiar and characteristic forms of Tiffany glass was the naturalistic glass

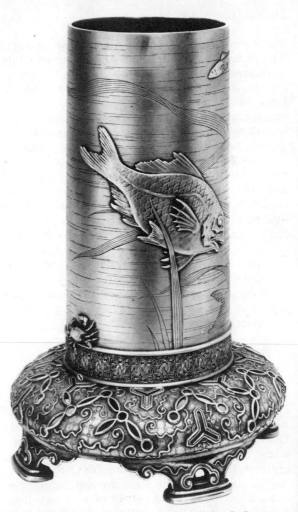

Silver cylindrical vase in Japanese style by C. L. Tiffany & Co., 1895.

lamp (q.v.), with its multitude of shades shaped like bell-flowers or lilies, drooping languorously from green bronze stems on a bronze base decorated with lilies or ivy-leaves, in the best Art Nouveau tradition. Leaded glass, a hangover from Tiffany's earliest experiments with stained-glass windows, was another speciality of the Tiffany companies. This was used to great effect in lampshades, being well-suited to the rather harsh illumination provided by electric light. Tiffany was keenly interested in electric lighting from its inception; in 1885 he decorated the Lyceum Theatre in New York, the first theatre to be lit entirely by electricity. Tulip and peony motifs were used in the earlier leaded glass shades and windows, but, from 1900, Tiffany favoured wistaria patterns. It is

generally accepted that credit for the wistaria pattern should go to Mrs. Curtis Freshel whose house in Chestnut Hill, Boston was surrounded by wistaria. She designed her own furniture, including lamps, using a wistaria pattern which she asked Tiffany to execute on her behalf. He agreed to halve the production costs, provided he was allowed subsequently to market the design. The twisting design and hanging blossom of this plant were well suited to Art Nouveau, though Tiffany's interpretations tend to suggest, rather than reproduce, the actual form of this plant. Stained-glass windows for private houses enjoyed a certain vogue at the turn of the century and Tiffany adapted his lampshade patterns for this medium.

Tiffany also specialized in the production of iridescent glass with an attractive metallic lustre and, although he was not the first to experiment with these techniques, he undoubtedly raised them to a fine art. Apart from the items which he sent to Bing in 1895, virtually all the pieces manufactured in that year were destined for various museums where they were to form the nuclei for the many large and important collections of Tiffany glass preserved to this day. Commercial production of art glass did not begin until 1896 and continued until 1920, by which time Tiffany glass had gone out of fashion. A numbering system was introduced at the outset, each piece being inspected and marked before being annealed. Each piece of blow glass was given a serial number with a letter indicating the year of manufacture. Those with the prefix A to N were produced from 1896 to 1900, those with a prefix from P to Z from 1901 to 1905, those with a suffix from A to N from 1906 to 1912 and those with a suffix from P to Z from 1913 to 1920. Especially prized are items with the prefix 'X' indicating 'not for sale', or 'O', which meant a special order for friends or relatives of Tiffany. A very few exceptional pieces were signed by Tiffany himself. Other names to watch out for are 'Nash' or 'Arthur Nash'.

Arthur Nash was born at Stratford-upon-Avon, England and had been a partner in the Whitehouse Glass Works in Stourbridge before emigrating to the United States in 1892. He was involved in the establishment of the Corona glassworks and is usually regarded as the inventor of the distinctive 'Favrile' glass for which Tiffany was renowned. Tiffany stated that the word was derived from an old English word 'Fabrile' meaning 'pertaining to a craft or craftsman', but on other occasions he claimed that the word was derived from the German *Farbe* (colour). Brilliant shades of greens, blues, yellows and browns; motifs such as peacock's feathers, sea-weed, ferns; effects such as lava or bronze long buried in the soil; these and many other effects are to be found in 'Favrile' glass. The range was fantastic; by the end of the nineteenth century, the Tiffany Glass and Dec-

Tiffany enamelled copper vase, *c*. 1900.

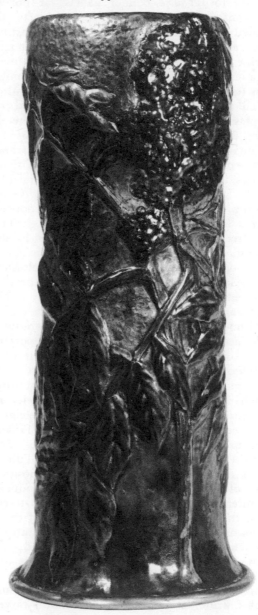

orating Company was producing several thousand articles, no two alike, each year, classified into some 5,000 different colours, patterns, textures and varieties. They ranged from clear crystal through a wide spectrum of shades to an opaque black, from austere simplicity to unrestrained, exotic eccentricity.

In the late 1890s, Tiffany and his associates began experimenting with enamel and, by 1901, were exhibiting a few examples of metalwork decorated with enamelled motifs at the Buffalo Exposition. Enamelling in various colours was applied to *repoussé* copper panels for boxes, inkstands (qq.v.) and other small objects, or applied to iridescent glassware as a contrasting form of decoration. Flowers, insects, fruit and marine life were freely interpreted in enamel. To a lesser extent, Tiffany also produced cameo glass (q.v.), engraving cameo reliefs on coloured 'cased' glass. Although principally regarded for his glassware, Tiffany produced excellent metalwork, usually subsidiary to his glass. Thus the mounts for punch bowls, or the bases for lamps, were worked in silver or bronze in the Tiffany studios, invariably in the same flowing plant-like motifs which distinguished his glass. Glass mosaics were an important side-line, produced mainly for church decoration; but though Tiffany freely admitted that he was inspired by the magnificent mosaics in Santa Sophia in Constantinople, his genius transformed the classical mosaic into something fresh and exciting through the medium of iridescent glass, offset by richly gilded ornament.

Although Tiffany produced comparatively little actual furniture, this was an important aspect of the Tiffany studios from about 1892 to 1905. Little trace of the prevailing Art Nouveau motifs was to be found in his furniture, which derived its lines from the light, elegant furniture fashionable in France in the late eighteenth century. The 'classical' nature of Tiffany furniture was emphasized further by the judicious use of marquetry (q.v.) described by Tiffany in his catalogue for the Columbian Exposition (q.v.) of 1893: 'our wood mosaic . . . is produced by an entire new method of work. The patterns upon this piece of furniture are made of thousands of squares of natural wood, sixteenth-of-an-inch in size, of different colors, and each individual square surrounded by a minute line of metal.' Glass balls, held in brass claw-feet, were a distinctive feature of Tiffany chairs and settles, while the naturalistic floral motifs carved

Gold iridescent 'Jack in the pulpit' vase by L. C. Tiffany, *c.* 1900.

on chair-backs have little in common with the writhing, contorted lines which characterize European Art Nouveau furniture.

Tiles

Delftware tiles in traditional blue and white designs were popular in Europe from the late Middle Ages mainly for the decoration of stoves and hearths. This fashion spread, via England and Holland, to North America in the seventeenth and eighteenth centuries. In Holland alone, however, tiles were used more extensively, often decorating entire wall surfaces. In the 1880s, tiles became fashionable for interior decoration, largely due to the stimulus provided by the Aesthetic Movement (q.v.). On both

Della Robbia earthenware frieze of five tiles, possibly by Carlo Manzoni, *c.* 1900.

sides of the Atlantic, great progress was made at the turn of the century in the manufacture of square or rectangular tiles with relatively uneven surfaces and shapes on which colours and glazes of the greatest variety were unevenly distributed, so that each tile had marked individuality of colour and texture. All sorts of *craquelé* and crystalline effects were devised, as well as the blending of two or more colours. Gilding and lustred effects were also developed on a com-

Tile panel by William de Morgan, *c.* 1890.

mercial scale. Pressed or moulded tiles, with intricate pictorial or floral designs, often with the background recessed in a contrasting colour, also became popular at this time. Amateur artists decorated plaques and tiles in their own manner; for technical reasons this form of art pottery lent itself admirably to the expression of late-Victorian *dilettante*.

From about 1880 to 1910, there was a craze for interior decoration with walls and ledges covered with majolica (q.v.) tiles manufactured by Doulton, Minton, Wedgwood (qq.v.) and other commercial potteries, as well as by the art potteries of the period: Linthorpe, Bretby, Ault, Pilkington (qq.v.) and others. Crane, Voysey (qq.v.) and Lewis Day designed tiles for Maw & Company of Jackfield as well as Pilkington's, while William de Morgan (q.v.) was a prolific artist in this field. He began making and decorating tiles in the late 1870s, when he was commissioned to renovate the Arab Hall of Lord Leighton's house in Kensington. The room was already covered with Near Eastern tiles and De Morgan succeeded in replacing the broken or missing tiles so cleverly that it was impossible to distinguish the replacements from the originals. Subsequently he furnished the tiles for the Tsar's yacht *Livadia* and no fewer than six P. & O. liners. De Morgan tiles fall into two broad categories. The early tiles, from his Chelsea period, were commercially manufactured for him and he only supplied the decoration. They can be recognized by the tell-tale ridges on the underside. Later, when De Morgan had begun to operate his pottery at Merton Abbey (q.v.), the tiles were hand-made on the premises; these tiles are plain on the reverse, except for the impressed De Morgan mark. His tiles were decorated in the so-called 'Persian' colours, in shades of blue, turquoise and green, using a transfer technique which he himself devised.

Tiles came back into fashion in the United

of encaustic tiles at the Centennial Exposition in 1876. By the 1890s, the more restrained encaustic tile had been supplanted by the glossy majolica tile in all the colours of the rainbow and, because of its decorative versatility, this type of tile was to be found not only on fire-places, floors and walls, but recessed in the panels of furniture, arranged in decorative patterns on the brickwork facades of houses and public buildings, or grouped in panels incorporated in screens and table-tops. Tiles were a major part of the stock-in-trade of all the commercial potteries of America, among the best-known exponents of this art being Grueby, J. B. Owens and Samuel A. Weller's pottery in Zanesville, Ohio (qq.v.).

'Etin' pattern tile by the Moravian Pottery and Tile Works, Doyleston, Pa, 1910.

Tillander, Alexander

Finnish jeweller and silversmith who founded a business in St. Petersburg in 1860. Tillander became a rival to Peter Carl Fabergé (q.v.) and supplied jewellery and *bijouterie* to the Russian Court and nobility. Alexander Tillander was lynched by his own employees when the Revolution broke out in October 1917, but his son managed to escape to Finland with the firm's stock of diamonds. Tillander's were subsequently re-established in Helsinki, with a branch in Stockholm, and are now the Swedish Court jewellers.

Tile panel designed by Lewis F. Day and made by Pilkington, 1902.

States in the late 1870s, their use for wall decoration, in place of the more expensive marble panels, being advocated by Charles Lock Eastlate (q.v.) and greatly stimulated by the display

Tobey Furniture

Charles and Frank Tobey of Chicago formed a furniture company in 1875, combining two earlier companies, the Tobey Company retail shop (founded by Charles Tobey in 1856) and the Thayer and Tobey Furniture Company (founded in 1870 by F. Porter Thayer and Frank Tobey). At first this company produced ordinary commercial furniture but, in 1888, a subsidiary, called the Tobey and Christiansen Cabinet Company, was formed for the express purpose of producing expensive, high-class furniture. Within two years, the company had established itself as the leading manufacturer of quality furniture in the United States. Tobey furniture combined two disparate elements: the clean, straight lines, reminiscent of contemporary Chicago architecture, and restrained carving and ornament in the Art Nouveau style. This unlikely combination may have resulted from the widely differing backgrounds of the two principals. Charles Tobey (1831–88) was trained in the Beaux Arts (q.v.) tradition, but his partner and successor William F. Christiansen was a Norwegian immigrant, who brought European ideas in design and decoration with him, and gave employment to other Norwegian designers and craftsmen. In the Tobey furniture of the late nineteenth century can be discerned the genesis of the simple styles which characterize the Scandinavian furniture of the present day. Christiansen, a disciple of William Morris (q.v.), realized that quality, craftsmanship and good materials did not require an excess of ornamentation to proclaim their virtues.

Toorop, Jan

Dutch painter and graphic artist, born at Poerworedjo, Java in 1858. Toorop came to Holland in 1869 and studied painting at the academies in Amsterdam (1880–1) and Brussels (1882–5). In the latter year, he travelled in England and, in 1887, he became a founder member of *Les Vingt*. Friendship with Maeterlinck and Verhaeren won him over to Symbolism in 1890, while his conversion to Catholicism in 1905 influenced his later work. Toorop died at The Hague in 1928. Many diverse elements combined in the art of Toorop; his Javanese ancestry, his English wife, his deeply-held

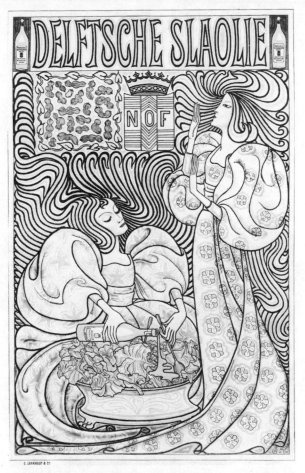

Lithographic poster for Delftsche salad dressing, by Jan Toorop, 1895.

religious feelings and the influence of the Pre-Raphaelites, the Symbolists and the Aesthetic Movement (q.v.). A mystical quality permeates his work, from the painting known as *The Three Brides* (1893) to his commercial posters (q.v.), of which *Delftsche Slaolie* (1900) is the most famous. In this poster, for salad dressing, the two girls are dressed in flowing robes and their tresses are wildly exaggerated, filling every available space in the poster. The ascetic qualities of Toorop's early work appealed strongly to the Macdonald sisters (q.v.) who developed their own peculiar brand of elongated female. Toorop's work became progressively more severe, reflecting the deeply religious mood which foreshadowed his conversion in 1905. The decorative element became subordinate to the severity of the posters designed for Arnhem Life Insurance (1900) and the charitable institution *Het Hooge*

275

Land (1902), or the semi-postal stamps (q.v.) of 1923 which were a late manifestation of his style.

Tostrup

Norwegian silversmiths, founded by Jacob Tostrup of Christiania (Oslo) in 1832. Under Oluf Tostrup, son of the founder, the firm expanded enormously in the late nineteenth century, reviving the former folk art of filigree and being one of the world's leading manufacturers of silverware enamelled in the *pliqué-à-jour* (q.v.) technique, mainly using designs by Torolf Prytz, Oluf's son-in-law. Oluf Tostrup took a keen interest in the arts and was the prime mover in the establishment of the Oslo Museum and the Royal School of Design.

Toulouse-Lautrec, Count Henri de

French artist born at Albi in 1864, scion of an old French noble family. At the age of fourteen, he was crippled by a fall and it was from this date that his interests turned to art. In 1881, he moved to Paris where he studied painting under Cormon, who introduced him to Van Gogh, Bernard and Anquetin. With these artists, Toulouse-Lautrec formed the *Ecole du Petit Boulevard*. His style was influenced by Princeteau and Degas, and by his admiration for Japanese woodcuts, and he concentrated on lithography as a medium for expressing his art. His lithographs illustrated aspects of Parisian night life: the bars, the brothels, circuses and the Montmartre scene in general. In 1891, he began producing posters advertising cabarets and revues and portraying individual artistes, such as La Goulue and Jane Avril. Compared with Grasset and Cheret (qq.v.), Toulouse-Lautrec's output of posters was small, some thirty-two produced in the decade before his death at Malorme in 1901. Of these a dozen were produced before the end of 1893; his later productivity was sadly marred by prolonged bouts of illness and insanity. These twelve include the six most famous posters, on which his reputation largely rests: three of Jane Avril, two of Aristide Bruant of *Les Ambassadeurs* and *La Reine de Joie*.

Unlike the other great French poster artists of the period, Toulouse-Lautrec did not roman-

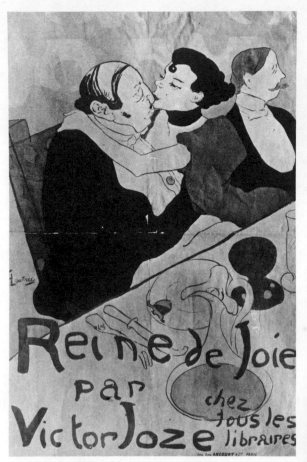

Lithograph advertising *Reine de Joie*, by Toulouse-Lautrec, 1892.

ticize the world or the young ladies in it. Instead he held up the seamier aspects of Parisian life for clinical examination. As Charles Hiatt wrote at the time, his posters were 'human documents, strangely eloquent at their moment'. Toulouse-Lautrec was never concerned to portray his subjects at their best. He often used combinations of garish lighting and distorted expressions to heighten dramatic effect. The posters of Jane Avril hardly flatter her, compared with contemporary photographs. One of his last poster designs portrayed Jane Avril encircled by a snake, reminiscent of *Jugendstil* (q.v.) rather than Art Nouveau.

Apart from his lithographs and posters, Toulouse-Lautrec illustrated books, the best known being Jules Renard's *Les Histoires Naturelles*, and designed covers for sheet music, a relatively neglected aspect of his art.

See *Posters*

Toys

Prior to the nineteenth century, children had relatively few toys and these, for the most part, were home-made. In certain districts, such as Nuremberg in Germany, toy-making assumed the proportions of a major industry but, as a rule, it was practised as a form of folk art. From about 1830 onwards, however, more attention was given to children's playthings. Inevitably the technical progress, particularly in wood and metalwork, which made rapid strides as the century wore on, affected toys; while the rise of the middle-classes in Europe and America at the same time, meant that more and more parents were able to buy toys for their children. Up to the time of the First World War, there were two main streams of toys: the hand-made, simple wooden toys which were sold cheaply at markets, fairs and street bazaars, and the more sophisticated, machine-made toys which began

American mechanical toy, late 19th century.

Cast iron mechanical clockwork figures of General Butler and a negro, *c.* 1890. (Barenholtz Collection)

to appear in shops from the 1840s onwards. By the 1890s, however, cheap machine-made toys were also being exported from Germany in vast quantities and gradually they supplanted the old stock-in-trade of the street markets. All sorts of small toys were stamped out of tin-plate, ingeniously jointed and seamed, and painted in garish colours. They ranged from penny whistles and pop-guns to whirligigs and automata, operated by clockwork. These tin toys were sold by street vendors at a penny each.

By 1900, the German manufacturers were beginning to face stiff competition from native producers in Britain, France and the United States, where a thriving industry in toys had developed in the 1890s. In addition, there were composite toys, which began with a basic set and could be added to piecemeal. These included toy kitchens, butchers' shops, theatres, farm-yards and forts, challenging the older established doll's house. The mass-production of clockwork toys began about 1860 and reached its peak

277

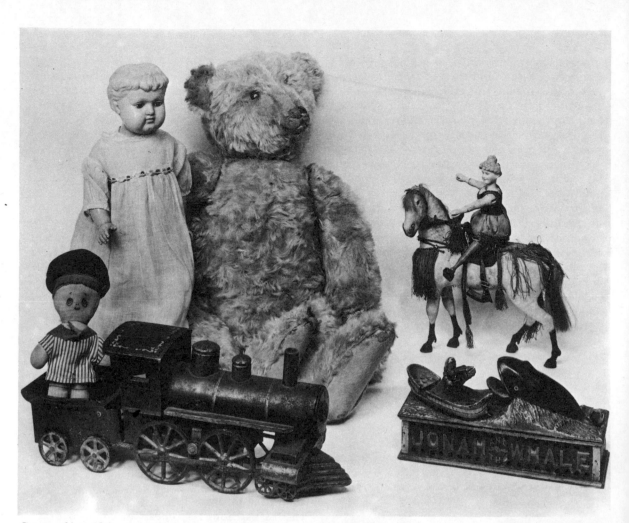

Group of late 19th century American toys: Teddy bear, 1903, rag horse, 1900, cloth doll, *c.* 1890, cast iron bank, *c.* 1890, locomotive, 1900, Schoenhut acrobat doll, 1908, celluloid doll, 1908.

in the decade before the First World War. This was the golden age of the clockwork train set, but circuses, whose animals and clowns were operated by clockwork, were also popular at the turn of the century.

In an age when photography was still in its infancy and motion pictures were yet to be invented, many toys were preoccupied with optical illusions. Various gadgets, incorporating strips of pictures rotated or moved quickly from side to side to simulate movement, were developed as children's toys in the late nineteenth century. These novelties rejoiced in pseudo-scientific names, such as the thaumatrope, the phenakistiscope and the zoetrope, all forms of peepshow. The kaleidoscope, with its arrangements of mirrors to create patterns of

shapes, is the only relic of late Victorian times which has survived to this day. Of the larger toys, the best remembered is the rocking horse, designed initially to train children for horseback riding, but enjoyed latterly as a toy in its own right.

See also *Dolls, Games and Pastimes, Miniature Items, Model Soldiers*

Travelling Cases

The period from 1880 to 1920 was one in which it was possible to make journeys to the other end of the earth in comfort and with some degree of facility, but not yet with the speed which was to come with air travel. Thus more

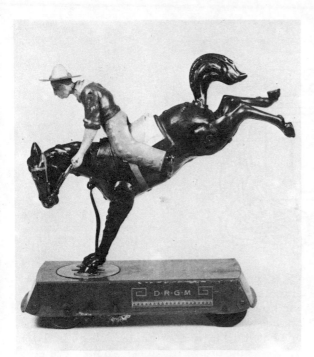

and more people were able to travel, but travelling itself was still a complicated business, with journeys which might last from several days to many weeks. The relative freedom from bureaucratic restrictions such as passports and visas, and a natural curiosity about the world, stimulated travel on an unprecedented scale and gave rise to a minor industry catering to the needs of travellers. Travelling furniture of all kinds was manufactured at the turn of the century, ranging from camp-beds and folding stools to portable baths and wash-stands. This is an aspect of furniture which has been almost entirely neglected, the so-called 'military chest' alone being regarded highly by collectors. More compact and convenient for the collector, however, are the many kinds of travelling case patented in this period, containing numerous tiny compartments, each for a specific purpose. Such cases might include crockery and cutlery, flasks and other paraphernalia for eating and drinking *en route;* but toilet accessories were, and are, the main content of such cases. The more opulent examples had silver mounts and were decorated lavishly in the contemporary style.

Painted tin clockwork 'Bucking Bronco', by Lehmann, German, early 20th century.

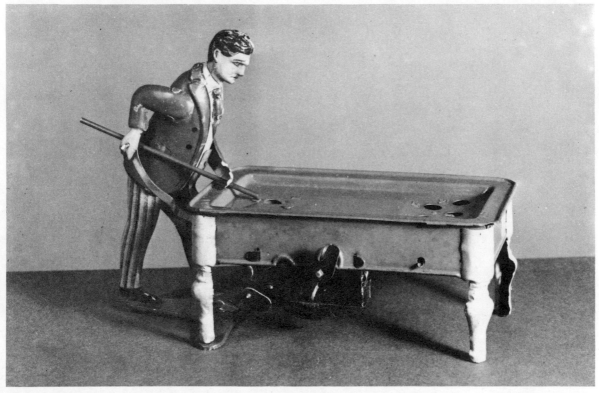

German clockwork toy, 'the Great Billiard Champion', *c.* 1905.

Unger Brothers

Small manufacturing company of Newark, New Jersey which produced high-quality silverware between 1881 and 1910. By 1900, the firm was manufacturing decorative and useful wares lavishly ornamented with Art Nouveau motifs.

Girls' profiles with long, swirling tresses, floral and plant forms and other motifs associated with the flowing, dreamy qualities of this style, were applied to all manner of objects, from brooches and belt-buckles to door-knobs, bell-pulls, letter-openers and drawer handles. Though criticized for being over-elaborate, Unger silverware was

Sterling silver jewellery and ornaments by Wm. B. Kerr and Unger Brothers, c. 1900.

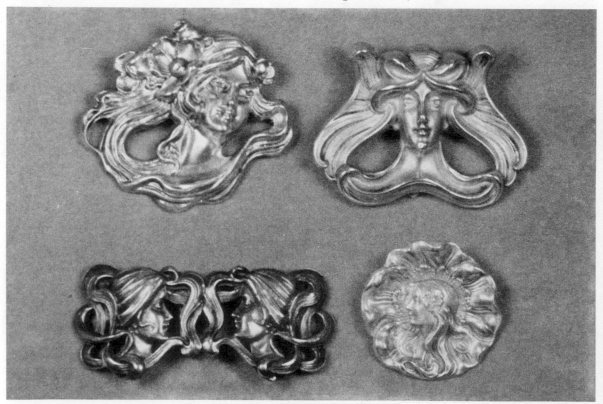

always exquisitely fashioned and was more typical of the period than the *martelé* silver (q.v.) produced by the rival Gorham Manufacturing Company (q.v.). Unger silver was marked with the 'UB' monogram and 'STERLING 925 FINE'.

Union Porcelain

The Union Porcelain Works of Greenpoint, New York was founded in 1853 and known originally as William Boch and Brother. Thomas C. Smith took over from Boch in 1862 and adopted the patriotic name. As the Union Porcelain Works, it continued to function until about 1910 when it closed down. At the Centennial Exposition of 1876, Union's *chef d'oeuvre* was a pedestal, standing seven feet high, decorated with classical bas-reliefs by Karl Mueller. This stupendous achievement in ceramics was subsequently edited in a smaller version for sale to the public. Other cups, vases, bowls and dishes

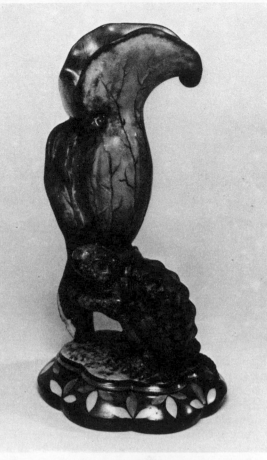

Vase in the form of a turtle and pitcher plant, by the Union Porcelain Works, Greenpoint, N.Y., late 19th century.

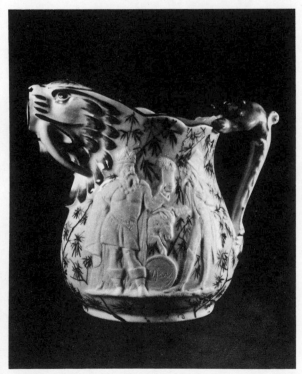

Late 19th century pitcher by the Union Porcelain Works.

produced at this time were lavishly gilded and decorated in the classical style and this continued to be the company's mainstay throughout the rest of its existence. In the 1890s, Union Porcelain was renowned for their magnificent dinner services, emulating French and German originals of the late eighteenth century. The only concession to the American way of life was the series of distinctive plates, produced at the turn of the century in the shape of clams, oysters, mussels and other shell-fish for which these plates were designed. The borders of these irregularly-shaped dishes were decorated with trailing seaweed, baby crabs, whelks and other forms of marine life. Union porcelain was marked 'U.P.W.' with an eagle's head.

Valentines

Special greetings cards sent by lovers on St. Valentine's Day (14th February) developed in the 1830s, thus surprisingly ante-dating Christ-mass cards (q.v.) by almost a decade. Early Valentines, complete with their distinct lace-embossed envelopes, are now very rare. The use of special Valentine envelopes increased in popularity after 1840 with the introduction of uniform postal rates, but it was not until the 1880s that the sending of such *billets doux* became universal. At the same time, unfortun-ately, the quality of design and production declined and the fashion itself fell into disrepute. Comic Valentines, often of a malicious nature, became increasingly popular in the 1890s and the advent of the picture postcard (q.v.) popu-larized and cheapened the Valentine even fur-ther. This, in a sense, was its undoing, for the cheap joke Valentines of the Edwardian era put an end to the serious side of St. Valentine's Day customs.

Edwardian Valentines in postcard form were sent by the million and thousands of them have been preserved in the postcard albums of the period. The custom of sending Valentines died with the First World War, but revived in 1926 when Raphael Tuck mounted a Valentine cam-paign as part of their centenary celebrations. The commercialization of the greetings-card industry, especially in the United States, and the institution of the special greetings-telegram

Late 19th century English Valentine.

282

Tail-piece by Felix Vallotton from *Simplicissimus*, 1896.

by the British Post Office in 1936, stimulated the revival of the Valentine which has gone from strength to strength ever since. Especially prized are examples in the languid styles popularized by the Aesthetic Movement (q.v.) and the dreamy qualities of Art Nouveau. Novelty Valentines, especially those parodying contemporary postal stationery, are also in great demand nowadays.

Vallin, Eugène

French architect and designer (1856–1922) of the Nancy School (q.v.). Vallin was one of the pioneers of re-inforced concrete in building structures. As a designer, his excellent graphic sense was occasionally marred by a tendency towards heaviness. He rejected the ornate qualities found in the furniture of Majorelle (q.v.) and held that the only decoration necessary was that created by the interplay of the lines of the furniture itself. His chairs and tables were noted for their fine sculptural character and, at his best, he could design small pieces, like sellettes and tripods, which have seldom been surpassed for elegance and lightness: features which were not always apparent in his larger pieces.

Vallotton, Felix

Swiss painter and graphic artist, born at Lausanne in 1865. Vallotton moved to Paris in 1882 where he studied at the *Academie Julian* and made the acquaintance of the *Nabis,* without actually becoming a member of their group. In 1890, he produced his first woodcuts, illustrating the *Revue Blanche,* in which he was subsequently a regular contributor. In his paintings (such as *The Bath*, 1890) and his woodcuts, Vallotton parallels the work of Aubrey Beardsley (q.v.). His later book- and magazine-illustrations were more severe in their use of black and white in contrasting masses. His woodcuts were also reproduced in *Simplicissimus* from 1896 onwards. In 1908, Vallotton became a lecturer in graphic art at the *Academie Ranson* and subsequently he travelled extensively in Russia, Italy and Germany. He died in Paris in 1925.

Original drawing by Vallotton for *Revue Blanche,* 1894.

Van Briggle, Artus

American ceramicist, born at Felicity, Ohio in 1869. Van Briggle worked under Karl Langenbeck at the Avon Pottery before joining Rookwood in 1887. As one of the most promising young decorators at that pottery, he was sent to Paris where he studied art at the *Academie Julian* for three years and the *Ecole des Beaux Arts* for much of that period. He was forced by ill health to leave Rookwood in 1899 and went to Colorado Springs where he established the Van Briggle Art Pottery two years later. He married in 1903 but died the following year. The Van Briggle Pottery flourishes to this day, though now wholly commercial in operation.

During the three years of his activity in Colorado, Van Briggle created pottery which reflected his belief that decoration should be an integral part of each shape and not merely an addition to it. This manifested itself in the flowing forms reminiscent of European Art Nouveau (q.v.). Van Briggle introduced matt glazes to the Rookwood pottery following his return from Europe in 1896, and produced a wide range of beautiful colours in soft shades. After his death, his wife continued to produce pottery designed to comply with the basic concepts which he had laid down. Early wares are marked with the name 'VAN BRIGGLE', often with the year given below; later wares bear the name and trademark of the pottery with the abbreviated form 'Colo. Spgs' for Colorado Springs. Van Briggle's younger sister, Leona, was a decorator at Rookwood from 1899 to 1904.

Van de Velde, Henry

Belgian architect and designer, born at Antwerp in 1863. After studying art in Antwerp and Brussels, he went to Paris in 1884 where he worked for a time in the *atelier* of the portrait painter Duran. He returned to Belgium in 1885, where his first paintings were exhibited. As a painter, he admitted to being influenced by Japanese woodcuts, Van Gogh, Anquetin and Bernard. In 1889, he joined *Les Vingt* in Brussels and, through Finch (q.v.) and Van Rysselberghe, was introduced to the ideas of William Morris and the Arts and Crafts Movement (qq.v.). A nervous breakdown turned him away from painting and he began studying architecture, subsequently designing a number of important build-

Initial letters designed by Henry Van de Velde for *Van Nu en Straks*, 1896.

ings in Germany. At the same time, his interests in the applied arts were developed. In 1893, for example, he showed at the exhibition of *Les Vingt* an embroidered wall-hanging, 'The Watching Angels', and in the same year began contributing illustrations to the periodical *Van nu en straks*. His earliest designs for furniture also date from this period. In 1894, he married and the following year he completed the construction of his own house 'Bloemenwerf' in Uccle, a suburb of Brussels.

Like Morris before him in a similar situation, Van de Velde designed the house and its contents as a total concept and this exercise laid the foundations for his later career as an interior designer. The furniture in 'Bloemenwerf' has an almost medieval logic, but already there were signs of those flowing lines which matured into his later work in the Art Nouveau style. In 1896, he collaborated with Lemmen, Bernard, Denis and Ranson (qq.v.) on the design and furniture for four rooms in Samuel Bing's *Maison de l'Art Nouveau* in Paris, but it was his contribution to the Dresden Exhibition of Arts and Crafts the following year which really established his international reputation. He subsequently moved to Germany, where he became artistic adviser to the Grand Duke of Saxe-Weimar-Gotha in 1901. He designed the Folkwang Museum in Hagen (1901); the Esche Haus, Chemnitz (1903); the *Kunstgewerbliches Institut*, Weimar (1906); the Ernst Abbe monument, Jena (1910) and the *Werkbund* theatre, Cologne (1914). During the First World War,

Tiffany Favrile glass. (Metropolitan Museum of Art, N.Y.) ▶

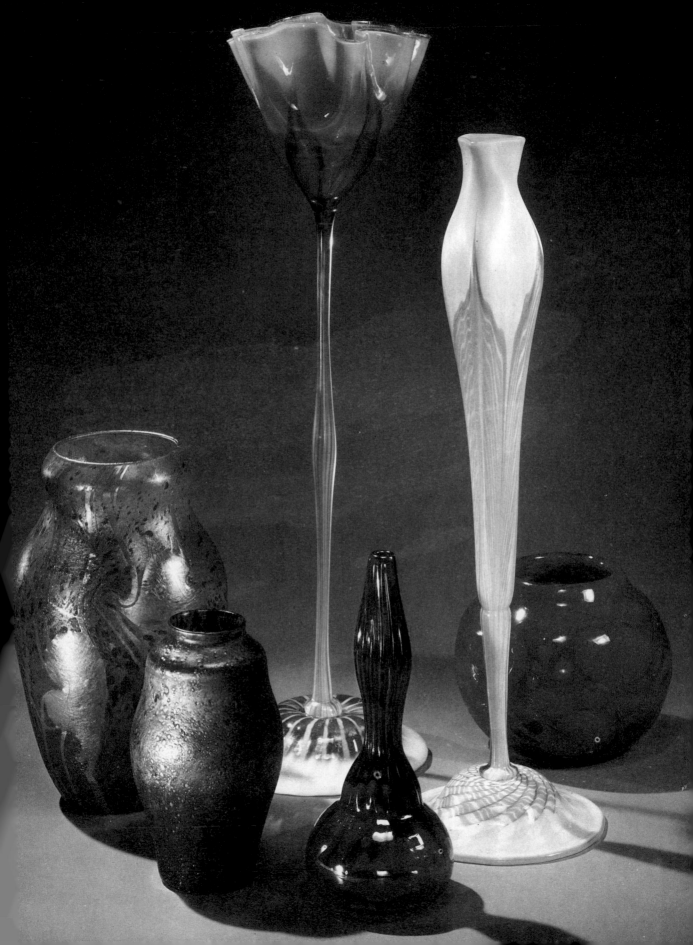

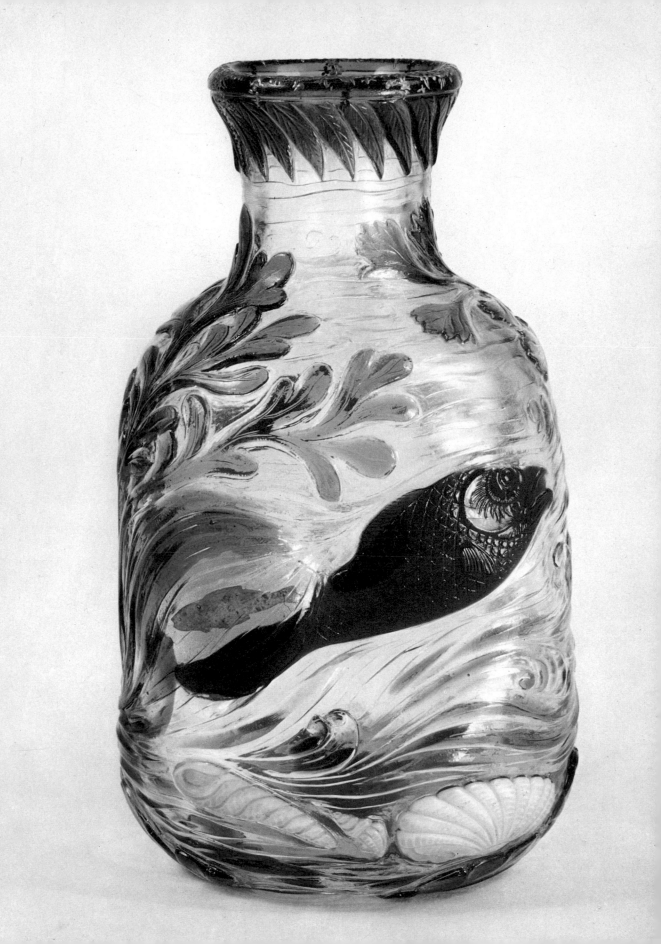

he moved to Switzerland and, in 1921, went to Holland. From 1926 onwards, he held appointments as Director of the Institute of Decorative Arts in Brussels and a professorship at the University of Ghent. In 1947, he retired to Oberägeri in Switzerland and died at Zürich in 1957.

Throughout his long and fruitful career, Van de Velde was always markedly receptive to new ideas and tendencies, yet his own work was highly personal and unaffected by contemporary doctrine or traditional concepts. His furniture, produced at the turn of the century, was made initially of native woods such as beech and oak but, in the early 1900s, he experimented with imported African woods from the Congo, mahogany and citrus which were fine-grained and allowed a clean line as well as fluidity and precision of form. His furniture was invariably intended for a specific interior or architectural design and, for that reason, tends to look out of place when moved from its original setting. This architectural quality was a characteristic of Belgian furniture of the period and appears particularly in the work of Horta (q.v.). Because he was largely self-taught, Van de Velde always had an experimental ·approach to furniture design. He was the most linear of the great Belgian designers and never employed moulding. For him, the curve, as an element of design, was '*dynamographique et structural*' : he used it first as a series of parallels and then to encompass larger areas which are edged with restrained carving. Like Mackintosh (q.v.), he favoured pure white surfaces for much of his furniture, especially the pieces designed during his sojourn in Germany. He thought long and deeply not only about the form and construction of furniture but also about its emotive effects, and was often articulate on the subject, setting out his philosophy in such essays as *What I will* and *The Animation of Material as the Principle of Beauty*, or his major work *Renaissance in modern en Kunstgewerbe* (1901).

Van de Velde was one of the most versatile designers of his time, turning his attention to book- and magazine-illustration, metalwork, jewellery, textiles, wallpapers (q.v.) and ceramics as well as architecture, interior design and furniture. His jewellery had the flowing lines of Art Nouveau without its femininity. His work in this field was regarded as the best example of

◀ Finely-carved six-colour Webb cameo glass vase.

NIETZSCHE DIONYSOS DITHYRAMBEN

Title page by Van de Velde for *Dionysos Dithyramben* by Nietzsche.

the abstract form of Art Nouveau, contrasting with the naturalism of Lalique and Wolfers (qq.v.). Like the German jewellers of the period, Van de Velde preferred silver and semi-precious stones to gold and diamonds. The hardness and clarity of his jewellery is paralleled in his designs for cutlery (q.v.) and hollow ware in silver. Even his more elaborate pieces, such as the samovar he designed in 1902, are noted for their simplicity of line and form and it was only in the more decorative items, such as table-lamps and candelabra (qq.v.) that he permitted himself the natural plant motifs which were more characteristic of French design.

Vereinigte Werkstätten

The 'united workshops' were formed in Munich in 1897 to co-ordinate the activities of artists, designers and craftsmen in the *Jugendstil* (q.v.) movement. The organization was largely inspired by Richard Riemerschmid (q.v.) and included among its members Theo Schmuz-Baudiss, Bernhard Pankok, and August Endell (qq.v.). The activities of the *Vereinigte Werkstätten* were absorbed by the *Deutscher Werkbund* on its formation in 1907.

Santler-Malvernia veteran car, 1898.

Ver Sacrum

Journal of the Association of Austrian Visual Artists, founded in 1898 to give expression to the aims, ideals and activities of the young artists and craftsmen who had formed the Vienna *Sezession* (q.v.) the previous year. This periodical reflected the development of the new styles in the applied and decorative arts in Austria at the turn of the century and is a goldmine of information on design in every medium. Moreover, *Ver Sacrum* fostered the development of a distinctly Austrian style of lettering and graphic art, in the hands of such artists as Adolph Böhm, Koloman Moser, Josef Hoffmann and Gustav Klimt (qq.v.). In the broader context, *Ver Sacrum* was the mouthpiece of Austrian *Jugendstil*. The name is Latin, meaning 'rite of spring'.

Veteran Cars

Horseless carriages propelled by steam had been in existence since the early nineteenth century, but never attained widespread popularity or usage for practical reasons. In 1885, Karl Benz mounted a small internal-combustion engine in a tricycle and gave the world its first petrol-driven motorcar. Since that first spluttering horseless carriage took to the roads, there have been many thousands of different models and marques and for many years the earliest examples have been eagerly sought after. In Britain, early automobiles are rigidly classified according to the year of manufacture and this principle has since been adopted in other parts of the world. Veteran cars are defined as those dating from the introduction of petrol-driven

288

vehicles in 1886 to the end of 1904; those from 1905 to 1918 are known (rather misleadingly) as Edwardians. Restrictive legislation in Britain prevented the development of the motorcar in the late nineteenth century and, until 1896, British motorists were hampered by the so-called 'Red Flag' Act which required motorcars to be preceded by a man on foot—he had not been required to carry a red flag since 1889—as a warning to pedestrian and horse-drawn traffic. After the passing of the Locomotives on Highways Act of 1896, vehicles were permitted to run at twelve miles an hour without a man preceding them. It was celebrated by the Emancipation Run from London to Brighton, since commemorated annually by the Royal Automobile Club. The speed limit was raised to 20 mph in 1904. The raising of the permitted speed had significant repercussions on the technical development of the automobile. Prior to that date, the industry was dominated by pioneers and prototypes and after that date, the series-produced motorcar was evolved, perhaps the best-known being the Ford Model T, of which over fifteen million were produced between 1908 and 1927. Many of the most highly prized names in the Veteran field are exceedingly rare and few examples are now in private hands. De Dion Bouton, (built by Count De Dion and Georges Bouton), René Panhard, Karl Benz, Leon Serpollet, Gottlieb Daimler, Frederick Lanchester and Percy Riley were among the early European manufacturers, while the United States workshops producing motorcars were operated by Charles E. Duryea, R. E. Olds, Elwood G. Haynes, Alexander Winton, Charles B. King, John D. Maxwell, Francis Edgar Stanley, Walter White and Herbert H. Franklin. Their cars were turned out in very small numbers at comparatively high cost because of the limited manufacturing facilities and the very small consumer demand.

The majority of the early cars were modelled on the design of contemporary horse-drawn carriages. They erred by slavishly copying features best suited to horse-drawn carriages, without probing into these features and forming a true assessment of the problems which were raised by the new form of locomotion. Thus carriages were open, doors were made low with pretty curves and decorative mouldings, and body-work was high and elegant, but offered considerable wind-resistance. As early as 1894, however, Panhard was designing cars with a

Advertisement for Winton and Haynes-Apperson 'motor carriages', 1901.

vertical Daimler engine under a streamlined bonnet or hood, and a modern-type chassis, but the majority of the models marketed at the turn of the century clung steadfastly to the earlier styles of coach-building.

During the first twenty years of their existence, cars of every type and description were produced: with chain, shaft or belt drive transmission;

with tiller or wheel steering; with planetary- or sliding-gear or fast-and-loose pulley change-speed mechanisms; with anything from one to eight cylinders; and with rear or forward mounted engines and all the variety of styling in bodywork to be found in contemporary carriages. Motoring was regarded as a sport, long before the notion of the car as a reliable means of transport took root. Widespread prejudice against a new invention, poor road conditions, the high cost of maintenance and the often exorbitant initial outlay; all conspired to retard the development of the automobile. Nevertheless growth of the industry was spectacular after 1900. In that year, some 4,192 cars were manufactured in the United States; by 1908 the figure had risen to 63,500; but in the ensuing two years alone production figures trebled to 181,000 and they doubled again, to 356,000, by 1912.

At the same time, the design of cars progressed steadily. Early in the 1900s, side rear-doors were introduced, doing away with the small door in the back of the carriage, copied from the governess-cart. Windshields became a standard feature, though they existed as an optional extra earlier. Cars with fixed tops had begun to appear in number; folding tops or 'convertibles' made their debut in 1910. Prior to 1910, very few cars had closed bodies, so that the majority of the vehicles in the period under review were of the open tourer variety. Mascots, badges and radiator filler caps were lavishly ornamented; the silver lady on the Rolls Royce, with her flowing Art Nouveau tresses and garments, is a vestige of this.

Industrialization influenced the European market rather later than the American, but many of the famous names in cars were established in the veteran period. Charles Rolls and Henry Royce formed their partnership in 1904 and produced their first Silver Ghost three years later. Daimler borrowed Mercedes Jellinek's first name as long ago as 1900 for a brand of quality car which has dominated the European market ever since; and about the same time the Swiss engineer, Marc Birkigt, financed by a group of Barcelona business men, formed the Hispano-Suiza company. Italy was among the pioneers of European cars, with the partnership of Cesare Isotta and Oreste Fraschini at the turn of the century. Bugatti (q.v.) built relatively few cars under his own name before 1909 when he established his own factory at Molsheim in Alsace. The exigencies of the First World War

stimulated the technical development of the motor industry beyond recognition, so that the models of the veteran era were antiquated within a decade.

Vever, Henri and Paul

Henri (1854–1942) and Paul (1851–1915) Vever inherited the family jewellery business on the death of their father, Ernest Vever, in 1874. Henri studied at the *Ecole des Arts Décoratifs* and worked under various jewellers and silversmiths, including Dufong, Hallet and Loguet. In 1889, the brothers were awarded two prizes at the *Exposition Universelle* (q.v.) in Paris and, two years later, the *Legion d'Honneur* was conferred on them, for their services in the French Exhibition staged that year in Moscow. In 1893, Henri Vever was one of the French commissioners for the Columbian Exposition (q.v.) and subsequently won important prizes at Bordeaux (1895), Brussels (1897) and Paris (1900). In 1908, he published his superb three-volume history of French nineteenth century jewellery, the third volume of which was devoted almost entirely to the work in Art Nouveau. His own jewellery, however, was too heavy and solid to suit the linear feeling of Art Nouveau, and betrays the strong traditional influences in his work.

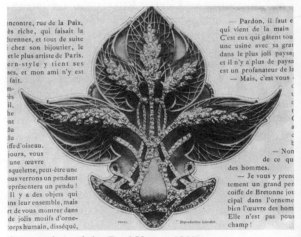

Corsage brooch by Paul Vever, 1907.

Voysey, Charles Francis Annesley

English architect and interior designer, (1857–1941). Voysey was the most important designer

290

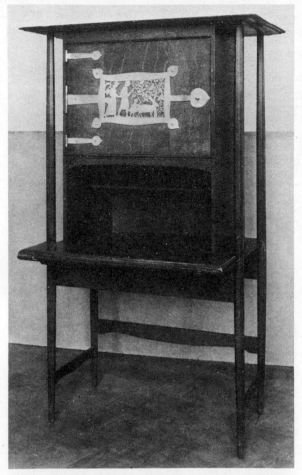

Writing desk designed by C. F. A. Voysey and made by W. H. Tingey in 1896.

in the applied arts in the generation after William Morris (q.v.). He studied architecture under Seddon and Davey and began designing houses in the late 1880s, developing a distinctive neo-Tudor style which has remained popular to this day. Like many of his contemporaries, he was deeply concerned with every aspect of interior design, down to door-hinges and wallpapers (q.v.) and he was a prolific designer of all manner of furniture, fittings, wallpapers, textile-patterns

Printed linen by C. F. A. Voysey, c. 1903.

and small metal accessories. Unlike Morris, he believed in mechanization and his designs were consequently tailored to factory production. His influence on European design in the 1900s was enormous.

Although he is best-known for his domestic and rural architecture, fashionable up to the outbreak of the First World War, he also designed metal hollow ware (tea services in both silver and brass), and in ceramics he was a prolific designer of tiles (q.v.) for Pilkington's (q.v.). His designs for wallpaper and fabrics (q.v.), such as 'Water Snakes' and 'Water Roses', have the flat colours, stark outlines and flowing lines in the tradition of Morris and Mackmurdo (qq.v.). His metalwork, in contrast, had relatively simple lines, anticipating the styles of the 1920s; while his furniture, designed about 1900, tended to be more rigidly geometric than the usual styles of that period. From 1891 onwards, he worked from his studio in West Kensington, London which he designed himself on functionalist principles. Among his many country houses still in existence, typical examples include Broadleys, Windermere (1898); Vodin House, Pyrford Common, Surrey (1902) and The Orchard, Chorley Wood (1899).

Wagner, Otto

Austrian architect and designer, born at Penzing near Vienna in 1841. Wagner was educated at the Technical High-school in Vienna (1857–60), the Berlin *Bauakademie* (1860–1) and the architecture school of the Vienna Academy (1861–3). Although his early work as an architect was in the mid-nineteenth century traditional style, he led the movement, from 1893 onwards, which culminated in the *Jugendstil* (q.v.). In 1894 he was appointed *K. K. Oberbaurat* (royal and imperial chief building councillor) and Professor of the Faculty of Architecture at the Vienna Academy. As such, his influence on the younger generation of designers and architects was enormous and he was adept at developing, fostering and exploiting the talents of his pupils, who included Josef Hoffmann and Joseph Maria Olbrich (qq.v.). He was the guiding light of the new Viennese school of applied arts which culminated in the *Sezession* movement in 1897, and he played a leading role in this until 1905. His writings, including the book *Moderne Architektur,* provided the texts for the architectural revolution which swept Europe at the end of the nineteenth century, though his own buildings were often a curious mixture of Art Nouveau with Baroque and Renaissance elements, as exemplified in the Vienna underground railway, its Hofpavillon and Karlsplatz stations, the Vienna Savings Bank and other public buildings executed between 1898 and 1904. Wagner's influence declined after 1905 and he died in Vienna in 1918. Wagner was a versatile designer of furniture, textiles, glassware, ceramics, silver and wrought-ironwork, produced in connection with his architectural designs.

Wallpaper

Wallpaper was in existence from the beginning of the sixteenth century in Europe but it was not until the development of colour printing presses in the mid-nineteenth century that its usage became really widespread. Stylistically this coincided with the Gothic revival and thus mid-Victorian wallpaper was dominated by the Gothic and medieval patterns pioneered by Augustus Welby Pugin in the 1840s. This influenced William Morris (q.v.) who began producing wallpaper patterns in the early 1860s and developed a wide range over the ensuing thirty years. Beginning with 'Daisy' and 'Trellis' in 1864 and ending with 'Myrtle' produced posthumously in 1899, Morris designed more than forty distinct patterns, subsequently printed on his behalf by Jeffrey and Company of Islington, London. In the last three decades of the century, a Morris wallpaper was absolutely essential to any home with aesthetic pretensions. Morris wallpapers were mainly hand-made, in accordance with his principles, but the designs were copied by other designers and manufactured by machine presses. Morris led the revival in interest in wallpaper design, which had languished for much of the nineteenth century. Regrettably, many of the imitations were mere parodies of the Morris spirit and a surfeit of over-ornamented wallpaper and the poor quality of much machine-made products led to a reaction against the use

'The Knapweed' hand-printed wallpaper designed by Heywood Sumner for Jeffrey & Co., 1900.

Walter, Amalric

French artist and glassworker of the Nancy School (q.v.), active at the beginning of the twentieth century. In collaboration with the sculptor Henry Berge, and the artists Joseph Cheret and Victor Prouve (qq.v.), he produced decorative glass in the *pâte de verre* technique (q.v.). From 1906 to the outbreak of the First World War, Walter had a contract with Daum Frères (q.v.), whereby he was allowed to use their plant and machinery in the production of his wares, but after the war, he established his own factory where the manufacture of glass ornaments and figures has carried on to this day.

Walton, George

English artist and designer (1867–1933). Walton was largely self-taught but became one of the most influential designers and interior decorators at the turn of the century. His best-known

Birchwood chair by George Walton, 1903.

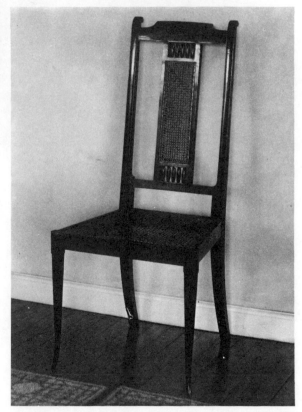

of wallpaper in interior design at the turn of the century. Majolica tiles (q.v.) and wood panelling enjoyed a certain vogue, but plain painted walls were more popular in the early 1900s, until the fashion for well-designed and printed wallpaper gradually revived in the 1920s.

In Europe, however, wallpaper enjoyed better treatment in the hands of many of the leading interior designers of the period. Among those who designed wallpapers of brilliance and originality were Henri Van de Velde in Belgium, Walter Leistikow, Otto Eckmann, Peter Behrens, Paul Bürck and Hans Christiansen in Germany (qq.v.). The best German wallpapers were printed by H. Engelhardt of Mannheim, while those designed by Van de Velde were produced by Essex and Company.

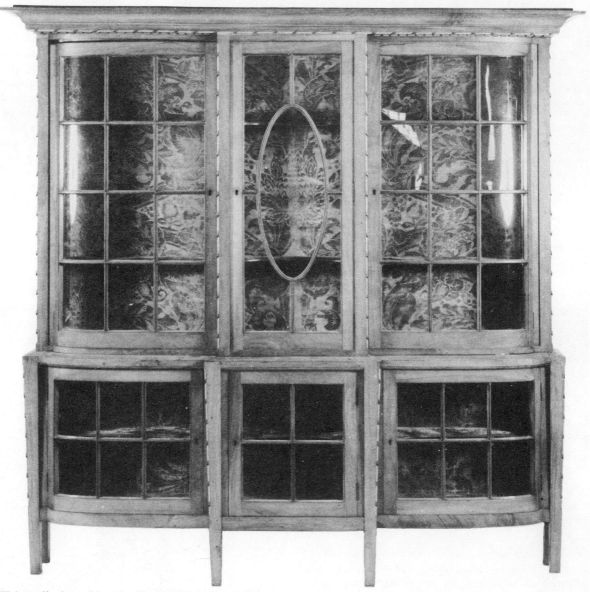

Walnut display cabinet by George Walton, *c.* 1905.

work is the 'Clutha' glass (q.v.) which he designed for James Couper and Sons of Glasgow between 1896 and 1898.

Wax Fruit

The simulation of nature in wax was a popular mid-Victorian pastime. This aspect of wax modelling came to the attention of the public at the Great Exhibition of 1851 and rapidly developed as an upper and middle-class type of

folk art. The ability to model blossoms and foliage in wax for a time ranked on a par with painting in water-colours, flower-arranging and playing the pianoforte; and was regarded as one of the more important accomplishments of the cultivated young lady. The art of modelling flowers in wax required great skill and patience, involving other disciplines such as sculpture, modelling and painting. The ultimate aim was to reproduce, as faithfully as possible, the art and vagaries of nature itself, to achieve flowers as close to the real thing as their frozen waxen

immobility would allow. The craze for wax flower compositions waned after 1870 but did not die out entirely until the First World War.

In the 1880s, however, attention turned instead to wax fruit. Apples, oranges, pears and grapes were the most popular subjects but more exotic fruits, such as nectarines and pomegranates, may also be found. Vegetables, surprisingly enough, were also considered a suitable subject; turnips, carrots, potatoes and even cabbages (complete with caterpillars!) were modelled realistically in wax. Less frequently found are wax arrangements of oysters, mussels, crabs and lobsters, while even cakes and biscuits were occasionally reproduced in wax, either alone or in combination with mounds of fruit. These elaborate ornaments, designed no doubt to stimulate the appetite, were mounted on china or ironstone bases and enclosed under tall glass domes. They were regarded as ideal decoration for the sideboard. The fashion for wax fruit began to die out after the turn of the century, and had passed from the scene by the outbreak of the First World War. The passion for wax fruit and vegetables was widespread on both sides of the Atlantic.

Webb, Philip

English architect and designer, born at Oxford in 1831. Webb was educated at Aynho, Northamptonshire and, after being articled to a Reading firm, entered the offices of the architect, George Edmund Street, where he met William Morris (q.v.). He established his own architec-

English wax fruit composition, late 19th century.

English wax floral bouquet, late 19th century.

and much of this was distinguished by slight horizontal bulbosities in parallel rings round the bowl. These simple shapes, in thinly blown metal, contrasted sharply with the massive and elaborately cut glassware which was so fashionable in late-Victorian England. Webb also contributed several designs, and collaborated on many others, subsequently produced by Morris as wallpaper or fabric-patterns.

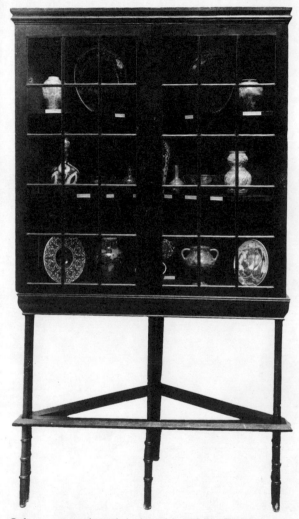

Oak corner cupboard designed by Philip Webb for Sir Edward Burne-Jones, *c.* 1890.

tural practice in London in 1856 and, six years later, began designing furniture, wallpaper, tiles, and fabrics (qq.v.) for Morris, Marshall, Faulkner and Company. Among the more important of his architectural commissions were the Red House, Upton (1859); Joldwyns (1873); Smeaton Manor (1878); Standen (1892); Rounton Grange (1872–6) and Clouds (1881–91); as well as Brampton Church, Cumberland (1874). Webb invented a method of preserving old buildings by filling the interior of the walls with new material, and this technique was used extensively by the Society for the Protection of Ancient Buildings which he and Morris founded in 1877. Webb died at Worth, Sussex in 1915.

Webb was one of the original partners in Morris's company when it was formed in 1862 and, although he dropped out of active partnership when the company was re-organized in 1875, he continued to design furniture and fabrics for Morris. His furniture was characterized by its sturdiness and medieval lines; tables, benches and massive oak settles were his favourites. He also designed glassware produced in clear glass by Powell and Sons of Whitefriars

Webb Glass

Thomas Webb and Sons, known as 'the crystal kings of England', produced art glass under licence from the American patent-holders, as

well as developing the cameo glass (q.v.) popular at the turn of the century. The firm was established at Stourbridge by Thomas Wilkes Webb and produced domestic and useful wares of a high quality, before diversifying into the art glass field. In 1874, the firm began producing cameo glass under the supervision of Thomas and George Woodall (q.v.). George Woodall was sent by the firm to study glass-engraving and decoration in Europe and he subsequently produced beautifully engraved flint glass and rock crystal. Techniques such as wheel-engraving and the use of acid-etching were adopted in the 1880s. Webb also patented a form of glass which simulated carved ivory and won prizes for it at international exhibitions from 1888 onwards.

'Ivory Cameo' vase by Thomas Webb & Sons, 1890.

Webb cameo glass table lamp, 1900.

Commercial cameo glass was marked 'Webb's Gem Cameo' on the more important pieces, and occasionally a date was also inscribed. The cameo glass was inspired by classical, Baroque or Chinese originals, but its eclecticism (q.v.) in no way detracted from the skill and artistry with which it was conceived.

From 1886 onwards, the company manufactured large quantities of art glass, the best known of which was the so-called Burmese ware (q.v.), patented by the Mount Washington Glass Company of America (q.v.). This beautiful opaque glass with its delicate ivory tints was marked on the base 'Thos. Webb & Sons, Queen's Burmese Ware, Patented': the epithet 'Queen's' alluding to a presentation of this glassware to Queen Victoria. Webb also manufactured other forms of art glass such as 'Pearl Satin', distinguished by its fine satin finish. Webb and Sons experimented with iridescent glass, obtaining the idea from Lobmeyr of Austria (q.v.), but never developed it to the

297

extent that Tiffany (q.v.) did. At the turn of the century, exquisitely engraved crystal was carried out by Kay and William Fritsche, who operated independent workshops within the Webb factory.

Wedgwood Pottery

Though the major part of the output of the Wedgwood factory at the turn of the century continued to be the black basalts and jasperware in Neo-classical designs established in the late eighteenth century, there were several important concessions to the fashion of the time. The familiar blue and white jasperware declined in quality in the mid-nineteenth century and, in a bid to stimulate public demand, experiments began in 1885 in white jasper vases with bas reliefs decorated in lilac and green. This type of ware, with the same classical motifs as before, enjoyed only limited popularity in the late nineteenth century. In 1870, Wedgwoods established a tile (q.v.) department which continued to function until 1902. It concentrated on transfer-printed designs, featuring fairy tales, Shakespearean scenes and Kate Greenaway (q.v.) children. Judging by the subjects chosen, these ornamental tiles seem to have been aimed at the nursery market. From the 1870s onwards, Wedgwoods manufactured parian ware (q.v.) in large quantities and also evolved 'Victorian' ware, a

Wedgwood cream-coloured earthenware, 'Edme' pattern introduced in 1908.

Wedgwood earthenware bowl designed and signed by Bernard Moore, 1893.

cross between bone china and 'Queen's earthenware', much used for services and other tablewares. Bone china itself was introduced in 1878 and, at the turn of the century, was one of the firm's more popular lines, distinguished by its gold lustre decoration and colourful floral motifs. From 1860 to 1910, Wedgwood produced majolica (q.v.) using soft lead glazes and a white body, unlike the majority of other manufacturers of that time who favoured a cane-coloured body. For this reason, the Wedgwood glazes were seldom opaque. Clear glazes were applied in brilliant colours to moulded relief plaques and dishes and these won wide acclaim in the 1890s. To a limited extent, Wedgwood's entered the field of studio pottery (q.v.), producing hand-decorated wares by Alfred and Louise Powell and Therese Lessore. Although firmly wedded to classicism, Wedgwood's could not resist the influence of *Japonaiserie* (q.v.) which swept Europe and America, and brought out a number of Japanese-inspired patterns, of which the 'Sparrow and Bamboo' is the best-known.

Wedgwood earthenware 'studio' vase decorated by a
Dutch artist, 1900.

Weiss, Emil Rudolf

German painter, graphic artist and designer, born at Lahr, Baden in 1875. From 1893 to 1901, he studied art in Karlsruhe, Stuttgart and at the *Academie Julian* in Paris. In 1895–6, he contributed illustrations to the art periodical *Pan* and, from 1897 onwards, was a prolific illustrator of books and magazines, working mainly for the publishers Eugen Diederichs and S. Fischer. From 1907 until he was driven from office by the Nazis, he held various official appointments in Berlin. His wife was the sculptress, Renée Sintenis. Weiss designed posters at the turn of the century and experimented in the design of lettering and type-faces. In the applied and decorative arts, he produced designs for stained-glass, furniture, wallpaper, fabrics and ceramics.

Weller, Samuel A.

American ceramicist (1851–1925) who founded a commercial pottery in Zanesville, Ohio in 1882. From rather crudely decorated flower-pots, Weller graduated to more elaborate and ornamental items, such as *jardinieres* and umbrella-stands in 1890. Three years later, at the Columbian Exposition (q.v.), his attention was turned towards art pottery by the magnificent array of Rookwood pottery (q.v.) and subsequently he negotiated the take-over of the Lonhuda Pottery (q.v.) run by William A. Long in Steubenville. The Lonhuda plant was transferred to Zanesville and the former Lonhuda art wares were subsequently manufactured under the name 'Louwelsa' (composed from the name of Weller's daughter Louise as well as his own initials). 'Louwelsa' art pottery closely resembled the contemporary Rookwood products, though the distinctive marks make identification easy. Weller expanded his art pottery and, by the early 1900s, was marketing several well-known brands. 'Aurelian' was similar to 'Louwelsa', but the background was applied with a brush rather than spray-painted. 'Dickensware' had incised designs, usually of Dickensian characters including the inimitable Sam Weller; 'Eocean' was similar to Louwelsa but had a lighter body colour and more delicate backgrounds. 'Turada' had white lacy decoration on a very dark ground, and *'L'Art Nouveau'* had relief designs on a semi-matt finish. The most famous of all the

Pottery jar by Jacques Sicard, for S. A. Weller's Zanesville Pottery, 1901–7.

Weller styles was 'Sicardo', created by the French potter Jacques Sicard, who was employed by Weller. It was characterized by metallic lustre designs on iridescent deep brown, purple or green backgrounds and was highly distinctive and original. Somewhat similar was 'Lasa', used for landscape and scenic motifs. High quality of production was matched by aggressive sales techniques and, by 1910, Weller could boast that his pottery was the largest in the world, with more than three-hundred thousand square feet of floor space. Weller continued to add new lines and even more exotic names to his range of products and it has been estimated that more than 120 names were used between 1895 and 1945. After 1910, however, the brand name was no longer marked on the item, so

names like 'Roma', 'Zona' and 'Blue Drapery' have academic interest only. Weller continued to have sole control of the company until 1922 when it was incorporated as a stock company, and he died three years later. The Samuel A. Weller Pottery continued to operate until 1949.

Wiener Werkstätte

Organization (signifying 'Vienna workshop') founded in 1903 by Josef Hoffmann and Koloman Moser (qq.v.) with the backing of Fritz Wärndorfer, the financier and patron of the *Sezession* (q.v.) movement. The *Wiener Werkstätte* embodied the tastes and aspirations of the *Sezession* members, combining the highest and purest traditions in art with the evolution of the new industrial economy in Central Europe. The principal aim of the workshops was to bring the artist or designer closer to the craftsmen and technicians entrusted with the execution of the design and, as far as possible, the artist was encouraged to be his own craftsman. The movement was strongly influenced by Mackintosh and the Glasgow group (qq.v.). After Klimt (q.v.) and his followers broke away from the *Sezession* in 1905, the *Werkstätte* became the focal point for the applied and decorative arts in Austria. Hoffmann and Moser (qq.v.) were its directors, and such artists as C. O. Czeska and Dagobert Peche were among its leading lights. The *Werkstätte* produced fabric-designs, furniture, wallpaper, glass, ceramics and metalwork, designed buildings like the Purkersdorf Sanatorium and the Villa Stoclet in Brussels. The last named was the crowning achievement of the *Wiener Werkstätte*, conceived by Hoffmann and built between 1905 and 1911. Its interior design, furniture and fittings were entirely carried out by members of the *Werkstätte*. Despite setbacks occasioned by the First World War, the *Werkstätte* continued to function until 1932, exerting a major influence on the arts and crafts of the interwar period.

Wilson, Henry

British architect and designer (1864–1934). Wilson joined the architectural practice of J. D. Sedding as chief assistant and became head of the

Hand-wrought silver dish by Dagobert Peche for the *Wiener Werkstätte*.

firm on Sedding's death in 1891. Four years later, however, he established a studio for metalwork and jewellery and, from the beginning of the twentieth century, taught metalwork at the Royal College of Art. Wilson was president of the Arts and Crafts Exhibition Society and Master of the Art Workers' Guild, carrying on the traditions of William Morris in the Arts and Crafts movement (qq.v.) though some of his best-known work—ecclesiastical silver and presentation pieces for public companies—was produced in the 1920s. Wilson was the author of *Silverwork and Jewellery* and had a profound influence on the younger designers of the early twentieth century.

Wolfers, Philippe

Belgian jeweller (1858–1929), trained originally as a sculptor under Isidore de Rudder (q.v.). Wolfers worked in the revived Rococo styles of the 1880s but, a decade later, he had been converted to Art Nouveau, in which style he produced objects of vertu before turning exclusively to jewellery in 1897. Although he worked in traditional materials (gold and precious stones), Wolfers also used opals, pearls, silver, semi-precious stones and enamelled silver, and was the first jeweller to experiment with such relatively unlikely materials as ivory (hitherto confined to boxes and carved panels). It was his use of unorthodox materials, rather than his style, which indicated his break with traditionalism, though his later jewellery business expanded enormously at the turn of the century with branches in Ghent, Antwerp, Liege, Budapest and Düsseldorf and showrooms in Amsterdam, London and Paris. In 1905, he switched back to silverware and sculpture from jewellery and, after 1910, he abandoned Art Nouveau and developed a more geometric style which culminated in his salon at the Paris Exhibition of the Decorative Arts in 1925, in which he designed everything, from the chandeliers to the carpet, including the drapes, china and furniture. This was his swan song and marked his retirement from the business. He died four years later.

The bulk of his jewellery was produced in the relatively short period from 1897 to 1904. His pieces were always expensive and today they are major rarities. They are comparable in quality to that produced by Lalique (q.v.), though generally heavier and using more varied materials. His skill and originality as a designer resulted in some remarkable brooches and pendants. The more important pieces were personally marked by Wolfers '*PW exemplaire unique*'; just over a hundred such items have been recorded. The vast majority of his jewels were unsigned, and attribution is often uncertain.

Woodall, George

English glassworker (1850–1925), employed with his brother Thomas (1849–1926) by Thomas Webb (q.v.) to engrave glassware. The Woodall brothers were nephews of Thomas Bott (1829–1870), who had worked for the Richardson glassworks before moving to the Worcester Porcelain factory (q.v.) where he was employed as a decorator. The Woodalls received their art training from their uncle and worked initially in the glass-decorating studio of J. and J. Northwood who made cameo glass (q.v.) for the Stourbridge glassworks of Stevens & Williams. About 1874, the Woodalls went to work for Thomas Webb where they began to build up the engraved glass side of the business. George Woodall was sent by the company to the South Kensington School of Art and also to Europe to study techniques of glass-engraving and carving. Woodall returned to Stourbridge in 1884 and, from then onwards, produced finely engraved flint glass and rock crystal. At the International Health Exhibition of 1884, Thomas Woodall was awarded a bronze medal for bowls and a vase. The Woodall brothers were inspired by Northwood's imitation of the Portland Vase, exhibited in 1878, and much of their cameo work consisted of Neo-classical figurative work, in the style of the contemporary painters Leighton and Alma-Tadema, though the influence of the sculptor Canova can be discerned in George Woodall's work. George Woodall worked as the head of a team combining diverse skills; his assistant was J. T. Fereday (1854–1942), while the gilder and enameller Jules Barbe and the engraver William Fritsche (1853–1924) collaborated with him on the more important pieces. Their work won high praise at the Columbian Exposition of 1893 (q.v.) and the Franco-British Exhibition of 1908. Three years later George Woodall retired. Glass produced

Wedgwood fairyland lustre plaque designed by S. Makeig-Jones.

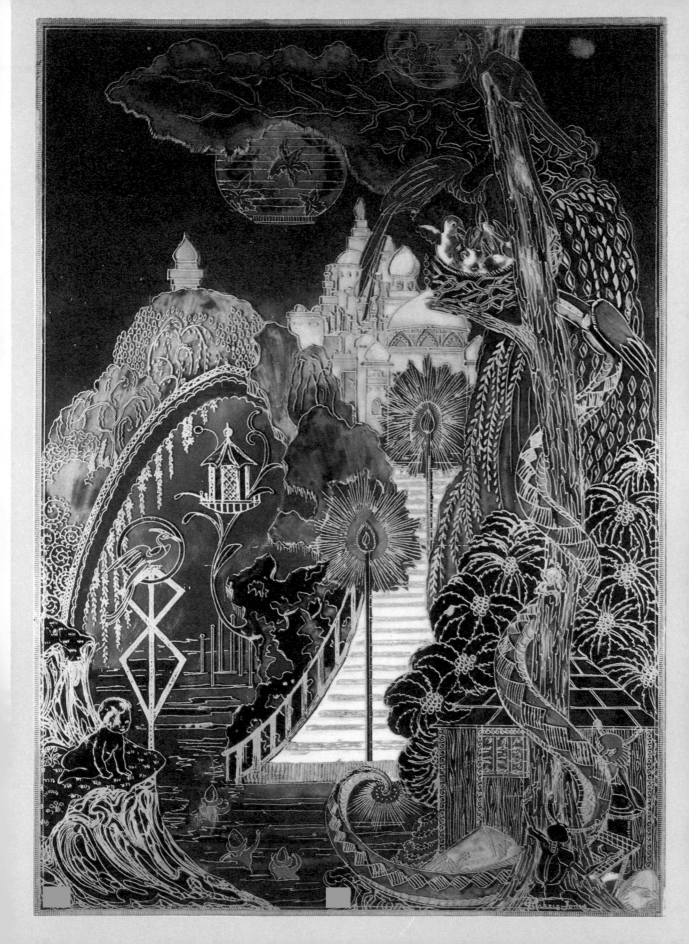

by the Woodalls was individually marked. Generally the inscription was 'T. and G. Woodall', though 'G. Woodall' (before 1895) and 'Geo. Woodall' (after 1895) may sometimes be found. 'T. Woodall' alone is very rare. The Woodall mark was usually placed on the opal overlay.

Worcester Porcelain

No fewer than four different potteries were operating in the English town of Worcester in the late nineteenth century, yet all were related in some respect to the old-established factory, known since 1862 as the Royal Worcester Porcelain Factory. In 1862, the partnership of Kerr & Binns was dissolved. W. H. Kerr retired and R. W. Binns formed a new joint stock company, henceforward known as the Royal Worcester Company. The floral motifs in delicate Limoges enamels, which distinguished the Kerr and Binns period (1852–62) were continued for many years, under Thomas Bott (1829–70) and his son, Thomas John Bott (1854–1932), but, after 1870, Royal Worcester began to develop new lines in decorative porcelain, strongly influenced by the current fashion for *Japonaiserie* (q.v.). Much of this ware was decorated by James Hadley (q.v.) and won wide acclaim at the Vienna Exhibition of 1878. Towards the end of the century, the decorative porcelain produced by Royal Worcester became even more eclectic, drawing on Persian, Indian and Italian Renaissance originals as well as Japanese wares for inspiration. As well as tablewares, Hadley modelled many figures, of which his children groups in Kate Greenaway (q.v.) costume are the best-known. At the turn of the century, George Owen worked as a modeller for Royal Worcester and pioneered an intricate form of decoration, known as reticulation, in which the porcelain was delicately pierced to simulate network or basket-weaving. The *Pottery Gazette* (1896), describing his work, stated 'the artist tooled every one of these minute apertures without having any tracery, or any other assist-

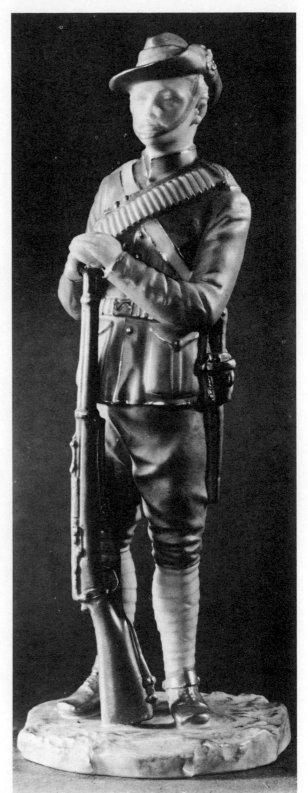

'The Volunteer in Khaki', a Boer War memento by Royal Worcester Porcelain, 1900.

◀ Necklace in gold, enamel, opals, pearls and cabochon emeralds, by Henry Wilson, 1900.

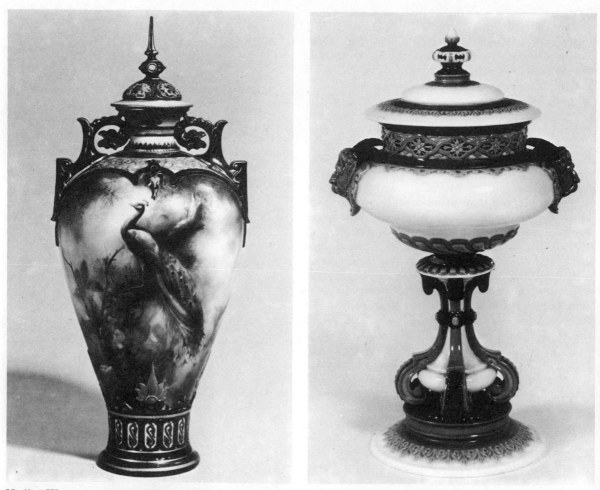

Hadley Worcester vase and cover, 1900–2.

Hadley Worcester porcelain stem vase and cover, 1897–1900.

ance whatever to guide him to regularity, except his eye and his hand . . . If on the last day of his work his knife had slipped, and so made two holes into one, the whole piece would have been ruined.' Work by George Owen is usually signed, in addition to the usual Worcester marks of the period.

Throughout the nineteenth century, there was a rival company in Worcester, founded by Thomas Grainger in 1800. As well as an earthenware known as 'semi-porcelain', the Grainger company produced *pâte sur pâte* (q.v.), but otherwise its wares resembled those of the Royal Worcester company. Reticulated decoration was practised in the closing decades of the century, but never attained the fineness of George Owen's work. The Grainger company was absorbed by Royal Worcester in 1889, but

continued in production quite separately, and used its own marks, until 1902 when its plant was closed down.

Two employees of the Royal Worcester company established their own potteries at the turn of the century. Edward Locke (1829–1909) founded the Shrub Hill works in 1895 and produced porcelain, both figures and tableware, emulating the more costly productions of Royal Worcester, but was forced to close down in 1904 after losing a legal battle with Royal Worcester over the use of the term 'Worcester' to describe his products. The other small factory was that founded by James Hadley in 1896, and absorbed by Royal Worcester after his death in 1903. The distinctive Hadley wares (q.v.), however, continued to be manufactured under the aegis of Royal Worcester for many years.

Wright, Frank Lloyd

American architect, interior decorator and fur-
niture-designer (1869–1959). Wright worked
from 1887 to 1893 in the drawing office of
Louis Sullivan (q.v.) and subsequently estab-
lished his own architectural practice in Chicago.
In the first decade of this century, he designed
many notable buildings, including the Larkin
Building in Buffalo (1906); the Unity Church
in Oak Park, Chicago (1906) and such private
houses as the Martin House in Buffalo (1906);
Coonley (1907) and Robie in Chicago (1909).
He was an active propagandist for the modern
style in architecture, and published two books
on the subject (1910–11) which had a tremendous
influence on the development of architecture all
over the world, especially since the First World
War. Even earlier, in 1894, he had published his
Propositions, setting out his theories on design
which governed his work up to 1910. During
his so-called Oak Park period (1893–1910), he
designed buildings which were organic: they
appeared to grow from their sites and harmon-
ized with the natural landscape in every detail.

Interior furnishings in this period followed the
same principles. Concerning furniture he wrote:

Pair of Grainger Worcester pierced vases, 1891–1900.

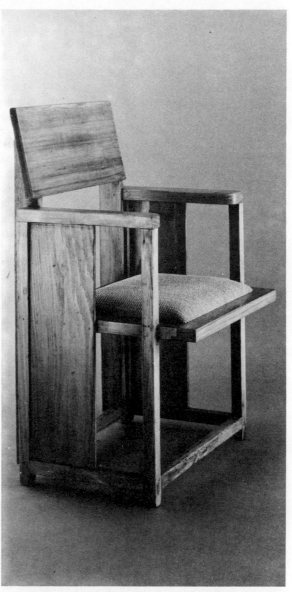

Armchair designed by Frank Lloyd Wright, 1904.
(Museum of Modern Art, N.Y.)

'The most truly satisfactory apartments are
those in which most or all of the furniture is
built in as part of the original scheme considering
the whole as an integral unit'. His advice to his
contemporaries was to 'bring out the nature of
the materials, let their nature intimately into
your scheme. Strip the wood of varnish and let
it alone—stain it . . . go to the woods and fields
for color schemes. Use the soft, warm, optimistic
tones of earth and autumn leaves.' Oak and
poplar were the timbers which he favoured most

307

for his furniture. His designs were regarded as revolutionary at the time and he had some difficulty in finding cabinet-makers who were prepared to interpret them. Most of his so-called 'progressive' furniture dating around the end of the nineteenth century was manufactured for him by George Niedecken of Milwaukee. Initially he preferred hand-made furniture, echoing the tenets of the English Arts and Crafts Movement (q.v.) but later he came to appreciate the qualities which could be attained by mechanical processes, to which he referred as 'the clean cut, straight-line forms that the machine can render far better than would be possible by hand'. As part of his concept of overall design in the interiors of his houses, Wright also designed metalwork in the 1890s, mainly in copper using geometric features which distinguished his architecture.

Writing Sets

Higher standards of literacy, together with cheap postage, which reached its apogee in 1898 with the introduction of Universal Penny Postage, encouraged the art of letter-writing and stimulated the growth of an industry devoted to providing elegant equipment and materials for this purpose. Writing sets may be divided into two broad categories: the table set and the travelling set. Table writing sets varied considerably in style, material and elaboration, and consisted basically of either a box or a tray with tiny compartments or recesses to hold ink, pens, paper, envelopes, wafers, seals, sealing wax, paper-clips, pins, erasers and other paraphernalia. *Papier mâché*, lacquerware with mother-of-pearl inlays, wood, ivory, porcelain and glass were used either alone or in combina-

Silver and silver-mounted writing set by the Goldsmiths and Silversmiths Co., 1904, presented to Mrs. Kelly, wife of the retiring Bishop of Moray, Ross and Caithness.

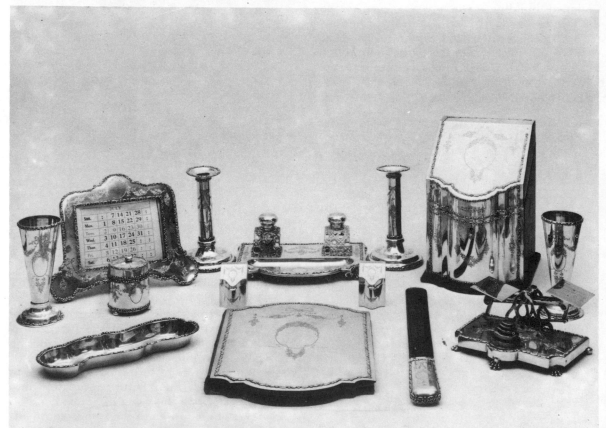

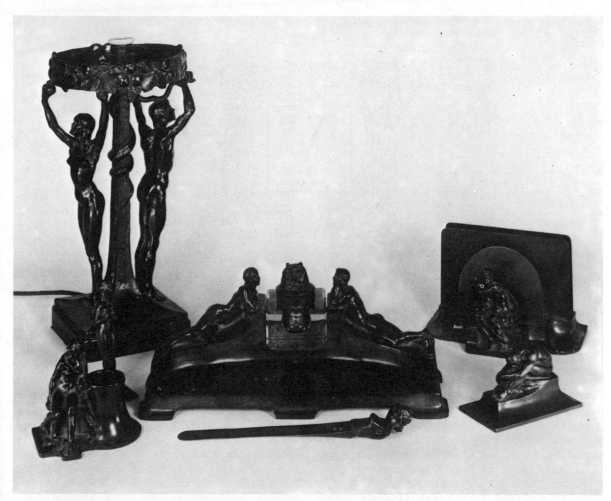

'Adam and Eve' writing set by Hermann Bergman and Otto Meyer, 1917–8.

tion; and handles, mounts, lids and fastenings might be of silver, brass or copper. Travelling writing sets were basically of leather or cloth-covered wood and usually resembled large wallets, with a blotter inside the cover and pockets to contain the writing materials; but the more ambitious examples contained tiny drawers, inkwells and compartments for stamps and paper, as well as clips or loops containing scissors, letter-opener, rulers, pens and pencils.

Yasuke, Date

Japanese weaver and textile designer of Kyoto (1844–92). More than any other craftsman, Yasuke was responsible for westernizing Japanese textiles. Tapestries in traditional Japanese designs and techniques were exhibited by Yasuke at the Vienna International Exhibition of 1873, where they helped to stimulate European interest in *Japonaiserie* (q.v.) but, at the same time, Yasuke enthusiastically absorbed the latest developments in the European textile industry. In the 1870s, he studied chemical dyeing processes in France and Germany and subsequently imported the first Jacquard loom into Japan. Yasuke pioneered the trend in Japanese textile design inspired by French originals, and this was later developed by Kawashima Jinbei (q.v.).

Yasuzuki, Namikawa

Japanese enameller of Kyoto (1845–1927). Namikawa helped to revive the ancient traditional art of *cloisonné* in Japan and, at the turn of the century, developed the distinctive translucent *cloisonné* decoration known as *shippo*.

Yellow Book

Quarterly journal devoted to the more aesthetic aspects of the arts, founded by John Lane in 1894. The title was probably derived from the so-called 'yellow-back' French novels of the period. *The Yellow Book* became the mouthpiece of the Aesthetic Movement (q.v.) but was roundly condemned by the Philistines of the 1890s. *The Times* described it as 'a mixture of English rowdyism and French lubricity'. It was savagely satirized by *Punch* who referred to its art editor as 'Danby Weirdsley'. *The Yellow Book* gained notoriety, and is best remembered because of the drawings by Aubrey Beardsley (q.v.); their elegant artificiality and elaborate decadence set the tone of the magazine more forcefully than the text. The erotic cynicism of the drawings antagonized late-Victorian society. In 1895, the trial of Oscar Wilde, arch-apostle of aestheticism, on sexual offences, was a victory for philistinism and inevitably *The Yellow Book* suffered a severe setback. Aubrey Beardsley, dying of consumption, was hounded as a scapegoat and forced to relinquish his post with the magazine. Inevitably *The Yellow Book* was unable to weather the storm, and ceased publication the following year.

Cover for *The Yellow Book* by Aubrey Beardsley, 1894.

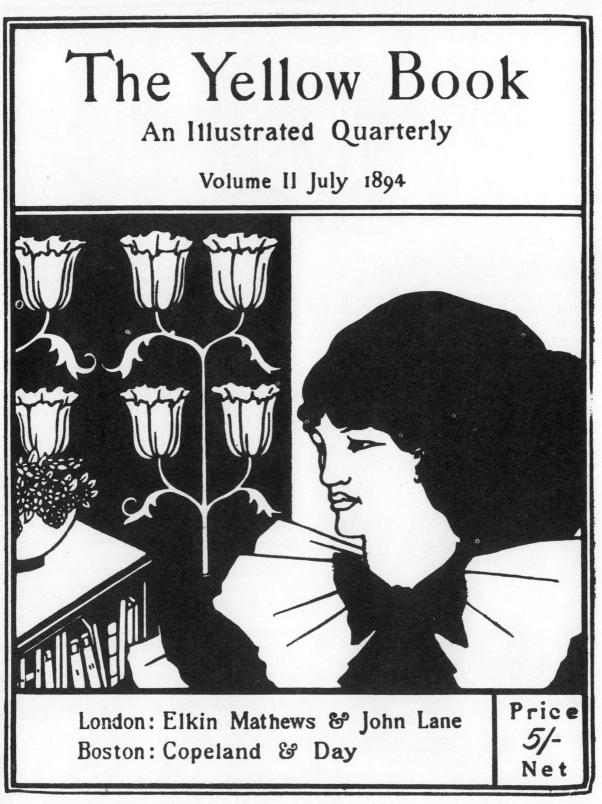

The Yellow Book

An Illustrated Quarterly

Volume II July 1894

London: Elkin Mathews & John Lane
Boston: Copeland & Day

Price
5/-
Net

Zasche, Adolf

Bohemian glass manufacturer active at the turn of the century. The Zasche glassworks was situated in Gablonz (now Jablonec in Czechoslovakia), and produced glasses of simple forms with iridescent splashes decorating the bowls. Galvanized silver overlay, to designs by Lederle, was a speciality of this factory. The overlay was relatively simple and had a characteristic whip-lash motif. Zasche glassware was often mounted in brass or bronze, worked in austere motifs, for use as candlesticks (q.v.).

Iridescent glass vase in blue and silver, by Adolf Zasche, *c*. 1900.

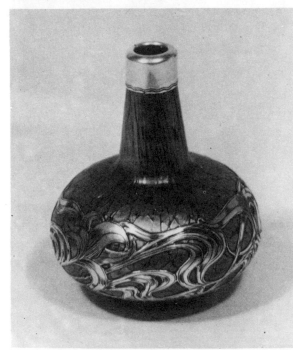

Zitzmann, Friedrich

German glassworker (1840–1906), employed at Wiesbaden at the turn of the century as an instructor in glass-blowing. Zitzmann was a pupil of Karl Köpping (q.v.) and produced elegant glasses on slender stems, with multicoloured bowls, after the manner of Köpping, using lamp-blown techniques. Professor Zitzmann also designed glasses manufactured by the *Ehrenfelder Glashütte* at the end of the nineteenth century.

Zsolnay Pottery

Art pottery was manufactured by W. Zsolnay at Fünfkirchen (now Pecs) in Hungary at the turn of the century. Both earthenware and stoneware were produced with distinctive iridescent glazes in shades of green, blue and brown. A speciality of this pottery was large vases with coloured lustre decorated in low relief with scenes from *Grimms' Fairy Tales*. Vinsce Wartha (1844–1914) was the chief designer for this company.

Zwollo, Frans

Dutch jeweller and metalworker, active at the turn of the century. Zwollo designed silverware

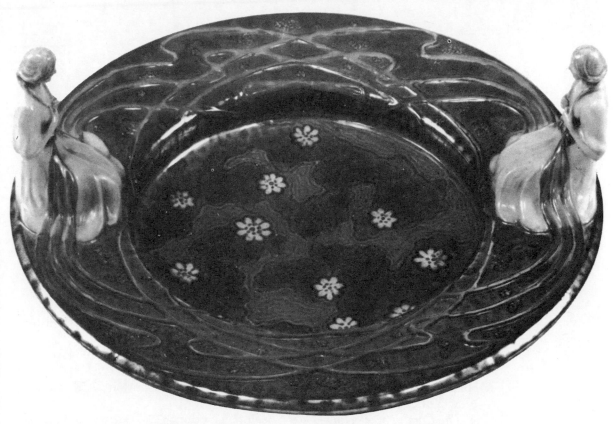

Lustre dish by Zsolnay, *c.* 1900.

and jewellery with floral motifs in the Art Nouveau style but, from 1910, he began to design brooches and pendants in the geometric patterns initiated by Hoffmann and the craftsmen of the *Wiener Werkstätte* (qq.v.). His metalwork, especially that conceived in copper or brass, was strongly influenced by the English Arts and Crafts Movement (q.v.). The lamps (q.v.), bowls and decorative hollow ware, which he produced in the 1890s, derived their forms from plants, sea-shells and other natural sources, but became more angular after 1910.

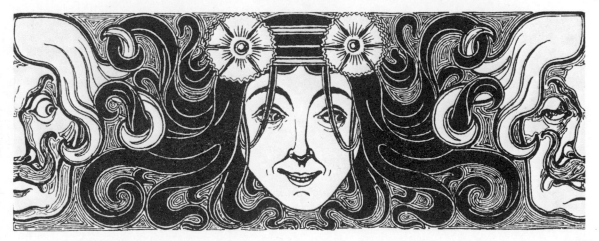

Bibliography

General

Laver, James *Victoriana* Ward Lock, London, 1973

Lichten, Frances *Decorative Art of Victoria's Era* New York

Lynes, Russell *The Taste Makers* Harper, New York, 1954; Hamish Hamilton, London, 1954

Mackay, James *Antiques of the Future* Studio Vista, London, 1970; Universe Books, New York, 1971

Mebane, John *New Horizons in Collecting* Yoseloff, London; A.S. Barnes, New York, 1967

 The Coming Collecting Boom Yoseloff, London; A.S. Barnes, New York, 1968

Pevsner, Sir Nikolaus *The Sources of Modern Architecture and Design* Thames & Hudson, London 1968

Whittington, Peter *Undiscovered Antiques* Garnstone Press, London, 1972; Scribner, New York 1973

Americana

Butler, Joseph T. *American Antiques, 1800–1900* Odyssey Press, New York, 1965

Larkin, Oliver W. *Art and Life in America* revised Holt, Rinehart & Winston, New York, 1960

Lipman, Jean *American Folk Art in Wood, Metal and Stone* Pantheon Books, New York, 1948

McClinton, Katherine Morris *A Handbook of Popular Antiques* Grosset, New York, 1950

Metropolitan Museum of Art *19th-Century America: Furniture and other decorative Arts* New York Graphic Society, New York, 1970

Art Nouveau (and related styles)

Amaya, Mario *Art Nouveau* Studio Vista, London; Dutton, New York, 1966

Battersby, Martin *Art Nouveau* Hamlyn, London, 1969

 The World of Art Nouveau Arlington Books, London, 1968; Funk & Wagnall, New York, 1969

Madsen, Tschudi *Sources of Art Nouveau* Wittenborn, New York, 1957
 Art Nouveau Weidenfeld & Nicolson, London; McGraw-Hill, New York, 1967
Metropolitan Museum of Art *Art Nouveau* (exhibition catalogue) Doubleday, New York, 1960; Mayflower, London, 1960
Musée National d'Art Moderne *Les Sources du XXe Siècle* Paris, 1960
Rheims, Maurice *The Age of Art Nouveau* Thames & Hudson, London; Abrams, New York, 1966
Schardt, Herman *Paris 1900* Berlin, 1968
Schmutzler, Robert *Art Nouveau* Thames & Hudson, London; Abrams, New York, 1964
Seling, Helmut and Bauch, Kurt *Jugendstil : der Weg ins 20. Jahrhundert* Munich 1959
Selz, P. and Constantine, M. *Art Nouveau* Mayflower, London; Museum of Modern Art, New York, 1959
Waissenberger, Robert *Die Wiener Sezession* Munich, Vienna, 1971

Bronzes
Horswell, Jane *Price Guide to the Bronze Sculpture of Les Animaliers* Antique Collectors' Club, Woodbridge, Suffolk, 1971
 Les Animaliers : Bronze Sculptures Newbury Books, 1973
 ed. *Bronze Sculptures of Les Animaliers* Gale, 1973
Mackay, James *The Animaliers : Animal Sculptors of the 19th and 20th Centuries* Ward Lock, London, 1973; Dutton, New York, 1973
Savage, George *Concise History of Bronzes* Thames & Hudson, London; Praeger, New York, 1969

Clocks and Watches
Baillie, G.H. *Watches : their History, Decoration and Mechanism* Methuen, London, 1929
 Watchmakers and Clockmakers of the World Methuen, London, 1929
Bruton, E. *Clocks and Watches, 1400–1900* Praeger, London; Barker, New York, 1967
Chapuis, A., and Jaquet, E. *Technique and History of the Swiss Watch* American Horologist and Jeweller, Boston, 1956
Cumhail, Philip W. *Investing in Clocks and Watches* Barrie & Rockliff, London, 1967
Cuss, T.P. Camerer *The Book of Watches* Country Life, London, 1967
Daniels, George *English and American Watches* Abelard-Schuman, London and New York, 1967
Dreppard, Carl W. *American Clocks and Clockmakers* Branford, Mass., 1958
Palmer, Brooks *Book of American Clocks* Collier-Macmillan, London; Macmillan, New York, 1950
 Treasury of American Clocks Collier-Macmillan, London; Macmillan, New York, 1967
Thomson, Richard *Antique American Clocks and Watches* Van Nostrand Reinhold, Princeton, 1968
Ullyett, K.R. *British Clocks and Clockmakers* Collins, London, 1947
 In Quest of Clocks Rockliff, London, 1950; Spring Books, London, 1969

Furniture

Aslin, Elizabeth *19th Century English Furniture* Faber, London, 1962

Bethnal Green Museum *Bentwood Furniture: the Work of Michael Thonet* London, 1968

Bjerkoe, E.H. *The Cabinetmakers of America* Doubleday, New York, 1957

Brackett, Oliver *English Furniture* Benn, London, 1928

 English Furniture Illustrated Benn, London; Macmillan, New York 1950

Bradshaw, A.E. *Handmade Woodwork of the Twentieth Century* John Murray, London, 1962

Exner, Wilhelm Franz *Das Biegen des Holzes* Leipzig, 1922

Hayward, Helena *World Furniture: A Pictorial History* McGraw-Hill, London and New York, 1965

Jervis, Simon *Victorian Furniture* Ward Lock, London, 1968

Joel, David *Furniture Design Set Free* Dent, London, 1969

Mannoni, Edith *Meubles et Ensembles Style 1900* Paris, 1968

Miller, E.G. *American Antique Furniture* Dover Publications, London, 1966

Moody, E. *Modern Furniture* Studio Vista, London; Dutton, New York, 1966

Otto, Celia Jackson *American Furniture of the 19th Century* Viking Press, New York, 1965

Glass

Amaya, Mario *Tiffany Glass* Studio Vista, London, 1968

Avila, George C. *The Pairpoint Glass Story* Reynolds-De Walt, New Bedford, Mass., 1968

Baar, A. *Retrospective de la Verrerie Artistique Belge* Liege, 1930

Bawelet, J. *La Verrerie au France* Paris

Beard, Geoffrey W. *Nineteenth Century Cameo Glass* Ceramic Books, Newport, R.I., 1956

Bergstrom, Evangeline H. *Old Glass Paperweights* Crown, New York, 1947; Faber, London, 1948

Bing, Samuel *Artistic America, Tiffany Glass and Art Nouveau* M.I.T. Press, Cambridge, Mass., 1970

Blount, B. and H. *French Cameo Glass* Wallace-Hamestead, Iowa, 1968

Cloak, Evelyn Campbell *Glass Paperweights* Studio Vista, London, 1969

Grover, Ray and Lee *Carved and Decorated European Art Glass* Tuttle, Rutland, Vt., 1970

 Art Glass Nouveau Tuttle, Rutland, Vt., 1967; Prentice-Hall, New Jersey, 1967

Hollister, Paul *The Encyclopedia of Glass Paperweights* Potter, New York, 1969

Hudig, F.W. *Das Glas* Vienna, 1925

Janneau, G. *Modern Glass* Studio, New York, 1931

Kampfer, F. and Bayer, K.G. *Glass: A World History* Studio Vista, London; New York Graphic, New York, 1966

Koch, Robert *Louis C. Tiffany, Rebel in Glass* Crown, New York, 1964

Lee, Ruth Webb *Nineteenth Century Art Glass* Barrows, New York, 1952

Mackay, James *Glass Paperweights* Ward Lock, London; Viking Press, New York, 1973

McKearin, George and Helen *American Glass* Crown, New York, 1941

 Two Hundred Years of American Blown Glass Crown, New York, 1966

Museum Stuck-Villa *Internationales Jugendstilglas* Munich, 1969

Pazaurek, Gustav, E. *Moderne Glaser* Leipzig, 1901

Powell, Harry J. *Glass-making in England* Cambridge University Press, London; Macmillan, New York, 1923

Revi, Albert Christian *Nineteenth Century Glass, its Genesis and Development* Nelson, New York, 1959

Rosenthal, L. *La Verrerie Française depuis Cinquante Ans* Paris, 1927

Schmidt, R. *Das Glas* Berlin, Leipzig, 1922

 100 Jahre Oesterreichisches Glaskunst : Lobmeyr 1823–1923 Vienna, 1923

Tiffany, Louis Comfort *Favrile Glass* New York, 1896

Van Tassel, V. *American Glass* Barrows, New York, 1950

Wakefield, Hugh *Nineteenth Century British Glass* Faber, London, 1961; Yoseloff, 1962

Weiss, Gustav *The Book of Glass* Praeger, New York, 1971

Jewellery and Objects of Vertu

Bott, Gerhard *Kunsthandwerkum 1900* Darmstadt, 1965

Fregnac, Claude *Jewellery from the Renaissance to Art Nouveau* Weidenfeld, London, 1965; Putnam, New York, 1965

Hughes, Graham *Modern Jewelry, an International Survey, 1890–1967* Studio Vista, London, 1968

Ricketts, Howard *Objects of Vertu* Barrie & Jenkins, London, 1971

Wittamer-de Camps, L. *Le Bijou 1900* Brussels, 1965

Posters

Beaumont, Demeure de *L'Affiche Belge* Brussels, 1897

Cogswell, M. and Breitenbach, E. *The American Poster* American Federation of Arts, New York, 1967

Dooijes, D. *The Dutch Poster* Amsterdam, 1968

Fern, Alan *Word and Image* Museum of Modern Art, New York, 1968

Hiatt, Charles *Picture Posters* G. Bell, London, 1895

Julien, E. *Les Affiches de Toulouse-Lautrec* Monte Carlo, 1950

Maindron, Ernest *Les Affiches Illustrées* Paris, 1896

 Les Affiches Etrangeres Paris, 1897

Myrbach, Felicien Freiherr von *Die Fläche* Vienna, 1904

Pennell, J. *Les Affiches etrangeres illustrées* Paris, 1897

Polak, B. *Het Fin de Siecle in de Nederlandse Schilderkunst* The Hague, 1955

Roger-Marx, Claude *Les Maitres de l'Affiche* Paris, 1896–1900

Schardt, Herman *Paris 1900* Berlin, 1968

Sloan, Helen Farr *American Art Nouveau : the Poster Period of John Sloan* Lock Haven

Sponsel, J.L. *Das moderne Plakat* Dresden, 1897

Pottery and Porcelain

Barber, Edwin Attlee *Pottery and Porcelain of the United States* Putnam, New York, 1901

Bemrose, Geoffrey *Nineteenth Century English Pottery and Porcelain* Faber, London, 1952

Berling, K. *Festschrift der Königliches Sachsisches Porzellan Manufaktur Meissen* Leipzig, 1910

Blacker, J.F. *Nineteenth Century English Ceramic Art* Stanley Paul, London, 1911

Clarke, H.G. *Pictorial Pot Lids* London, 1970

Cox, Warren *The Book of Pottery and Porcelain* Crown, New York, 1944; Batsford, London, 1947

Dennis, Richard *Doulton Stoneware and Terracotta 1870–1925* R. Dennis, London, 1971

Erzgraber, J. *Königlich Berlin* Berlin, 1913

Eyles, Desmond *Royal Doulton 1815–1965* Hutchinson, London, 1965

Fisher, Stanley *Worcester Porcelain* Ward Lock, London, 1968

Fontaine, G. *La Ceramique française* Paris, 1946

Gans, Dr L. *Nieuwe Kunst* Utrecht, 1966

Godden, Geoffrey *Victorian Porcelain* Jenkins, London, 1961

Hawes, Lloyd E. *The Dedham Pottery* Dedham, Mass.

Hayden, Arthur *Royal Copenhagen Porcelain* Unwin, London, 1911

Henzke, Lucile *American Art Pottery* Nelson, Camden, New Jersey, 1970

Hillier, Bevis *Pottery and Porcelain 1700–1914* Weidenfeld, London, 1968

Honey, W.B. *European Ceramic Art: Dictionary of Factories, Artists etc.* Faber, London, 1952
 English Pottery and Porcelain Black, London, 1969; Macmillan, Toronto, 1964

Kollmann, E. *Katalog Berliner Porzellan 1751–1954* Cologne, 1954

Leach, Bernard *Potter's Book* Faber, London, 1940; Transatlantic Arts, New York, 1965

Lechevallier-Chevignard, G. *La Manufacture de Porcelaine de Sèvres* Paris, 1908

Leistikow-Duchardt, A. *Die Entwicklung eines neuen Stiles im Porzellan* Heidelberg, 1957

Le Vine, J.R.A. *Linthorpe Pottery* Middlesbrough

Mackay, James *Commemorative Pottery and Porcelain* Garnstone Press, London, 1971

Mankowitz, Wolf *Wedgwood* Dutton, New York, 1953; Batsford, London, 1953

Peck, Herbert *The Book of Rookwood Pottery* Crown, New York, 1968

Purviance, L. and E., and Schneider, N.F. *Zanesville Art Poetry in Color* Mid-American Book Co., Leon, Iowa, 1969

Ramsey, John *American Potters and Pottery* New York

Rust, W.J. *Nederlands Porselein* Amsterdam, 1952

Savage, George *Porcelain through the Ages* Penguin, London, 1954; Barnes & Noble, Baltimore, 1963
 Pottery through the Ages Penguin, London, 1959; Barnes & Noble, Baltimore, 1964

Schultz, S. *The Royal Copenhagen Porcelain Manufactory* Copenhagen, 1953

Verlet, Grandjean *Sèvres* Paris, 1953

Wakefield, Hugh *Victorian Pottery* Jenkins, London, 1962

Ware, George W. *German and Austrian Porcelain* Crown Publications, New York, 1963

Weiss, Gustav *The Book of Porcelain* Barrie & Jenkins, London, 1971

Private Presses

Cave, Roderick *The Private Press* Faber & Faber, London, 1971

Franklin, Colin *The Private Press* Studio Vista, London, 1969

Sparling, H. Halliday *The Kelmscott Press and William Morris, Master Craftsman* Macmillan, London, 1924

Tompkinson, G.S. *A Select Bibliography of the Principal Modern Presses Public and Private in Great Britain and Ireland* First Editions, London, 1936

Silver and Electroplate

Buhler, K.C. *American Silver* World Publications, New York, 1950

Dingelstedt, K. *Jugendstil in der angewandten Kunst* Brunswick, 1959

Grautoff, O. *Die Krisis im Kunstgewerbe* Leipzig, 1901

Honour, Hugh *Goldsmiths and Silversmiths* Weidenfeld & Nicolson, London, 1971

Hughes, Graham *Modern Silver Throughout the World, 1880–1967* Studio Vista, London, 1967

Lux, J.A. *Das Neue Kunstgewerbe in Deutschland* Leipzig, 1908

Taylor, Gerald *Silver* Penguin, London, 1956; Penguin, Baltimore, 1964 *Continental Gold and Silver* Connoisseur, London, 1967

Wardle, Patricia *Victorian Silver and Silver Plate* Jenkins, London, 1963

Biographies of Designers, Artists and Craftsmen

Briggs, Asa and Shankland, Graeme *William Morris : Selected Writings and Designs* Penguin Books, London, 1962

Crane, Walter *An Artist's Reminiscences* Methuen, London, 1907

Fourcaud, Louis de *Emile Gallé* Paris, 1903

Hammacher, A.M. *Le Monde de Henry Van de Velde* Paris, 1967

Henderson, Philip *William Morris, his Life, Work and Friends* Thames & Hudson, London, 1967

Howarth, Thomas *Charles Rennie Mackintosh and the Modern Movement* Routledge & Kegan Paul, Glasgow, 1952

Konody, P.G. *The Art of Walter Crane* G. Bell & Sons, London, 1902

McGraw, Dorothy *The Van Briggle Story* Colorado Springs

MacLaren, Andrew *Charles Rennie Mackintosh* Edinburgh, 1968

MacLeod, Robert *Charles Rennie Mackintosh* Country Life, London, 1969

Pevsner, Sir Nikolaus *Charles R. Mackintosh* Milan, 1950

Spielman, M.H. and Layard, G.S. *Kate Greenaway* A & C Black, London, 1905

Vallance, Aymer *William Morris, his Art, his Writings and his Public Life* G. Bell & Sons, London, 1897

Wilkinson, Raymond *William Morris as Designer* Studio Vista, London, 1967

Acknowledgments

The author and publishers would like to thank the following for supplying photographs and for permission to reproduce illustrations:

American Clock and Watch Museum, Bristol, Conn.; Ancient & Curious, London; Wayne Andrews, N.Y.; the Art Institute of Chicago, Mr and Mrs Victor H. Bacon II; Miss Mary Whitney Bangs; the Edith Barenholtz Collection; Miss S. D. Bliss; Bowes Museum; Sir John Briscoe; the Chicago Historical Society; Jeremy Cooper; the Irving Cooperman Collection; W. T. Copeland and Sons Ltd; the Corning Museum of Glass, Corning, N.Y.; Culver Pictures Inc., New York; Deane & Adams, London; the Everhart Museum, Scranton, Pa.; The Gamble House, Pasadena, California; the Gorham Manufacturing Company; the Collections of Greenfield Village and the Henry Ford Museum, Dearborn, Michigan; Haslam & Whiteway Ltd; Joseph H. Heil; Heritage Plantation of Sandwich, Mass.; the Hershey Museum, Hershey, Pa.; Angelo Hornak; the Elbert Hubbard Library Museum; Dr and Mrs Robert Koch; the London Museum; the Macklowe Gallery, New York; Mrs Doris Langley Moore; Musée des Arts Décoratifs, Paris; Museum of Modern Art, New York; Museum of the City of New York; the National Trust; the New York Public Library, Astor, Lenox and Tilden Foundations; the Newark Museum, New Jersey; Poster Originals; the Princeton University Art Museum, Princeton, New Jersey; Mr and Mrs George ScheideMantel; the Sladmore Gallery, London; the Smithsonian Institution; Sotheby's Belgravia; the Toledo Museum of Art, Ohio; the University of Glasgow, Mackintosh Collection; the Victoria and Albert Museum, London; Wartski Ltd, London; Josiah Wedgwood and Sons Ltd, the Worcester Royal Porcelain Company.

The publishers would like to thank Mr Angelo Hornak and Mrs Jeanette Kinch for taking the special photographs. They would also like to thank the staff of Sotheby's Belgravia, in particular Jeanette Kinch, Jeremy Cooper and Philippe Garnier, for invaluable help and advice, and Mrs Rosemary L. Klein for undertaking the picture-research in the United States.